Russian Jewish Artists
in a Century of Change 1890-1990

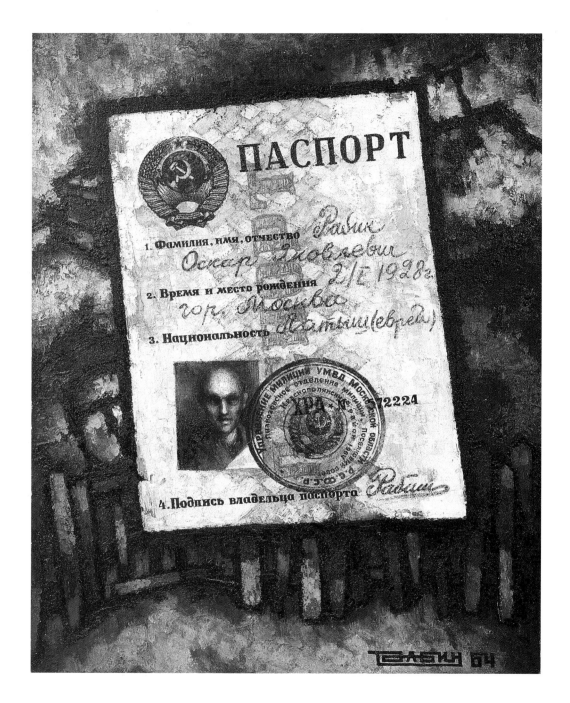

Russian Jewish Artists in a Century of Change 1890-1990

Edited by
Susan Tumarkin Goodman

With essays by
Ziva Amishai-Maisels
John E. Bowlt
Boris Groys
Viktor Misiano
Alexandra Shatskikh
Michael Stanislawski
Seth L. Wolitz

Prestel
Munich · New York

This book has been published in conjunction with the exhibition *Russian Jewish Artists in a Century of Change, 1890–1990* held at The Jewish Museum, New York, 21 September 1995–28 January 1996.

Russian Jewish Artists in a Century of Change, 1890–1990 has been supported by leadership grants from the National Endowment for the Humanities and the National Endowment for the Arts, federal agencies, The Skirball Foundation, The Dorot Foundation, the American Express Company, and a gift in memory of Kurt Hurst.

Transportation has been provided with the kind support of Lufthansa German Airlines.

Major gifts have been provided by Eugene and Emily Grant, the Trust for Mutual Understanding, the Louis and Anne Abrons Foundation, The Joseph Alexander Foundation, The Gloria and Sidney Danziger Foundation, The Lucius N. Littauer Foundation, and The Joe and Emily Lowe Foundation.

Additional funding has been provided by the Alfred J. Grunebaum Fund.

Indemnity for the exhibition has been provided by the Federal Council on the Arts and the Humanities.

The exhibition has been endorsed by the Ministry of Culture of the Russian Federation.

Exhibition Curator: Susan Tumarkin Goodman
Consulting Curator: Michael Stanislawski
Senior Exhibition Consultant: John E. Bowlt
Consulting Curator for Documentation: Marek Web
Exhibition Coordinator: Heidi Zuckerman
Manuscript Editor: Andrea P. A. Belloli, London
Exhibition Design: L. Breslin Architectural Design

Prestel-Verlag
Mandlstrasse 26, D-80802 Munich, Germany
Tel. (89) 38 17 09-0; Fax (89) 38 17 09-35
and 16 West 22nd Street, New York, NY 10010, USA
Tel. (212) 627-8199; Fax: (212) 627-9866

Front cover: Grisha Bruskin, *Memorial*, 1983
(detail; see ill. 13)
Frontispiece: Oscar Rabin, *Passport*, 1964 (see ill. 93)

Designed by Konturwerk, Rainald Schwarz
Typeset by Max Vornehm GmbH, Munich
Offset lithography by Fotolito Longo, Frangart
Printed and bound by Schoder, Gersthofen

Printed in Germany
ISBN 3-7913-1601-X

Photo Credits

Contents

Lenders to the Exhibition

A La Vieille Russie
Svetlana Aronov, New York
The Art Institute of Chicago
Badisches Landesmuseum, Karlsruhe
Bakhrushin State Central Theater Museum, Moscow
Galerie Garig Basmadjian, Paris
Beinecke Rare Book and Manuscript Library,
 Yale University, New Haven, Connecticut
Claude Bernard Gallery, Ltd., New York
Central Museum of the Armed Forces, Moscow
Ronald Feldman Fine Arts, Inc., New York
Fondation Dina Vierny—Musée Maillol, Paris
Frankel Nathanson Gallery, Maplewood, New Jersey
Barry Friedman Ltd., New York
Habimah Theater, Tel Aviv
Helix Art Center, San Diego
Houk Friedman, New York
Leonard Hutton Galleries, New York
The Israel Goor Theatre Archives & Museum,
 Jerusalem
The Israel Museum, Jerusalem
The Jane Voorhees Zimmerli Art Museum, Rutgers, The
 State University of New Jersey, The Norton and Nancy
 Dodge Collection of Nonconformist Art from the
 Soviet Union
The Jewish Museum, New York
The Jewish National and University Library,
 Jerusalem
The Jewish Theological Seminary of America,
 New York
The John F. Kennedy Center for the Performing Arts,
 Washington, D.C.
Kunsthalle in Emden—Stiftung Henri Nannen
Galerie Alex Lachmann, Cologne
Barbara Leibowits Graphics Ltd., New York
The Leo Baeck Institute, New York
Los Angeles County Museum of Art
Ludwig Forum für Internationale Kunst, Aachen
Marlborough Gallery, New York
The Metropolitan Museum of Art, New York
Mishkan Le'Omanut, Museum of Art, Ein Harod, Israel
Musée National d'Art Moderne, Centre Georges
 Pompidou, Paris
Museum Bochum, Germany
Museum Ludwig, Cologne
The Museum of Modern Art, New York
Museum of Private Collections of The State Pushkin
 Museum of Fine Arts, Moscow
Museum of the Russian Academy of Arts, St. Petersburg
New York Public Library
Pasternak Trust, Bristol
The Philadelphia Museum of Art
Productive Arts, Brooklyn Heights, Ohio
Rifkin-Young Fine Art Inc., New York
Russian State Archive of Art and Literature, Moscow
Ryback Art Museum, Bat Yam, Israel
Howard Schickler Fine Art, New York
Shchusev State Scientific Research Museum of
 Architecture, Moscow
The Solomon R. Guggenheim Museum, New York
State Museum of Art of the Republic of Belorussia, Minsk
State Museum of Theater and Musical Art, St. Petersburg
State Tretyakov Gallery, Moscow
Tambov Gallery of Art, Russia
The Tate Gallery, London
Tel Aviv Museum of Art

The Theater Museum (Haaretz Museum), Tel Aviv
Virginia Museum of Fine Arts, Richmond
Vitebsk Museum of Regional and Local History
Wadsworth Atheneum, Hartford
Witnesses to History Poster Collection, The Judah
 L. Magnes Museum, Berkeley
YIVO Institute for Jewish Research, New York
Zaraisk Museum of History and Art, Russia

Arledan Properties, Ltd., Jerusalem
Art Co. Ltd. (The George Costakis Collection)
Kenda and Jacob Bar-Gera, Cologne
Anatole and Maya Bekkerman, Forest Hills,
 New York
Bernie Bercuson, Bal Harbour, Florida
Merrill C. Berman
Jeff Bliumis, New York
Himan Brown, New York
Grisha Bruskin, New York
Farideh Cadot, Paris
Evgenia and Feliks Chudnovsky, St. Petersburg
The George Costakis Collection, Athens
Norton and Nancy Dodge
Theodore and Rivkah Friedgut, Jerusalem
Barry Friedman/Patricia Pastor, New York
Alfred and Pie Friendly, Washington, D.C.
Gilman Paper Company Collection
John Githens, New York
Alexander Glezer, Moscow
Gross Family Collection, Tel Aviv
Manfred Heiting, Amsterdam
Nicolas V. Iljine, Frankfurt/Main
Ilya and Emilia Kabakov, New York
Francine and Samuel Klagsbrun, New York
Vitaly Komar and Alexander Melamid, New York
Alexander Kosolapov, New York
Natalia Kropivnitskaya, Stamford, Connecticut
Inessa and Olga Lamm, New York
Leonid Lamm, New York
Evgeny and Irina Lein, Jerusalem
Alexander Levin, New York
Mireille and James I. Levy, Lausanne
Lilya Lion, Moscow
Vladimir Maramzin, Paris
Alexandra R. Marshall
Boris Mihailov, Kharkov, Ukraine
Moldovan Family Collection, New York
Ernst Neizvestny, New York
Diane Neumaier, New York
K. Nowikovsky Collection, Vienna
Vladimir Paleev, St. Petersburg
Vladimir Patsukov, Moscow
Alex Rabinovich, New York
Dr. and Mrs. Ira Rezak, Stony Brook, New York
Steven and Susan Rosefielde, Chapel Hill,
 North Carolina
Sackner Archive of Concrete and Visual Poetry, Miami
Alexander M. Shedrinsky, New York
Family of David Shterenberg, Moscow
Alexander Sidorov, Moscow
Collection Vyacheslav Sohransky, Moscow
John L. Stewart, New York
Craig H. and Kay A. Tuber, Northfield, Illinois
Drs. Irene and Alex Valger, Belle Harbor, New York
Mikhail Yershov, Moscow
Alexander Yulikov, Moscow

Private Collections

Foreword

With *Russian Jewish Artists in a Century of Change, 1890–1990,* The Jewish Museum is presenting the first major museum exhibition devoted to the work of Russian Jewish artists. This survey, including paintings, drawings, prints, posters, and sculpture of the century spanning 1890 to 1990, focuses attention on the surprisingly distinguished contribution of Jewish-born artists in the last years of the Tsarist empire and the entire era of the Soviet Union. While the role of Jews in Russian literature, science, religion, and especially the performing arts has been chronicled in some detail, their participation in the fine arts has only been studied sporadically and has never been the subject of such a large-scale critical investigation.

The over three hundred works of art and documents in the present exhibition include remarkable examples by the best-known figures—Isaak Levitan, Marc Chagall, El Lissitzsky, and Ilya Kabakov—but there are also a host of surprising discoveries such as Alexander Tyshler, Yehuda Pen, and David Shterenberg. Through these original works of art drawn from around the world, especially those from Russian collections never before seen in the West, as well as the catalogue essays by an international roster of scholars, the exhibition addresses many of the key issues of this century, which witnessed such dramatic cultural, political, and social upheaval. These themes, which appear as leitmotifs throughout the distinctive periods detailed here, include the interaction and the survival of Russian and Jewish identities, the nature of assimilation, and the institutionalization and control of artistic expression in a totalitarian state. As our authors make abundantly clear, there is no one right interpretation of these events, and the visitor and reader will be challenged to come to their own conclusions about this era, which while traumatic saw the production of such brilliant art.

During the very time that this exhibition was being organized, the Soviet Union actually underwent the most overwhelming change since its creation following the Bolshevik Revolution. The post-Perestroika Russia that emerged provided unprecedented access to collections long hidden or unknown, both public and private. Archives became available to foreigners for the first time. Just as important was the opportunity for the Russian community of artists, historians, and critics to engage in open exchange with the outside world. This process, as our exhibition makes evident, has provided the chance to present the extraordinary story of Russian Jewish artists as both mainstream and marginalized cultural figures. Although the exhibition focuses on a period that is already part of history, its subject has much contemporary relevance. The response of art to tumultuous times and the ongoing survival of a Jewish voice in the unstable new Russian world will be issues that continue to concern us in the twenty-first century.

This project has been an enormous undertaking. As such it has depended on the cooperation of an unusually large number of individuals and institutions, beginning with those curators and scholars who initially gave shape to the show, the funders who supported its planning, and all the museum staff members, consultants, lenders, granting agencies, government officials, and trustees who devoted time and effort to bringing the concept to fruition. My heartfelt thanks for a job well done go to Susan Tumarkin Goodman, Chief Curator of The Jewish Museum and the person who first conceived the project and whose abiding commitment to the subject made this exhibition a triumph of discovery and the catalogue a significant addition to scholarship. In her preface Ms. Goodman acknowledges all those whose contributions to both the exhibition and catalogue have been so invaluable.

Here I should like particularly to thank all the lenders listed on page 6. These institutions and individuals in Russia, the United States, Israel, and Europe have made the exhibition possible, and we are greatly indebted to them all. Exceptional cooperation came from the State Tretyakov Gallery in Moscow, under the direction of Valentin A. Rodionov and Deputy Director Lidia I. Iovleva, with assistance from Deputy Director Raisa A. Litvinova and Chief Registrar Tatiana Gorodkova, each of whom provided a sincere and sustained commitment to this project. The gracious consideration they showed to The Jewish Museum deserves our profound gratitude. In addition, the Russian State Archive of Art and Literature, Moscow, was extremely generous with the loan of rare documents. Both Natalya B. Volkova, Director, and Olga Rozhkova, Chief of the Department, must be credited for their assistance in the identification and selection of relevant works from the archive. Of crucial importance was the official support given to this project by the Ministry of Culture of the Russian Federation under the direction of Deputy Minister Mikhail E. Shvydkoi, assisted by the chief of the Museum Department, Vera A. Lebedeva. The Vuchetich All-Union Artistic Production Association (VUART-VKHPO), under General Director Alexander Ursin, agreed to coordinate loans from institutional and private lenders in Russia and the former Soviet Union.

8

The exhibition would also not have been possible without the very generous grants we received from both the National Endowment for the Arts and National Endowment for the Humanities. These essential government agencies provided funds in both the planning and implementation stages, thus enabling us to create the exhibition, produce the catalogue, and present a series of related events. Over the last few years, Nicolas V. Iljine, Manager of Public Affairs, Lufthansa German Airlines, has shown a sustained commitment to the exhibition of significant works from Russian collections in the West. Our sincere thanks to him and to Lufthansa, which not only helped with the early stages of research-related travel but also provided us with generous assistance in the transportation of both art and individuals from Russia, Europe, and Israel. Over the years, Lufthansa has been an important and reliable partner to the Museum in its efforts with international exhibitions. In addition, the Museum received support from the Trust for Mutual Understanding, and we are grateful to the trust's director, Richard S. Lanier, whose vision and support at the outset of planning enabled the pursuit and development of this project. The late Eric Estorick also provided funds for which we are most grateful. Further assistance for the exhibition and its programs came from The Dorot Foundation, The Skirball Foundation, the American Express Company, a gift in memory of Kurt Hurst, Eugene and Emily Grant, The Louis and Anne Abrons Foundation, The Joseph Alexander Foundation, The Gloria and Sydney Danziger Foundation, The Lucius N. Littauer Foundation, The Joe and Emily Lowe Foundation, and the Alfred J. Grunebaum Fund. Moreover, the insurance of the non-Russian foreign loans was supported by an indemnity kindly granted by the Federal Council on the Arts and the Humanities.

This atmosphere of collaboration and generosity on an international scale grew up in response to the unique and fascinating role played by Russian Jewish artists throughout the past century. The momentous recent changes in Russia have made it possible for The Jewish Museum in New York to undertake *Russian Jewish Artists in a Century of Change, 1890–1990*, on a monumental scale, and we hope that our visitors will find seeing the exhibition as moving and overwhelming an experience as it has been for all of us to assemble it.

Joan Rosenbaum
Helen Goldsmith Menschel Director

Preface and Acknowledgments

Since the break-up of the Soviet Union, scholars everywhere have sought to acquire a better understanding of Russia's past. The Jewish Museum seized the opportunity to examine the unique place of Jewish artists in the history of a nation that has long been home to a major segment of world Jewry.

An examination of the works in this exhibition and of the related documentation that accompanies it reveals a great deal about the ambiguous situation faced by many who saw themselves simultaneously as Russians, as artists, and as Jews. Their lives were colored by a society in which identity was and still is determined by a particular religious, ethnic, or national inheritance. For Jews, the effect of being outside the ethnic mainstream in a country renowned for its nationalism had a significant impact on their creative life and work.

Although issues related to the Jewish experience and its manifestations in art have been debated in the West, such discussions are just beginning in Russia. It is not surprising, then, that the preparation of this exhibition was met with concern by artists and art professionals in Russia and abroad as to how issues of ethnic and national identity would be treated. In discussions with scholars and critics in Russia, several different points of view were revealed. Some echoed the emigré poet Joseph Brodsky, who believes that there is "something very wrong about addressing—not to mention stressing—an artist's ethnic identity." Brodsky claims that this is "like going in the direction exactly opposite to that of [the artist's] brush." Others were decidedly uncomfortable with reclassifying as Jewish artists those traditionally seen as Russian national figures.

While it is certainly not our intention to reduce art to a question of ethnic identity, we do aim to highlight some of the complexities of life for Jewish artists in a world that has been partially hidden from Western eyes for decades. Indeed, the near loss of their distinct minority culture, as well as the struggle of Jews to reconcile their multiple identities, might account for the near absence of explicit Jewish content in their work. This exhibition may raise more questions than it answers, but, as Senior Exhibition Consultant John E. Bowlt has observed, it will direct "broader attention to the issue of the Jewish presence in Russian art that for too long has been considered an exclusively Russian achievement."

In assembling a new perspective on both the art and the history of a turbulent century, we have benefitted from the cooperation of numerous individuals. A project of this scope and complexity could not have been realized without the confidence and encouragement of Joan Rosenbaum, Helen Goldsmith Menschel Director of The Jewish Museum. Our entire Board of Trustees, in particular the Exhibition Committee chaired by Stuart Silver, supported the project from its earliest conceptual discussions.

I am especially grateful to Michael Stanislawski, Nathan J. Miller Professor of Jewish History at Columbia University, who was involved from the initial planning stages. His insights and advice were crucial to the project. My sincere thanks to John E. Bowlt, Professor of Slavic Languages and Literatures at the University of Southern California, Los Angeles, for making wise suggestions and generously sharing his extensive expertise.

From the outset it was our intention to create a strong contextual framework in which to place the works of art. My gratitude is extended to Marek Web, Chief Archivist, YIVO Institute for Jewish Research, who worked with us to gather an impressive array of documentary material from Russia, Israel and the United States in order to elucidate the works in the exhibition. I would also like to acknowledge the significance for this project of the ground-breaking material presented in the exhibition and catalogue entitled *Tradition and Revolution: The Jewish Renaissance in Russian Avant-Garde Art, 1912–1928*, organized by The Israel Museum, Jerusalem, in 1987.

I wish to acknowledge the support provided throughout the years of exhibition planning by Nicolas V. Iljine, Manager of Public Affairs, Lufthansa German Airlines. His willingness to share his vast knowledge of the Russian art world, along with his encouragement and advice, figured significantly in realizing this project.

While this exhibition could not have been mounted without the assistance of many people in Russia, I would like to thank, in particular, Zelfira Tregulova, chief of the Exhibition Department of VUART, who coordinated and directed every phase of the loans from that country. Her tireless efforts to ensure that the works would be of the highest caliber were invaluable. Also appreciated was the gracious assistance of—and tenacious pursuit of works of art in Russia by—Inna Balakhovskaya, art expert at VUART. I wish to thank Nina Galkina, art expert at VUART, for her work as well.

An exhibition of this scope required the dedication and commitment of a superb group of Jewish Museum associates. I am grateful for the wise advice and counsel provided in the formative stages by former Assistant Director of Programs Ward

Mintz and, in the later stages, by Sharon Blume, consultant to the Museum's curatorial departments, and Eric Zafran, Deputy Director of Curatorial Affairs. My deepest appreciation goes to Heidi Zuckerman and Ellen Adams for their tireless and efficient efforts. Ms. Zuckerman coordinated the intricate details of the catalogue and solved numerous complex problems crucial to the realization of the exhibition. Ms. Adams skillfully and tactfully managed the correspondence and oversaw the checklist with calm and cheer. We very much appreciate the efforts of Emily Whittemore, former Curatorial Assistant. Kathleen M. Friello provided cogent suggestions during the early stages of this project that were greatly appreciated. The late Jean Moldovan was a valued member of our research team who provided significant resources and astute recommendations for the documentation section. Troy Moss deserves a special acknowledgment for her gracious and capable advice and assistance with many aspects of the catalogue text. We are also grateful for the varied tasks performed by Idana Goldberg, Julia Goldman, Emily Greenberg, Mariani Lefas-Tetenes, Penny Liebman, and interns Charlotte Berger, Robert Finkelstein, Emily Fox, Pamela Friedman, Dana Kanter, Jan Kotik, Juliana Kreinik, Olga Liebkind, Ruth Lilienstein-Gatton, Sally Lindenbaum, Melissa Robbins, Melissa Rosenberg, Jena Schwartz, Alexandra Warren, and Joshua Waxman. Simon Rasin's assistance with Russian translation was also important and appreciated.

Numerous other colleagues at The Jewish Museum provided invaluable expertise and advice. We are particularly indebted to Dennis Szakacs, former Manager of Program Funding, for his efforts in crafting the grant proposals that led to the successful funding of the project by the National Endowment for the Arts and National Endowment for the Humanities. Geri Thomas, former Administrator of Exhibitions and Collections, and Susan Palamara, Registrar, skillfully handled the multitude of detailed arrangements necessary for the gathering, shipping, insuring, and touring of the exhibition. Publicity was masterfully coordinated by Anne Scher, Director of Public Relations. A rich offering of lectures and special events was organized by Jack Salzman, Deputy Director of Media and Public Programs; Aviva Weintraub, Manager of Public Programs; Judy Siegel, Director of Education; and Wanda Bershen, former Director, National Jewish Archive of Broadcasting. Claudette Donlon, former Deputy Director for Administration, William Jackson, former Acting Deputy Director for Administration, and Jane Dunne, Deputy Director for Administration, supplied expertise on contract and administrative matters, while

our controller, Donna Jeffrey, helped us tackle challenging budgetary issues. Norman Kleeblatt, Susan and Elihu Rose Curator of Fine Arts, Susan Braunstein, Associate Curator for Archeology, Irene Zwerling Schenck, Research Associate, and Samantha Gilbert, Administrator, provided varied advice and assistance. The enthusiasm of the Museum Shop director, Robin Cramer, for the material in this exhibition resulted in a panoply of related Russian products for the shop. Ann Appelbaum, Counsel, The Jewish Theological Seminary of America, provided astute and wise guidance on the legal matters that arose during exhibition preparation.

My deepest gratitude goes also to the museum professionals, scholars, critics, and art dealers in Russia, Germany, Israel, and the United States who gave generously of their time, ideas, and professional expertise. They include (in Russia) Joseph Bakstein, Julia and Marat Guelman, Pavel Khoroshilov, Semyon Laskin; (in France) Lili and Michel Brochetain; (in Germany) Aliki Kostaki, Alex Lachmann, Vasily Rakitin; (in Israel) Ziva Amishai-Maisels, Ruth Apter-Gabriel, Bill Gross, Lola Kantor, Grigory Kazovsky; (in the United States) Jacob Baal-Teshuva, Stephanie Barron, Zvi Gitelman, Raffi Grafman, Phyllis Kind, Inessa Lamm, Aaron Lansky, Alexander Levin, Diane Neumaier, Alla Rosenfeld, and Alex Shedrinsky.

A number of other individuals deserve special thanks for their assistance. Galina Main provided abundant help at the outset of this project, sharing her experience and knowledge of contemporary Soviet art. Yaacov Goodman enabled us to borrow work from Belorussia. Molly Raymond at the United States Information Agency offered suggestions that led to important contacts. My initial exposure to the issues surrounding this exhibition go back to illuminating conversations I had with Michael Grobman in Tel Aviv. He kindly shared his insights and experiences as one of the first Jewish artists, following the Khrushchev thaw, to address his Jewish heritage. It was also a particular pleasure to become familiar with the significant collection of Norton Dodge, and his willingness to lend pivotal works to the exhibition is most appreciated. I am also grateful to Dr. Alfred Moldovan, who with his late wife, Jean, graciously put their extensive holdings of Jewish books, documents, and posters at our disposal. Aliki Kostaki, Vladimir Paleev, and Evgenia B. Chudnovsky, whose families were active collectors during the Soviet period, have generously shared some of their major works.

I would like to thank our manuscript editor, Andrea P.A. Belloli, and the staff of Prestel-Verlag, our copublisher. The Russian essays were skillfully

translated by Jane Bobko (Shatskikh), Tamara Glenny (Misiano), and Rawley M. Grau (Groys).

Lynne Breslin created an effective exhibition design, which thoughtfully and clearly integrated the works of art with related ideas. Her talent as an architect combined with her experience as a professor of Russian architecture enabled Ms. Breslin to provide expert advice on how to transform her design concept into reality.

Throughout the preparation of this exhibition, my husband, Jerry Goodman, offered constant support and encouragement. For his assistance in countless ways, as well as his patience, he has my gratitude.

Russian Jewish Artists in a Century of Change, 1890–1990 ends with Perestroika, marked in the art world by the first auction of contemporary Soviet art, organized by Sotheby's in Moscow in 1988. The inclusion of nonconformist artists in an approved commercial venture designed to attract hard currency from abroad neutralized the distinction between official and unofficial art. All artists in what was still the Soviet Union hoped that this was the beginning of the end of the politicization of artists by state authorities. For Jewish artists this dawning era brought with it a new and promising dimension— one that had eroded with the end of the Jewish cultural renaissance in the 1920s. Now there was the possibility of a resurgence of Jewish consciousness which, in time, could lead to a consideration of their Russian and Jewish heritage as a significant creative source. This exhibition is one step in that direction.

Susan Tumarkin Goodman

The quote from Josph Brodsky is from a letter to the author dated 5 July 1994. That from John E. Bowlt is from a telephone conversation with the author on 11 April 1995.

Notes to the Reader

For this catalogue, we have generally adopted the system of transliteration employed by the Library of Congress, with a few modifications. First, the Russian *ye* has been represented by *e*, and we have used *ee* rather than *eye* (i.e., Moiseevich instead of Moiseyevich). Second, no symbols have been employed for the Cyrillic hard and soft signs. Third, *y* has been used rather than *ii* at the end of proper names. The Russian *ia* has been written as *ya*, while *iu* has been transliterated as *yu*. For the names of artists, we have combined two methods. For artists who were or are active chiefly in Russia, we have transliterated their names according to the modified Library of Congress system. In the case of artists known in the West, we have used either the spelling the artist adopted or the one that is generally recognized.

Only works created in Russia or the Soviet Union by artists of Jewish origin have been included in the exhibition. Dimensions of works of art are indicated in the following order: height precedes width precedes depth. Bibliographic entries on the artists and in the selected general bibliography at the end of this volume were selected on the basis of their importance within the framework of the exhibition. In any volume proposing to range over many aspects of a broad subject, detail must be sacrificed at some point in the interest of breadth. The artists' biographies are, for this reason, fairly summary. We trust, however, that no essential information has been omitted. Readers interested in finding out more about a specific individual are referred to the artists' bibliographies and/or to the selected general bibliography. The artists' biographies and bibliographies were prepared by Kathleen M. Friello, Nina A. Gourianova, Troy Moss, Diane Neumaier, Alla Rosenfeld, and Ekaterina Yudina.

Illustrations referred to in the essays are numbered accordingly as figures. Illustrations of works in the exhibition are designated by either the term *plate* or the abbreviation *ill.* Plate numbers refer to color illustrations, while ill. numbers refer to black and white reproductions accompanying the artists' biographies.

Seth L. Wolitz

Experiencing Visibility and Phantom Existence

Beginning with the Enlightenment (Haskalah) in the late nineteenth century, the Jews of Russia faced a major ontological and epistemological crisis of identity. Westernization, with its new categories of truth, objectivity, consciousness, and behavior, deeply disturbed the Jewish intelligentsia, producing a fragmentation of its old cultural values, structures, and institutions along the basic fault line of accommodation or rejection.[1] For the first time, the Jewish people were offered a glimpse of an alternate perspective of themselves, a perspective not just of a sacral community in exile, but of a new secular peoplehood with contemporary concerns and interests comparable to and shareable with those of other "enlightened" peoples.

Rejecting traditional religious and cultural traditions, the Enlightenment valorized secular aesthetic production in its various media as a new and basic attribute for cultural representation. By proffering aesthetic production as an instrument of cultural expression and experimentation, the Enlightenment rejected the perceived fixity of Jewish traditional culture and placed Jewish artists in the vanguard of change. At the same time, Jewish artists (and intellectuals) acquired aesthetic theory, as well as new theoretical conceptions of self and ethnos, from Enlightenment thinkers and artists in the West. Jewish artists also had to reckon with the subalternity of the Jewish people within the Slavic reality. The Tsarist regime functioned as a hegemonic power demanding assimilation while reinforcing Jewish marginality in a quasi-colonialized condition. Placed by Jewish birth in a condition of political and cultural marginality and rejected by their own traditional society, Jewish artists, in a double bind, used their art to affirm the autonomous self, rally the secular national idea, and participate in the "universal" Republic of letters and arts. The artistic performance of Jewish artists in Russia always informed a multifaceted undertaking with extra-aesthetic intentions.

How could it not be this way? Jewish artists expressed the deterritorialized condition of their people with all its historical and quotidian realities. In nineteenth-century Russia, traditionalist Jews with their God-centered universe, their frozen time—and—space perspectives of Jewish sacral history waiting for fulfillment at the messianic moment, necessarily sought religious freedom over more secular forms of empowerment. Jewish artists, conversely, whether on the printed page, on canvas, or on the stage, sought to articulate the experience and aspirations of the folk, as well as to envisage new cultural parameters for a restored Jewish people.

The absence of Jewish secular art production in Russia until the latter part of the nineteenth century meant that the representation of the Jew was in the gaze of the Other. How many Gentile artists depicted Jews in the past two centuries! In Tsarist Russia, most of the Gentile artists who represented Jews were Poles, since they came into daily contact with Jews residing within the Pale of Settlement.[2] Gentile representations of Jews, whether serious or caricatural, emphasized what Gentiles had determined was typical or exotic.

By creating their own artwork, Jewish artists in Russia brought to an end the monopolization by the Other of the visual definition of the Jew. Jewish artists asserted their own gaze, removing Jews from their marginalized condition by reading them into the center of their cultural representation. The Jewish gaze restored, normalized, and legitimized the Jewish body and its cultural presence.[3] By appropriating the Jewish self and its representation, Jewish artists in Russia claimed self-legitimacy and established a cultural space, a symbolic reterritorialization, a canvas, on which projections, subversions, reinventions, and assimilations were performed upon themselves, the nation, and the Other.[4] Thus, Jewish artists constructed Jewish cultural identity from their own gaze, beholden neither to the Other nor to Tradition as defined by the shtetl leadership. Jewish artists acquired by their performance their own voices and authority.[5]

We must never forget that the act of figurative drawing for Jews in Eastern Europe automatically and dramatically violated a religious taboo inscribed in their traditional culture. Sholem Aleichem's little hero, Motl, for example, is severely reprimanded for drawing.[6] And the violence visited on Chaim Soutine in his Lithuanian shtetl for drawing was heartrending.[7] The act of becoming a Jewish artist implied a revolutionary statement, a break with a traditional norm of great consequence: art served to reconfigure traditional culture (not its religion). Both Judaism and Islam as religious structures have inspired remarkable cultural artifacts in the form of calligraphy, tomb carvings, and cultic objects whose aesthetic character, however secondary in importance, has heightened the quality of ritual performance. These artifacts often served as a ground from which newly secularized artists could draw inspiration to create art objects within a new, secular space.

This secular aesthetic space implied a necessary cultural hybridity.[8] In order to become secular art-

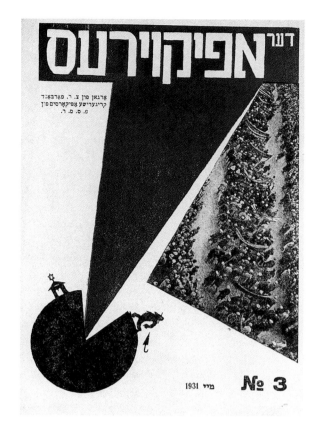

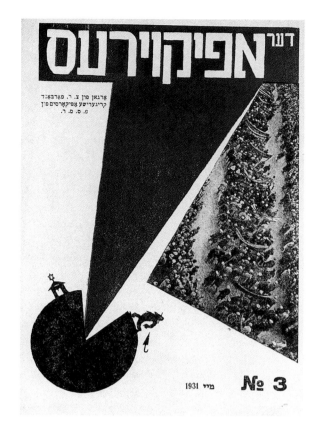 (cover image shows)

דער אפיקורעס

אָרגאַן פֿון צ. ר. פֿאַרבאַנד
קריגעֿרישע אַפּיקאָרסים פֿון
פ. ס. ס. ר.

1931 מײַ № 3

El Lissitzky
The Atheist
(Moscow: Association of
Militant Atheists, May
1931, no. 3)
12 x 8¹/₂ in. (30.5 x 21.6 cm)
YIVO Institute for Jewish
Research, New York
© 1995 Artists Rights Society
(ARS), New York/VG Bild-Kunst,
Bonn

and nonobjective plastic terms.[11] Jewish artists in Russia and the Soviet Union, with their artifacts of culture, produced metonymies of the new Jewish consciousness engaged in the world.

Seth L. Wolitz
is Gale Professor of Jewish Studies and Professor of French and Slavic Languages at the University of Texas at Austin.

ists, Jewish painters and those of other subaltern groups sought to integrate into their emerging new cultures Western modes of aesthetic expression and ideological norms. This meant the utilization and adaptation of various aesthetic properties of the Other, the West: visual grammar and vocabulary, media, painterly techniques, modes of stylistic expression, and even iconography. If this "assimilation" of the West proved excessive, the resulting artwork might appear epigonic, cliched, or exotic.[9] Imitation, as Ahad Ha'am noted, should not lead to a loss of self-consciousness. Cultural hybridity expresses the creativity of the artist, inventing and renewing old/new culture. Tradition, fixed in a self-sustaining, immutable ideal, argues for an essentialist vision of culture—a purity—which it alone possesses.[10] Jewish artists in Russia and the Soviet Union, by rejecting cultural solipsism, introduced a seemingly antithetical element drawn from the difference of the Other, thereby generating a new, evolving synthesis and reshaping their culture.

Jewish artists, in hindsight, mistakenly sought to create an Absolute, an unobtainable renewed cultural purity and fixity, when, in fact, their artworks were components of the evolutionary process of a living culture released from stagnation. Jewish artists interpreted and offered their people a mirror of the modern by providing legitimizing perspectives on Jewry with its new concerns in both objective

Notes

[1] Jonathan Frankel, *Prophesy and Politics* (Cambridge: Cambridge University Press, 1981), p. 30; Eli Lederhendler, "Modernity without Emancipation or Assimilation? The Case of Russian Jewry," in Jonathan Frankel and Steven J. Zipperstein, eds., *Assimilation and Community* (Cambridge: Cambridge University Press, 1992), pp. 324–43.
[2] Marek Rostworowski, ed., *Zydzi w Polsce, obraz i slowo* (Warsaw: Wydawnictwo Interpress, 1993), pp. 38, 42–43, 56, 154–56, 220–23.
[3] Sander Gilman, "The Jewish Body: A Footnote," in Howard Elberg-Schwartz, ed., *People of the Body* (Albany: State University of New York Press, 1992), p. 223.
[4] Gilles Deleuze and Felix Guattari, "What Is a Minor Literature?" in *Kafka: Toward a Minor Literature* (Minneapolis: University of Minnesota Press, 1986), pp. 16–27.
[5] Richard I. Cohen, "Self-Image through Objects: Toward a Social History of Jewish Art Collecting and Jewish Museums," in Jack Wertheimer, ed., *The Uses of Tradition: Jewish Continuity in the Modern Era* (New York: Jewish Theological Seminary of America, 1992), pp. 203–42.
[6] Sholem Aleykhem, *Motl Peyse dem Khazns* (Buenos Aires: Icuf, 1953), vol. 4, chap. 17, pp. 153–54.
[7] Efraim Sicher, "Chaim Soutine," in Glenda Abramson, ed., *The Blackwell Companion to Jewish Culture* (Oxford: Basil Blackwell, Inc., 1989), p. 725.
[8] Homi K. Bhabha, *The Location of Culture* (London: Routledge, 1994), p. 38; Mary Schmidt Campbell, ed., *Harlem Renaissance Art of Black America* (New York: Harry N. Abrams, 1987), p. 16.
[9] Frantz Fanon, *The Wretched of the Earth* (New York: Grove Weidenfield, 1963), pp. 222–23.
[10] Eric Hobsbawn, "Inventing Traditions," in Eric Hobsbawn and Terence Ranger, eds., *The Invention of Tradition* (Cambridge: Cambridge University Press, 1983), pp. 2–8; Norman Salsitz as told to Richard Skolnik, *A Jewish Boyhood in Poland* (Syracuse: Syracuse University Press, 1992), p. 169.
[11] Michael Berkowitz, "Art in Zionist Popular Culture and Jewish National Self-Consciousness, 1897–1914," in *Art and Its Uses*, vol. 6 (New York: Oxford University Press, 1990), pp. 35–36.

Michael Stanislawski

The Jews and Russian Culture and Politics

In order to understand the fascinating and con-founding story of Jews as artists in Russia and the Soviet Union from the end of the nineteenth century to the end of our own, one must have a broad and yet somewhat detailed knowledge of the history of the Jews in those societies. Most importantly, one must attend with sensitive eyes and ears to the com-pelling and contradictory history of Jewish involve-ment in the culture and politics of Russia and the Soviet Union in the last century. For the strange story that unfolds in this exhibition—as in the history it documents—is one of both attraction and aliena-tion, conscious intimacy and unconscious repul-sion. As such, it involves many of the most profound wellsprings of Jewish history and Russian history in the modern period.

Precisely because this history is so important to both the Jews and the Russians, an objective retell-ing of the story is well-nigh impossible or, at the very least, will be deeply unsatisfying to those who like their history, and especially their "national histo-ries," cut and dried, neatly divided into good guys and bad guys, us and them, victims and aggressors. Like much of the art displayed in this exhibit, this history does not follow traditional patterns of light and dark, observer and observed, subject and object, real and unreal, Jewish and Gentile, Russian and foreign. Much of the story that follows, then, will be disturbing and dismaying, even frightening at times, full of horrors and pain, though punctuated intermittently with episodes of rapturous hopeful-ness and untrammeled belief in the possibility of human freedom and salvation. And the story ends not with clarity and finality, but with confusion and uncertainty, trepidation mixed with a little hope.

This essay will attempt, in brief, to summarize and analyze the history of the Jews in Russia and the Soviet Union from 1881 to 1988 with particular emphasis on the relationship of the Jews to Russian culture and Russian politics, and to their intersec-tion. It will ponder the nature of the increasing but always problematic Russification of the Jews, and particularly the persistent paradox that envelops and defines that Russification: that even the most Russi-fied Jews understood (as they do today) that they were not Russians, nor could they ever become Rus-sians. They were Jews, however one defined that term. Even as they adopted Russian as their mother tongue, abandoned the traditional practices of the Jewish religion, replaced the Bible and Talmud and

Jewish folk culture with Pushkin and Turgenev and Gogol and the talk of the street, they could become bearers of Russian culture, creators of Russian and then Soviet culture, and even proud and loyal citi-zens of Russia and the Soviet Union—but not Rus-sians, i.e. Russians by nationality.[1]

This, it must be stressed, was not solely the result of anti-Semitism, on the one hand, or of Jewish eth-nic/national/religious pride, on the other, not to speak of an ineffable Jewish spirit or *Volksgeist*, as some commentators would have it—though both anti-Semitism and the Jewish will to survive were crucially involved. Of overriding importance was the fact that both the Russian Empire and the Soviet Union were multinational states, dominated demo-graphically and politically by the Russians, but always with a clear distinction between the Russian nation and its underlings: Jews, Georgians, Lithua-nians, Uzbeks, etc. Indeed, in the Russian language there is a crucial distinction between two adjectives which we translate as "Russian": *russkii*—Russian by nationality—and *rossiiskii*—Russian by political or cultural affiliation. In sum, there was, and remains today, a distinction, clear and palpable if oftentimes unselfconscious, between Russians and Jews that could not be effaced, even if and when the Jews might be entirely Russified.

This was radically different from the situation that obtained not only in France, England, Germany, and the United States, but even in neighboring countries such as Hungary and Poland. In these lands, Jews could and did believe themselves to be Americans, Frenchmen, Englishmen, Germans, Hungarians, or Poles of the Jewish religion, "Mosaic faith," Jewish origin—or, more recently, Jewish eth-nicity. Though much of Jewish cultural, ideological, and intellectual history in the modern period has revolved around debates over the saliency of these terms and their political correctness, no one would doubt that masses of Jews so conceived of them-selves and were conceived of by others from the French Revolution on.

But Russia was different. Russians and Jews seem-ed to inhabit two distinct semantic spheres, no mat-ter how much they interacted or intersected. Though one could conjure up appellations such as "Russian Jews" or even "Russians of the Jewish faith," these were understood by all to be artificial constructions, since it was clear that Russians were Russians and Jews were Jews, even if the content of both terms would change radically over the cen-turies.

The most important fact to understand about Russian Jews prior to 1881 is that this largest Jewish community in the world lived in the Russian Empire,

not in Russia proper but in the Belorussian, Lithuanian, and Ukrainian provinces of the Russian Empire, lands annexed in the late eighteenth century as a result of the dismantling of the Polish-Lithuanian Commonwealth.[2] For reasons both religious and economic, the Russian state from the late eighteenth century to the middle of the First World War refused to allow the masses of the Jews to move from these provinces—the so-called Pale of Settlement—to the interior of Russia itself, to live among the ethnic Russian population. And so most Jews living in the Russian Empire had very little truck with Russians proper other than government officials and military personnel. They lived their lives mostly within the Jewish community, albeit with extensive economic interaction with the non-Jewish populations among whom they had lived for centuries—mostly Ukrainian, Belorussian, Polish, and Lithuanian peasants; nobles who were either Polish or Polonized; and a motley mix of mercantile groups including Germans, Armenians, Italians, and Greeks.

Only very slowly and fitfully did the Russian government actually begin to attempt to integrate these provinces and provincials into the cultural, social, and linguistic orbit of "Russianness," and when the policy of Russification did commence (roughly from the 1820s on, and then more forcefully in the 1840s), it was always halfhearted, quixotic, and compromised by a heavy dose of repression and rejection.

In essence, the Tsarist government was very ambivalent about how to treat the millions of Jews under its sway. On the one hand, it regarded them as totally alien, foreign, and bizarre, as well as economically undesirable, religiously impious, and morally corrupt; hence the proper treatment was repression, persecution, exploitation. On the other hand, the government sensed that the best way to solve the "Jewish problem" was to attempt to level the distinctions between Jews and Gentiles, to destroy the autonomy of the Jewish community, to draft the Jews into the Russian army, to weaken the hold of traditional Judaism, the Jewish school system, the Yiddish language—in sum, to effect what was variously called a "rapprochement" or a "merging" of the Jewish and Russian populations. Thus, the Jews were encouraged to enter Russian-language schools and universities; to serve in the army; to learn to speak, read, write, and think in Russian; to "enlighten" Judaism and Jewish culture in line with the dictates of modern, and especially Russian, society; and to retool themselves economically as farmers or craftsmen, or even as professionals, rather than as small-time merchants and traders. That this policy of rapprochement, or Russification, essen-

tially contradicted the overarching policy of repression and exclusion was in fact noted by some clear-thinking Russian bureaucrats in the nineteenth century. But the Tsarist state was riddled by dozens of such contradictions and tensions in regard to issues far more central to its concerns than the Jews—economic modernization, industrialization, serfdom, foreign policy, and legality, to name only a few.

And so, in the midst of—and despite so much—repression and persecution, small but significant numbers of Jews nonetheless began to adopt Russian as their preferred language of communication and creativity, to attend Russian schools and universities, to be moved by Russian culture and Russian literature. This was a result partly of intellectual design—the legacy and influence of the Jewish Enlightenment movement—but also of political and economic expediency. In the early 1860s, Tsar Alexander II began to include the Jews as beneficiaries of his liberalizing policies and attempt to recast Russia as a more benign state. Thus, the horrific conscription system that had brutalized Russian Jewry for a generation was significantly eased; Jews were encouraged to enter Russian-language schools, gymnasia, and universities without restriction; even the rules regarding the Pale of Settlement began to be eased, as wealthier Jews and those with university educations or training as artisans were permitted to reside outside the Pale and in the interior of Russia itself.

Even within the Pale, significant numbers of Jewish parents began to realize that the acquisition of the Russian language and a Russian education might ease their children's lives, improve their economic status, allow them to move out of conditions of constriction and poverty. As the Russian state began, albeit hesitantly, to modernize its economy—to build railroads and factories, to encourage the development of the liberal professions, and the like—the attraction of Russification and the concomitant abandonment of the old, traditional Jewish way of life increased proportionately, though of course severely limited by the political constraints and repressive policies of the very same regime.

Typical of the processes just described is the story of none other than Mark Antokolsky, the most famous Russian Jewish artist of the nineteenth century (fig. 1).[3] Born in Vilna in 1843, his youthful work came to the notice of General Nazimov, the governor-general of Vilna Province, whose wife sponsored Antokolsky's move to St. Petersburg and entry into the Imperial Academy of Arts in 1863. The next year, he received the silver medal of the academy for his wood carving *Jewish Tailor* (Maisels, fig. 1), which launched his career. In 1868,

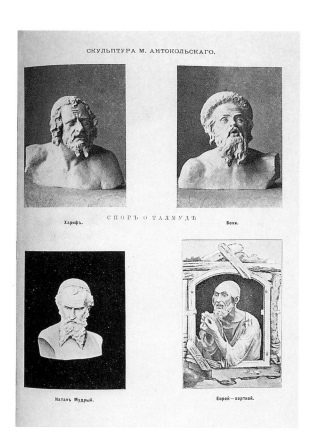

Fig. I
Article on Antokolsky from
the Russian Jewish
encyclopedia, *Evreiskaya
entsiklopedya*
(St. Petersburg: Brokgauz
ephron, ca. 1912),
vol. I, p. 785

after a short stay in Berlin, he returned to St. Petersburg, produced his famous statue of Ivan the Terrible (see ill. 4), and was appointed a member of the academy at the express command of Alexander II. From this point on, Russian themes and historical figures predominated in Antokolsky's work, though he did not neglect Jewish themes and interests. After receiving a gold medal at the Paris Exposition of 1878 and being made a Knight of the Legion of Honor, Antokolsky moved to France in 1880, a decision based primarily on aesthetic concerns, but colored and reinforced by the rising tide of anti-Jewish sentiment in Russia at the time, during which he was excoriated as a Jew. In subsequent years, Antokolsky was criticized by both Russian and Jewish nationalists for portraying Russian and Christian personages rather than Jewish national heroes or exclusively Jewish concerns. He clearly viewed these attacks as outrageous: he was an artist, first and foremost, and then both a proud Jew and a loyal subject of Russia and Russian culture. In this assertion and steadfastness, he was paradigmatic of many of the later artists in this exhibition, though the torrents of history and ideology never allowed them the peace and plausibility of their personal and artistic self-conceptions.

That peace and plausibility were rudely assailed in 1881, when, following the assassination of Tsar Alexander II by revolutionary terrorists, there began

a wave of physical attacks against the Jews which continued intermittently until the fall of the Tsarist regime. At the same time, and not unconnected with the outbreak of these pogroms, there began a mass emigration of Jews from the Russian Empire, mostly to America and other Western lands and, in much smaller numbers, to Palestine as well. Soon, a series of new laws and restrictions on Russian Jews was put into effect: the infamous May Laws of 1882, which restricted even further Jewish residence rights and economic activities and, perhaps even more importantly, strict quotas on Jews in Russian educational institutions. The latter began in 1882 and culminated in the establishment, in 1887, by the Russian Ministry of Education of a formal quota system (*numerus clausus*) for Jews at all educational establishments under its control: ten percent within the Pale of Settlement, five percent outside the Pale, and three percent in Moscow and St. Petersburg. Although these quotas were not always strictly enforced—Russian officials at all levels were notoriously susceptible to pecuniary emoluments—they did betoken the introduction of a fundamental obstacle to the hopes and aspirations of the Russifying elements of the Jewish community. Many Jews who previously had believed in the possibility of a benign future for the Jews in a liberalizing Russia now began to lose that faith; as a result, emigration reached epic proportions, ultimately leading to the ascendancy of American Jewry as the largest Jewish community in the world, though most Jews did not, in fact, choose to leave Russia. At the same time, in the course of the 1890s and early years of the twentieth century, ideologies such as Zionism, socialism, populism, and anarchism began to attract more and more Russian Jews who could no longer believe either in traditional Judaism or in the possibility of progress within Russian society such as it was.

However paradoxically, this ideological efflorescence only served to extend the Russification of the Jews. This is clearest and easiest to understand in regard to the Leftist currents in Russian Jewry from this period on—naturally overrepresented in the artistic community, there as everywhere else. Jews who ceased to remain within the traditional world of East European Judaism and began to look to social revolution, however defined, as the solution to their plight naturally began to involve themselves more and more in the literature, culture, and illegal political intrigue of the various Russian revolutionary movements. Though eventually a specifically Jewish socialist movement—the Bund—would emerge in Russia, dedicated to Yiddish secular culture almost as much as to socialism, the fact is beyond question that most of its leaders, just like most of the leaders

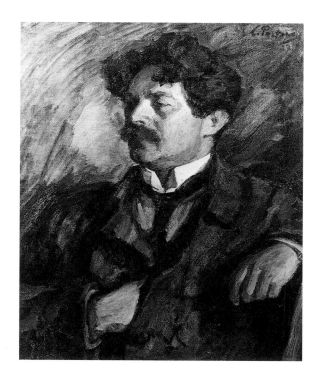

A new period for Russian Jews and for the Russian Empire as a whole began in 1905, when Tsar Nikolai II was forced to concede reforms that transformed Russia more or less from an autocracy into a constitutional monarchy. Most importantly for our purposes, many of the legal restrictions pertaining to the Jews were modified. Jews were permitted to organize themselves into political parties, to be elected to the newly constituted parliament, to join their demands for legal emancipation with the flurry of calls for reform and reorganization of Russia itself. At the same time, censorship rules were significantly liberalized, and there began an efflorescence of Jewish culture, literature, and politics in all their guises and manifestations, just as it became possible for Jews to participate actively in the outburst of Russian culture, literature, and politics. And these two worlds did indeed intersect fruitfully. In the realm of politics, a man like Maxim Vinaver could at one and the same time be one of the leaders of the Russian liberal party, the Constitutional Democrats, and the founder of the League for the Attainment of Equal Rights for the Jews and the St. Petersburg Jewish Historical Society; in the realm of the arts, Leonid Pasternak could portray both Tolstoy and Bialik and serve as a leading Russian portraitist and professor at the Moscow Arts School without either denying or emphasizing his Jewishness (fig. 2).

of the Zionist parties, were Russified Jews, immersed in Russian culture and Russian literature. Suffice it to say that most of the great names of Hebrew and Yiddish culture and Jewish politics in this period, whatever their political beliefs, used Russian as their language of everyday life, spoke Russian to their spouses and children, corresponded in Russian with their friends and enemies—from Sholem Aleichem to Chaim Nachman Bialik to Vladimir Medem to Chaim Weizmann to Chaim Zhitlowsky to Vladimir Jabotinsky to Nachman Syrkin, and beyond. Thus, even in the period of greatest repression, the Russification of the Jews continued apace. By the end of the century, census figures maintained that while only three percent of Russian Jews claimed Russian as their mother tongue, thirty-two percent of Russian Jewish males and seventeen and a half percent of Russian Jewish females could read Russian. If one subtracts from this number children under the age of 10, the figures rise to 45 percent of males and 25 percent of females; among urban Russian Jews the rate rises even higher—to 51 percent of males and 31 percent of females.[4]

While the exactitude of these statistics and the depth and extent of Russian knowledge they reveal can be questioned, there remains no doubt that they betoken a radical shift in the cultural life of Russian Jewry and, more difficult to define, in Jews' perceptions of themselves as well. Although there was no doubt in their minds that they remained Jews, they were becoming more and more Russified as each day passed.

This does not mean, to be sure, that the old tensions, disabilities, hatreds, and outbursts of violence disappeared. On the contrary, in the aftermath of the 1905 Revolution, a wave of horrible pogroms erupted and political anti-Semitism increased. As Jews became more and more prominent in the anti-autocratic forces, and especially in the revolutionary movement, reactionary Russians from the Tsar down increasingly blamed them for the country's demise. A world-famous figure such as Leon Trotsky, then, served as a personification of both the extent of the integration of Jews—their utter Russification—and the dangerous limits and consequences of that same Russification.

But for most of the Jewish artists functioning in this period—like their literary and political counterparts, and like masses of ordinary people—the years between 1905 and the outbreak of the First World War were undoubtedly more important for their unprecedented freedom than for their political failures. For it was in this period that both Russian culture and Jewish culture experienced an explosion of artistic creativity and experimentation that would reverberate for decades in the art displayed in this exhibition. That creativity would be stifled by the outbreak of war in the summer of 1914 and by the military, economic, ideological, and biological crises

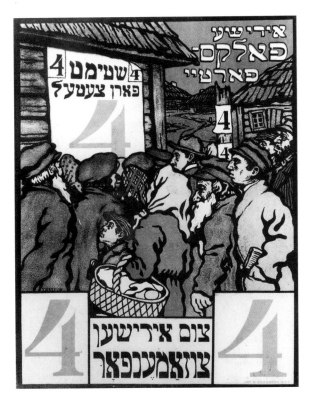

Fig. 3
Solomon Yudovin
Yidishe Folkspartei Election
Poster, 1918
28 x 21 in. (71.1 x 53.3 cm)
Moldovan Family
Collection, New York

now emancipated, free and equal citizens of a new Russian state. In the months that followed, their pent-up creativity exploded into the open—in art, literature, theater, politics, religion, ideology. They had never experienced such freedom—nor would they again for a very long time.

The Provisional Government was fatally weakened by internal division, a losing war, economic devastation, and personal ineptitude. In October 1917, that government fell, to be replaced by the Bolsheviks led by Lenin and Trotsky. Most of the Jews of Russia were not sympathetic to the Bolshevik coup and voted en masse against the Bolsheviks in the first—and last—free election, held in late 1917 (fig. 3).[5] The Jews clearly would have preferred a government more along the lines of the provisional regime. But the tide of Jewish sympathies turned dramatically as Russia became embroiled in a devastating civil war that included a wave of pogroms unprecedented in their horror and toll of death since the Khmelnytsky Uprising of the seventeenth century. By far the vast majority of these pogroms were waged by Ukrainian nationalist and White Army soldiers; while some Red Army units did engage in pogroms early in the Civil War, Trotsky and other leaders of the Bolshevik Army quickly prohibited such attacks and forcefully punished their perpetrators. As a result, for the vast majority of the Jewish population, the only real defense against pogrom, plunder, rape, and devastation appeared to be the Red Army and a stable and strong Bolshevik regime. There was no time to ponder the ideological or cultural ramifications of such a conclusion: life or death seemed to hang in the balance.

With the victory of the Bolsheviks and the establishment of the Union of Soviet Socialist Republics, the Jews were in a peculiar situation. On the one hand, they were optimistic about the new Soviet regime and its promise to build a new society in which restrictions based on religion and nationality would be outlawed, in which all the powerless could share in the bounty of honest labor and untrammeled human freedom. On the other hand, the new regime was dedicated to eradicating from its midst two of the fundamental features of pre-Revolutionary society which had largely defined Jewish life: the marketplace and religion. The economic goals of the Soviet state threatened the livelihood of the vast majority of the Jews, just as its aggressively atheistic and secularizing stance pledged itself to the extirpation of religious beliefs, rituals, and institutions in the new Soviet world.

Very problematical in this regard was the central role of Jews—or, more precisely, Bolsheviks of Jewish origin—in the new regime. Though the actual

that ensued, both for the entire Russian population and for the Jews in particular. As the Pale became the focus of large portions of the war, a veritable refugee crisis assailed Russian Jewry as never before, with probably close to a million Jews displaced and expelled from their homes. The famous shtetl—the small market town—that had defined so much of East European Jewish life for centuries now in large measure simply ceased to exist. The Jews who had lived in these towns, villages, and cities were on the run, mostly to the interior of Russia itself, and especially to the great capital cities of Moscow, Petrograd, and Kiev, where there was rumored to be more food, more medicine, more ways to eke out a living in the midst of the disaster. Indeed, this new reality was acknowledged by the Russian government itself in the summer of 1915, when the Pale of Settlement was abolished as a temporary war measure. It was never reinstated, since the Tsarist state that had invented it soon collapsed.

The social, political, biological, spiritual, and economic devastation of Russia in the course of the First World War led to the Revolution of February 1917, the abdication of Tsar Nikolai II, and the establishment of a Provisional Government that attempted to remake Russia into a liberal democratic and pluralistic state. One of the first acts of the Provisional Government was the abolition of all laws restricting Russian citizens on the basis of religion or nationality. In other words, the Jews of Russia were

Fig. 4
Iosif Chaikov
Shveln (Doorways) **by**
Peretz Markish
(Kiev: Yidisher Folks
Farlag, 1919)
Illustrated book,
8$^1/_2$ x 5$^3/_8$ in.
(21.7 x 13.8 cm)
YIVO Institute for Jewish
Research, New York

Fig. 5
Artist Unknown
Religion Is an Obstacle to
the Five-Year Plan, **1930s**
Poster, 30$^1/_4$ x 42 in.
(76.8 x 106.7 cm)
Moldovan Family
Collection, New York

immersion in and dedication to the Revolution. Of course, they were still regarded as Jews by most outsiders, and especially by enemies of the regime at home and abroad. But they viscerally rejected that identification as reactionary and racist, viewing themselves as purely and unilaterally sons and daughters of the Revolution. Their identification with the Soviet Union and its cosmopolitan culture and identity (reflected in numerous works in this exhibition) would remain in place and only be ratified and extended as the decades progressed.

Still other Jews were attracted to the new regime since it promised to sponsor a "revolution on the Jewish street," as contemporary jargon had it—i.e. the creation of a proletarian Jewish culture, a new secular and socialist but distinctively Jewish identity, based on the Yiddish language, understood as the language of the masses (fig. 4). Indeed, it was Jewish Communists, dedicated to refashioning Jewish identity in a Bolshevik mode, who planned and led the attack on traditional Jewish culture, the synagogue, the Hebrew language, and religious observance, as well as on non-Communist forms of Jewish identity such as Zionism or Bundism. The famous Jewish Section of the Communist Party—known by its Russian acronym as the Evsektsiya—was thus mostly responsible for the aggressive and vicious attacks on Jewish life and practice within the Soviet Union throughout the 1920s (fig. 5).[6]

This specific Jewish component of the new Soviet regime was predicated on an unintended consequence of the Revolution: the naming of the Jews as one of the legally recognized nationalities of the Soviet Union. Herein lies a central paradox of Soviet-Jewish life. Lenin and the other Bolshevik leaders sincerely believed that the Jews were not a nation, but a religiously defined economic caste. Abolish private property, outlaw anti-Semitism, and educate the masses to the effect that religion was merely their opiate, and the Jewish problem would simply disappear, the Jews would merge into the new Soviet population. However, given the way the Revolution actually unfolded, Lenin was forced to make a large number of strategic compromises to solidify his rule; one of these was the acquiescence of his government to the demand of all Jewish parties that the Jews be recognized as a nationality in the new Soviet Union, on a theoretical par with the Russians, Ukrainians, Belorussians, Uzbeks, Georgians, and the like. This is the origin of the inclusion of the designation "Jewish" on the Soviet passport—not, as it would later become, a mark of prejudice and discrimination, but, to the contrary, a recognition of the Jews as a distinct and respected national group within the multinational edifice of the Soviet

percentage of Jews in the Bolshevik Party was small, they were vastly overrepresented in its uppermost ranks and in its fearsome security apparatus. Most of these men and women had ceased to regard themselves as Jews in any meaningful sense of the term; they were internationalists, Communists, atheists whose ghetto origins had been superseded by their

Union. This policy even led, in the late 1920s, to the designation of Birobidzhan, in the Soviet Far East, as the "Jewish Autonomous Region" of the Soviet Union—a mini-Jewish state within the fabric of Soviet socialism (fig. 6).

To be sure, these centripetal forces were belied by the deepest beliefs of the Soviet leadership—that national distinctions would weaken, and ultimately disappear, as socialism progressed and blossomed into full-fledged Communism. To square this circle, national identities, culture, and education would be promoted by the Soviet state, but would be "national in form, socialist in content," as Stalin himself put it in a famous phrase. In our exhibition, we see the ramifications of these cultural politics in the fascinating art with Jewish content of the early Revolutionary and Soviet periods, from El Lissitzky's *Had Gadya* of 1919 (see pl. 8) to Natan Altman's stage and theater designs of the 1920s (see ill. 3).

Ironically, perhaps, this artistic and ideological efflorescence was of little concern and less comfort to the masses of Soviet Jews, who began to understand that their future lay not in a new, specifically Jewish, subculture but in integrating themselves as forcefully as possible into Soviet society via the Russian language and Soviet cosmopolitan culture. Again, this was not a fully conscious decision so much as a visceral reality. Throughout the 1920s, the urbanization of the Jews continued apace, as hundreds of thousands of them moved from small towns to larger and larger cities, both within the tra-

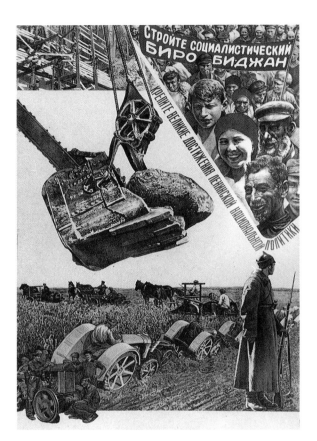

Fig. 6
Mikhail Dlugach
Build a Socialist
Birobidzhan, 1932
Lithograph on paper,
41³/₈ x 27¹/₈ in.
(105.1 x 68.9 cm)
Moldovan Family
Collection, New York

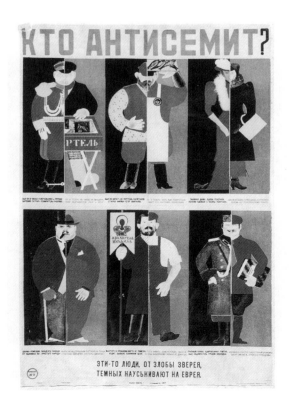

Fig. 7
Nikolai Denisovsky
Who Is an Anti-Semite?,
1927–30
Lithograph on paper,
42 x 28⁷/₈ in.
(106.7 x 73.3 cm)
The Jewish Museum,
New York

ditional centers of Jewish population (Ukraine and Belorussia) and, perhaps most importantly, in Russia proper. Moscow and Leningrad—which before the Revolution had minuscule Jewish communities—now hosted Jewish populations rivaling those of Warsaw and Vienna, but these were Jews bent on becoming Soviets in the fullest sense of the term. Intermarriage between Jews and non-Jews became extremely common; Russian became the language par excellence of Soviet Jews, with Yiddish quickly falling into decline and disuse and Hebrew totally outlawed and suppressed. Slowly but surely, Jewish writers, artists, and musicians ascended to the top rungs of Soviet culture, both in its official manifestations and in its small pockets of resistance and private rebellion—from the great literary figures such as Osip Mandelstam and Boris Pasternak to hundreds upon hundreds of lesser-known poets, painters, playwrights, composers, journalists, sculptors, novelists, and short-story writers.

These demographic and cultural shifts were grounded in a veritable social and economic revolution of Soviet Jewry which no one could have predicted. From the mid-1920s on, the Soviet regime required massive numbers of managers, functionaries, technicians, and professionals to run the new state economy and bureaucracies, and Soviet Jews entered en masse into these new, essentially white-collar positions. At the same time, and in the

23

**A. Dovgal
Illustration from *A Story about a Girl with a Red Scarf* by Leib Kvitko
(Odessa: Kinder Farlag, 1936)
9 x 11½ in. (22.9 x 29.2 cm)
Moldovan Family Collection, New York**

absence of any limits or restrictions, their children rushed into universities and other educational institutions at rates unparalleled either in Soviet society at large or in the West. This socio-economic mobility continued and indeed accelerated through the tragic years of the 1930s, when the policies of forced collectivization and massive industrialization were put into effect with great brutality, at the cost of millions upon millions of lives. Due to forces beyond their control or design, Soviet Jews became the most upwardly mobile, most educated, and most professionally successful minority in the country (fig. 7).[7]

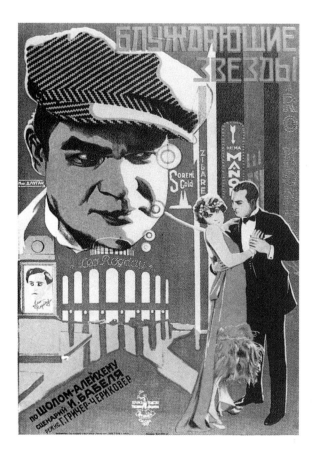

**Mikhail Dlugach
Film Poster for *Wandering Stars*, 1927
Poster, 42 x 27¾ in. (106.5 x 70.5 cm)
Productive Arts, Brooklyn Heights, Ohio**

To be sure, this economic and social success merely accentuated and cemented the identification of the Jews with the Soviet state, its ideology and its perceived successes. But it also took place against the backdrop of Stalinism, whose murderous excesses and outrages included the utter devastation of any vestiges of Jewish national, cultural, or artistic expression. Beginning in 1930 and 1931, all attempts at creating a Soviet Jewish culture were all but smothered in the general obliteration of artistic and cultural creativity throughout the Soviet Union, followed by the massive purges of all those vaguely suspected of antigovernmental activity.

Since Jews were disproportionately represented in the institutions most susceptible to the purges—the intelligentsia, the artistic elite, the top levels of the bureaucracy, the officer corps of the Red Army—they were overrepresented in the purges of the middle and late 1930s. But it would be too easy to portray them simply as victims of Stalinism, as many of them surely were, and as Jewish culture, religion, and national feeling quite definitely were. For as this exhibition demonstrates all too graphically, Jews were at the same time in the front ranks of the supporters and lionizers of Stalin at the height of the "cult of personality." It is not to judge or justify this behavior, but merely to contextualize it, to note that the true extent of the murders and horrors was deliberately hidden from the population as a whole, and that all this was taking place against the backdrop of the rise of anti-Semitism, Fascism, and Nazism in the West.

The stance of the Soviet Union as the bulwark against Fascism was fatally complicated in late August 1939, when it was announced that Stalin and Hitler had signed a non-aggression pact. With the Soviets out of a potential war, Hitler had a free hand to invade Poland and the rest of Europe, and the Second World War began, with its specifically horrific consequences for the Jews.

But not—as yet—for the Jews of the Soviet Union. Indeed, after the Soviet Union seized large chunks of eastern Poland and western Ukraine as a result of its deal with Germany, over a million Jews came under Soviet control, and then another half a million after Stalin annexed the previously independent states of Lithuania, Latvia, and Estonia and parts of Rumania. In these new territories, the Jewish populations were subjected to the expected process of Sovietization—but in a grotesque rerun of the Russian Civil War, it soon became clear that the horrors of Bolshevization paled utterly in comparison with the emerging Nazi Final Solution. Indeed, in the early months of the war, hundreds of thousands of Polish Jews, caught under Nazi control, voluntar-

ily (and presciently) escaped to the Soviet-occupied territories, vastly preferring Soviet to Nazi masters, Sovietization to ghettoization—and, ultimately, to death.[8]

Unbeknownst to them all, of course, was the looming horror of the Holocaust, which began in fact on Soviet territory, only a few months after the Nazis' surprise attack on the Soviet Union on 21 July 1941. As the Axis forces cascaded through the western Soviet Union, the so-called *Einsatzgruppen* began to shoot Jews en masse, as the first stage in the planned extermination. The murder of thousands of Jews at Babi Yar near Kiev on Yom Kippur 1941 was only the most infamous of these early massacres; within the next four years, approximately a million Soviet Jews would be murdered, along with millions of their brethren in the rest of Europe.[9]

Once more, behind the battle lines, the war against the Nazis only served to reinforce the identification of the Jews with the Soviet Union, now engaged in an all-out life and death battle against Fascism. To complicate matters further, in the course of the war and in order to boost morale, Stalin permitted the expression of a variety of sentiments and beliefs previously banned, including the Russian Orthodox faith, Russian nationalism, and Jewish collective concerns. Thus, the Jewish Anti-Fascist Committee, led by the famous Yiddish actor and director Solomon Mikhoels, openly cultivated Jewish national, political, and cultural interests both at home and abroad, tying ever more tightly the intertwined fates of the Jews and the Soviet Union (fig. 9). And after the Red Army succeeded in defeating the Nazis, the gratitude and loyalty of Soviet Jewry was all the more keen and heartfelt.

Indeed, in the immediate postwar years, that loyalty and gratitude would only grow as a result of a totally unexpected development: the support of the Soviet Union for the establishment of a Jewish state in the Land of Israel. Thus, in the debates over the partition of Palestine in the United Nations, Stalin ordered not only the Soviet representatives but also those of his client states in Eastern Europe to support the Zionist side; when the vote for partition was actually cast, the support of the Soviet Bloc was decisive. When the State of Israel was established in May 1948, the Soviet Union was the first country to recognize it de jure and then provided—via Czechoslovakia—crucial arms to the Israeli fighting forces in the resulting war. To be sure, all of this was done for Stalin's own reasons—as the Hebrew cliché has it, not out of love of Mordecai, but out of hatred for Haman; in other words, Stalin's goal was not truly to aid the Jews, but to dislodge the British from the Near East. It is only against this backdrop that the subsequent explosion of Stalinist anti-Semitism can be fully appreciated in all of its complexity and unexpectedness.

Virtually coterminous with this support of the new Jewish state came a dramatic volte-face on Stalin's part regarding the Jewish population within the Soviet Union: they now appeared to be the enemy, the counter-revolutionaries, the Zionist fifth column out to destroy the Soviet Union. And so a new frenzy of arrests, murders, and purges began, now specifically directed against Jews and Jewish culture. In January 1948, Mikhoels was murdered in a trumped-up automobile accident; in November of that year, the Jewish Anti-Fascist Committee was disbanded; in April 1949, the most famous—and

Fig. 8
Cherepanov
Zionism—Puppet of CIA,
1982
Poster, 26$^1/_2$ x 17$^1/_2$ in.
(67.3 x 44.5 cm)
Collection Evgeny and Irina Lein, Jerusalem
© 1995 VAGA, New York

Fig. 9
Sholomovich
Mikhoels, Tyshler, and Zuskin Discussing the Staging of the Musical Comedy Freylekhs, ca. 1946
Photograph, 6 x 9 in.
(15.2 x 22.9 cm)
YIVO Institute for Jewish Research, New York

loyal—Yiddish writers and poets were arrested (soon to be killed), the leadership of Birobidzhan decimated. Even more broadly and insidiously, Jews began to be eliminated, slowly and surely, from positions of power and influence in Soviet life, from the Politburo and the top officer corps of the Red Army to other high bureaucratic and educational positions. More publicly, there began a simultaneous campaign against both "Jewish nationalism" and "rootless cosmopolitanism"—that is, against Jews specifically engaged in Jewish affairs and those no longer rooted in their Jewish identity who were completely Sovietized. Finally, a "Doctors' Plot" led by Jewish physicians was officially uncovered, aimed at murdering no less than Stalin himself. Rumors began to swirl through Moscow and Leningrad about a mass arrest and deportation of all Soviet Jews, no matter how well integrated. Millions of loyal Soviet citizens, many of whom had ceased to regard themselves as Jews in any meaningful way, now began to quake in a private, unspoken dread. Could the unthinkable actually be occurring? What would happen next?

Fortunately, what happened was that Stalin died, in March 1953. Soon it was revealed that the Doctors' Plot had been concocted out of whole cloth by Stalin's henchman Beria, who was executed by the junta in control. The most egregious crimes of Stalin and Stalinism were denounced, many victims were rehabilitated, and a "thaw" began in both cultural and economic terms under the leadership of Khrushchev—more liberal censorship rules, attempts at economic and structural reform. For the Jews more than for all other Soviet citizens, this meant a distinct relaxation of the terror and horrors of the late Stalinist years. However, it soon became clear that the policy of eliminating Jews from positions of power and prominence in Soviet life was being

retained and even extended under Khrushchev. While Jews did not have to worry about mass deportations or arrests in the middle of the night, they now began to worry about a far more subtle, but in some ways even more far-reaching problem: what would be their future, and the future of their children, in this society which they had worked so hard to build?

In the artistic and cultural realms, however, the benefits of the thaw seemed clearly to outdistance the subtle signs of danger. Not surprisingly, in the late 1950s and early 1960s, individual Jewish artists—as well as poets, novelists, etc.—began to come to light in the fledgling avant-garde artistic worlds.[10] Even more than in the West, in the Soviet Union the quest for artistic freedom was inevitably politicized, bound up with a crucial, if often unarticulated, dissent from political orthodoxy. The fact that Jews were coming out in the open as dissidents only reinforced the anti-Jewish elements of Soviet officialdom, including the artistic and cultural establishments. In response, Yevgeny Yevtushenko's famous poem "Babi Yar" poignantly and potently attacked this new sort of anti-Semitism, resurrecting the philosemitic traditions of the best part of the old, pre-Revolutionary Russian intelligentsia.

Especially after the fall of Khrushchev and the accession to power of the neo-Stalinists Brezhnev and Kosygin, a dramatic reversal of history took place. For decades, the Soviet Union had been believed by millions of Jews both within its borders and abroad to be the defender of Jewish lives and the place in the world where the most thoroughgoing integration of the Jews was both possible and actually occurring. Now, that very same Soviet Union was a manifestly anti-Semitic regime, persecuting the Jews in its midst and leading the charge against Jewish interests throughout the world, especially after the Israeli defeat of the Soviet-allied Arab states in the Six-Day War of 1967. From this point on, the virulent anti-Zionist stance and propaganda of the Soviet regime were matched by a deeply entrenched policy of anti-Semitism at home (fig. 8).

At the same time, three interrelated processes were at play which would be crucial to the future. First, the middle and late 1960s witnessed the beginning of a true ideological and spiritual crisis in large parts of Soviet society. Masses of people now simply lost faith in Communism, the Soviet state, and the Soviet leadership; the lies, suffering, and repression were no longer bearable, especially as it became more and more apparent that the economic system itself was rotten to the core and falling apart fast. The most visible manifestation of this phenomenon was the emergence of an influential and broadly based dissident movement, comprised

Fig. 10
Mikhail Grobman
Complete Prayer Book,
1968
Watercolor and ink
on paper
14¹/₂ x 23 in. (37 x 58.5 cm)
Collection Kenda and Jacob
Bar-Gera, Cologne

mostly of intellectuals, writers, and artists struggling for freedom of expression. Again, not surprisingly, many of these young artists and intellectuals were of Jewish origin, though largely unconcerned with their Jewishness per se.

At the same time, another group of Jews began—at first surreptitiously and then more and more openly—to explore their Jewish identities, to study Hebrew and Yiddish and Jewish history, religion, and culture, even to press for emigration to Israel (fig. 10). A large number of these Jews hailed either from the Baltic territories acquired by the Soviet Union in 1940 or from the non-European parts of the Soviet Union, where the Jewish populations were far less Sovietized and hence far more knowledgeable about Jewishness and dedicated to the preservation of Jewish identity. However, a surprisingly large part of the Jewish revival stemmed from ordinary, previously loyal, de-Judaized Soviet Jews sharing in the crisis of faith pervading their society at large. Into the void where belief in Soviet socialism had once held sway moved all the old national and religious movements long banned by the regime, including Zionism and religious Judaism.

And then, yet another previously unimaginable process unfolded. The economic crisis of the Soviet Union forced the regime to seek financial and technological aid from the West, particularly the United States, which proceeded to tie that aid to—of all things!—the right of Soviet Jews to emigrate. Beginning in the late 1960s, the Soviet leaders began to allow larger and larger numbers of Soviet Jews to do that which was forbidden to all other Soviet citizens: to leave the country. At first, virtually all the departing Jews emigrated to Israel—especially those who came from the less Sovietized territories such as Lithuania, Moldavia, and Georgia. Soon, however, the vast majority of the emigrants, particularly those from Moscow, Leningrad, Odessa, and the other fully Sovietized regions, chose to move to the United States and other Western lands.

The lives of all Soviet Jews were now irrevocably transformed by the decision whether or not to leave, often complicated by the crucial facts that most Soviet Jews were products of families with high rates of intermarriage with non-Jews and that the only real culture, language, and identity of the vast majority of Soviet Jews was Russian culture, the Russian language, their identity as Soviet citizens of a largely meaningless and stigmatized Jewish origin. Yet, as the attacks and restrictions on Jews and Jewishness became more and more virulent and open, the option of remaining at home and hoping for change and reform appeared more and more grim—even as, through the early and mid-1980s, the option of emigration was also more and more foreclosed, as the Soviet authorities began to clamp down and at times virtually forbid further Jewish emigration.

In the end, though, the Jewish problem proved to be merely a small part of the overarching crisis and collapse of the Soviet system as a whole. By the middle and late 1980s, the economy was in a total shambles, the political structure had largely disintegrated, and hundreds of millions of Soviet citizens had come to the painful conclusion that the ideological underpinnings of their lives, and those of their parents and grandparents, had rotted away. The dream of a classless society, a future of boundless freedom, opportunity, and equality, now appeared to be but a treacherous trick, a deceitful delusion for which millions upon millions had suffered and died, to no avail. The depth of this crisis of faith and politics rendered hopeless the Gorbachev regime's attempt at Perestroika—at reforming the society and state from within. What almost no one had predicted was now on the horizon: the end of the Soviet Union.

For the majority of Soviet Jews who had not left—because they had not been permitted to do so or did not want to—the age of Perestroika and its aftermath witnessed an explosion of artistic, cultural, religious, and ideological possibilities. Despite everything, Jews could still be at the forefront of cultural, artistic, and possibly even political experimentation, though now it was impossible to dream the same dreams, to hope the same hopes, and—perhaps most especially—to predict what the future would bring.

Artist Unknown
Group Aleph, Leningrad, 1974
Photograph, 8 x 10 in. (20.3 x 25.4 cm)
Archives of Norton and Nancy Dodge

Michael Stanislawski
is Nathan J. Miller Professor of Jewish History at Columbia University, New York.

Notes

[1] For the most sensitive treatment to date of this problem, see Alice Stone Nakhimovsky, *Russian-Jewish Literature and Identity* (Baltimore and London: Johns Hopkins University Press, 1992).

[2] The most reliable history of the Jews in Russia and the Soviet Union remains Salo Wittmayer Baron, *The Russian Jew under Tsars and Soviets* (New York: Macmillan, 1964). On the first half of the nineteenth century, see my *Tsar Nicholas I and the Jews: The Transformation of Jewish Society in Russia, 1825–1855* (Philadelphia: Jewish Publication Society of America, 1983).

[3] There is no reliable biography or scholarly analysis of Antokolsky, despite the substantial literature on him produced in the Soviet Union. For the present, see the most recent Russian-language study, E. V. Kuznetsova, *M. M. Antokolsky: Zhizn i tvorchestvo* (Moscow: Iskusstvo, 1989).

[4] Ya. Shabad, "Gramotnost evreev v Rossii," *Evreiskaya entsiklopediya*, vol. 6 (St. Petersburg: Brokgauz and Efron, n.d.), pp. 756-59.

[5] See Oliver Henry Radkey, *The Election to the Russian Constituent Assembly of 1917* (Cambridge, MA: Harvard University Press, 1950).

[6] For the best study of the Jewish Sections—and of early Soviet Jewish history in general—see Zvi Gitelman, *Jewish Nationality and Soviet Politics: The Jewish Sections of the CPSU, 1917-1930* (Princeton: Princeton University Press, 1972).

[7] See Benjamin Pinkus, *The Jews of the Soviet Union: The History of a National Minority* (Cambridge: Cambridge University Press, 1988).

[8] See Jan T. Gross, *Revolution from Abroad: The Soviet Conquest of Poland's Western Ukraine and Western Belorussia* (Princeton: Princeton University Press, 1988).

[9] See R. Ainsztein, "Soviet Jewry in the Second World War," in Lionel Kochan, ed., *The Jews in Soviet Russia since 1917* (London: Oxford University Press, 1972).

[10] The most compelling memoir of a Jew growing up in this period is Joseph Brodsky's "In a Room and a Half," in *Less Than One: Selected Essays* (New York: Farrar, Straus and Giroux, 1986), pp. 447–501.

Susan Tumarkin Goodman

Alienation and Adaptation of Jewish Artists in Russia

The period in Russia from the turn of the century until the breakup of the Soviet Union was one of great importance and vitality in the lives of Russian Jewish artists. Their contributions permeated Russian and Soviet art, and in each period Jewish artists were innovators in the cultural arena and central to the evolution of new artistic styles. Despite this fact, they were considered outsiders within a society often hostile to them as Jews. It was not possible for them to assimilate fully into the majority population, even if they wished to do so. In fact, Jewish artists in Russia had multiple identities which they sought to fuse in the face of inextricable tensions between their status as Russians, as Jews, and as artists.

By the end of the nineteenth century, most Jews lived in urban areas within the Pale of Settlement, rather than in the shtetls that existed midway between the vastness of rural Russia and its growing cities. As members of a national minority, with a separate language—Yiddish—and educational system, Jews found it more difficult in Russia than in other countries to enter the art world. Extraordinary determination, notable talent, and (at times) influential patrons were required to achieve the status of professional artist.

Fig. 1
Boris Anisfeld
September—Tver, 1908–17
Oil on canvas, 76 x 55 in.
(193 x 139.7 cm)
Joey and Toby Tanenbaum
Collection

Beginning in the 1860s with a weakening of religious practices, language, and the traditional ways of life, together with a relaxation of restrictive laws, a growing stream of Jewish artists made their way to Moscow and St. Petersburg from the small towns to which they had been restricted. Only a few were able to overcome social and cultural barriers and gain recognition in the world of Russian high culture. Nevertheless, from the middle of the nineteenth century on, Jewish artists could be found in many areas of Russian artistic activity. Acculturation, which proceeded rapidly in Russian Jewish society at the end of the century, is apparent in the art of the most successful Jewish artists of this period, and their work developed within both Russian and European traditions.

The last third of the nineteenth century brought about a split in Russian academic art circles. For years, students had felt constrained by the prescribed canons of the art academies and had wished to create paintings that reflected contemporary Russian life. In 1870 they broke with tradition and organized the Society of Traveling Art Exhibitions. This new group of painters, known as the Peredvizhniki (Wanderers) brought their art and exhibitions to the provinces, providing an alternative to the neoclassical subject matter being taught and exhibited at the Imperial Academy of Arts. As this artistic opposition strengthened, an increasing number of young Jews joined the movement toward realism, influenced by Russian populism and nationalism. The artworks they produced dealt with social issues and were critical of bourgeois mores. In a sense, the part played in Russian art by Jewish painters commenced with the Peredvizhniki movement, which opened up educational alternatives and opportunities as teaching situations became more numerous. Of tremendous import was the fact that at about the same period private art schools and studios began to admit Jewish artists who had previously been denied entry due to the quota system. As Marc Chagall pointed out in his autobiography, this shift allowed some Jewish artists without residence permits to justify their stay in the large urban centers.[1]

St. Petersburg, the primary center of European influence in Tsarist Russia, and Moscow became meeting places for proponents of the new European movements, many of which had an impact on Russian art in the first decades of the twentieth century. At the same time, increased foreign travel by artists resulted in an exposure to developing modernist styles. A number of the assimilated artists in the fields of sculpture and painting achieved fame as a result of their ability to interpret the Russian spirit in art. This was the case with Mark Antokolsky and

Isaak Levitan. Though many Jewish artists converted or attempted to integrate into Russian culture as they ascended socially, their position in society was fraught with difficulty. From the 1890s on, and throughout the Soviet period, they continued to be perceived by Russians as Jews.

Levitan was considered the father of Russian landscape painting. Not only did his work reflect the nationalist tendencies of the period, but paradoxically, his dramatic landscapes were thought to express Russian nature and the Russian spirit more fully than those of any other artist of his time (see pl. 2). Antokolsky was among the first internationally important Russian sculptors—and the first East European Jew—to achieve fame as a sculptor. Although a product of the Jewish ghetto in Vilna, he portrayed Russian historical figures with extraordinary psychological realism and great technical precision (see ill. 4). A number of other Jewish artists also gained renown at this time, such as the sculptor Ilya Gintsburg and the painters Leonid Pasternak and Boris Anisfeld (fig. 1).

The realist approach propounded by the Wanderers was limited, and their break with the academy and its aesthetic dictates was thematic rather than formal; it did not affect the underlying stylistic character of their art. When a new organization, World of Art (Mir iskusstva), appeared at the end of the 1890s, it claimed to move beyond the provincialism and academic conservatism of the period and to open Russian art to European styles, most notably Art Nouveau.

Within this movement, the role of Léon Bakst in influencing stage and costume design in Russia and the West is significant. Initially, he excelled at portraits of society figures from his circle of wealthy and artistic friends. A shift occurred in 1909, when he chose the theater as a career. From the time he joined Sergei Diaghilev's Ballet Russes in Paris, Bakst's costume and set designs were intended as organic components of theatrical productions, unlike the naturalistic backdrops produced by most of his contemporaries. Conceived as fusions of color, draftsmanship, music, and motion, Diaghilev's ballet productions were dramatic dance spectacles (see pl. 5).

Jewish discontent with renewed pogroms, restricted rights of residence, and the quota system at educational institutions in the last two decades of the nineteenth century had various results. Some felt that freedom could only be obtained through baptism in the dominant Russian Orthodox Church; others emigrated. Many turned to the ideas of the Enlightenment movement (Haskalah) in an attempt to synthesize Jewish tradition with new ideas derived from Russian secular culture. While Yehuda Pen, for example, painted traditional Jewish genre scenes (see ill. 90), his works are an indication of a world in flux. His historical importance derives from his success as a professional Jewish artist who returned to his native Vitebsk in 1897 to open a recognized art school after studying at the St. Petersburg Academy of Arts. A number of Jewish artists who attended his school were encouraged to enter the art world. Many, including Chagall, Ilya Chashnik, Benjamin Kopman, El Lissitzky, Abel Pann, and Solomon Yudovin, were later recognized as major artists in Russia and internationally.

The waning of Tsarist rule brought with it the removal of restrictions on Jews and Jewish publications, which served as a stimulus for an unprecedented Jewish cultural renaissance. Yiddish literature, poetry, music, theater, and the plastic arts flourished as Jews explored new avenues through which to express their national and cultural identity, as well as to uncover their Jewish artistic heritage (fig. 2). Vladimir Stasov, a leading Russian art and music critic, was a driving force behind the search for a Jewish style with which to express a unique cultural heritage that paralleled the Russian/Slavic national cultural revival. Stasov's encouragement of Jewish secular expression was meant to encourage the creation of art that, while formally indistinguishable from Russian art, related to Jewish experience.[2]

A significant factor in the fostering of Jewish artistic expression may be traced to the patronage of

members of the Jewish elite of St. Petersburg. The St. Petersburg Jewish Historical and Ethnographic Society, inaugurated in 1908, was instrumental in documenting the history of Jewish life in Russia and in studying Jewish folk practices. The society launched a major ethnographic expedition into the Pale of Settlement that was underwritten by Baron Horace Guenzberg. Led by Semyon An-sky, a former social revolutionary and author of *The Dybbuk*, the expedition journeyed into the Ukraine, Podolia, and Volhynia between 1912 and 1914, collecting hundreds of Jewish religious and folk objects. Besides the group's artist and photographer, Solomon Yudovin, the expedition included a musicologist as well as students from the Jewish Academy at the University of St. Petersburg. In subsequent years, images from this journey would serve as source material for Jewish artists, in particular the woodcuts of Yudovin (see ill. 133).[3]

An-sky's findings were reported in the press and resulted in the establishment of a Jewish museum on Vasilevsky Island in Petrograd, where the finds were exhibited temporarily as early as 1916, undoubtedly creating an interest in Jewish folk art.[4] The Society later financed two young but accomplished artists, Lissitzky and Issachar Ryback, to carry on An-sky's work in 1916 with research into the art and architecture of the Jewish towns and villages along the Dnieper in Belorussia.

It was particularly the Russian Jewish critics such as Abram Efros, Maxim Syrkin, and Yakov Tugendkhold who called attention to the possibility of expressing artistic individuality through the use of folklore. Such leading artists as Natan Altman, Chagall, Iosif Chaikov, Lissitzky, Ryback, and Yudovin were among those drawn to and inspired by Jewish folk sources—including popular prints (*lubki*), illuminated manuscripts, and gravestone carvings—as well as religious objects. These artists aspired to

create a modern Jewish style by fusing Eastern European folk sources with the most contemporary Western European artistic techniques and languages. If their attempts were often less experimental than those of their Russian avant-garde colleagues, they were nevertheless strikingly innovative when compared to earlier traditional renderings of Jewish themes (see ill. 21).

As Jewish artists explored new avenues through which to create a style based on traditional Jewish forms, the Jewish theater became a magnet for artistic expression, providing a meeting ground for avant-garde activity in drama, dance, music, literature, and stage design. Two important groups emerged: the Hebrew-speaking Habimah Theater, under the leadership of Natan Zemach, which was committed to the renewal of Jewish national life, and Alexander Granovsky's Jewish Chamber Theater, which became Goset, the Yiddish-language State Jewish Theater.[5] It was Granovsky's intention to create a Yiddish theater completely removed from the old Jewish ghetto theater and on a par with other Soviet avant-garde groups. Both Jewish groups proved an excellent outlet for many painters who adapted their innovative approaches in art to dramatic needs. Among those especially active in creating major costume or stage designs were Chagall, Altman (see ill. 3), Isaak Rabinovich (fig. 3), Robert Falk, and Nisson Shifrin.[6]

Yiddish literature, poetry, music, and theater were also encouraged by the Kultur Lige, a Yiddish secular cultural organization founded in Kiev in 1918 that established a network of publishing and educational activities; its members cultivated music, theater, and the plastic arts. Artists' organizations played a special role in the development of a new Jewish identity, notably the Makhmadim (Precious Ones), a group composed of Russian Jewish artists working in Paris who were united by their concern

Fig. 3
Isaak Rabinovich
The Witch, 1922
Pencil, colored pencil, oil, and india ink on paper,
16³/₄ x 38 in. (6.6 x 15 cm)
Bakhrushin State Central Theater Museum, Moscow

Fig. 4
Natan Altman
Design for Decorations for Palace Square, Petrograd, for the Anniversary of the October Revolution, 1918
Oil on plywood,
20¹/₂ x 28¹/₂ in.
(52 x 72.5 cm)
State Russian Museum,
St. Petersburg
© 1995 VAGA, New York

for Jewish art. In Petrograd, the Jewish Society for the Encouragement of the Arts, founded in 1916, sponsored art exhibitions and publications. Participation in exhibitions of modern Jewish art called attention to the work of young Jewish artists such as Altman, Chagall (see ill. 18), Falk, and Lissitzky (see pl. 8) who, while aware of Jewish tradition, were seeking original directions that owed much to the examples of Cubism and Futurism.[7]

The October 1917 Revolution signified for many artists the end of the old system and the beginning of a new order dedicated to the building of a new state based on technology and industrialization. The avant-garde was, in the years preceding and following the Bolshevik Revolution, among the boldest and most advanced in Europe. Motives for a sharp increase in the Jewish contribution to art and culture during the first years of the Soviet period were the same as those which attracted Jews to the Revolution itself.[8] The new Fine Arts Department of the People's Commissariat for Education (Izo Narkompros), organized in May 1918, was headed by the painter David Shterenberg, who had taken an active role in Bundist activities. Altman, who had joined the Revolution because of his Leftist beliefs, moved to Moscow to succeed Shterenberg as Director of Fine Arts of the People's Commissariat in 1921. Other Jewish artists who held administrative positions included Vladimir Baranov-Rossine, Sofya Dymshits-Tolstaya, and Solomon Nikritin.

The appointment of Anatoly Lunacharsky, who was sympathetic to modern art, as the new People's Commissar of Education, greatly advanced the placement of members of the avant-garde in teaching and administrative positions. As an individual whose tastes were eclectic and whose mind was open to innovation, Lunacharsky encouraged the pluralism that emerged in the arts during the decade following the Revolution. The leadership believed that the message of the Revolution could resonate most effectively in the various national languages, and the

still fragile Soviet state encouraged the development of the arts among the various nationalities.[9]

Of course, not all artists worked with enthusiasm for state-sponsored schools and arts administrations, distrusting the idea of art under government control. Others were drawn to state cultural programs, often with enthusiasm for the opportunity to forge a new utopian society and assume newly available positions, albeit under official restrictions. A decade of intensive struggle followed between various styles and ideologies, until political and social restrictions placed a seal on the development of artistic styles and individual talents.[10] Conservative and avant-garde artists who objected to current cultural policies, and who opposed proletarian and revolutionary ideology as well as the privations of daily life, left the country. Between 1920 and 1925, many of the principal Russian Jewish artists, including Anisfeld, Chagall, Naum Gabo, Pasternak, Anton Pevsner, and Ryback joined the exodus. (Gabo and Chagall had returned to Russia from Europe at the outbreak of the First World War.)[11]

In 1922, a last major exhibition of Jewish artists in Moscow was organized by the Kultur Lige with works by Altman, Chagall, and Shterenberg. Despite an intensified crackdown on minority nationalities, a modest Jewish presence remained in the Soviet Union, notably in the theater. An exhibition surfaced briefly in 1939, when the State Museum of Ethnography in Leningrad organized *Jews in Tsarist Russia and the USSR*. This proved to be the last official exhibition devoted solely to Jewish culture.[12] During the first half of the 1920s, public art was directed toward reaching the broad masses of people. Artists of all generations applied their skills to the creation of Revolutionary propaganda, the decoration of public squares and mass festivals, and the design of posters, porcelain objects, and books (fig. 4). More often than not, work by Jewish artists in the post-Revolutionary era was so international as to be almost indistinguishable from contemporary work by their Russian, German, and French colleagues. Gabo, Pevsner, Baranov-Rossine, Chashnik, Anna Kagan, Lazar Khidekel, and Dymshits-Tolstaya, to mention but a few, were clearly more at home with Cubism, geometric abstraction, and Suprematism than with Jewish themes (fig. 5). A manifestation of the groundswell overtaking many artists is seen in the work of Altman, Chaikov, Lissitzky, and Ryback, each of whom worked on Jewish subjects in their youth and shifted direction as their art began to serve the needs of the Revolution.

Russian-speaking Jewish intellectuals gravitated toward the Russian political organizations, and the proportion of Jews in the management of early state

Fig. 5
Sofya Dymshits-Tolstaya
Glass Relief, ca. 1920
**Mixed media on glass with
steel frame,**
9¹/₂ x 6⁷/₈ x 2 in.
(24 x 17.5 x 5 cm)
**Private Collection, Courtesy
Rosa Esman, New York**

attend Alexandra Exter's school, and the presence of so many Jewish artists there between 1917 and 1920 was notable.[15] Likewise, Vitebsk enjoyed a remarkably rich cultural life; Chasnik, Nina Kogan, Khidekel, Efim Royak, and Lev Yudin were all enrolled in the art school Chagall established there.[16]

Shortly after the Revolution, Chagall was appointed Art Commissar in Vitebsk. As such, he had to contend with both traditional and avant-garde factions. Dissatisfied with the Suprematist faction, which became the predominant group at the school after the arrival of Kazimir Malevich in 1919, Chagall left for Moscow in June 1920. Malevich, who had been brought in as a teacher by Lissitzky, preached his ideology of Suprematist abstraction to a group of devoted disciples. Greatly affected by Chagall's departure and Malevich's arrival, Lissitzky began to develop his Prouns, in which geometric forms were depicted as weightless, without scale or a sense of pictorial space (see ill. 70). Lissitzky and Nina Kogan headed divisions of the school and, as members of the group Unovis (Affirmers of the New Art), implemented many new projects. Despite the marked Jewish composition of the group, Unovis members avoided all reference to Jewish tradition. Works executed in Vitebsk by Chashnik, Khidekel, Kogan, Royak, and Yudin reveal a complete dedica-tion to the principles of Cubism and Suprematism (see ills. 24, 48).[17]

Nevertheless, avant-garde abstract art, even at its height, never supplanted mainstream figurative art. In fact, several modern art movements devel-oped simultaneously, and aspects of Impressionism, Symbolism, Post-Impressionism, Expressionism, Cubism, and Futurism can all be detected in work of the period. Artists such as Falk, Nikritin, Shteren-berg, and Tyshler continued working in a figurative mode. While their work took individual paths, in certain instances it can be construed to express the conflicts and tensions felt throughout Soviet society (fig. 6). In Moscow, Alexander Labas, Nikritin, Tysh-ler, and others developed expressive styles in place of what they considered to be officially approved "empty heroism" (see pls. 20, 21).[18] Espousing a return to easel painting, Shterenberg become a founding member of the Society of Easel Painters (OST). This artists' group advocated the viability of modern painting as an alternative to utilitarian art or conservative realism. Although the Society was opposed to abstraction, it accommodated many varieties of figuration, and a generation of painters moved away from literal depiction, developing new strains of expressive and symbolic realism during the 1920s.

agencies was relatively high. This situation can be understood to have come about because of the Jews' education and training, as well as the general polit-ical circumstances of the time, including significant Jewish support for the ideals of the Revolution.[13] Those in power found it effective to employ Jews, who had existed outside the pre-Revolutionary (Tsarist) power structure, to help uproot traditional Russian culture, including institutions such as the Academy of Arts that were still controlled by the old ruling elite. Thus, some Jewish artists from varied political or cultural backgrounds were catapulted into positions of power, becoming spokespersons for their generation and active at the center of artistic and political activities. While some did so out of political conviction, not a few put their talents at the service of the regime out of fear or simple career-ism.[14] Jews were helped not only by the absence of restrictions but also by a staunch campaign against everyday anti-Semitism, which authorities defined as anti-Soviet.

Many members of the Revolutionary generation of Jewish artists had been born in remote villages in the Ukraine, Belorussia, and the Baltic area and were eager to move to more cosmopolitan centers such as Kiev or Odessa, where vital art communities existed. Artists such as Boris Aronson, Rabinovich, Shifrin, and Alexander Tyshler relocated to Kiev to

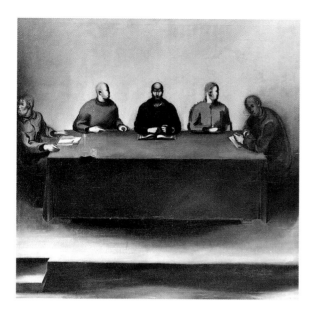

Following Lenin's death in 1924, Stalin assumed complete control of the Communist Party. After the introduction in 1928 of his first Five-Year Plan calling for the collectivization of agriculture and development of heavy industry, ideological and cultural energies became subordinated to these aims. Between 1928 and 1932, art was subject to a gradual tightening of state control, and a rewriting of Russian art history to suit the demands of the Communist Party was part of a wider revision of Russian and Soviet history which began in the late 1920s. As personal expression became subordinate to the objectives of the state, artists who persisted in expressing their commitment to abstraction or non-approved styles faced persecution for ideological deviation.[19] This culminated in 1932 with an edict by the central committee of the Communist Party dissolving all existing literary and artistic organizations, the latter to be replaced by a single union. Thereafter, the Party had complete control over cultural expression.[20]

A leading artist in the evolution of Socialist Realism was Isaak Brodsky, generally considered the creator of the thematic Revolutionary picture in Soviet art. Brodsky became well known in the 1920s for his portrayals of Lenin and his scenes from Revolutionary history. As an avid promoter of the wishes of Stalin and, later, Stalin's cultural henchman, Andrei Zhdanov, Brodsky painted dozens of portraits of Lenin set immediately after the Revolution. These propagandistic images were used to advance the goals of the state (see pl. 27). During the 1920s, a number of realist artists' groups were founded, the most conservative being the Association of Artists of Revolutionary Russia (AKhRR). It included Evgeny Katsman—a portrait painter (see pl. 25) and, with Vladimir Perelman, one of the group's founders—as well as such talented artists as Brodsky, all dedicated to Revolutionary themes and heroic images of the proletariat intended to appeal to mass taste and comprehension (see ill. 11).

In 1934, at the first conference of the Union of Writers, Socialist Realism was proclaimed as the definitive Soviet literary and artistic style. While Socialist Realist art was never a static phenomenon, the writers' constitution demanded of artists that they represent historically accurate depictions of reality, glorify the Revolution, and communicate the meaning of Communism to the people. Emphasizing the tradition of Russian realism from the late nineteenth century, the new Soviet intelligentsia contended that such popular, story-telling art would be most easily understood by the masses and the best vehicle for propaganda.

As with the earlier avant-garde movements, there were Jewish artists who followed this trend, although their political involvement varied. Many Jews were firmly tied to the various agencies of the regime and thus dependent on its changing positions. As restrictions on artistic license tightened, they found themselves promoting government figures and programs that were increasingly repressive. Positions of leadership in the arts were taken by former AKhRR members. Isaak Brodsky became president of the renamed, newly formed All-Russian Academy of Arts in 1934.

However, the proportion of Jews who participated in this transformation of culture into Socialist Realist pseudo-culture was noticeably lower than that which took part in activities of the initial post-Revolutionary years. Notable exceptions were Iosif Chaikov, Vladimir Ingal, Katsman, Lev Kerbel, Viktor Perelman, and Grigory Shegal, who were aggressive advocates of the officially approved styles. This does not mean that the percentage of Jews in Soviet art decreased in the early 1930s. Rather, their importance in the official sphere declined, and many were prevented from reaching higher levels due to their Jewish nationality.[21]

In architecture, Stalin's call for art that would be national in form and socialist in content guided the competition in 1931–33 for a Palace of Soviets in Moscow. The winning entry by Boris Iofan, chosen over 160 other submissions, was to be surmounted by a 245-foot-high statue of Lenin capable of expressing the power of the working people (see pl. 22).[22] Photographers such as Arkady Shaiket and Georgy Zelma, as well as book illustrators and graphic artists including Lissitzky and Solomon Telingater (see pl. 24), employed their art to chronicle the achievements of the regime.

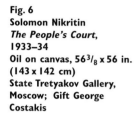

Artist Unknown
***Bier for Mikhoels's Coffin,
Belorussian Railroad
Station, Moscow,** 1948*
Photograph, 6³/₄ x 9¹/₂ in.
(17.1 x 24.1 cm)
Private Collection, Moscow

The 1930s and the decades that followed were times of increasing repression and control during which many artists were deprived of a living or forced to make compromises. Some adapted to the new dictates, as Yudovin did in his graphics of factories and collective farms (see ill. 134), and some, like Kagan, ceased to work or exhibit. Some of the earlier experimental artists such as Falk, Boris Gurevich, and Tyshler turned to illustrative, theatrical, or decorative work. They represent the lone nonconformist artists whose work did not go beyond the walls of their studios and the circle of their closest friends, remaining deeply personal. Everyone understood that they were living in an atmosphere where secrets were almost impossible to keep and that to create art without ideological approval would be considered treasonous. Thus, a number of artists moved away from subjects of social concern to create domestic art.[23]

As Stalin's power grew and terror and oppression penetrated all corners of Soviet life, many Jewish intellectuals and writers fell victim to a wave of purges (1935–39) and deportations, including numerous former leaders of the Jewish Section (Evsektsiya) of the Party. By the late 1940s, at the height of Zhdanovism, anti-Semitism had begun to spread so that even Jews who were Socialist Realists found themselves barred from major commissions and key positions, with few exceptions. The 1940s and 1950s were a time of considerable suffering for all the Soviet people (see ill. 44 a). Although Stalin removed Jews from key political positions, reportedly in preparation for an accord with Hitler, they were found to be needed in the ranks of the establishment following the German invasion of Russia in 1942. The Jewish Anti-Fascist Committee was formed to enlist support from the American Jewish community for the Soviet war effort, and for this purpose, the noted Yiddish actor Solomon Mikhoels and the poet Itzik Feffer traveled to America in 1943.[24]

Anti-Semitism surfaced once again after the war, and the treatment of Jewish artists corresponded to the general attitude toward Jews in the Soviet Union. Its manifestations included the brutal dissolution of the Jewish Anti-Fascist Committee, the liquidation of Yiddish schools, and the imprisonment of major figures connected with Soviet Jewish culture. Mikhoels, by this time an unofficial spokesman for Soviet Jews, was murdered by Stalin's agents in 1948, and the Yiddish theater collapsed. It may be more than coincidence that these attempts to eradicate Soviet Jewish culture came at the same time as the founding of the State of Israel and its appeal to Jewish national sentiments.

Although Socialist Realism persisted as the guiding principle in official art, by the end of the 1950s, Khrushchev had given back to artists the sense that there was a possibility for individual expression. Thus, signs of diversity began to emerge. Khrushchev's "secret speech" to Party cadres condemning the "cult of personality" surrounding Stalin and denouncing his crimes resulted in a loosening of aesthetic strictures and also relaxed some of the barriers cutting artists off from contact with the West and from their own artistic heritage.

By the early 1960s, disenchantment with Soviet culture was being expressed by artists in a limited fashion. Within the next decade, this disenchantment spread, and what was thought of as official art was broadened to include artists interested in traditions of primitive and naive art which had been buried in Stalin's drive toward an academic style. The ideal of Socialist Realism is entirely absent from the work of such artists. Thus, the Leningrad artist Anatoly Kaplan, who produced a series of graphics illustrating Jewish folk tales derived from the world of the shtetl (see ill. 45), was tolerated during the 1950s and 1960s. While the rigid Soviet cultural machine did not change overnight, there were increasing manifestations of pluralism in the art of a considerable number of talented Soviet artists.[25]

Nonconformist art reflected a creative force with no specific direction or single style. The only common denominator binding the artists together was the search for individual expression outside official doctrine. Jews constituted a high proportion of nonconformist artists and played a significant role in this movement from the moment the split between officially accepted Socialist Realism and alternative styles appeared. They gravitated toward nonconformist art since it did not require losing any entrenched positions in society. Their oppositional activity was determined, as it had been almost a hundred years earlier, by the isolated position of their confreres in Russian and Soviet life.

Interest in Russian and Soviet artistic precedents grew among young artists who had been deprived of

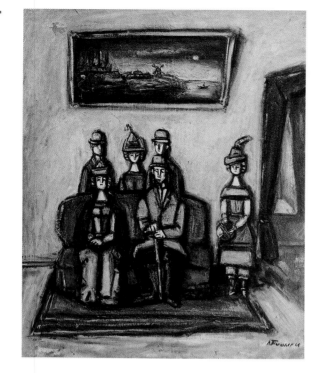

Fig. 7
Alexander Tyshler
Neighbors from My Childhood, 1965
Oil on canvas,
30⁷/₈ x 24³/₈ in.
(78.5 x 62 cm)
Courtesy Národni Galeri v Praze, Prague

knowledge of their artistic heritage. Furthermore, Jewish artists still had vague memories from their youth of a discontinued tradition; they describe stories told by their elders about the artists of the Revolution, such as Chagall or the Cubists. In Moscow, the widows of Falk, Tyshler, and other Jewish artists organized private showings of their husbands' work. In 1966, the Moscow Union of Artists organized a posthumous exhibition of works by Falk, but, although a catalogue was even published, it was not allowed to open. That same year, the Ministry of Culture presented an exhibition of Tyshler's work at the State Pushkin Museum in Moscow; this was his first solo exhibit in 40 years. Though Soviet officials were hardly enthusiastic, the government steadily increased its exposure of avant-garde works of art. In his first visit to the country since his emigration in 1922, Chagall was present at the opening of an exhibition of his works in 1973 at the State Tretyakov Gallery. Older artists who maintained their ties with the past provided a link with the pre-Stalin artistic tradition, establishing an important reference point for younger artists in the post-Stalin era (fig. 7).[26]

During the brief period between 1956 and 1963, de-Stalinization and an effort at detente resulted in a new opening to the West, and the cultural vacuum created during the long years of Stalin's rule began to be filled with new information. The Sixth World Festival of Youth and Students held in Moscow in the summer of 1957 made a profound impression, providing the first opportunity for many young Russians to see the work of contemporary

Western artists. But the very existence of a gifted, free-thinking younger generation, albeit within the confines of Socialist Realism, was a threat to the Union of Artists, and reaction to the new liberalism set in. In 1962 Khrushchev, who had no personal judgment about art, used the occasion of the union's 30th anniversary exhibition, held in the Manezh Exhibition Hall, the largest exhibition hall in the center of Moscow, to condemn what he saw as the dreadful art infecting the country. The exhibition was carefully planned to include some nonconformist artists, among them Ernst Neizvestny, Ullo Sooster, and Vladimir Yankilevsky (see ills. 130, 131). Khrushchev viciously denounced the artists for formalism. It was at this exhibition that the conflict between "official" and "unofficial" art burst into the open.[27] Although neither Neizvestny nor any of the other artists involved were arrested, the door was once again slammed on nonconformist artistic activity (fig. 8). Those artists who refused to compromise were eliminated from official artistic life and forced to join the nonconformist counterculture. Even Khrushchev's fall in October 1964 did not result in a new thaw. During the tight cultural controls of the Brezhnev era, "writing for the desk" or "painting for the closet" became more widespread. As the counterculture became stronger, some artists began to share mutual concerns or aspirations and form small groups.

The Leva (Left) group of Moscow avant-garde artists and poets included some of the most signifi-

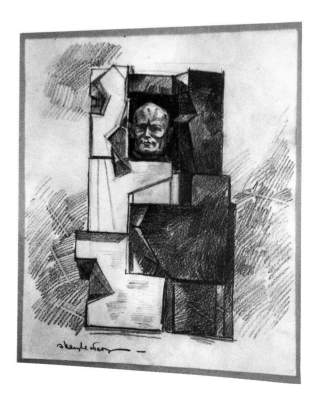

Fig. 8
Ernst Neizvestny
Sketch for Khrushchev's Tomb, 1971–72
Pencil and pen on paper,
17 x 14 in. (43.2 x 35.6 cm)
Collection of the Artist,
New York

cant nonconformist artists of the late 1950s. Seventy percent of them, according to Mikhail Grobman, were Jews.[28] Much of the work produced by the Leva group was concerned with the use of art as a metaphor to express what could not be said aloud, and, with the exception of Grobman, it contained no explicit Jewish references. Oscar Rabin's Lianozovo Group of painters and poets focused on their immediate environment, using the detritus of life which, they believed, could show off the absurdity of the Soviet system (see pl. 30). Another significant group of like-minded artists was the Sretensky Boulevard group, comprising Erik Bulatov, Ilya Kabakov, Viktor Pivovarov, Eduard Shteinberg, and Yankilevsky (see ills. 16, 91; pl. 37). Although they shared no ideology or aesthetic, all of these artists were Jewish. Joining together provided moral support and creative stimulus, leading to various attempts at group exhibitions. Most trained as illustrators or book designers and joined the graphics section of the Union of Artists, thus assuring themselves of the official privileges of Soviet society.

For certain artists, abstraction offered a means to explore philosophical or theological realms. Dmitry Lion, Boris Turetsky (see ills. 65, 118), Yury Zlotnikov, and Grobman found inspiration in visual signs and explored the symbolic and paradoxical nature of society (fig. 9).[29] However, in both Moscow and Leningrad, Russian artists rarely came together on the basis of a single style. Overall, the artists of

the 1960s demonstrated a turmoil of styles, from conceptual art to abstraction to various forms of symbolism.

The ongoing impossibility of unofficial artists exhibiting their work officially led Rabin and collector Alexander Glezer to devise the idea of an outdoor exhibition in a field on the outskirts of Moscow. What has come to be known as the "Bulldozer" exhibition brought the status of nonconformist artists to international attention in 1974. Just as the first visitors arrived, the exhibition was forcibly disbanded by the authorities, who sent in professional thugs, water trucks, and bulldozers to break up the crowd of thousands and literally plow down the art. Many works were damaged or destroyed, while foreign journalists looked on, appalled.[30] The Soviet government was embarrassed into permitting another exhibition two weeks later in Izmaylova Park, at which anyone was allowed to exhibit. A tremendous success, this show included over a hundred artists and attracted thousands of visitors.

The need for artists to unite in their efforts to exhibit their work was also felt in Leningrad that year. The early unofficial artists of Leningrad were not always drawn to Western abstraction and Pop Art as their contemporaries in Moscow were. While they wished to incorporate aspects of international art which for so many years had been forbidden, they also wished to retrieve their own lost cultural heritage. Shalom Shvarts was one of the pioneer nonconformist Leningrad artists, and in subsequent years, Anatoly Belkin, Alexander Gurevich, Alexander Manusov, and Vadim Voinov drew from a range of stylistic precedents. Paradoxically, it was these artists' physical isolation that enabled them to maintain an inner orientation, often looking backwards and summoning up their Russian heritage—be it religious art, folk painting, or the art of pre- and post-Revolutionary Russia. Thus, styles varied from one artist to another.[31] The first officially sanctioned exhibitions of nonconformist artists were shown simultaneously in Moscow and Leningrad due to contacts among the leadership of artists' groups. Only the Moscow events received international publicity, perhaps due to the fact that foreign consulates did not open in Leningrad until 1973. While several large unofficial exhibitions were mounted there during 1974–75, the authorities responded with physical threats and intimidation. These exhibitions essentially marked the disintegration of any unified movement of artists in Leningrad.[32]

Denied the ability to exhibit, publish, or have their work studied, nonconformist artists developed an underground alternative that led them to display their works in private apartments or artists' studios.

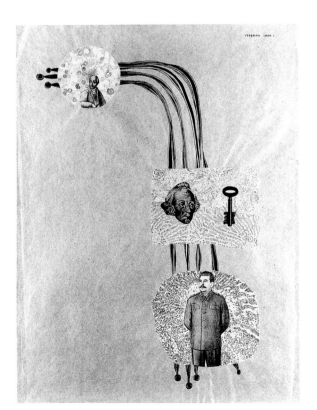

Fig. 9
Mikhail Grobman
Generalissimo, 1964
Collage and ink on paper,
23⅝ x 17⅝ in.
(60 x 44.8 cm)
Museum Ludwig, Cologne

In such circumstances, like-minded artists, writers, and collectors showed newly created pieces, shared ideas, and discussed recent artistic events. In Moscow, these artists increasingly favored the most extreme forms of conceptual art; however, they demonstrated no unified style, but rather a mix of formal and thematic interests.[33] With few opportunities to exhibit their work, artists found that it was appreciated and supported by diplomats, correspondents, foreign collectors, a few friends, and fewer local collectors.[34]

The emergence of Sots Art in 1972 is usually identified with the artistic scene in Moscow. This new tendency developed when the artists Vitaly Komar and Alexander Melamid joined with Alexander Kosolapov to make use of the iconic language of Soviet propaganda and Socialist Realism. Their work took the form of art that expressed opposition to governmental prescriptions of the preceding generation and dared to treat Socialist Realism with irony and irreverence (see pl. 42). Mocking the myths of official Soviet culture, Sots artists displayed a sensibility similar to that of American Pop artists. In effect, Sots Art took its visual vocabulary from everyday life, but in the Soviet version the imagery derived primarily from political sources (see pl. 38).[35]

For Soviet Jews, the impact of the Six-Day War in 1967 was profound. A new-found Jewish consciousness often coincided with disillusionment with their position in Soviet society, the latter resulting from the anti-Israeli and anti-Semitic propaganda offensive that followed Israel's victory. Although many of the artists of the new avant-garde were Jews, only a small number had an interest in going to Israel. Some preferred to stay and continue to fight for their rights in their homeland, while others, when given permission, chose to emigrate to Western Europe or the United States.

These issues, complex to begin with, assumed even more importance as individual Soviet Jewish artists began to paint Jewish themes and attempted to exhibit their works during the 1960s and 1970s. Those who identified themselves as Jews tended to emphasize ethnic subjects and to include Hebrew inscriptions in their paintings. Others concentrated on personal interpretations of literary themes. When Jewish themes did appear—in the work of Samuil Rubashkin, Evgeny Abezgauz, and Marc Klionsky, and others, they usually were drawn from biblical texts, traditional ceremonies, or Yiddish culture remembered from a world that had been destroyed within the Soviet context (fig. 10).[36]

Artists who were committed to Jewish expression became one small but significant component in an attempt to revive Jewish culture in the Soviet Union. The Leningrad Jewish artist's group Aleph was formed in 1975 in order to exhibit "a group of works linked to the spirit and life of the Jewish people and its national and cultural traditions."[37] The 12 members, who exhibited neither stylistic nor philosophical unity, did not underestimate the dangers of identifying themselves as Jewish artists, especially since two were not even Jewish. Not only did they run the obvious risk of reprisals; they also encountered the more subtle problems of distinguishing between personal and national identity. This involved a decision about how membership should be determined by nationality, religion of the artist, or content of the art. During this same period, however, an entirely different reaction was forthcoming among the majority of Jewish artists in the Soviet Union, whose art reflected international influences rather than Jewish themes, thus echoing the trend toward modernism at the beginning of the century, and who felt no particular identification with a Jewish community.

Jewish emigration from the Soviet Union was an important factor in Russian artistic life in the late 1970s and 1980s. The large percentage of Jewish émigrés accounts for the number of exceptional Soviet Jewish artists residing in Paris, New York, and Israel today. Among the most notable are (in Paris) Eric Bulatov, Yuri Cooper, Rabin, Mikhail Roginsky (see pl. 29), and Oleg Tselkov (see ill. 117); (in New York) Grisha Bruskin, Komar and Melamid, Alexander Kosolapov, and Leonid Lamm; and (in Israel) Samuel Ackerman, Mikhail Grobman, and Josef Jackerson. Those who emigrated gave those who remained a constant feeling of transience. But emigration also established a permanent channel

Fig. 10
Evgeny Abezgauz
Isroelke (Little Israel) Wandered and Wandered throughout Russia in Search of Happiness, 1975
Oil on pasteboard,
15³/₈ x 20⁷/₈ in.
(39 x 53 cm)
Jane Voorhees Zimmerli Art Museum, Rutgers, The State University of New Jersey, New Brunswick, The Norton and Nancy Dodge Collection of Nonconformist Art from the Soviet Union

Artist Unknown
Bulldozer Exhibition, Moscow, 15 September 1974
Photograph, 4$^1/_8$ x 6$^3/_4$ in. (10.5 x 17.1 cm)
Collection Alexander Glezer, Moscow

between the Soviet Union and the West, thereby allowing Russian artists to learn about Western artistic activities, styles, and trends.[38]

For Soviet artists working within a tradition in which the very act of producing a painting was political, it is notable that Jewish artists have continued to figure prominently in the contemporary avant-garde community. Indeed, works by a number of former nonconformist Jewish artists formed the core of the first auction of avant-garde and contemporary Soviet art at Sotheby's in Moscow in July 1988. The auction became an international phenomenon, highlighted by the sale of a painting by Grisha Bruskin for a record sum.

Although all Soviet Jews have had to reconcile their identities as Russians and as Jews, the Jewish experience has not figured explicitly in the work of the major Soviet Jewish artists with the exception of Bruskin (see pl. 46). For some, their Jewish identity was a matter of indifference; for many others, it was a source of shame and embarrassment, a stigma carried for life. Some sought to merge into Russian society completely, feeling that their Jewishness was a burden and that the only way to escape was to cease being Jewish. Others boldly affirmed their Jewishness and rejected the larger society, which, in their view, had rejected them.

Today, Jewish artists enjoy a new cultural and social status. In the post-Soviet era, anti-Semitism is no longer an instrument of the state, and Jews are able to find their voice. It remains to be seen whether they will articulate their Jewish identity, however, in a society that continues to define its citizens by religious or national affiliation.

Susan Tumarkin Goodman
is Chief Curator at The Jewish Museum, New York.

Artist Unknown
First Auction of Russian Avant-Garde and Soviet Contemporary Art in Russia, Sotheby's, Moscow, 7 July 1988
Photograph, 8 x 10 in. (20.3 x 25.4 cm)
© 1988 Sotheby's, Inc.

Notes

[1] Marc Chagall, My Life (New York: Orion Press), p. 78.

[2] Vladimir Stasov is discussed in Seth L. Wolitz, "The Jewish National Art Renaissance in Russia," in Ruth Apter-Gabriel, ed., *Tradition and Revolution: The Jewish Renaissance in Russian Avant-Garde Art, 1912–1928*, exh. cat. (Jerusalem: Israel Museum, 1987), pp. 24–25.

[3] Alexander Kantsedikas, "Semyon An-sky and the Jewish Artistic Heritage," and Abram Efros, "Aladdin's Lamp," in Semyon An-sky, *The Jewish Artistic Heritage: An Album* (Moscow: RA, 1994), pp. 28–32.

[4] For a description of the material gathered during the expedition and its disposition in subsequent years, see Igor Krupnik, "Jewish Holdings of the Leningrad Ethnographic Museum," *Soviet Jewish Affairs* 19, no. 5 (1989), pp. 35–48.

[5] Avram Kampf, "In Quest of the Jewish Style in the Era of the Russian Revolution," *Journal of Jewish Art* 5 (1978), p. 51.

[6] Avram Kampf, "Art and Stage Design: The Jewish Theatres of Moscow in the Early Twenties," in *Tradition and Revolution* (note 2), pp. 125–39.

[7] John E. Bowlt, "From the Pale of Settlement to the Reconstruction of the World," in *Tradition and Revolution* (note 2), pp. 47–49.

[8] For further information regarding the reaction by and to Jews in the years around the Revolution, see Igor Golomstock, "Jews in Soviet Art," in Jack Miller, ed., *Jews in Soviet Culture* (London: Institute of Jewish Affairs, 1984), pp. 30–38; Alice Stone Nakhimovsky, *Russian-Jewish Literature and Identity* (Baltimore and London: Johns Hopkins University Press, 1992), pp. 18–20).

[9] Avram Kampf, *Chagall to Kitaj: Jewish Experience in 20th Century Art*, exh. cat. (London: Barbican Art Gallery, 1990), pp. 28–30.

[10] See Colin Gardner, "Brave New World," *Artforum* 29, no. 6 (February 1991), pp. 110–14.

[11] For a contemporaneous reaction to the loss of artistic freedom, see Ivan Narodny, "Art under the Soviet Rule," *International Studio* 76, no. 310 (March 1923), p. 464.

[12] Bowlt (note 7), p. 60.

[13] See Semen Markovich Dubnow, *History of the Jews in Russia and Poland*, vol. 3 (Hoboken, NJ: Ktav, 1975), pp. 428–37, for a discussion of the situation for Jews during this period.

[14] Shmuel Ettinger, "The Position of Jews in Soviet Culture: A Historical Survey," in *Jews in Soviet Culture* (note 8), p. 14.

[15] Bowlt (note 7), p. 53.

[16] See Dimitri Horbachov, "A Survey of Ukrainian Avant Garde," in Jo-Anne Birnie Danzker *et al.*, eds., *Avantgarde & Ukraine*, exh. cat. (Munich: Villa Stuck, 1993), pp. 67–72.

[17] Alexandra Shatskich [*sic*], "Chagall and Malevich in Vitebsk," in *Marc Chagall: The Russian Years 1906–1922*, exh. cat. (Frankfurt: Schirn Kunsthalle, 1991), pp. 62–67.

[18] See Brandon Taylor, "Russians on the Road, Part 1: Vienna," *Art in America* 76, no. 10 (October 1988), pp. 33–47, for a discussion of Russian and Soviet art from 1910 until 1932.

[19] For a discussion of this period, see Boris Groys, *The Total Art of Stalinism* (Princeton: Princeton University Press, 1932); Igor Golomstock, *Totalitarian Art* (London: Icon Editions, 1990).

[20] See Matthew Cullerne Bown, *Art under Stalin* (New York: Holmes and Meier, 1991), pp. 86–95.

[21] Golomstock (note 8), p. 49.

[22] For a recent publication presenting extensive information and documentation on the evolution of Iofan's design for the Palace of Soviets, see Peter Noever, ed., *Tyrannei des Schönen: Architektur der Stalin-Zeit*, exh. cat. (Österreichisches Museum für Angewandte Kunst, 1994), pp. 151ff.

[23] Bown (note 20), pp. 219–20.

[24] Salo W. Baron, *The Russian Jew under Tsars and Soviets* (New York: Schocken Books, 1987), pp. 261–78; Bown (note 20), pp. 219–20.

[25] Margarita Tupitsyn, "The Ludwig Collection: Contemporary Soviet Art," *Vanguard* 14, no. 2 (March 1985), pp. 21–25.

[26] For an early source on the subject, see Paul Sjeklocha and Agar Mead, *Unofficial Art in the Soviet Union* (Berkeley and Los Angeles: University of California Press, 1967), p. 105.

[27] Ironically, years later Khrushchev's family commissioned Neizvestny to design the former leader's gravestone.

[28] They included the artists Kropivnitsky, Kulakov, Masterkova, Neizvestny, Rabin, Weisberg, and Zverev. See Stephen Feinstein, "Soviet Jewish Artists in the U.S.S.R. and Israel," in Robert O. Freedman, ed., *Soviet Jewry in the 1980s: The Politics of Anti-Semitism and Emigration and the Dynamics of Resettlement* (Durham and London: Duke University Press, 1989), pp. 186–213.

[29] Helena Kantor, "Jews—Artists in Russian Post-War Avant-Garde Moscow, 1950–1970s" (paper presented at the Third International Seminar on Jewish Art, Center for Jewish Art, Hebrew University, Jerusalem, 7 May 1991).

[30] See Alexander Glezer, *Contemporary Russian Art* (Paris, Moscow, and New York: Third Wave, 1993).

[31] See Selma Holo, ed., *Keepers of the Flame: Unofficial Artists of Leningrad*, exh. cat. (Los Angeles: Fischer Gallery, University of Southern California, 1990).

[32] See Constantine Kuzminsky, "Two Decades of Unofficial Art in Leningrad," in Norton Dodge and Alison Hilton, *New Art from the Soviet Union* (Mechanicsville, MD: Cremona Foundation, 1977), pp. 27–30.

[33] See introduction by Margarita Tupitsyn and Victor Tupitsyn, in Norton Dodge, ed., *Apt Art: Moscow Vanguard in the '80s*, exh. cat. (New York: Contemporary Russian Art Center of America, 1984).

[34] In the United States, collector Norton Dodge amassed thousands of works by the unofficial artists (see John McPhee, *The Ransom of Russian Art* [New York: Farrar, Straus and Giroux, 1994]). The most prominent collection of work by the official artists was gathered by German collector Peter Ludwig (see note 25 above).

[35] See Margarita Tupitsyn, *Sots Art*, exh. cat. (New York: New Museum of Contemporary Art, 1986).

[36] Alla Rosenfeld, *Struggle for the Spirit*, exh. cat. (New Brunswick: Jane Voorhees Zimmerli Art Museum, Rutgers, The State University of New Jersey, 1993), p. 3.

[37] For documentation regarding the Aleph group (members included E. Abezgauz, Y. Kalendarev, A. Manusov, T. Kornfeld, A. Gurevich, O. Shmuilovich, A. Basin, A. Okun, A. Rapoport, S. Ostrovsky, L. Bolmat, O. Sidlin), see Michael Borgman, *12 from the Soviet Underground*, exh. cat. (Berkeley: The Judah L. Magnes Museum, 1976).

[38] Marilyn Rueschemeyer, Igor Golomshtok, and Janet Kennedy, *Soviet Emigré Artists: Life and Work in the USSR and the United States* (Armonk, NY, and London: M.E. Sharpe, Inc., 1985), pp. 1–15, 110.

John E. Bowlt

Jewish Artists and the Russian Silver Age

> My art, i.e. my plastic art, possesses one advantage over the word or literature: it is *international* and can be understood in all languages. Painting, drawing, a landscape, a portrait, whether painted by a Swede, a Frenchman, a Russian, or a Jew, can be understood by everyone, and for the moment we have no need of a special language, a special Jewish art. It does not exist yet, and it can exist only in its native land, because every national art derives from the native life it lives.
> ——Leonid Pasternak[1]

The position of the Jewish artist within the Russian cultural renaissance of the late nineteenth and early twentieth centuries is an extremely complex issue, because it touches on a range of delicate and equivocal questions. Any examination of the role and function of the Jewish artist in late Imperial Russia must confront a basic philosophical question that, however crucial to our understanding of Jewish culture, defies adequate explication, i.e. what is Jewish art and how does it differ from other national expressions?[2] Russian Jewish critics of the early twentieth century such as Moisei Balaban, Abram Efros, and Maxim Syrkin suggested responses, but these are far from satisfactory and leave many attendant questions unanswered. In wondering "What do we call Jewish art?" for example, Balaban simply compiled

Fig. I
Osip Braz
Portrait of Anton Chekhov,
1898
Oil on canvas,
47 $\frac{1}{4}$ x 31 $\frac{1}{2}$ in.
(120 x 80 cm)
State Tretyakov Gallery,
Moscow

a list of objects that had been "created by Jews and carry all the features of distinctive Jewish creativity" such as "items of the synagogue, carvings, candlesticks, reflectors, illustrated manuscripts."[3] The famous ethnographer Semyon An-sky, who made frequent contributions to the debate on Russian Jewish art, tended to agree and seemed to find a common ethnic and aesthetic denominator in all the diverse artifacts he collected and categorized, from Hanukkah lamps and spice boxes to Torah shields and ancient *pinkasim* (congregational record books).[4] This argument was supported by the less famous but important artist, critic, and ethnographer Lev Antokolsky (nephew of the sculptor Mark Antokolsky) in his synthetic commentary on synagogues, Israels, and Isaak Levitan.[5] Efros, however, was less adamant in his attributions, contending that "Jewish artists belong to the art of the country where they are living and working" and that "[Russian Jewish] artists do not feel themselves to be Jews in art and do not aspire to convey the aroma or express the beauty of Jewishness in plastic terms."[6] Syrkin followed a similar argument, maintaining that "wherever fate carried them, Jews—willingly and without the slightest compunction—accepted the art of their environment for their own domestic concerns."[7] Ultimately, such assessments led to the same kind of misleading generality that accompanies most attempts to define national culture, even though, of course, certain pronounced stylistic and thematic tendencies might have inspired some observers to assert that Jewish art was "quite unlike any other."[8] There again, perhaps Jewish art was and is unique, because of its diasporic path of development, full of zigzag displacements and sudden intermissions. Only a fundamental inconsistency could explain why, on the one hand, "the Jews never had a really intense cult of plasticity,"[9] and yet, on the other, they identified their artistic rebirth with the sculptural attainments of Antokolsky, Naum Aronson, Moisei Ginzburg, Iosif Chaikov, Naum Gabo (see his *Column* [pl. 14]), and Noton Pevsner.

Whatever the perimeters of the Jewish presence in Russia, the contributions of Jewish artists to Russian modernism left a profound and permanent imprint, and Russia's Silver Age (the twilight of Imperial Russia) would lose much of its brilliance if the names of Léon Bakst, Marc Chagall, Nadezhda Dobychina, Genrietta and Vladimir Girshman, El Lissitzky, Benedikt Livshits, Osip Mandelshtam, and Leonid and his son, the writer Boris, Pasternak were subtracted from its constellation. Recent and current scholarship of the problem of Russian Jewish art has done much to bring these contributions to public attention, but the entire territory has yet to be

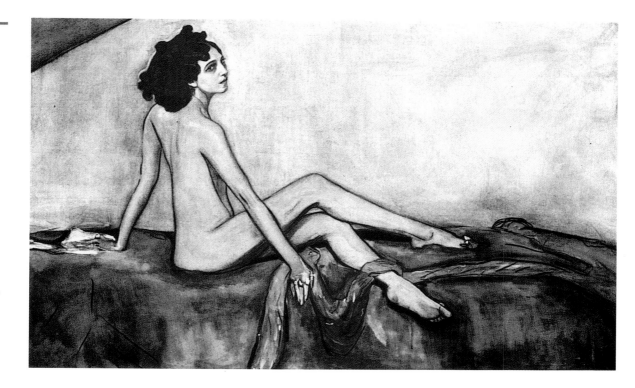

Fig. 2
Valentin Serov
Portrait of Ida Rubinstein,
1910
Tempera on canvas,
57$7/_8$ x 91$3/_4$ in.
(147 x 233 cm)
State Russian Museum,
St. Petersburg

Fig. 3
Mikhail Larionov
Jewish Venus, 1912
Oil on canvas,
38$1/_2$ x 54$3/_4$ in.
(98 x 139 cm)
State Art Gallery,
Ekaterinburg

charted, and many other individuals and institutions should be added to the repertoire of Jewish culture in Moscow and St. Petersburg before the October Revolution. The landscapes of Isaak Levitan such as *Above Eternal Peace* (see pl. 2), for example, are well known and hang in prestigious museums, but we hear little about the paintings and drawings of his brother Avel. The Realist Mark Antokolsky is the subject of at least eight monographs, while the Impressionist Naum Aronson, a disciple of Rodin and a teacher of Iosif Chaikov, has been almost forgotten. The salon portraits by Osip Braz (e.g. of An-

ton Chekhov [fig. 1]) and Savely Sorin (e.g. of Anna Pavlova) occupy a central position in the gallery of Russian intellectuals and patrons, but they are overshadowed by the portraits of their more famous colleagues Bakst (see ills. 7, 8) and Valentin Serov (fig. 2). The private studios of Mikhail Bernshtein in Moscow and Savely Zeidenberg in St. Petersburg nurtured many important artists of the Russian avant-garde, including Vera Ermolaeva, Vladimir Lebedev, Yury Annenkov, and Chagall; no less influential than the more familiar Yehuda Pen, at best they have been relegated to footnotes. The painters Adolf Milman and David Shterenberg were no less active in the avant-garde than Chagall and Robert Falk, while in the history of Russian book illustration, Mark Kinarsky and Mikhail Solomonov should also be recognized alongside Solomon Telingater and Solomon Yudovin. Of course, the availability of works, difficulty of transportation, and schedule conflicts always influence the consistency of a museum exhibition, but, as we contemplate *Russian Jewish Artists in a Century of Change, 1890–1990,* we should be aware of its inevitable limitations and remember that the mosaic of Russian Jewish art is even more intricate than this panorama suggests.

The culture that flourished during the Russian Silver Age was a heady mixture of national ethnic components (Ukrainian, Polish, Georgian, and Armenian, as well as Jewish), so much so that the term "Russian" loses any absolute meaning. Moreover, many of the Jewish painters and sculptors who are associated with Russian art of this time were born

not in Russia, but in the Ukraine (Iosif Chaikov, Tyshler) or White Russia (Bakst). As the art and ballet historian Andrei Levinson mentioned in 1923, "The history and definition . . . of the Russian school of painting cannot be constructed along racial or territorial lines."[10] Perhaps it was because of such dilation that Jewish artists, writers, and musicians participated readily in the process of Russian Symbolism, Cubo-Futurism, Suprematism, and Constructivism and why, in turn, many of their Russian colleagues paid particular attention to the values of Jewish culture and ritual. Often this interest was merely "exotic" rather than ethnographical—manifest in such gestures as Natalya Goncharova's Jewish cycle of paintings[11] and Mikhail Larionov's *Jewish Venus* (fig. 3)—and was generated by the same concern with "outsider" and alternative systems that placed Jewish culture in the same "primitive" or "Asiatic" lexicon as the art of the Aztecs, the Chinese, the Japanese, and the Madagascarans.

In his long essay entitled "Jews and Art" of 1916, Syrkin even implied that Jews, too, represented a primitive and pristine race that, like the "colored races, the Polynesians and the Negroes,"[12] was the bearer of its own artistic genius, which had yet to be rediscovered and developed. Incidentally, Syrkin's association of Jewish art with other outsider expressions such as Black culture and his conclusion that these were no less original than the achievements of the Italian Renaissance would have met with the approval of Goncharova and Larionov, who included

Jewish scenes among their Neo-Primitivist and Rayonist contributions to the *Target* exhibition in 1913 and Black sculpture in Nikolai Vinogradov's 1913 exhibition of popular prints (*lubki*). Syrkin's argument also helps to explain why the new Jewish artists gave particular attention to Blacks as subjects, e.g. Altman's *Negress* (1929; St. Petersburg, Evgenia and Feliks Chudnovsky Collection) and Falk's *Negro from the Circus* (fig. 4). But in the 1900s and 1910s, there was also a more serious philosophical interest that culminated in numerous Russian translations of Yiddish and Hebrew poetry rendered by Russia's leading intellectuals such as Yury Baltrushaitis, Valery Bryusov, Vladislav Khodasevich, Vyacheslav Ivanov, and Fedor Sologub.[13] This was also reflected in thoughtful essays such as Ivanov's "Concerning the Ideology of the Jewish Question"[14] and Dmitry Merezhkovsky's "The Jewish Question as a Russian Question"[15] and in much of Vasily Rozanov's writing, even though the ostensible alignment was not always devoid of friction. Andrei Bely, for example, was being accused of "anti-Semitism" after the publication of his novel *Petersburg* in 1913.[16]

The Russian interpretation and promotion of Jewish culture during the early 1900s is an important chapter in the history of the Russian-Jewish symbiosis. Such a study, for example, would take account of the many articles on ethnography, epistemology, politics, sociology, and aesthetics that appeared in the "thick" Russian Jewish periodicals of the 1910s such as *Jewish Almanac* (*Evreiskii almanakh*, Kiev, 1908); *Jewish Week* (*Evreiskaya nedelya*, 1916), *Jewish World* (*Evreiskii mir*, 1918), and *New Path* (*Novyi put*, 1916–17) (all Moscow); and *Jewish Antiquity* (*Evreiskaya starina*, 1909–28), *New Dawn* (*Novyi voskhod*, 1910–15), and *Experiences* (*Perezhitoe*, 1909–10) (all St. Petersburg).[17] Stimulated in part by the Imperial ban on Yiddish and Hebrew presses in July 1916 and by the necessity to publish in Russian, these journals were a major vehicle for the dissemination of the Jewish cause, attracting many able publicists such as Simon Dubnov, Efros, S.V. Lurie (a collector of early Chagall, incidentally), Nikolai Lavrsky, Syrkin, Yakov Tugendkhold, Maxim Vinaver (a member of the Duma), and, of course, S. An-sky. However different their critical attitudes and styles, a leitmotif that connected their writings was the concern with the adjustment of traditional Jewish culture to the pressures of foreign systems such as Russian and European Christianity, capitalist commercialization, and Marxist ideology, as well as to new and radical intellectual concepts such as abstract art and atheism.

In the context of the visual arts, this cultural, religious, or political adjustment coincided with the

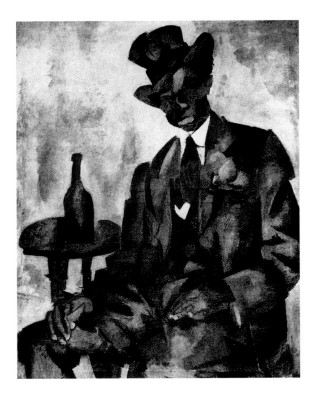

Fig. 4
Robert Falk
Negro from the Circus,
1917
Oil on canvas, 51 x 40 1/8 in.
(129.5 x 102 cm)
State Art Gallery, Erevan
© 1995 VAGA, New York

physical move of a Jewish artist from the periphery (e.g. Vinnitsa or Zhitomir) to the center (St. Petersburg or Paris). This journey from the shtetl to the metropolis was not, therefore, merely geographical, for it frequently confronted the artist with new and often daunting choices, leaving a profound imprint on social and political consciousness. In any case, the Jewish responses to these conditions oscillated between fervent enthusiasm (expressed by the young Ilya Gintsburg after being invited by join Antokolsky in St. Petersburg) and outright condemnation ("A decent Jew is incapable of leading a life in the spirit of piety and devotion in St. Petersburg," admonished Gintsburg's mother as her son prepared to leave for the big city).[18] Some Jewish artists, such as Bakst, hastened to don the studio painter's garb (*Self-Portrait* [1898; St. Petersburg, State Russian Museum]) and embraced the urbane cultures of St. Petersburg and Paris wholeheartedly, never looking back to their humble beginnings, while others, such as Altman (see ills. 1, 2) and Chagall (see ill. 18), produced subtle combinations of the Jewish and the gentile, the provincial and the cosmopolitan. Still others such as Pen—with his holy men and watchmakers (see ill. 89; pl. 4)—remained faithful to the types and rituals of the *mestechko*—the Russian term for shtetls—not that such loyalty always ensured the respect of the Jewish public (see pl. 35). On the contrary, a constant vocabulary of "palm trees, Stars of David, emaciated, tired faces of Old Jews and exalted, elongated faces of youths"[19] was even seen as a mark of immaturity and parochialism. It was better, as Efros said of Shterenberg, "to be born in Zhitomir, study in Paris, and become an artist in Moscow."[20] Clearly, for some Russian Jewish artists such as Bakst (born in Grodno) and Braz (born in Odessa), entry into Russian or French society paralleled a conscious rejection, or at least neglect, of Jewish heritage. Bakst, retaining his pseudonym

instead of the family name Rozenberg, seemed to have no qualms in converting to the Lutheranism of his wife in 1903 and then back to Judaism after his divorce in 1910, while Pevsner professed Catholicism, not Judaism, during his long emigration in France. Furthermore, the inventories of their works are almost devoid of Jewish themes, if we can discount Bakst's occasional costume for Jewish dancers in Diaghilev's ballet productions in Paris.

On the other hand, close investigation reveals that some of the leading Jewish artists who are closely associated with the formal experimentation of Russia's avant-garde were not entirely oblivious of their ethnic prerogative. For example, among the analytical still lives, portraits, and landscapes of the "Cézannist" Robert Falk, a colleague of Petr Konchalovsky and Aristarkh Lentulov within the Jack of Diamonds (Bubnovyi valet) group, there are obvious Jewish subjects, such as *Portrait of the Artist's Father* (Rome, Private Collection), *Portrait of Mitkhad Refatov (Rifadov)* (1915; Moscow, State Tretyakov Gallery), and *The Old Man* (St. Petersburg, State Russian Museum), a pictorial homage that brings to mind Altman's *Portrait of an Old Jew* (Amishai-Maisels, fig. 5), Iosif Chaikov's *Head of an Old Jew* (Shatskikh, fig. 6), and Chagall's numerous renderings of his Jewish elders (see ill. 17). Boris Anisfeld, also remembered for his scintillating sets and costumes for the Ballets Russes and the Metropolitan Opera, New York, drew on his knowledge of the Old Testament in his illustrations for the 1910 Russian edition of Rudolf Borchardt's *Book of Joram (Kniga Iorama)* with a preface by Rozanov (fig. 5). Perhaps Anisfeld's "unsightly and incomprehensible" paintings that shocked the secretary of the American Federation of Arts in New York in 1918 expressed a subliminal allegiance that also caused his *Crucifixion* to be "little short of blasphemous—horrifying to one who reveres Christ."[21]

Leonid Pasternak was also a victim of the double faith—"neither Russian, nor Jewish"—that the St. Petersburg lawyer Oskar Gruzenberg described in his memoirs.[22] Here was an august professor of the Moscow Institute of Painting, Sculpture, and Architecture, a colleague of Konstantin Korovin, an exponent of Russian Impressionism, and a founding member of the Union of Russian Artists who, as he recalled, "grew up in a Russian environment, received a Russian education, developed under the influence of the tendencies of the Russian '80s . . . with the duty of serving the Russian people. And I devoted my life to that duty—both as a teacher of the young generation of Russian artists and as a creative artist in Russian art."[23] The billeted soldiers listening in *News from the Motherland* (see pl. 3) would

Fig. 6
Naum Aronson
Bust of Lev Tolstoy, 1901
Plaster, h: 23⅝ in. (60 cm)
Tolstoy Museum, Moscow

appear to be Russian, not Jewish, and yet the very fact that in his writings, at least, Pasternak returned again and again to the issue of Jewish art and literature (see his portrait of An-sky reading *The Dybbuk* [ill. 87]), to the "Jewishness" of Rembrandt,[24] to the acute problems of a Jewish student in Tsarist Russia, and to the position of the Jewish artist in Russian society undermines the apparently unequivocal assertiveness of the above statement. Indeed, in rebuffing the accusation of indifference toward the Jewish cause that Chaim Bialik leveled at Pasternak, the latter (see ill. 85) polemicized:

> I'm guilty, I know, but the fault lies not within me, but without—in you, in the Russian Jewry of my generation, for whom my art is alien and will be so for a long time to come . . .
> I used to paint what was in front of me in Jewish life: a provincial Jewish street, the time before Passover . . . an old rag and bone man . . . an apple hawker.
> And it was the artillery generals in the local regiment—and not the Jewish representatives of the financial aristocracy that acquired these things . . .
> No-one knew about these Jewish artists. Neither the flower of the Jewish intelligentsia, nor the moneyed class—let alone the poor hungry Jewish masses—needed art. The Jews were just not interested. [25]

But not all Jewish Russian artists wrestled with this existential problem, and some—perhaps even Chagall—gave it little thought. Instead, they took practical advantage of the debate, distancing themselves from the issues of ethnic and religious allegiance, discovering a social mobility that enabled them to feel at home in the synagogue, the Orthodox church, and the Catholic cathedral. Altman is a case in point, for he had no reservations about contributing paintings of Russian and Parisian scenes to the same exhibitions, while making no attempt to conceal his Jewish derivation—a gesture manifest in his plaster and bronze self-portrait (see ill. 1) and his many portraits of Jewish socialites and patrons such as *Esfira Shvartsman* (1911; St. Petersburg, State Russian Museum) and *Portrait of Nadezhda Kret* (St. Petersburg, State Russian Museum). In his review of the November 1916 *Jack of Diamonds* exhibition in Moscow, Efros implied that there was a contrived ambiguity in the work of Altman, Chagall, and Falk, even though he praised them for their high technical proficiency and emphatic Jewish contribution to a major Russian exhibition:

> A national art rides on two anchors—a consciousness of being national and a knowledge of the

sources on which it can draw in the quest to be original. Russian Jewish artists lack the former, but they have the latter . . . Maybe this is only one half, but it is a very important one. Indeed, sometimes it seems that our artists are about to disclose the other half and to acknowledge their Jewishness in their art. It seems that any moment the terrible exacerbation of the nationalist sentiment occasioned by the war will break out with the lightning of a spiritual convulsion and that the individual and the people will see the light.[26]

We detect a similar ambiguity in the ways in which Jewish artists and writers related to the social and cultural institutions of Tsarist Russia. On the one hand, it was an intolerant and odious machine responsible for innumerable insults to the Jewish race—from mass phenomena such as the pogroms to isolated incidents such as the denial of Bakst's St. Petersburg residence application. On the other hand, Jews were quick to recognize the intellectual and artistic prerogatives of their territorial homeland and held Russian writers and artists in high regard, especially the elderly Lev Tolstoy, who for Antokolsky, Naum Aronson (fig. 6), Gintsburg, and Leonid Pasternak was a humanitarian and humanistic model of universal value. Pasternak, who visited Tolstoy several times (see ill. 86), remembered that "even before I came to know him personally, I was drawn to him not only as a great artist, but also as a man in whom I discerned the presence of spiritual qualities, which condition the basic expression of morality: sympathy, compassion—the principle of love for one's neighbor."[27] The young Aronson was even more ecstatic in recalling his first commission to portray Tolstoy in 1901:

> I was 27 years old when the dazzling invitation came to visit Lev Tolstoy and make a bust of him. On my own I would never have imagined doing such a daring thing, and for good reason. It was not that I suffered from false modesty: I adored my art and felt that I was maturing as an artist. I had great hopes and ambitions, but would never have aspired to sculpt the gods—for that is what Tolstoy was for me. Even to approach him seemed blasphemous . . . Listening to Tolstoy I felt that I was beginning to believe in the triumph of good.[28]

The Jewish national respect for Russian culture did not go unrequited. When we survey the primary essays on Jewish culture published in Russian in the early twentieth century, we are struck by the number of promotions, prizes, and other honors bestowed by the Russian establishment on Jewish citizens and by the Jews' ungrudging recognition of them. Indeed, the highest commendation for a Jewish artist

in Russia seems to have been recognition by the Academy of Arts, and the respectful tone in which the Russian Jewish press described these merits indicates that, however much they despised the Tsarist regime, Jews could also be flattered by its ostensible magnanimity: in 1895, the Museum of the Academy of Arts acquired Isaak Ashkenazi's painting *The Ecclesiast* for five thousand rubles; in 1901, Levitan's *Hut* for four hundred rubles; and in 1909, Pasternak's *Self-Portrait* for six hundred. Unexpectedly, the academy also conferred the title of Academician or Academic Artist on a number of Jewish artists—Mariya Dillon in 1888, Moisei Maimon in 1893, Gintsburg in 1911, Arnold (Aaron) Lakhovsky in 1912, Moshek Blokh in 1913, and Bakst and Braz in 1914.

Of course, the alliance was frail, and many Jewish artists left Russia for Western Europe precisely because the academy operated with a system of ethnic quotas that denied enrollment to most Jews or, if they did manage to enroll, embarrassed them with constant reminders of religious difference. Wearied of this predicament, in 1908 Lakhovsky even tried to assert his Jewish identity by emigrating to Palestine and working for the Bezalel Art School as a professor of drawing, but owing to the intolerable interference of the administrative committee in Berlin, which preferred its own candidate for the job, in 1909 he returned to Russia.[29] Antokolsky and Gintsburg, victims of the Imperial procedure, were forced to work abroad for many years, even though their subjects, such as Peter the Great and Tolstoy, were thoroughly Russian (see ill. 4). A manifest example of this inequity would seem to have been the academy's reprimand of Bakst in 1886 for his "unorthodox" interpretation of a student assignment on the theme of the *Pietà* and his coerced resignation motivated by a "worsening eye disease."[30]

Curiously enough, the further south one moved away from the autocracy of St. Petersburg, the stronger were the connections between Jewish artists and Tsarist institutions. Among the most popular teachers at the Moscow Institute of Painting, Sculpture, and Architecture were Leonid Pasternak and Valentin Serov, and even though the former was hired there as a visiting professor without tenure (*sverkhshtatnyi*), he regarded the institute as a center of progressive, liberal ideas at loggerheads with the Ministry of the Court and—ideologically and artistically—far in advance of the St. Petersburg Academy, which only in 1916 decided to expand the Jewish student quota to six "as a test."[31] The Kiev Art Institute seems to have been even more tolerant (Abraham Manievich, Isaak Rabinovich, Issachar Ryback, Nisson Shifrin, and Tyshler were all students there in

the 1900s and 1910s), while the Odessa Art Institute, as Syrkin pointed out in 1911,[32] was a principal instrument for the inculcation of Jewish artists into the Tsarist system (Anisfeld, Isaak Brodsky, and Savely Sorin all proceeded from there to the St. Petersburg Academy).

Of course, it would be improper to forget the harsh legal and social strictures that the Tsarist regime continued to impose upon the Jewish population and the ineradicable disdain of its military and bureaucratic structures in particular. As the Futurist poet Benedikt Livshits recalled of his military conscription into the Petrovsky Infantry Regiment near Novgorod in 1912:

> By virtue of my birth I was severed from the Leviathan of the Russian State. The few pints of blood which filled my veins divided me from it like an ocean . . .
> [But] in contrast to the units stationed in the Jewish Pale, there was no particular anti-Semitism in the Petrovsky Regiment. Even the word "Yid" seemed to be absent from the lexicon. It was supplanted by another term—"shmul"—which was generally understood to mean a weak creature ill-equipped for military service, although the original meaning of the term did not leave much doubt about which weak creatures were meant.
> Anti-semitism in the Petrovsky Regiment . . . was merely part of the wholesale persecution of foreigners . . .
> [But] they wore out feeble and frail Jewish artisans with gymnastics on the various apparatuses and transformed the horizontal bars into real weapons of torture.[33]

Sorin was also the victim of these deep-seated ethnic tensions, which surfaced especially at moments of stress and conflict. Known in the 1910s for his courtly portraits of society beauties and ballerinas, he was an extension of the St. Petersburg haut monde that also patronized Bakst and Serov. Like them, Sorin trained at the Academy of Arts, paid homage to the classical tradition, and refused to embrace either the anarchical idea of the Moscow avant-garde or An-sky's folklore revival. Moving in a cosmopolitan environment, he seems to have had little interest in his own ethnic heritage or in the issue of Jewish culture at large. Describing the musician Miron Yakobson, for example, he spoke of his "little talent lower than average, but he narrates Jewish anecdotes very well."[34] On the other hand, as in the case of Bakst, Livshits, and Pasternak, Sorin was often the victim of Russian discrimination. Vera Sudeikina, later the wife of Igor Stravinsky, recalled such a moment in 1918: "Sorin had been offended by an army officer who had been gathering works of

art for a lottery for the officers . . . Sorin had been given to understand that he was not Russian and that, of course, he could not understand the feelings of a Russian officer; in other words, 'You're a yid, so watch out.'"[35]

Life for Jewish artists and intellectuals became easier on the eve of the October Revolution. The generation of Altman, Chagall, Chaikov, Falk, Lissitzky, and Adolf Milman encountered a surprising receptiveness on the part of the Russian establishment that coincided with a general intellectual, social, and commercial rediscovery of the Jewish legacy. A concrete example of this later, happier alignment between Jews and Russian institutions of higher learning is a competition for a war monument that the St. Petersburg Academy inaugurated in August 1916. Open to artists of all races and creeds, the competition received many entries, including a bold project by a Jewish "provincial sculptor" who described his project as follows:

> Two cannons and two factory smokestacks rise up on the second pedestal of the monument intertwining full-length figures with laurels. These wear the national costumes of a Great Russian, a Little Russian, a Pole, a Latvian, a Caucasian highlander in a Circassian coat, a Volga Tartar, a Buriat, and a *Jew*. All these figures are holding hands. Ornamental script around the lower pedestal proclaims: "In fraternal unity lies unconquerable force."[36]

The new freedoms that the Jewish intellectual and artist found in wartime Russia were the result of many conditions, not least of which were the intense ethnographic and anthropological researches undertaken by An-sky. In turn, An-sky was drawing on the tentative precedents set by Vladimir Stasov, who, in spite of his vigorous criticism of any trend that undermined the status of realism, shared a principle with the early avant-garde in his reassessment and

propagation of folk art and decoration. He and Baron David Guenzberg had published their huge study of Jewish ornament in Russian, along with a French version in 1905—the same year, incidentally, that Stasov published his monograph on the Jewish sculptor Antokolsky "dedicated to all Russian artists."[37] Here was the same kind of transnational ploy that the Jewish writer Mikhail Tseitlin (under the pseudonym of Atari) used in contributing an article on Natalya Goncharova to a book called *The Soul of Russia* in 1916.[38]

Much has been written about the An-sky expeditions, and there is no need to repeat the essential details here.[39] Suffice it to emphasize that the materials collected were vast in number and diverse, encompassing photographs, documents, manuscripts, silverware, brass and wooden artifacts, cylinder recordings of songs, and verbatim descriptions of rituals and ceremonies. An-sky himself hoped that the museum established to house them would cater to "Jewish writers, poets, and artists who henceforth would not reject their roots, who would not lose themselves in their search for motifs and whose works . . . would not wander among those of other nations like pale shadows, but would live their own forms."[40] However, there was not a unanimously positive response on the part of young Russian Jewish artists to the museum—or vice versa. Renderings of synagogue ornaments and tombstones by Lissitzky and Yudovin were an important part of the collection, and perhaps the designs inspired the graphic experiments of Altman, Chaikov, and Lissitzky. Indeed, Lissitzky seems to have had in mind the motifs he saw in the Mogilev Synagogue in 1916 as he worked on his illustrations for the so-called *Legend of Prague*—a "graphic, decorative fusion of style and content with the wonderful Assyrian script."[41] Judging from the An-sky photographs of rabbis and traditional ceremonial wares vis-à-vis *The Praying Jew* (see ill. 17), *Purim* (see ill. 19), and *The Cemetery* (see pl. 9), Chagall was also looking very attentively at the kind of material An-sky had been collecting. It is also reasonable to assume that Altman created his series of graphic vignettes of 1913–14 (published as *Jüdische Grafik/Evreiskaya grafika* in Berlin nine years later) as a direct result of his acquaintance with the An-sky collections, and the several experiments in Jewish typography that he undertook in 1913–16 (such as his logo for the Judaica Publishing House and the Jewish Society for the Encouragement of the Arts [fig. 7]) demonstrate a serious interest in the traditions of Jewish decoration and script. In fact, Efros identified these ornaments with the beginning of Altman's "national populism" after his "Parisian

Fig. 7
Natan Altman
Logo for the Jewish Society for the Encouragement of the Arts, 1916
© 1995 VAGA, New York

frenzies,"[42] contrasting them with what he described as Pasternak's "worthless and condescending copies of heraldic beasts from synagogue screens and the mantles of Torah scrolls."[43] That the Jewish intelligentsia and plutocracy preferred the young Altman to the venerable Pasternak as the instigator of a new Jewish art is implied in Altman's *Portrait of Mrs. Gintsburg*, in which the *Recumbent Deer* from his *Evreiskaya grafika* is prominently displayed on the wall.[44]

Even so, the influence of the museum would seem to have been oblique rather than direct, and, in any case, the material culture An-sky gathered seems to have been seen by very few of the artists represented in *Russian Jewish Artists in a Century of Change*. On the other hand, the fact that such a complex enterprise had been funded and implemented, and that it was discussed in extensive detail in the Jewish and Russian press, is symptomatic both of the marked tendency of Russian Jewry to rediscover its folklore and of a broader Russian and Western European impetus to redefine and preserve the "primitive" past.

One of the clearest manifestations of this impetus was the exhibition called the *Target* that Mikhail Larionov organized in Moscow in 1913 and to which, incidentally, Chagall contributed three works. The accompanying manifesto declared: "We aspire toward the East and direct our attention toward national art. We protest against the servile subordination to the West which has vulgarized our own forms and those of the East, has reduced everything to a uniform level and has delivered them back to us."[45] This Primitivism or, rather, Neo-Primitivism, as it was called by the artists of the Russian avant-garde, was a polymorphous concept. But for all their prejudices and special interests, artists such as Pavel Filonov, Natalya Goncharova, Larionov, and Kazimir Malevich endeavored, on the one hand, to synthesize the culture of the Orient and, on the other, to continue the reassessment of Russian folklore undertaken by the art colonies of Abramtsevo and Talashkino in the late nineteenth and early twentieth centuries. Like the Symbolists and the Romantics before them, these artists sought an innocence and spontaneity in the alternative tradition, something that the Latvian art historian and ethnographer Vladimir Markov (Waldemars Matvejs) emphasized in his essays of 1912–14: "The ancient peoples and the East did not know our scientific rationality. These were children whose feelings and imagination dominated logic. These were naive, uncorrupted children who intuitively penetrated the world of beauty."[46] Markov and his colleagues often repeated this sentiment, contending that modern artists should also assume the role of the "savage" and restore intuition and caprice to the artistic process, a condition discussed in his pioneering study of Black art (published posthumously in 1919 with a cover designed by Altman).

Alexander Shevchenko, author of the 1913 Neo-Primitivist manifesto, also emphasized the connection between the gyration toward the "primitive" East and the contemporary search for national roots:

Generally speaking, the word "primitive" is applied not only to the simplification and unskillfulness of the ancients, but also to peasant art—for which we have a specific name, the *lubok*. The word "primitive" points directly to its Eastern derivation, because today we understand by it an entire pleiad of Eastern arts—Japanese art, Chinese, Korean, Indo-Persian, etc.[47]

Not surprisingly, Larionov contributed Persian, Chinese, Japanese, and other foreign prints to the exhibitions of icons and *lubki* which he organized in Moscow in 1913; his private collection also contained Jewish *lubki*, which may also have been on display. That Chagall, at least, was indebted to the concept of the primitive seems clear from his conscious or unconscious borrowings from Larionov's pictures—the collapsing table in *Feast of the Tabernacles* (1916; Private Collection) brings to mind Larionov's *Walk in a Provincial Town* (1907; Moscow, State Tretyakov Gallery).

The artists of the Russian avant-garde developed disparate perceptions of the primitive, but they all related directly to the Jewish experience, sharing an interest in the technical rediscovery of the primitive through exploration and expedition both in Russia and in Western Europe. True, these investigations emphasized the indigenous traditions of the numerous ethnic groups of the Russian Empire, including Jews and Gypsies, and also the remote past of Eurasian nomads from the Scythians to the Unni. At the same time, many of the "new barbarians"[48] were active supporters of the general reevaluation of Russian national folklore in the form of the applied arts and handicrafts—from embroidery to store signboards, from wooden ornament to the *lubok*—which had been encouraged in the late nineteenth century by wealthy patrons eager to sustain an artisan culture doomed to extinction. After all, Vasily Kandinsky imparted particular significance to his artistic baptism—the revelation visited on him when he encountered the decorated walls and furnishings in a peasant's hut during an anthropological expedition in the Vologda region in 1889.

This anthropological, if often somewhat amateur, appreciation provided a strong foundation for

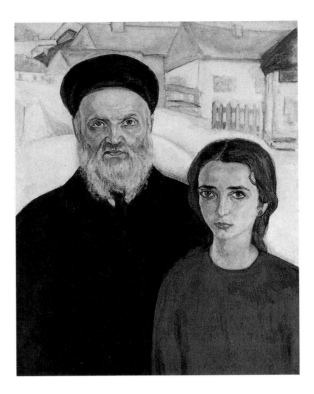

Fig. 8
David Shterenberg
Portrait of My Father and Sister, 1914
Oil on canvas, 31⁷/₈ x 24 in.
(81 x 61 cm)
Collection Shterenberg
Family, Moscow

the subsequent investigations of the avant-garde, which were intended to reveal not only new outward forms and aesthetic combinations but also to divulge the "primitive spirit" of the peoples of the East, of Russian peasants, even of children and shamans. Inherent in this pursuit of the primitive was the desire to find a pure and universal language—a transrational gesture (*zaum*) that could be associated with the speaking in tongues of the holy fool (*yurodivyi*)—in the ecstasies of shamans or even in the secret meaning of Talmudic texts. Efros seemed to have had this in mind when he wrote in his 1918 essay "Aladdin's Lamp":

> The *lubok*, the gingerbread, the toy and the printed cloth constitute an entire program for the practical aesthetics of contemporaneity . . .
> If Jewry wishes to live artistically and if it is looking out for its aesthetic future, then this presupposes an inexorable, thorough, and totally active connection with the popular arts.[49]

As far as Jewish art was concerned, the Primitivist movement was refracted in practical and didactic efforts to promote the aesthetic, if not philosophical, value of Jewish heritage and to try and create a modern Jewish art that relied on this, while assimilating the new trends of Cubism and Futurism. Of particular importance here was the program of the Jewish Society for the Encouragement of the Arts (JSEA) that Ilya Gintsburg, Altman, Ashkenazi, Maimon, Vinaver, and others established in Petrograd in January 1916. Without substantial reference to this organization

and to the many activities it sponsored or encouraged, the history of the Jewish cultural renaissance in Russia cannot be understood.

The primary aim of the JSEA was to "develop and encourage the plastic arts among Jews" because "Jews do not know their own artists,"[50] and while Gintsburg and his colleagues recognized the achievements of An-sky, they felt their own duty to lie in the formation of a new Jewish artistic style, summarized by the caption that was meant to accompany Altman's design for the society's logo: "Drink the Water at Its Source." During the spring of 1916, the JSEA contemplated various projects that involved young Jewish painters and sculptors, including plans for a modern gallery, a special art library, and a network of affiliations in Kiev, Kharkov, and other towns. But the most important event was the opening in April–May of its first *Exhibition of Members of the JSEA*, in which Altman, Brodsky, Chagall, Lakhovsky, Maimon, Zeidenberg, and others showed over 150 paintings and sculptures. The ideological and commercial success of the exhibition was repeated by another *Exhibition of Paintings and Sculpture by Jewish Artists* staged by the Moscow affiliation of the JSEA at the Lemercier Gallery in Moscow in April 1917. The latter show devoted an entire room to Levitan and included several bronzes by Antokolsky, but the emphasis of the 400 examples of painting, applied art, and architectural design by 70 artists was on the younger generation, represented by Anisfeld, Bakst, Brodsky, Chagall, Lissitzky, Milman, Nina Niss-Goldman, and Rabinovich. Even the catalogue cover was designed by Lissitzky.

The JSEA functioned for less than two years, but its activities were multifarious. For example, also in 1916 it organized an exhibition of sculpture for Passover and a permanent, commercial exhibition of works of art at the Jewish Club in Petrograd; it also sponsored the publication of a set of 24 postcards of Jewish works of art. Not surprisingly, the JSEA gave particular attention to the work of Gintsburg, planning a solo show and a monograph on him, a gesture that indicated the high regard in which the Jewish community held this student of Antokolsky. Indeed, to many younger artists, Gintsburg, son of a Talmudist, must have been a model for emulation. Born into a strict Jewish family in Vilna, he was brought by Antokolsky to St. Petersburg, learned Russian, and received his higher education there before going to Paris with a scholarship from Baron Horace Guenzberg. From 1878 until 1886, he studied at the St. Petersburg Academy, winning a gold medal for his bas-relief *Jeremiah on the Ruins of Jerusalem*. Gintsburg received numerous portrait

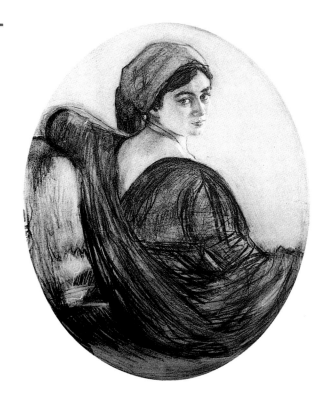

Fig. 9
Valentin Serov
Portrait of Genrietta
Girshman, 1911
Pastel on board,
37¹/₈ x 30 in.
(94.4 x 76 cm)
State Tretyakov Gallery,
Moscow

commissions and in 1911 became an Academician. But in spite of his Russian and French experiences, he remained deeply attached to his Jewish roots, played an active role in the Jewish Historical and Ethnographical Society, donated important documents to the Jewish National Museum, and even became its director in 1923. He was a tireless missionary of the Jewish cause and a popular lecturer and writer on subjects such as "Sculpture and the Jews," "Antokolsky and the Plastic Arts," and "L. N. Tolstoy and the Jews," as well as being an astute sculptor of Jewish themes.

There were many reasons for the establishment of the JSEA, practical, psychological, and cultural, but a primary reason lay in the realization on the part of many Jews that a new cultural center was needed in the wake of an increasing disenchantment with the traditional values of Jewish society. Moreover, as Leonid Pasternak emphasized in his memoirs, there had never been a "market" for Jewish art,[51] and it was Russian generals, not Jewish patrons, who collected paintings and sculptures on Jewish themes. The lawyer and politician Vinaver, one of Chagall's early sponsors, pointed out in a speech to the JSEA that St. Petersburg Jews were moving away from the synagogue,[52] while even An-sky, in his 1909 essay on Jewish folk art, observed that the doctor, the professor, and the writer were replacing the rabbi as the axis of Jewish spiritual life.[53] Perhaps this shift of gravity and centrifugal expansion of intellectual and social interests

might explain why the new generation of Jewish collectors and patrons in Petrograd (such as Nadezhda Dobychina [Altman painted her portrait in 1913] and Yakov Kagan-Shabshai [Chaikov made a plaster bust of him in 1917]), Moscow (such as the Girshmans [Serov painted portraits of them; fig. 9]), and Paris (such as Mariya and Mikhail Tseitlin [Serov also painted their portraits]) tended to acquire works of art independent of their Jewish orientation. Their outlooks were now sophisticated and cosmopolitan, and it was surely this broadening of artistic taste rather than "shame" and "indifference" that caused them to neglect Jewish art.[54]

Of course, given the mandate of the Jewish National Museum, the JSEA, and the many other Jewish ethnographic and folklore centers that sprang up in St. Petersburg, Moscow, and Kiev in 1914–17, it is surprising to learn that, by and large, young, visible artists such as Altman, Falk, Lissitzky, Shkolnik, and Shterenberg did not give their exclusive concentration to Jewish history. It would be a mistake, therefore, to look for their ethnic commitment only in their recognizably ethnic subjects. Rather, the Jewishness of such artists may lie in other, more subtle or abstract qualities characteristic of Jewish culture as a whole—an emphasis on the literary or didactic purpose of art, a reductive or "Talmudic" treatment of images (as in Lissitzky's Prouns [see ill. 70]), or what Syrkin identified as a "spontaneity," an "intimacy," and a "cosiness" of visual expression.[55] In any event, the 1910s witnessed an attempt to identify a Jewish art not through the veracity of depictions of everyday scenes, but, on the contrary, through an artist's ability to assimilate and reprocess themes and styles that, ostensibly, had nothing to do with the traditions of the shtetl and the Pale of Settlement.

This laicization (some would have called it profanation) of Jewish art contributed to many important developments, including a strong orientation toward abstract painting, since it enabled artists to free themselves from the doctrinal and esoteric strata of the Jewish tradition and look at items of the synagogue, for example, as aesthetic and formal entities, much in the same way that David Burlyuk and Larionov reinterpreted *lubki* and icons. That is why some exhibitions of the 1910s such as *The Target* and the *Exhibition of Paintings and Sculpture by Jewish Artists* at the Lemercier Gallery showed new studio paintings alongside naive and folk art—the work of art had now become a formal and aesthetic entity devoid of ideological and social function. In turn, this attitude would explain why young Jewish artists felt free to transfer a motif from one discipline to another, often achieving a shocking stylistic

catachresis. Altman's early biographer Max Osborn saw this as one of the progressive features of Altman's attitude toward the folkloric heritage: "He wished to study the characteristic elements, to inspect them on the objects that he saw, to remove them from these objects, and, in this manner, to find the paths to creativity which were to have been both private and at the same time objective."[56] In spite of his Jewish background, Chagall even applied devices from the Russian icon to his easel paintings, as is demonstrated by his *Pregnant Woman* (1913; Amsterdam, Stedelijk Museum), which derives from the prototypical icon of *Our Lady of the Sign*, or by his *Flying Carriage* (1913; New York, Solomon R. Guggenheim Museum), which paraphrases the iconic treatment of Elijah in his fiery chariot. Altman had no qualms about painting *Catholic Saint* (1913; St. Petersburg, Vladimir Paleev).

These refreshing attitudes toward art, literature, and music could have flourished only in an environment of religious and artistic freedom, however brief its existence may have been. Writing of Chagall in 1916, for example, Tugendkhold implied that the "curious snouts of oxen and calves peering into Chagall's interiors"[57] were a protest against the oppression of Jewish taboos. Whether, of course, the new paintings and sculptures by Altman, Chagall, Chaikov, Manievich, Sorin, and others constituted Jewish modernism is a moot point, but in

1914–17 a substantial number of young Russian Jewish artists were producing art that was au courant with the most radical trends in Russia and Western Europe. In turn, these conditions favored the activities of the primary private commercial gallery in Russia at that time, Nadezhda Dobychina's Bureau, which was operative in St. Petersburg between 1911 and 1919 (fig. 10). Dobychina, a Jew, was the foremost dealer in modern Jewish and Russian art in the 1910s, and she did much to advance the cause of young artists such as Altman (who painted her portrait [St. Petersburg, Evgenia and Feliks Chudnovsky]), Chagall, Goncharova, Kuzma Petrov-Vodkin, Olga Rozanova, Shkolnik, and many others, either by granting them solo shows or by including them in her regular group shows. Dobychina hoped that her Bureau would act as a "vital mediation between artist and public for the sale of works of art and the execution of all kinds of works of art."[58]

The Bureau was a major center for the promotion of Jewish and Russian modernism, and although Dobychina favored the restrained elegance of the World of Art (Mir iskusstva) artists over the extreme statements of Malevich and Vladimir Tatlin, she did host the sensational *0.10* exhibition in December 1915–January 1916, at which Malevich presented his Suprematist paintings, as well as regular exhibitions of contemporary Russian painting. Among the most important solo exhibitions she sponsored was that of Manievich in January–February 1916. Newspapers described this show as a "Jewish exhibition,"[59] despite the fact that the hundred pictures had much more to do with Paris than with Jewish life (although certainly, Manievich returned to his national heritage from time to time, as in *Destruction of the Ghetto, Kiev* [see pl. 10]). However it is regarded, the Manievich retrospective was a great success, with two thousand visitors, an illustrated catalogue, provocative press coverage, and many works sold, including one, *Paris*, to the Academy of Arts. In 1915, Dobychina also offered her Bureau as a space for an auction of Jewish art as part of the war effort. She acquired works for her private collection by Jewish artists, including Altman and Chagall, and in the 1920s and 1930s did much to promote the cause of Jewish music and musicians, including the celebrated pianists Mikhail Druskin and Mariya Yudina.

The October Revolution transformed the structure of artistic life in Russia—private collections were nationalized, art schools reformed, and commercial galleries closed. The "Olympian"[60] Dobychina held her last exhibition at the Bureau in 1919, as its principal artists and clients were emigrating temporarily or permanently to Berlin, Paris, and

Fig. 10
Alexander Golovin
Portrait of Nadezhda
Dobychina, **1920**
Oil on canvas, 38 x 38⅝ in.
(96.5 x 98.2 cm)
State Russian Museum,
St. Petersburg

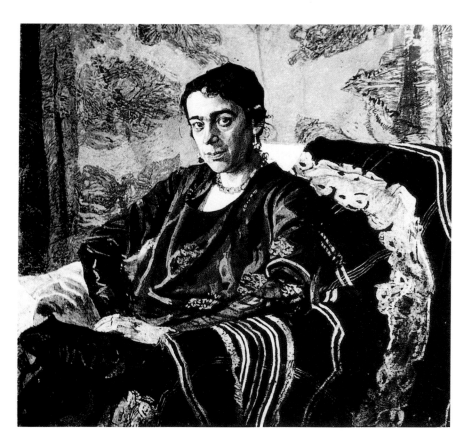

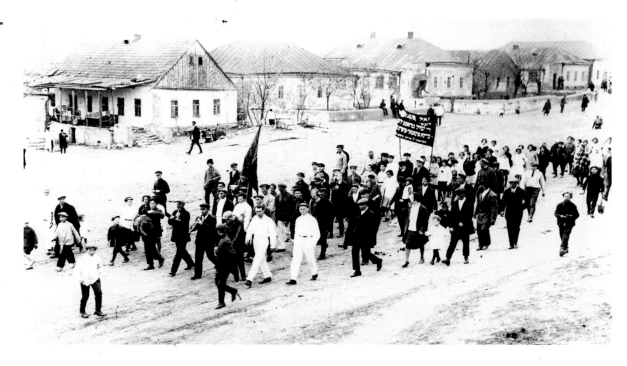

Arkady Shaikhet
Parade through the Village,
ca. 1925
Photograph, 8⁷/₈ x 11¹/₄ in.
(22.5 x 28.6 cm)
Howard Schickler Fine Art,
New York

New York. As far as the Jewish faction was concerned, many representatives of the new art—Altman, Anisfeld, Bakst, Chagall, Chaikov, Lissitzky, Manievich, Pasternak, Sorin—joined the exodus, leaving a vacuum that was filled by the radical generation of Ilya Chashnik, Lazar Khidekel, Solomon Nikritin, Alexander Tyshler, and others, who adjusted their art to the service of politics as they planned the bright utopia. The champions of the "ethnographic" heritage, especially An-sky (who died in emigration in 1920), continued to argue for a broader recognition of Jewish folklore and ritual, but the Jewish National Museum was never given a permanent facility, and eventually its collections were dispersed among other museums. On the one hand, the material and spiritual consequences of that tragic era were disastrous—people and artifacts were destroyed, pogroms were rife (Yudovin's Pogrom series may refer to Imperial or to Soviet Russia [see ill. 132]), and many Jews began to question the strong conventions of their own faith. On the other hand, some of the most remarkable achievements in the history of Russian Jewish art were made precisely at this moment—from Lissitzky's *Had Gadya Suite* and Ryback's *Old Synagogue* (see pl. 8; ill. 101) to the abstract experiments of Altman (see pl. 15), Chashnik (see pl. 12), Lissitzky, Anna Kagan (see ill. 43), and Nina Kogan. Perhaps an explanation for this apparent contradiction is to be found in the pseudo-Hebrew, tongue-in-cheek *shish* (a Russian sign of contempt) that Altman used as an illustration for Alexei Kruchenykh's Futurist poem "Explodity" ("Vzorval") in 1913, (Shatskikh, fig. 1). The title and theme of this work—explosion—predicted the military conflagration of the First World War and the social fragmentation and diaspora that ensued. The implication of Altman's tailpiece seems to be that the Russian Jewish artist flourishes at such moments of uncertainty, that disorientation and displacement are essential to the Jewish cultural experience, and that a constant movement across national and social boundaries provides a deep source of inspiration. In his *shish*—a linguistic and scriptural combination reminiscent of a candelabrum—Altman paid homage to this international impetus, but he was also telling us that the Jewish artist is not to be identified with any one national vocabulary and is free to absorb, reject, and parody. In some perverse sense, such a dramatic artistic stance can be adopted only at moments of the dislocation of all social and cultural axes. That is why, in 1916, as the shells exploded and empires crumbled, Efros could declare confidently and correctly that "there are Jewish artists, but there is no Jewish art,"[61] indicating that the aspiration to create a national art was of much greater import than its realization.

John E. Bowlt
is Professor of Slavic Languages and Literatures at the University of Southern California, Los Angeles.

Notes

1 Leonid Pasternak, *Fragmenty avtobiografii* (1943), unpub. typescript, p. 49, Private Collection. I would like to thank Alexei Korzukhin for access to a copy of this typescript. These "autobiographical fragments" were not included in the *Zapisi raznykh let* that Josephine and Alexander Pasternak prepared for the Russian edition of their father's memoirs (Moscow: Sovetskii khudozhnik, 1975; translated into English as *Memoirs of Leonid Pasternak* [London: Quartet Books, 1982]).

2 The problem of the Jewish artist in late nineteenth- and twentieth-century Russia has received particular attention in recent scholarship. Of immediate relevance are the exhibitions *Tradition and Revolution: The Jewish Renaissance in Russian Avant-Garde Art, 1912–1928*, which was shown at the Israel Museum, Jerusalem, and other institutions in 1987–88 (catalogue edited by Ruth ApterGabriel); *Tradition and the Vanguard: Jewish Culture in the Russian Revolutionary Era* at the Founders Gallery, University of San Diego, in 1994; and *Chagall e il suo mondo* at the Comune di Bari, Italy, in 1994. Abram Kampf's essay "In Quest of the Jewish Style in the Era of the Russian Revolution" (*Journal of Jewish Art* 5 [1978], pp. 48–75) remains a fundamental source. Mention should also be made of Igor Golomshtok's "Sobirateli ili souchastniki," '*22* (Tel Aviv), no. 6 (1979), pp. 160–81; the two volumes edited by M. Parkhomovsky called *Evrei v kulture russkogo zarubezhya* (Jerusalem: Parkhomovsky, 1992–93); and G. Kazovsky's *Khudozhniki Vitebska: Ieguda Pen i ego ucheniki/Artists from Vitebsk: Yehuda Pen and His Pupils*, which is volume two of the five-volume set *Masterpieces of Jewish Art* published by Image (Moscow) in 1993. Important details on the Jewish–Russian connection in the late nineteenth century are provided by Mirjam Rajner in her article "The Awakening of Jewish National Art in Russia," in *Journal of Jewish Art* 16–17 (1991), pp. 98–121. A complete bibliography of the subject of Jewish art in modern Russia has yet to be compiled, although a first attempt was made by V. Makhlin in his "Bibliografiya sovetskogo evreiskogo iskusstva," in *Informatsionnyi byulleten Evreiskoi gruppy otdela natsionalnostei Gosudarstvennoi Publichnoi biblioteki im. Saltykova-Shchedrina v Leningrade*, no. 34 (Leningrad: Saltykov-Shchedrin Library, 1935), pp. 3–17. Literary references will be found in V. Lvov-Rogachevsky, *Russko-evreiskaya literatura* (Moscow: Gosizdat, 1922).

3 M. Balaban: "Evreiskie istoricheskie pamiatniki v Polshe," *Evreiskaya starina* (St. Petersburg) 1 (1909), p. 55.

4 See, for example, An-sky's letter to the editor of *Evreiskaya starina*, Simon Dubnow, in 8 (1915), pp. 239–40.

5 See the anonymous report on the lecture "Toward a History of Jewish Art" that Lev Antokolsky delivered to the general assembly of the Jewish Historical and Ethnographical Society, St. Petersburg, on 2 February 1911, in *Evreiskaya starina* 4 (1911), p. 153.

6 A. Efros, "Zametki ob iskusstve," *Novyi put* (Moscow), nos. 48–49 (1916), pp. 39, 60.

7 M. Syrkin, "Evrei i iskusstvo," *Evreiskaya nedelya* (Moscow), no. 25 (1916), p. 40.

8 M. Syrkin, "Doklad o evreiskom iskusstve v Evreiskom Istoriko-etnograficheskom obshchestve," *Novyi voskhod* (St. Petersburg), no. 7 (1911), p. 37.

9 Syrkin (note 7), p. 39.

10 A. Levinson, "Russian Art in Europe," *Zhar-ptitsa* (Berlin), no. 12 (1923), p. 2.

11 Goncharova painted several Jewish scenes, the most familiar of which is known as *Jewish Family* (1911–12; Private Collection). Goncharova contributed three "Jewish" pictures to the *Target* exhibition and four to the 1914 St. Petersburg showing of her solo exhibition at Dobychina's Bureau.

12 Syrkin (note 7), p. 39.

13 See, for example, *Den iskusstva* (in Polish, Ukrainian, Russian, and Hebrew) (Vilna) 8 (December 1914) (carried poems by Bryusov); Vladislav Khodasevich and L. Yaffe, eds., *Evreiskaya antologya: Sbornik molodoi evreiskoi poezii* (Moscow: Safrut, 1918) (translations from Hebrew into Russian by Baltrushaitis, Bryusov, Khodasevich, Fedor Sologub, etc.); book three of Yaffe's *Safrut* (Moscow: Safrut, 1918) (translations by Bryusov and Ivan Bunin).

14 V. Ivanov, "K ideologii evreiskogo voprosa," in Leonid Andreev, ed., *Shchit* (Moscow: Mamontov, 1915), pp. 84–86.

15 D. Merezhkovsky, "Evreiskii vopros, kak russkii," in *Shchit* (note 14), pp. 136–38.

16 See, for example, L. Vygodsky's review of Bely's *Petersburg*, in *Novyi put*, no. 47 (11 December 1916), pp. 27–32.

17 For further information on the Russian Jewish periodical press, see I. Yashunsky, *Evreiskaya periodicheskaya pechat v 1917 i 1918 gg.* (Petrograd: Vestnik, 1920); U. Ivask: *Evreiskaya periodicheskaya pechat v Rossii* (Tallinn: Society of Friends of the Yiddish Scientific Institute, 1935).

18 I. Gintsburg, *Iz proshlogo* (Leningrad: Gosizdat, 1924), p. 14.

19 B. Aronson, *Sovremennaya evreiskaya grafika* (1924). For an English translation, see *Tradition and Revolution* (note 2), p. 237.

20 A. Efros, "Shternberg" [*sic*], in *Profili* (Moscow: Federatsiya, 1930), p. 296.

21 Leila Mechin to Christian Brinton, 25 September 1918, published in *New York Times*, 19 October 1918.

22 Oskar Gruzenberg entitled one section of his memoirs "Moe dvoeverie: Ne to evrei, ne to russkii. V evreiskom mestechke." See his *Vchera: Vospominaniya* (Paris: Dom knigi, 1938), pp. 21–24.

23 Pasternak (note 1), p. 47.

24 See Pasternak's book *Rembrandt i evreistvo v ego tvorchestve* (Berlin: Saltzmann, 1923).

25 Pasternak (note 1), pp. 46–48.

26 Efros (note 6), p. 60.

27 *Memoirs of Leonid Pasternak* (note 1), p. 126.

28 N. Aronson, "Memoirs," ed. Musya Glants, *Experiment* (Los Angeles), no. 1 (1995). I would like to thank Musya Glants for allowing me to quote this extract.

29 Nirit Shilo-Cohen, *Bezalel 1906–1929*, exh. cat. (Jerusalem: Israel Museum, 1983), pp. 68–69, 72, 153, 362, 372. Nikolai Lavrsky reported in his book *Iskusstvo i evrei* (Moscow: Zhizn, 1915), p. 26, that Lakhovsky found the conditions intolerable.

30 Discharge document for Léon Bakst, quoted in I. Pruzhan, *Lev Samoilovich Bakst* (Leningrad: Iskusstvo, 1975), p. 10.

31 As reported in "Khudozhestvennye vesti," *Evreiskaya nedelya*, no. 3 (17 January 1916), p. 42.

32 M. Syrkin, "Vystavki," *Novyi voskhod*, no. 11 (17 March 1910), p. 29.

33 Benedikt Livshits, *The One and a Half-Eyed Archer*, trans. John E. Bowlt (Newtonville: Oriental Research Partners, 1977), pp. 97, 103. *Shmul* is a Yiddish rendering of *Shmuël* (Samuel).

34 V. Sudeikina (Soudeikine), Diary entry, 9 June 1919, unpag. manuscript, Private Collection.

35 *Ibid.*, 20 June 1918.

36 Unsigned report, *Novyi put*, no. 30 (14 August 1916), p. 10.

37 The dedication appears on an unnumbered prefatory page in Stasov's *Mark Matveevich Antokolsky: Ego zhizn, tvoreniya, pisma i stati* (St. Petersburg and Moscow: Volf, 1905). See V. Stasov and D. Guenzberg, *Drevne-evreiskii ornament po rukopisiam* (St. Petersburg: Guenzberg, 1886); *idem, L'Ornament hébreu* (Berlin: S. Calvary, 1905).

38 Atari (Mikhail Tseitlin), "Natalie Goncharova," in W. Stephens, ed., *The Soul of Russia* (London: Macmillan, 1916), pp. 76–80.

39 For information on An-sky and the expeditions, see Judith C. E. Belinfante and Igor Dubov, eds., *Tracing An-sky: Jewish Collections from The State Ethnographic Museum in St. Petersburg*, exh. cat. (Amsterdam: Joods Historisch Museum, 1992).

40 This according to a letter written by An-sky and quoted by F. Shargorodskaya, in "O nasledii An-skogo," *Evreiskaya starina* 11 (1924), p. 307.

41 M. Broderzon, *Sikhes Kholin* (Moscow: Nashe iskusstvo, 1917), p. 1 (in Russian and Hebrew). For useful information on the connections between Lissitzky's art and traditional Jewish sources, see Haya Friedberg, "Lissitsky's *Had Gadia*," *Jewish Art* (Jerusalem) 12–13 (1986–87), pp. 294–303.

42 N. Altman, "Altman," in *Profili* (note 20), p. 268.

43 *Ibid.*

[44] The portrait of Mrs. Gintsburg is reproduced in color in M. Etkind, *Nathan Altman* (Dresden: VEB, 1984), pl. 14. It is not discussed in the text, however, nor is it included in the list of works, and its whereabouts are not given.

[45] M. Larionov, from untitled introduction to the catalogue of the *Target* exhibition, *Mishen* (Moscow, 1913). The text is reprinted in G. Pospelov, *Bubnovyi valet* (Moscow: Sovetskii khudozhnik, 1990), pp. 248–49.

[46] V. Markov, "Printsipy novogo iskusstva," *Soyuz molodezhi* (St. Petersburg) 1 (April 1912), p. 15.

[47] A. Shevchenko, *Neo-primitivizm: Ego teoriya. Ego vozmozhnosti. Ego dostizheniya* (Moscow: Shevchenko, 1913), p. 7.

[48] This translates the title of David Burlyuk's essay "Die 'Wilden' Russlands," in W. Kandinsky and F. Marc, eds., *Der Blaue Reiter* (Munich: Piper, 1912).

[49] A. Efros, "Lampa Aladina," in A. Sobol and E. Loiter, eds., *Evreiskii mir* (Moscow), no. 1 (1918), pp. 297–310.

[50] M. L-n, "V 'Evr. OPKh,'" *Evreiskaya nedelya*, no. 4 (1916), p. 29.

[51] Pasternak (note 1), pp. 46–48.

[52] Unsigned report on the opening of the First Jewish Social Club in Petrograd and the speech of its president, Maxim Vinaver, in *Novyi put*, no. 10 (25 March 1916), p. 26.

[53] S. An-sky, "Evreiskoe narodnoe iskusstvo," *Perezhitoe* (St. Petersburg) 1 (1909), p. 207.

[54] Pasternak (note 1), pp. 47, 48.

[55] Syrkin (note 7), p. 40.

[56] M. Osborn, *Jüdische Graphik/Evreiskaya grafika* (Berlin: Razum, 1923), p. 10.

[57] Ya. Tugendkhold, "Mark Shagal," *Apollon* (Petrograd), no. 2 (1916), p. 17. Tugendkhold republished his text in A. Efros and Ya. Tugendkhold, *Iskusstvo Marka Shagala* (Moscow: Gelikon, 1918).

[58] Quoted from anonymous article, "Slava zhizni!" in *Muzykalnaya zhizn* (Moscow), no. 3 (1993), p. 30. I would like to thank Thea Durfee for bringing this publication to my attention.

[59] Unsigned report in *Novyi put*, no. 4 (13 February 1916), p. 30.

[60] Livshits (note 33), p. 116.

[61] Efros (note 6), p. 58.

Ziva Amishai-Maisels

The Jewish Awakening:
A Search for National Identity

The first stirrings of a Jewish national art in Russia were precipitated by a non-Jew, the art critic and theorist Vladimir Stasov. In discussions with Mark Antokolsky from the early 1870s on, Stasov promoted both the use of Jewish subject matter and the discovery of a Jewish style. Whereas Stasov did not convince Antokolsky to create such a style or to participate in a Jewish school of art, he did stimulate him to formulate plans for a Jewish art school, which would concentrate on the handicrafts that were already widespread as folk art among Russian Jews. By promoting the teaching of these crafts in art schools, Antokolsky validated Jewish folk art as a form of artistic expression.[1]

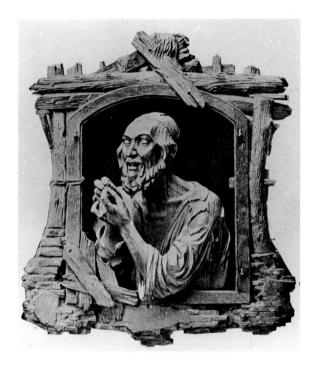

Fig. 1
Mark Antokolsky
Jewish Tailor, 1864
Wood, 14 1/2 x 12 1/4 x 4 1/4 in.
(36.5 x 13 x 11 cm)
State Russian Museum,
St. Petersburg

Parallel to Stasov's and Antokolsky's discussions—and to Antokolsky's early depictions of Jewish life such as *Jewish Tailor* (fig. 1)—an art that fulfilled Stasov's demand for Jewish subject matter was being created in Eastern Europe by Jewish artists who depicted shtetl life realistically.[2] Yehuda Pen can be seen both as a scion of this East European Jewish school and as having put Stasov's and Antokolsky's ideas into practice. In 1897, Pen opened an art school in Vitebsk, where he opened the eyes of his mostly Jewish students to Jewish art through the subjects he set for them (see ills. 88, 90)

and by using the varied illustrations in the Berlin magazine *Ost und West* as a manual. It is thus not by chance that his students—Marc Chagall, El Lissitzky, and Solomon Yudovin—were in the vanguard of the Jewish artistic renaissance.[3]

The first steps in the formation of this renaissance were taken by Chagall. His early works—a Jewish cemetery, Jewish musicians, Jewish weddings, a pogrom, and refugees—show that he had absorbed Pen's teachings.[4] His interest in Jewish art was reinforced during his student days in St. Petersburg (1907–10) by his patrons, Baron David Guenzburg and Maxim Vinaver, who in 1908—soon after Chagall's arrival—founded the Jewish Historical and Ethnographical Society in that city.[5] Vinaver was one of the owners of *Novyi voskhod*, the Russian-language organ of assimilated Jews who wished to promote a Jewish *national* consciousness.[6] Chagall may also have heard the lectures S. An-sky began to give in 1908 in which he suggested that emancipated Jews use their folk culture to build a secular Jewish identity.[7] Chagall—who felt so close to Jewish folk art that he claimed Chaim ben Isaac Halevi Segal, the painter of the Mogilev Synagogue, as his actual and artistic forefather[8]—absorbed the idea that this folk culture belonged to the past, but that it could be adapted to modern life. Since Russian artists were then modernizing their own folk art,[9] this approach enabled Chagall to join the avant-garde without relinquishing his Jewish roots. At the same time, his orthodox family's antipathy to his art, and the anti-Semitism he experienced in his youth—as well as the problems he had as a Jew living in St. Petersburg—made him ambivalent to both Judaism and Christianity. Under the influence of his teachers (Pen, Léon Bakst, and Mstislav Dobuzhinsky), he began to meld Jewish folk art, Yiddish idioms, a mordantly humorous view of Jewish and Christian subject matter, and modern styles.[10]

This new approach is apparent in Chagall's first major painting, *Dead Man* (fig. 2).[11] Here, he translated the East European way of depicting sad Jewish funerals into a modern folk art idiom with childlike figures and an atmosphere blending mystery with humor. Chagall placed the corpse with his glaring white eyes out of doors, under an eerie sky, in danger of being swept away by the street cleaner. In order to convey the impression of a lonely, deserted street, Chagall literally rendered the Yiddish idiomatic term for such a location—*toite gas* (dead street)—into visual form. In his earliest explanation of this work, he suggested that the unearthly fiddler on the roof was the soul of the dead man, playing his fiddle to express his joy at being freed from both his earthly life and "his Jewish fate."[12]

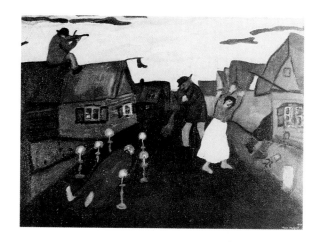

Fig. 2
Marc Chagall
Dead Man, 1908
Oil on canvas,
26⁷/₈ x 33⁷/₈ in.
(68.2 x 86 cm)
Musée Nationale d'Art
Moderne, Centre Georges
Pompidou, Paris

Chagall went to Paris in August 1910, absorbing fauve color and cubist faceting into his "folk" style and becoming one of the many foreign artists who successfully took part in the French avant-garde. Yet, instead of depicting Paris, he redid his major Russian Jewish works in his new French style[13] and portrayed memories of Russia, seeing himself as a Russian artist working in Paris.[14] He expressed his multifaceted identity in *Self-Portrait with Seven Fingers* (fig. 3), where he appears as an elegant Parisian dandy appropriately portrayed with cubist facets, sitting before a folk art version of a Russian peasant theme, *To Russia, Asses and Others*, thus stressing his stylistic dichotomy and its sources.[15] Turning his back on Paris, visible through a window at the left, Chagall dreams of Vitebsk, which appears in the clouds above *To Russia*. These images are labeled in Yiddish, stressing the artist's Jewish identity and providing a clue to the meaning of his seven fingers. In

Yiddish, doing something with seven parts of the body means doing it intensively; thus, Chagall here intensively creates art. In this painting, he encapsulated the identity crisis many newly emancipated Jewish artists expressed in their works.[16] Chagall's Parisian style, with its folk art elements, cubist facets, and Expressionist colors, laid the basis for the style of the Jewish artistic revival in Russia. To understand the formation of this style and its acceptance by Russian Jewish artists, several factors must be taken into account.

By early 1911, while Chagall was forming his new style, Natan Altman was living in Paris. Altman had studied art in Odessa and had later worked as a sign painter in his native Vinnitsa. He seems to have painted few Jewish themes before 1911.[17] Like Chagall, Altman quickly assimilated fauvism and cubism, but joined them to an academic style, depicting neutral subjects: portraits, still lifes, and landscapes.[18] He had a more accurate understanding of cubist principles than Chagall, who was primarily interested in adapting them to his own goals. Altman had been introduced to modern French art by a fellow student from Odessa, Vladimir Baranov-Rossine, a friend of Sonya Terk-Delaunay. Baranov-Rossine probably introduced Altman into the Delaunay circle, which Chagall also frequented.[19] One can only speculate on Altman's contacts with Chagall during this period, but Altman's works after his return to Russia at the end of 1911 strongly suggest that he was acquainted with Chagall's art.

In 1912, Iosif Chaikov, Leo Koenig, Itzhak Lichtenstein, and other young Jewish artists produced the first Jewish art journal, *Makhmadim*. The style is academic, reminiscent of the work being produced at the Bezalel Art School under Boris Schatz, but it also copies traditional folk art in the title pages and borders.[20] While producing the journal, the artists avidly discussed the essence of Jewish national art. This group had a strong effect on Chagall. He knew the members and claimed to have heard their discussions through the wall that separated their studios at La Ruche. He reacted with scorn to both their theories and their art, stating that while they talked about Jewish art, he was creating it. In fact, some of the biblical themes he painted in 1912, such as *Cain and Abel* and *Adam and Eve*, seem to have been responses to their versions of these subjects. In these paintings, Chagall wanted to show how a modern Jewish artist should render such themes.[21]

In the summer of 1912, four events inspired Chagall to a greater involvement in Jewish art. First of all, he must have heard from his patron Vinaver that An-sky had mounted an expedition to Volhynia and that his youthful acquaintance from Pen's stu-

Fig. 3
Marc Chagall
Self-Portrait with Seven Fingers, ca. 1912
Oil on canvas,
50³/₈ x 42¹/₈ in.
(128 x 107 cm)
Stedelijk Museum,
Amsterdam

Artist Unknown
*Marc Chagall and Solomon
Mikhoels in Stage Cos-
tumes*, 1921
Photograph, 5⁵/₈ x 3³/₈ in.
(14.3 x 8.4 cm)
Russian State Archive of Art
and Literature, Moscow

Fig. 4
Natan Altman
Study for Jewish Funeral,
1911
Watercolor and gouache on
paper, 10 x 12 in.
(25.5 x 30.5 cm)
Collection Evgeniya and
Feliks Chudnovsky,
St. Petersburg
© 1995 VAGA, New York

dio, Solomon Yudovin, was the expedition's official artist, in charge of documenting and collecting Jewish ritual and folk art (see ill. 133).[22] This search for roots—specifically by An-sky, who saw them as the basis for a new secular art and identity—reinforced Chagall's inclination in the same direction.

Secondly, Chagall received An-sky's article on Pen, in which Chagall himself was mentioned as a

student who had exhibited in the Paris Salon.[23] This article inspired Chagall to do a series of religious Jews based on the traditions Pen had taught him. *The Pinch of Snuff* (Krefeld, Private Collection) and *Jew in Prayer* (Jerusalem, Israel Museum) even paraphrase a painting reproduced in the article, but are rendered in Chagall's own style and with changes in iconography that express his ambivalence toward traditional Jewry.[24]

Thirdly, at about the same time, El Lissitzky—another fellow student from Pen's school—arrived for a visit to Osip Zadkine, who was acquainted with Chagall.[25] It is probable that Lissitzky called on Chagall and saw his work, especially given the mention of his success in An-sky's article. After leaving Pen's school, Lissitzky had studied architecture in Darmstadt, and although most of his surviving works from this period depict churches, he also studied the Worms Synagogue and the tombstones in the Worms cemetery.[26] Although no date is given for this trip, the mention of the tombstones suggests that it was after his visit to Paris and return to St. Petersburg, where he worked in the autumn of 1912 in an architect's office.[27] Here, he would have heard from Yudovin of the An-sky expedition and seen the first season's results, which must have stimulated him to study similar monuments of Jewish art.[28]

The fourth event that heightened the Jewish awareness of all these artists in 1912–13 was the Beilis affair, which attracted attention in both Russia and the West. This blood libel case, which lasted from 1911 to 1913, inspired a wave of anti-Semitism and fears of pogroms in Russia. Chagall reacted with ironic paraphrases of Christian themes in *Golgotha* (New York, Museum of Modern Art) and *Pregnant Woman* (Amsterdam, Stedelijk Museum).[29]

The Paris period was vastly important for the formation of modern Russian Jewish art. Being there allowed artists not only to create a new blend of styles but also to obtain a new perspective on Jewish life. What is particularly striking in the next stage of this movement's development is that it was the return to Russia and the shock of renewed contact with traditional Jewry which fired the artists' imaginations. After living a free and assimilated life in the West, they looked at and interpreted their background in new ways.

Thus, it was on his return to Vinnitsa that Altman began painting Jewish themes. *Study for Jewish Funeral* (fig. 4) is a "memory" of the death of one of his grandfathers, both of whom had died when he was seven.[30] To understand Altman's innovations, this painting must be compared with Chagall's *Dead Man*. Both artists set the corpses on the ground surrounded by candles, but Altman's treatment is more

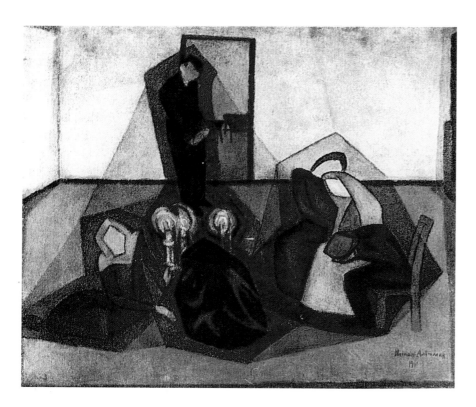

traditional: the body is entirely covered, and it is inside the house, not on the street. Moreover, there are no fiddlers on the roof, street cleaners, or strange colors, and even the perspective is basically correct.[31] The faceting here is unlike Altman's usual use of cubism; it seems instead to be his reaction to Chagall's expressionistic facets in the "cubist" version of *Dead Man*, painted while Altman was in Paris.[32] Whereas Chagall used them to disrupt the stability of his scene, Altman enclosed his simplified figures in geometric gray ones, some of which suggest coffins, heightening the pathos of the individual mourners while uniting them in an expression of familial grief. The result is entirely different from Chagall's painting. Deeper in feeling, Altman's work remains conceptually traditional. It is a stylistically modern version of the East European pictures of funerals against which Chagall had revolted.

Altman's and Chagall's approaches were equally important for the Jewish artistic renaissance. It was, in fact, easier for artists to modernize their style while keeping their iconography traditional, as Altman had done (see ill. 1), than to innovate in Chagall's manner (see pl. 9). However, this adherence to tradition does not mean that Altman fully accepted it. His ambivalence is suggested in his *Catholic Saint* (1913; St. Petersburg, Vladimir Paleev), painted after he moved to St. Petersburg at the end of 1912 and based on a baroque statue of St. Charles Borromeo found in a St. Petersburg church.[33] Altman, who made stained glass windows for a living,[34] must have visited or worked in this church and been struck, on a formal level, by the sharp,

almost cubist quality of the statue's baroque folds. On a personal level, his work on *Study for Jewish Funeral* must have recalled his grandmother's death during a cholera epidemic, and he must have been drawn to the saint who tended the sick during a plague as a comforting image, the opposite of his helpless Jewish mourners. He treated this figure in a straightforward fashion, with none of the caustic ambiguity that Chagall employed for his contemporary Christian themes.[35]

In 1913, Altman also became aware of the An-sky expedition. He was probably amazed that while he had come to St. Petersburg in search of art and culture, an expedition from that city had gone to investigate these elements around his hometown! Moreover, from late 1912 to mid-1913, An-sky himself lectured on the finds and successfully convinced famous writers and artists, such as Chaim Nachman Bialik and Leonid Pasternak, to take part in the expedition.[36] Pasternak, who had done a few works in the tradition of Eastern European shtetl and pogrom painting, now drew a heavy "Torah ark" as a cover for Joel Engel's *Jewish Folksongs*.[37] Finally, Christian artists had begun to deal openly with Jewish themes. Goncharova and Lukomsky exhibited them at the World of Art (Mir iskusstva) in January 1913; Goncharova and Larionov showed several in April at the *Target* exhibition in Moscow (Bowlt, fig. 3).[38] Jewish subjects had become fashionably avant-garde. It was at this time, before June 1913, that Altman illustrated the last sheet of Kruchenykh's "Explodity." In keeping with Kruchenykh's wish to master all foreign languages, which he pretended to have done on the previous page using "transrational" (*zaum*) words, Altman designed the Russian word *shish* to resemble Hebrew letters (Shatskikh, fig. 1).[39]

Thus, when Altman visited relatives in Gritsev, not far from Vinnitsa, in the summer of 1913, it is not surprising that he produced modern Jewish art. Struck by the contrast between his family's orthodoxy and his own secular life, he painted his uncle in *Portrait of an Old Jew* (fig. 5).[40] Despite the light sculptural facets of the face and hands, the old man is presented in a traditional manner. Yet, in contrast to Pen's depictions of old Jews, Altman's uncle is not piously studying or praying, nor is he poverty-stricken. Proud and learned, as the worn books piled behind him testify, he regards us with stern eyes, his mouth tightly closed, set in a thin line. The feeling of rigid belief thus conveyed is reinforced by the hard facets of the sitter's head and hands, his stiff posture, the closed books, and the minutely detailed wood graining.[41] Altman's portrait is thus not just a stylistically modern version of a traditional theme; it expresses his attitude toward his uncle's religious

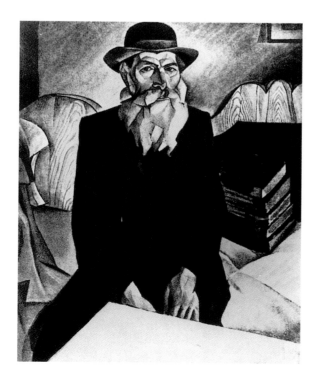

Fig. 5
Natan Altman
Portrait of an Old Jew,
1913
Oil on canvas
Location unknown
© 1995 VAGA, New York

convictions, which was not, however, as caustic as Chagall's view of Judaism in his 1913 *Jew in Prayer*.[42]

During his visit to Gritsev, Altman supposedly went alone to nearby Shepetovka and copied tombstones in the Jewish cemetery. These copies form the basis for his *Jewish Graphics* (Jüdische Grafik), two works from which were exhibited in December 1913 with the World of Art in Moscow.[43] This story has been heavily "edited." In fact, the An-sky expedition was working in the area at the time. Yudovin photographed and drew monuments in Shepetovka and copied tombstones in Gritsev while Altman was there.[44] At least four of Altman's designs in *Jewish Graphics* have exact parallels in Yudovin's tombstone copies. One Yudovin drawing of paired lions is particularly important as he inscribed it *1913 Gritsev*. The reclining deer and another of the paired lions both artists drew are from Gritsev and Vinnitsa, while the single lion on the ex libris may be from Proskurov.[45] Thus, Altman did not discover the tombstones on his own, but was attached temporarily to the An-sky expedition. It was Yudovin who inspired Altman's *Jewish Graphics*, whether they made their copies together in the field or later in St. Petersburg.[46]

Yet, in contrast to Yudovin's exact copies, Altman drew his own in a modern style. Whereas Yudovin preserved the sculptural feeling of the reliefs, and in reworking his drawings in 1914–20 gave them a grainy, stonelike texture, Altman added facets and dramatic contrasts of light and shade, changed details at will, and turned the reliefs into artistic graphic designs.[47] While Yudovin copied the inscriptions exactly, Altman personalized them, making spelling mistakes that prove that he lacked a good Jewish education.[48] In one plate, he wrote his own name—Natan ben Isia—as if inscribing it on his tombstone.[49] The two artists thus had different approaches to Jewish ethnography. Yudovin, completely absorbed in his task as the expedition's documenting artist, needed to create *exact* copies.[50] Altman, just because he was *not* a true member of the expedition, looked on the tombstones as a storehouse of material that he felt free to modernize in the same way as he had the *Jewish Funeral* and the *Portrait of an Old Jew*. Adopting An-sky's and Chagall's ideas, he used Jewish folk art to create modern Jewish art. Writing about this series in 1915, he also echoed Stasov's theory on the Oriental origins of Jewish art, stating that Jewish folk art preserved Assyrian influences.[51]

Altman's goal explains why his *Jewish Graphics* include applied graphics that are variations on the tombstone motifs, as well as two independent works of art inspired by them.[52] The development of the independent plates is revealing. The fruit on a branch in a pitcher is based on the central part of the Gritsev paired-lion tombstone he had copied without the fruit, having interpreted the vine twined around the tree as a snakelike form.[53] *Eve and the Serpent* (fig. 6), part of a biblical series Altman planned to do, unites the snake twined around a tree with the fruit. It was also inspired by Yudovin's circa 1912 copy of a Torah crown finial from Lutsk depicting the Fall.[54] As there, Altman's Eve, now a semicubist nude, lifts her arm to pluck a fruit offered by a snake twined around a central tree with dividing branches. The Torah crown's bulbous fruit have been enlarged as in the tombstone, and stylized folk art leaves and flowers have been added. The snake, however, has forelegs, like Gauguin's lizard-cum-snake in *Te Nave Nave Fenua* (Kurashiki, Ohara Museum), and the way its phallic tail curves provocatively between Eve's legs recalls the sexual innuendos in Gauguin's work.[55] Here, Altman blended traditional Jewish and modern sources to create something entirely new, giving impetus to the use of graphics in the Jewish revival movement that Pasternak's design for Engel's folksongs could not provide.[56]

At this point, in mid-1914, Chagall returned to Vitebsk. Suffering his own culture shock on re-encountering his past, he enthusiastically depicted his family and the town's orthodox Jews in a manner so close to Pen that his *Jew in Red* of 1914 (Geneva, Private Collection) is based on Pen's *Shamash* (Minsk, State Museum of the Republic of Belorus-

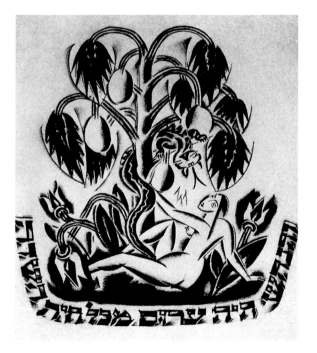

Fig. 6
Natan Altman
***Eve and the Serpent*, from *Jewish Graphics* by Max Osborn**
(Berlin: Petropolis, 1923)
12 x 9³/₈ in. (30.5 x 23.8 cm)
Collection Nicolas V. Iljine, Frankfurt/Main

sia).[57] Chagall, however, changed his subject into a wandering Jew, an expression of the Jewish refugees passing through Vitebsk during the war. This phenomenon, according to Chagall, was also symbolized by the Jew wandering through the village (in Yiddish, "over the village") in *Over Vitebsk* (see ill. 18 for a later version).[58] In paintings such as this, Chagall interpreted traditional Jewish types in a new way. Thus, the sorrowful *Jew in Green* (Geneva, Private Collection) and *Jew in Bright Red* (St. Petersburg, State Russian Museum) of 1914–15 are set against a background of Biblical quotations to stress the sitters' faith and biblical past. Chagall expressed his identification with them in his choice of passages and by setting his Hebrew name into the text in the latter painting.[59] The first of this series, *Praying Jew* of 1914 (Geneva, Private Collection; see ill. 17 for later version),[60] with its severely limited palette, seems to be a response to Altman's *Portrait of an Old Jew*.[61] As opposed to Altman's proud Jew in modern clothes, Chagall's Jew wears phylacteries and a

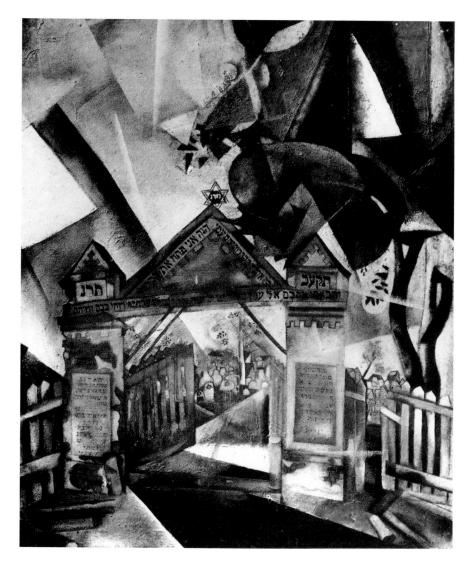

Fig. 7
Marc Chagall
Cemetery Gates, 1917
Oil on canvas,
34 1/4 x 26 7/8 in.
(87 x 68.6 cm)
Private Collection

prayer shawl, and his face is lined with suffering. Instead of gazing at us sternly, his eyes seem directed toward heaven, and his mouth seems open in prayer. In these works, there are fewer ambiguities than in Chagall's depictions of religious Jews done in Paris. However, his ambivalence *is* expressed in *Festival Day* (*Rabbi with* Etrog), where a similar Jew, holding a *lulav* and an *etrog*, goes to the synagogue to recite prayers on the Feast of the Tabernacles. The forbidding black interior of the synagogue causes his *neshama yiteira* (literally, extra soul), depicted as a little old man on his head, to scurry away.

Chagall married in July 1915 and soon afterward moved to St. Petersburg to work in an army office. Almost all of his compositions of 1915–16 express his private life.[62] Since Chagall's return, Altman too had not been active in Jewish art,[63] although both artists exhibited works with Jewish themes in major modern art shows.[64]

Until 1916, the artists of the Jewish revival had known and influenced each other, but had remained independent. In January of that year, while still under Tsarist rule,[65] they organized the Jewish Society for the Encouragement of the Arts (JSEA) in Petrograd, and the movement began to grow.[66] In May 1916, Altman won the competition for the JSEA logo. His design (Bowlt, fig. 7)—like some of the other entries—is a variation on Yudovin's copies of tombstones and ritual art. The JSEA's 1916–17 modern Jewish art exhibitions included works ranging from Antokolsky through Maimon to Chagall and Altman, providing the first historical review of Russian Jewish art.[67] They also marked a change in the thinking of the artists, who—since Antokolsky—had participated in major Russian art shows, seeing themselves as Russians who happened to be Jews. Now, they declared themselves to be Jews who were part of Russia. However, they continued to participate in avant-garde art circles and to exhibit Jewish art there, trying to fuse their two identities.[68]

The JSEA influenced Altman and Chagall to return to Jewish art. In November 1916, after exhibiting with the JSEA and after his *Head of a Young Jew* had appeared in *Evreiskaya nedelya*, Altman sent the work to the *Jack of Diamonds* show to stress his Jewish identity to the Russian avant-garde.[69] This realistic statue emphasizes Altman's slanted eyes, hooked nose, and sensuous lips, but adds side-curls and a hat like his uncle's. These attributes, the artist's facial expression, and his upright stance indicate his pride in being a Jew.[70] However, the hat is detached from his forehead, and it, his ear, and his side-curls are sharply cut off on the right, suggesting that his break with his young religious self did not leave him unscathed.

In December 1916, also after exhibiting with the JSEA, Chagall chose the avant-garde *Modern Russian Painting* show in Petrograd to exhibit his illustrations for the Yiddish author Der Nister and possibly for I.L. Peretz. Chagall was inspired by his contacts with Jewish authors and—perversely—by the prohibition against publishing in Hebrew or Yiddish. His illustrations combine strong black and white contrasts with a folk art simplicity.[71] It may have been through the JSEA that Chagall was commissioned to decorate a Jewish high school in Petrograd. He produced works such as *Purim* (see ill. 19) based on his own version of Jewish folk art.[72] In 1917, he did two paintings of a Jewish cemetery (fig. 7; see pl. 9), fusing the theme of tombstones and inscriptions which the An-sky expedition and Altman had popularized with an expressive, monumental cubism recalling Chagall's Paris style. These works, together with his book illustrations and 1914–15 portraits of Jews, strongly influenced the young artists who now joined the revival movement.[73]

Lissitzky, after returning from Germany in 1914 and meeting Chagall in Vitebsk, studied architecture and engineering in Moscow.[74] In the summer of 1916, after the JSEA opened there, he and Issachar Ryback, who had just graduated from the Kiev Art Institute, were sent by the Jewish Historical and Ethnographical Society to document Jewish art around Mogilev.[75] There, architect and artist switched roles. Lissitzky copied the paintings in the Mogilev Synagogue, while Ryback sketched the ceiling and possibly the synagogues in nearby Chiklov and Dobrovna, which he later painted.[76]

Whereas Lissitzky's paintings of this period appear to be lost, Ryback's demonstrate a search for a Jewish style.[77] In one of his post-Mogilev works, elongated dancing Hasids—influenced by Jakob Steinhardt's 1913 woodcuts—expressionistically capture the rhythms of the dance. They are set under a Gothic arch decorated with heraldic folk art lions, flowers, trees, and vines that recall Lissitzky's Mogilev copies.[78] In his 1918 Pogrom series (see ill. 99), Ryback blended Russian and Jewish folk art with Chagall's slightly distorted faces and an extreme version of East European pogrom iconography.[79] Ryback's *Old Synagogue* (see ill. 101) recalls Chagall's cemeteries, especially in the way the large, sharp triangular facets of the sky interact with and echo the objects.[80] Chagall's influence is also seen in the small Jew with a *lulav* and an *etrog* at the lower right. Yet, Chagall's *Cemetery Gates* seems stable in comparison to Ryback's painting, in which the synagogue heaves upward, its pyramidal roof echoing the almost equally solid pyramidal facets in

the sky. In the process, the houses at the sides are dislodged. This kind of convulsive movement is present in Chagall's other, horizontal *Cemetery*, with its feeling of upheaval, and in Lissitzky's contemporary woodcut of the synagogue on the Dvina in Vitebsk, a large brick building entirely unlike Mogilev's wooden synagogue.[81] By incorporating such movement into their works, all three artists created a dramatic expression of Jewish life in upheaval. However, Ryback and Lissitzky made an important innovation here: they painted synagogues, whereas Chagall and Altman had painted churches and cemeteries!

After the February 1917 Revolution, the ban against publishing in Hebrew and Yiddish was lifted, and artists searched for a distinctly modern Jewish style for book illustration.[82] Two models existed, both of which were cited by Ryback and Boris Aronson in their 1919 article on Jewish art.[83] Altman's *Jewish Graphics* of 1913–14 and his 1916–17 logos had modernized folk art with mild faceting and strong contrasts of light and shade. Chagall's 1916 Der Nister and Peretz illustrations (published in 1917) used stronger black and white contrasts in a simple folk style.[84] The popularity of these styles can be judged by their impact on Lissitzky.

In 1917, Lissitzky produced Moshe Broderzon's *Secular (or Everyday) Conversation* (*Sikhes Kholin*; Tel Aviv, Gross Family Collection) as a boxed scroll resembling a traditional Scroll of Esther. He ingeniously varied the compositional formats used in Hebrew illuminated books, amalgamating several stylistic sources into a coherent Jewish style.[85] While copying the synagogue paintings in Mogilev, his eye and hand had repeated the circular motion of the baroque forms and interlaced arabesques.[86] These curving lines echo those in the Oriental manuscripts published by Stasov and are repeated in the paper cuts and pages from *pinkasim* in An-sky's *Jewish Artistic Heritage*. An-sky's album also contains a calligraphic marriage contract from Volhynia composed of scrolls, arabesques, and birds set around sections of text.[87] Lissitzky deduced that this curvilinear folk style had old Oriental roots and was the missing link between Stasov's and Antokolsky's ideas on Jewish art. He wrote in the colophon that he wished "to fuse the style and content of ornament drawing with the wonderful Assyrian script," and in the colophon's design he indeed merged Oriental and folk art.[88] He based the colophon on a *pinkas* page from An-sky's album, but his lines are more curved and fluid, and the stylization of the animals recalls such Japanese artists as Sotatsu. Lissitzky also replaced the symmetrical interwoven design below with free scroll lines, recalling both

Fig. 8
El Lissitzky
Logo from Abram Efros and
Ya. Tugendkhold, *Iskusstvo*
Marka Shagala **(Moscow:**
Gelikon Press, 1918)

the flourishes in the marriage contract and Arabic script.[89]

In late 1917, Lissitzky solidified his curvilinear style, moving from Oriental toward folk art. This is apparent in his first *Had Gadya* series and in his cover for *By the Waters of Babylon*, which copies a Yudovin drawing, indicating contact with the Petrograd artists.[90] Influenced by Altman and Chagall, Lissitzky soon adopted larger black and white areas and a more angular style.[91] The change is particularly evident in the Gelikon Press logo for the first book on Chagall (fig. 8), which contains both Russian works and two of his Paris paintings, *Self-Portrait with Seven Fingers* and *Paris through the Window* (New York, Solomon R. Guggenheim Museum). Lissitzky's logo is an homage to Chagall. The goat-artist with exposed udders is tied to—or stands triumphantly before—his easel above a well, ready to nourish the reader with the milk and water of his art. This hybrid indicates that Lissitzky also knew Chagall's hybrid self-portrait in *Dedicated to My Fiancée* (Kunstmuseum Bern).[92]

The well in the Gelikon Press logo reappears in two plates of Lissitzky's 1918–19 *Had Gadya*. This series received a stylistic impetus from Chagall's merging of folk art and cubism illustrated in his book, but retained Lissitzky's curvilinear forms. Lissitzky even copied the position of the goat in a Cha-

gall drawing illustrated in the book into the first and last plates of the *Had Gadya*.[93] Lissitzky used the *Had Gadya* to preach the Russian Revolution to the Jews; his interest was beginning to veer from purely Jewish concerns to general Russian ones, still, however, within a Jewish context.[94] This aspect is reinforced by the Kultur Lige logo he made for the *Had Gadya* cover. Here, instead of a goat, the father hands his son a *Simhat Torah* flag and stands victorious on a defeated animal that resembles the dog being beaten in the series, a symbol of the vanquished oppressor of the Jews. The flag connotes a new beginning, as the festival marks the new cycle in reading the Torah, starting over from Genesis. Even after Lissitzky changed his style and became involved with the Revolution in more general terms, he continued to illustrate Yiddish books. When working for Jewish clients, he continued to use the accepted components of a modern Jewish style.[95]

Many artists adopted variations on this style no matter what their original style had been. Thus, while Chaikov's 1917 *Temerl* illustrations had been a decorative version of his academic *Makhmadim* designs, his illustrations after 1918 show the influence of Chagall, while his 1920 *Self-Portrait* (Location unknown) owes a debt to Altman.[96] Aronson also succumbed to Chagall's influence, even including the latter's 1914 *Praying Jew* in his own 1920 *Pogrom* (Jerusalem, Israel Museum).[97] This modern "Jewish" style spread from artist to artist. Thus, Ryback's *Old Synagogue*, influenced by Chagall, in turn influenced his friend, Abraham Manievich, to abandon naturalism in depicting the Jewish quarter of Kiev in 1919 (see ill. 73). Manievich set his synagogue amid a mountain of geometric houses against a faceted orange sky.[98]

This spread of a common style was part of a broad development in the Jewish revival movement after the Revolution. Inspired by the art of Altman, Chagall, Yudovin, and Lissitzky, writers and other artists published articles defining the nature of Jewish art. In 1918, Abram Efros stated that the two sources of the new Jewish style were folk art and modernism, but that artists must strip Jewish folk art of its foreign accretions to discover its principles. He warned against basing a new Jewish art on copying (as Altman had done), demanding that artists reshape tradition creatively (as Chagall and Lissitzky were doing).[99] In 1919, Ryback and Aronson published "Paths of Jewish Painting," stressing the contributions of Altman and Chagall.[100] They and other writers stated that the principles of Jewish folk art included flatness (even in sculpture), ornamental design, the autonomy of the Hebrew letter, subdued colors, abstraction, and symmetry.[101]

Artist Unknown
*Rabinovich, Alexander Gra-
novsky, and Natan Altman,*
1924
Photograph, 4 1/8 x 5 3/4 in.
(10.5 x 14.5 cm)
Russian State Archive of Art
and Literature, Moscow

Meanwhile, new organizations of Jewish artists arose in various cities, the most important being the Kultur Lige in embattled Kiev. They held exhibitions of modern Jewish art and published illustrated books to help "nationalize Jewish art" and educate children.[102] At the same time, major Jewish artists established and taught in art schools. Chagall founded and ran the Vitebsk art academy from 1919 to mid-1920, hiring several Jewish teachers, including Lissitzky, Yudovin, and Pen, for its many Jewish students. In Kiev, Chaikov and Ryback were teaching, while Altman helped with reorganization and taught in the art schools in Petrograd.[103] All this activity masked deep problems. Whereas Pasternak's portraits of Bialik, An-sky, and others (see ills. 85, 87) document his involvement with the revival,[104] and Lissitzky and Chaikov produced book illustrations, Altman and Chagall were too busy with the Revolution and their schools to create Jewish art.[105]

Abstraction soon began to infiltrate the movement. Altman's 1918–19 works display Suprematist elements, and by 1920 he was alternating between abstraction and lightly faceted academic portraits.[106] Lissitzky, after finishing the *Had Gadya*, added a geometric design, influenced by Lyubov Popova and dated 6 February 1919, to the inside of the cover.[107] The cover, whose insert was folded in three, juxtaposes different aspects of his style, with the abstract design "hidden within" the accepted Jewish revival style on the outside. At the center of the outer cover, Lissitzky stamped an earlier version of the first plate of the *Had Gadya* (ca. mid-1918), based on the man and goat in Chagall's *Rain* of 1911 (Venice, Peggy Guggenheim Collection), of which Lissitzky must have seen a photograph.[108] To the right he set a Kultur Lige logo, whose style is close to his 1918–19 cover for Andersen's *Mayselakh*.[109] The signatures on the inside of the cover (*lamed yud* [*li*] and *lamed lamed* [*ll*]) also show him seeking a new identity, evolving from his usual *aleph lamed* (for Eliezer Lisitsky), written out on the title page, to

Lazar Lisitsky and—ultimately—to El Lissitzky, a witty amalgam of abbreviations of his Hebrew and Russian names. A newly discovered abstract painting attributed to Lissitzky, with a collage from a Yiddish paper, shows the combined influence of Popova and Alexandra Exter, which would date it to 1919, after he left Moscow for Kiev and before he came under Kazimir Malevich's aegis.[110] In these works, Lissitzky produced Jewish abstract art. His change to abstraction explains why he persuaded Chagall to invite Malevich to Vitebsk.[111]

Ryback, who moved to Moscow in 1919, also began to produce cubist and semi-abstract paintings that often incorporate Yiddish texts and folk art figures. His *Aleph-Beth* (see pl. 7) recalls Popova's *Objects from the Dyer's Shop* (New York, Museum of Modern Art) and Rozanova's *Tavern* (Kostroma, Museum of Fine Arts) of 1914 in its combination of lettering, sharp diagonal facets, and fragments of more naturalistic objects.[112] Chaikov's *Electrifier* of 1921 (see pl. 13) and his *Young Jew* (Location unknown) of 1921 are geometric constructions, and even Chagall tried abstraction after Malevich arrived at Vitebsk, although he made fun of the approach even as he adopted it.[113]

In fact, Chagall's contact with Suprematism was not positive. The inevitable explosion with Malevich and Lissitzky led him to leave Vitebsk for Moscow in May 1920, feeling frustrated and betrayed.[114] Yet, this defeat was a blessing in disguise. It spurred Chagall on to open up the Jewish theater to avant-garde Jewish art. He and Altman had earlier worked in the Russian theater, but the Jewish Chamber Theater, founded by Alexander Granovsky in 1919 in Petrograd, had preferred realistic sets by Mstislav Dobuzhinsky and P. Schildknekht. After the theater moved to Moscow on 20 November 1920, Efros's appointment as artistic director and competition with the nascent Hebrew-speaking Habimah—which was rehearsing An-sky's *Dybbuk* and had hired Altman by 11 November 1920—led to Chagall's commission to design the opening performance and to decorate the theater space. The resulting works, completed by 1 January 1921, had a decisive effect on Jewish theater.[115]

In his murals for the State Jewish Theater, Chagall blended all his styles (folk art, naturalism, cubism, and Suprematism), added Yiddish idioms that the audience would appreciate, and stated his ideas on the components needed for a revolutionary Yiddish theater.[116] In the panels around the windows, he suggested his ideas for staging *The Dybbuk*, since Habimah had already chosen Altman over himself as a designer.[117] Chagall's murals immediately influenced the actors, to the point that on

opening night the audience could not differentiate between them and the figures on the walls.[118] His sets for works by Sholem Aleichem were also highly influential. For *Mazel Tov*, he produced geometric forms and a tilted table, an inscription playing with the author's name, and an upside-down goat and tombstone. For *The Agents*, he created a minimalist Constructivist set, and for *The Lie*, a witty "Suprematist" backdrop.[119]

In the spring of 1920, Altman arrived in Moscow to sketch Lenin. Since Chagall had problems working with directors, Altman was hired not only to design *The Dybbuk* for Habimah (see ill. 3) but also to replace Chagall at the State Jewish Chamber Theater. He thus became the major set designer in the Jewish theater. Altman's designs were staged to great acclaim in 1922. They reinforced Chagall's choice of styles, adapting them more successfully to the stage. The *Dybbuk* designs recall Chagall's *Mazel Tov* set, and Altman's Constructivist sets for *Uriel Accosta* recall that for Chagall's *Agents*.[120] Combinations of these styles became synonymous with the Yiddish theater, so much so that Max Osborn wrote in 1923 of the striking similarity between Isaac Rabichev's sets for *200,000* and Chagall's paintings.[121] This influence is also evident in Falk's designs, while Altman's 1926 sets for *The Tenth Commandment* echo his own earlier ones for *Uriel Accosta*.[122]

Rebuffed by the theater, in the winter of 1921-22 Chagall returned to book illustration, interweaving letters and images in a new way and exhibiting his works in 1922 with those of Altman and Shterenberg.[123] His covers for *Troyer* and the periodical *Shtrom* modernize traditional illuminated Hebrew letters, while his illustrations combine geometric forms, truncated images, and texts in a manner deriving from his 1919–21 "Suprematist" compositions.[124]

In 1922, the leaders of Russian Jewish art were in Berlin. Ryback had moved there in 1921 and was soon followed by Lissitzky, who traveled via Warsaw, where he preached international art, particularly to Jewish artists. Ryback and Lissitzky both published in *Rimon*, the organ of the German Jewish art movement, and Lissitzky reported there on his Mogilev expedition.[125] Altman arrived with Shterenberg in the autumn of 1922, as did Chagall, who traveled via Kaunas, where he exhibited and met Jewish intellectuals. Chagall and Aronson—who also arrived in Berlin in 1922—studied etching with Hermann Struck, a major German Jewish artist.[126]

The confluence of Russian and German Jewish artists produced a last flowering of avant-garde Russian Jewish book illustration. On the one hand,

Chagall and Ryback returned to their roots to reconstruct their past. Chagall created his etchings for *My Life* in 1922, and Ryback published his *Shtetl* album in the accepted Jewish revival style in 1923.[127] On the other hand, basing themselves on their 1919–20 abstract posters and paintings, Lissitzky and Altman turned modern Hebrew letters into major elements in their Yiddish book covers.[128] Despite Lissitzky's design on the inside of the cover of the *Had Gadya*, they did not deem abstraction appropriate for their Jewish works until their simultaneous contact in Germany with Bauhaus, De Stijl, and Jewish avant-garde artists. The intermingling of traditional and modern can be seen in Lissitzky's 1922-23 covers for *Ukrainian Folktales* and *White Russian Folktales*. The illustrations in these books remain in his "Jewish style" and include copies of a Mogilev Synagogue design and Chagall's 1913 *Violinist* (Amsterdam, Stedelijk Museum) and use a play of light and shade which recalls Altman's *Jewish Graphics*. On the cover for *Ukrainian Folktales*, traditional letters with a decorated initial *aleph* still appear. On the back, however, Lissitzky did dynamic variations on this letter—the upper right-hand one most resembles the original— and one of the more abstract of these is echoed in the design under the title on the front cover.[129]

The interplay among the Russian, Western, and Jewish avant-garde movements led Lissitzky to juxtapose elements playfully in his 1922 illustrations for Ilya Ehrenburg's *Six Tales with Easy Endings* in order to express a state of being between cultures as well as between styles (Shatskikh, fig. 3). In *Tatlin at Work*, Tatlin's assistant, Sofya Dymshits-Tolstaya, is silenced as the Constructivist measures Lissitzky's Prouns. In other illustrations, a headless man leaps between Russia and Paris, framed by Delaunay semicircles; a photograph of a steel construction and naturalistic heads are separated by Malevich's forms; childrens's drawings appear above a variant of a design from Lissitzky's contemporary children's book, *Story of Two Squares*; and Mona Lisa becomes a film star. In the unused *Black Sphere*, a figure dives from Suprematist crosses into a Rodchenko black hole; the unused *Footballer* aims his ball into a Proun composition, echoing the Dadaist journal *Everyman His Own Football*. In this context, *A Journey to America*, with its *peh nun* (here is buried) embedded in Lissitzky's hand-print and set on a kabbalistic text and Jewish star, stresses the artist's Jewish identity, poised between different flags and cities.[130] This identity is also found in his 1924–25 designs for a skyscraper executed in Switzerland. In them, three pillars support an abstract shape, which makes little architectural sense until one realizes that seen from below, it forms the Hebrew letter *beth* (house). Here,

Lissitzky expressed his Judaism within an international language of form and functionalist content.[131]

Following these works, the Russian Jewish art movement split asunder. Lissitzky decided he could not serve two masters and returned to Russia in 1925 to serve Communism.[132] Altman went back in 1923, but soon stopped being an official Soviet artist. He illustrated books, including *Genesis* and those of Sholem Aleichem, and worked for the Yiddish theater, stating in 1927 that his ideology was close to theirs.[133] In 1923, Chagall went to Paris, where he created few independent Jewish works that are not variations on earlier themes until the rise of Nazism re-awoke his Jewish identity.[134] As late as 1960–61, he copied Yudovin's designs from *Idishe Folks-ornament* in his Hadassah Synagogue windows.[135] Ryback decided to pursue Jewish art and was influenced by Ludwig Meidner and Jankel Adler. Returning to Russia in 1925 to collect material in the Ukraine and work for the Jewish theater, he then moved to Paris. Aronson also opted for Jewish art and worked for the Jewish theater in the United States.[136] Thus, strangely, the Russian Jewish art revival can be said to have blossomed in Paris and withered in Berlin. Those who continued to work in the movement in Russia were either students of Pen and the Kultur Lige or focused around the Yiddish theater, which served as a living arm of the Jewish revival movement long after it had faded in the visual arts.

Ziva Amishai-Maisels
is Alice and Edward G. Winant Chair for Art History at Hebrew University, Jerusalem.

Notes

The research for this article was made possible by a grant from the Israel Academy of Sciences. I would like to thank Ruth Apter-Gabriel and Grigor and Lola Kasovsky for their help.

1 See Avram Kampf, "In Quest of the Jewish Style in the Era of the Russian Revolution," *Journal of Jewish Art* 5 (1978), p. 49; Seth L. Wolitz, "The Jewish National Art Renaissance in Russia," and John E. Bowlt, "From the Pale of Settlement to the Reconstruction of the World," in Ruth Apter-Gabriel, ed., *Tradition and Revolution: The Jewish Renaissance in Russian Avant-Garde Art, 1912–1928*, exh. cat. (Jerusalem: Israel Museum, 1987), pp. 24–25, 27, 43–44, 58 n. 1; Mirjam Rajner, "The Awakening of Jewish National Art in Russia," *Jewish Art* 16–17 (1990–91), pp. 99, 106–10, 115–16; V. Stasov and D. Guenzberg, *L'Ornament hébreu* (Berlin: S. Calvary, 1905) (translation of the 1886 Russian edition).

2 See Cecil Roth, ed., *Jewish Art* (Tel Aviv: Massadah, 1961), pp. 555–63, 591, 611, 618–22, 635–38.

3 Grigor Kasovsky, *Artists from Vitebsk: Yehuda Pen and His Pupils* (Moscow: Image, 1992), pp. 14–70. Pen would have known the ideas of Antokolsky and Stasov through Ilya Repin (*ibid.*, pp. 24–25). For the influence of *Ost und West* on Chagall, see Ziva Amishai-Maisels, "Chagall and the Jewish Revival: Center or Periphery?" in *Tradition and Revolution* (note 1), pp. 73, 78–79, 84, 92–93 nn. 11–14.

4 Franz Meyer, *Marc Chagall: Life and Work*, trans. Robert Allen (New York: Harry N. Abrams, 1963), pp. 55, 70, 78; nos. 7, 30, 33; Amishai-Maisels (note 3), pp. 72–75, 92–94.

5 Wolitz (note 1), p. 25.

6 Chagall told of living in the offices of this paper (Marc Chagall, *My Life* [New York: Orion Press, 1960], pp. 97–99; see Amishai-Maisels (note 3), pp. 73, 93, 99 n. 104). For the reasons for these Jewish activities, see Bowlt (note 1), pp. 46–47.

7 Corinne Ze'evi-Weil, "In Search of a Lost Innocence: A Biography," in Rivka Gonen, ed., *Back to the Shtetl: An-sky and the Jewish Ethnographic Expedition, 1912–1914*, exh. cat. (Jerusalem: Israel Museum, 1994), pp. 16–18 (in Hebrew).

8 Amishai-Maisels (note 3), pp. 71–72, 91 n. 6.

9 For this parallel development of modern Russian art, see Bowlt's essay in the present volume.

10 Amishai-Maisels (note 3), pp. 73–75; *idem*, "Chagall's Jewish In-Jokes," *Journal of Jewish Art* 5 (1978), pp. 76–93. For the reactions of his parents to his art and his problems with anti-Semitism, see Chagall (note 6), pp. 13, 54–59, 76, 78, 83–85, 105–06; Wolitz (note 1), p. 22.

11 The date of this painting is unclear, as it was first exhibited in April 1910 (Meyer [note 4], pp. 28, 92). Chagall's statement (*ibid.*, p. 92) that he exhibited at the Union of Youth in 1909 is incorrect; the group was founded and held its first exhibition in March 1910 (Camilla Gray, *The Great Experiment: Russian Art 1863–1922* [London: Thames and Hudson, 1962], pp. 98–99; Donald E. Gordon, *Modern Art Exhibitions 1900–1916* [Munich: Prestel, 1974], vol. 2, pp. 380–81). Chagall did not participate, as he wrote Benois in 1911 that his works had been rejected (*Chagall*, exh. cat. [Martigny: Fondation Pierre Gianadda, 1991], p. 235).

12 Maxim Syrkin, "Mark Shagal," *Evreiskaya nedelya*, no. 20 (15 May 1916), p. 44. Syrkin, who made it clear that he neither liked nor understood modern art (pp. 41–44), was his friend Chagall's mouthpiece and was the first to state that Chagall's art was "fantastic-humoristic" (p. 44). The setting of the fiddler near a cobbler's sign also suggests that his music is disharmonious; in Yiddish, "he plays the violin like a cobbler." For other meanings, see Amishai-Maisels (note 10), pp. 77–78; Susan Compton, *Chagall*, exh. cat. (London: Royal Academy of Arts, 1985), pp. 155–56.

13 Meyer (note 4), pp. 105, 113; no. 66.

14 Alexander Romm's "Memories of Marc Chagall" (*Marc Chagall: Il Teatro dei Sogni*, exh. cat. [Milan: Fondazione Antonio Mazzotto, 1994], pp. 38–39) stresses the Russian nature of Chagall's Paris period.

15 The methodological nature of this contrast is proven by his choice of a small sketch of *To Russia* in a naive style rather than the large semi-cubist painting (Meyer [note 4], p. 159). This juxtaposition of styles is seen in many paintings of this period (see Amishai-Maisels [note 3], pp. 76–78).

16 See, for instance, Mauricy Gottlieb's many self-portraits in different roles (Nehama Guralnik, *In the Flower of Youth, Maurycy Gottlieb 1856–1879*, exh. cat. [Tel Aviv Museum, 1991], pp. 29, 121, 156–57, 159, 161, 173).

17 Mark Etkind, *Nathan Altman* (Dresden: Verlag der Kunst, 1984), p. 166. The only pre-Paris Jewish themes that Etkind lists (pp. 214–15) are portraits of Jews and *The Jerusalimka (Vinnitsa)* of 1909, which depicts the poor Jewish quarter where Altman grew up (*ibid.*, pp. 12, 161). Altman portrayed his orthodox grandmother with a kerchief entirely covering her hair and her hands folded in her lap (Mark Etkind, *Natan Altman* [Moscow: Sovetskii khudozhnik, 1971], p. 17).

18 Etkind (1984) (note 17), pp. 14–19; pl. 2.

19 *Ibid.*, pp. 14–16; Meyer (note 4) p. 114; Wolitz (note 1), p. 26; *Vladimir Baranoff-Rossiné*, exh. cat. (Paris: Musée National d'Art Moderne, 1972), p. 5.

20 Koenig and Lichtenstein had studied at the Bezalel Art School in Jerusalem, where a quest for a national style influenced by Stasov was under way (Nurit Shilo-Cohen, ed., *Bezalel 1906–1929*, exh. cat. [Jerusalem: Israel Museum, 1983], pp. 371–72). For information on *Makhmadim*, see Kampf (note 1), pp. 64–65; Wolitz (note 1), pp. 26–28; *Tradition and Revolution* (note 1), pp. 217–21, 240.

21 Marc Chagall, "Bletlakh," *Shtrom* 1 (1922), pp. 44–46, trans. in Amishai-Maisels (note 3), pp. 71–72; see also pp. 75–78.

22 Vinaver was in frequent contact with Chagall to check on his progress (Meyer [note 4], pp. 146–47). Chagall and Yudovin both studied at Pen's in 1906 (Amishai-Maisels [note 3], p. 92 n. 9; Ruth Apter-Gabriel, *The Jewish Art of Solomon Yudovin [1892–1954]: From Folk Art to Social Realism*, exh. cat. [Jerusalem: Israel Museum, 1991], p. xii).

23 S. An-sky, "Jurij Paen," *Ost und West* 12 (August 1912), pp. 733ff. This was up-to-date information, as Chagall had only exhibited at the Salon des Indépendents in March-May 1912.

24 Amishai-Maisels (note 3), pp. 78–80.

25 Sophie Lissitzky-Küppers, *El Lissitzky: Life, Letters, Texts* (London: Thames and Hudson, 1968), p. 19; Alan Curtis Birnholz, *El Lissitzky* (Ann Arbor: University Microfilms, 1974), p. 7; fig. 3. For this three-way relationship, see Amishai-Maisels (note 3), pp. 73, 93 n. 15; Ruth Apter-Gabriel, "El Lissitzky's Jewish Works," in *Tradition and Revolution* (note 1), p. 123 n. 12.

26 El Lissitzky, "Memoirs on the Mohilev Synagogue," *Rimon/Milgroim* 3 (1923), pp. 9–12 (in Hebrew and Yiddish), trans. in *Tradition and Revolution* (note 1), pp. 233–34, where the section on the Worms synagogue should read: "This plan is very ancient: it is the kind we saw in a picture of the interior of the oldest Synagogue in Germany (from the thirteenth century), the Synagogue of Worms." This refers to the 1840 lithographs, which show the division between the men's and women's sections that no longer existed when Lissitzky visited Worms (Richard Krautheimer, *Mittelalterliche Synagogen* [Berlin: Frankfurter, 1927], pp. 151–76; figs. 22, 35, 41–50, 52–57. Lissitzky-Küppers (note 25), p. 16, mentioned Lissitzky's copies of lion reliefs in the synagogue that do not exist, in fact. She may have been referring to the tombstones or the lions that decorate the twelfth-century cathedral in Worms (Paul Ortwin Rave, *Romanische Baukunst am Rhein* [Bonn: Friedrich Cohen, 1922], pl. 8). Nothing is known of Lissitzky's work before his stay in Germany, although his wife mentioned a "revolutionary" almanac in which he participated in 1905 while studying at Pen's school (Lissitzky-Küppers [note 25], p. 16).

27 Birnholz (note 25), p. 9, who also stated that Lissitzky exhibited two unidentified paintings at this time.

28 Yudovin and Lissitzky studied at the same time at Pen's (Apter-Gabriel [note 22], p. xii; Birnholz [note 25], p. 1; Lissitzky-Küppers [note 25], p. 16).

29 Amishai-Maisels (note 10), pp. 86–88; *idem*, "Chagall's Golgotha: Sources and Meanings," in *Proceedings of the Eleventh World Congress of Jewish Studies* (Jerusalem: World Union of Jewish Studies, 1994), Division D, vol. 2, pp. 39–46; "Chagall's 'Dedicated to Christ': Sources and Meaning," *Jewish Art* (forthcoming).

30 Etkind (1984) (note 17), pp. 12, 19, 211 n. 9. The painting is dated 1911, but was exhibited only in November 1913 (Gordon [note 11], p. 767) with his Paris works. Between Paris and Vinnitsa, Altman stopped in Bruges and sketched a Christian funeral procession (Wlademar George and Ilya Ehrenberg, *Natan Altman* [Paris: Le Triangle, (1933)], unpag. pl. 2).

31 Perspective and color are distorted in Chagallesque fashion only in the inner room, with its red floor and tilted furniture.

32 Meyer (note 4), no. 66. Romm saw the similar cubist version of *Birth* (*ibid.*, p. 105) in Chagall's studio in the autumn of 1911 (Romm [note 14], p. 38), so Altman could have seen the cubist *Dead Man* before leaving Paris.

33 According to Karl Baedeker (*Russland nebst Teheran, Port Arthur, Peking* [Leipzig: Karl Baedeker, 1912], p. 83), there were three Roman Catholic churches in St. Petersburg. The Polish church, St. Catherine off Nevsky Prospekt, built by de la Mothe in 1763, seems the most likely candidate, but it is closed and information on its statues has not been forthcoming. Altman had painted a Polish Catholic churchyard in Vinnitsa in 1910 (Etkind [1984] [note 17], p. 215).

34 Etkind (1984) (note 17), p. 24.

35 Amishai-Maisels (note 10), pp. 86–88.

36 Benjamin Lukin, "From Folklore to Folk: An-sky and Jewish Ethnography," and Ruth Apter-Gabriel, "In the Spirit of An-sky: Folk Motifs in Russian Jewish Art" (in Hebrew), in *Back to the Shtetl* (note 7), pp. 32, 111–12. Nothing came of this plan.

37 Chaim Nachman Bialik and Max Osborn, *L. Pasternak: His Life and Work* (Berlin: Stybel, 1924), pp. 2–3, 51, 57; Apter-Gabriel (note 36), pp. 111–12. The cover design was based on the title page of a *pinkas* of the Kremnitz Society for Visiting the Sick, which is preserved in An-sky's album of material collected during the expeditions (Alexander Kantsedikas, *Semyon An-sky: The Jewish Artistic Heritage—An Album* [Moscow: RA, 1994], fig. 62 [caption no. 63]). Since Kremnitz was visited during the 1913 expedition (Lukin [note 36], p. 33), Pasternak's graphic may date to that year. For an analysis of the hidden Jewish levels of his work, see Mirjam Rajner, "Russian Jewish Art—1862–1912" (Master's thesis, Hebrew University, Jerusalem, 1990), pp. 163–83.

38 Gordon (note 11), pp. 656–58, 708–09. Altman would have been aware of both shows as he exhibited neutral subjects there. It was only after these shows, in November-December, that he exhibited Jewish themes (*ibid.*, pp. 754, 767, 770).

39 Susan Compton, *The World Backwards* (London: British Library, 1978), pp. 104, 125; Gerald Janecek, *The Look of Russian Literature: Avant-Garde Visual Experiments 1900–1930* (Princeton: Princeton University, 1984), pp. 94–97. Altman had befriended Kruchenykh and Vladimir Burlyuk at the Odessa Art Institute (Etkind [1984] [note 17], pp. 165–66) and thus had an entrée into avant-garde circles in St. Petersburg.

40 Etkind (1984) (note 17), p. 32. The painting was exhibited in November 1913 with the World of Art in St. Petersburg and in December at their show in Moscow (Gordon [note 11], pp. 754, 770). For a description of the impression Gritsev made on Altman, see Max Osborn's introduction to Natan Altman, *Jüdische Graphik/Evreiskaya grafika* (Berlin: Razum, 1923), pp. 10–11.

41 The "hardness" of the features and composition become evident when the painting is compared to Pen's softly rendered faces and twinkling or suffering eyes. Altman's depiction of his uncle recalls that of his grandmother, but while she is dour and uncommunicative, he is stern and demanding.

42 Amishai-Maisels (note 3), pp. 78–80.

43 Etkind (1984) (note 17), pp. 26–28; Gordon (note 11), p. 770; Altman (note 40), pp. 10–11; Kampf (note 1), p. 56. The graphics were probably finished just before the exhibition, as they were added to works he had shown with the World of Art in St. Petersburg in November (Gordon [note 11], p. 754). It is not clear which were exhibited, and the series should be dated 1913–14. They were individually framed and sold; one hangs on the wall

in Altman's *Portrait of Mrs. Gintsburg* of 1918–20 (Etkind [1984] [note 17], pl. 14).

44 *Back to the Shtetl* (note 7), p. 28; S. Yudovin and M. Malkin, *Idisher Folks-Ornament* (Vitebsk: I.L. Peretz Society, 1920), pl. 26; Apter-Gabriel (note 22), pp. iv, 14–15; nos. 2, 5, 8. The 1913 expedition was in Volhynia in the summer for two and a half months. Gritsev, Shepetovka, and Proskurov lie close together; thus, Yudovin was there while Altman was visiting his relatives. Vinnitsa was in Podolia, which Yudovin visited later with the expedition. Since the expedition included researchers who were natives of the area (Lukin [note 36], pp. 33–34), Yudovin may have asked Altman for help in Gritsev or in St. Petersburg. This would explain Altman's visit to his relatives at this time.

45 Altman (note 40), nos. 2–4, 10; Yudovin and Malkin (note 44), nos. 8, 1; Apter-Gabriel (note 22), pp. iv, 14; no. 5; an unpublished drawing from Proskurov (Jerusalem, Israel Museum). See also Apter-Gabriel (note 22), p. vii; *idem* (note 36), p. 112; and compare the scroll around the lion in Altman (note 40), pl. 10; the scroll between lions in Yudovin and Malkin (note 44), pl. 4; and an unpublished Yudovin drawing of interlaced branches and leaves. When Yudovin published the deer relief from Gritsev in 1920 (*ibid.*, pl. 8), he labeled it *Vinnitsa*, Altman's hometown.

46 The dated Gritsev drawing indicates that Yudovin did draw from the graves in situ, although some of his drawings are based on photographs. In one case, a drawing done in situ shows a misreading of the antlers, which he corrected in a later version from a photograph (ApterGabriel [note 22], pp. 6–7). Given Altman's debt to Yudovin and his exhibition of works from the *Jewish Graphics* series in December 1913 in Moscow (Yudovin was based in St. Petersburg), it is possible to understand why he published these works only later in Berlin, where his drawings appeared to Osborn to be entirely original.

47 This is stressed by Osborn (Altman [note 40], pp. 11–12).

48 His Hebrew signature is misspelled "Halthman," with the "m" written in the form it takes at the end rather than the middle of a word, and he used the initials "N.H." (Altman [note 40], pls. 3, 8–9). Altman stated that he spent one year in *heder*, one in a Russian Jewish school, and three in a Jewish elementary school (Etkind [1984] [note 17], p. 162). He did not even remember how to write his name.

49 Altman (note 40), pl. 4. Altman's father's name was Isaiah (Etkind [1984] [note 17], pp. 10 n. 1, 211 n. 7); thus "Isia" should be "Isai." In another design (pl. 2), he added the truncated letters *ayin shin* around a reclining deer above *Natan ben Is*. This could be an abbreviation for *al shem* (in the name of), so that the inscription would read *in the name of Nathan the son of Isaiah*, or—given his other mistakes—it could be an incorrect abbreviation of *alav hashalom* (may he rest in peace), which should be abbreviated *ayin heh* or *ayin heh shin*.

50 To see how exact his copies are, see the photograph and drawings in Apter-Gabriel (note 22), pp. 6–7. In his reworkings of his tombstone designs for publication between ca. 1924 and 1941, Yudovin copied Altman's modernist style (*ibid.*, pp. iii, v, 4, 23, 25).

51 Etkind (1984) (note 17), p. 148; Altman (note 40), pp. 11–15.

52 Altman (note 40), pls. 1, 5, 7, 9–10. By 1917, Altman had corrected his initials to "N.A."

53 A comparison with a plant in a flowerpot on a tombstone (D. Goberman, *Jewish Tombstones in Ukraine and Moldova* [Moscow: Image, 1993], pl. 152) points up Altman's innovative approach. See also his use of the Gritsev motif in his *Safrut* cover of 1917 (Bowlt [note 1], p. 53).

54 Altman (note 40), p. 15; Yudovin and Malkin (note 44), pl. 23. The expedition was in Lutsk in October 1912 (Lukin [note 36], p. 30), and this may date Yudovin's copy. Altman's use of the results of a pre-1913 expedition shows that he continued working with Yudovin and on expedition material after returning to St. Petersburg. Moreover, given the spelling mistakes he made on the other plates, it is clear that he had help on the inscription here, probably from Yudovin. Since An-sky moved the entire contents of the Lutsk Synagogue to Petrograd in the autumn of 1915 (*ibid.*, p. 36), Yudovin's drawing may be from that period. However, given the similarity between his and Altman's drawings, this

does not seem likely. For other reasons for Altman's choice of the Temptation, see Amishai-Maisels (note 3), p. 80.

55 Altman could have seen Gauguin's 1894 woodcut of this theme (*Gauguin*, exh. cat. [Paris: Réunion des Musées Nationaux, 1989], pp. 332–33) in Paris. This would also explain the choice of palm leaves, which are clear in the Gauguin, and the pointed leaves of the flowers which frame Eve. For the sexual innuendos of Gauguin's painting, see Ziva Amishai-Maisels, *Gauguin's Religious Themes* (New York: Garland, 1985), pp. 180–90. The snake with legs and the sexual overtones are also clear in Altman's 1933 version of this theme (Etkind [1984][note 17], p. 121).

56 For Altman's intentions, see Altman (note 40), pp. 22–23; Wolitz (note 1), p. 26. Jewish art also penetrated Altman's secular designs. His composition for the cover of Arnold Volkovisky's *Kiss of the Sun*, exhibited at the *Graphic Art* show in St. Petersburg in November 1913 (Etkind [1984] [note 17], p. 29; Gordon [note 11], p. 759) recalls the frontispiece of a *pinkas* from Derazhnia (Kantsedikas [note 37], fig. 46), although the circular motif now contains an Indian, and the vase resembles a Russian folk design.

57 Amishai-Maisels (note 3), pp. 80–81. Chagall's approach had mellowed from his earlier variations on Pen.

58 Syrkin (note 12), pp. 47–48; Amishai-Maisels (note 10), p. 89.

59 Amishai-Maisels (note 10), pp. 89–93; *idem* (note 3), pp. 81–83.

60 The early dating of the original painting is suggested by its mention in his autumn 1914 letters to Benois (written on the same type of paper) about the works he wished to show with the World of Art (Meyer [note 4], p. 243; *Chagall* [note 11], pp. 235–36, 238. The paintings he listed are all straightforward representations without his usual fantasy and thus would have had a reasonable chance of being shown with the World of Art. *Praying Jew* is also the only clearly identifiable painting of this series that he exhibited in April at the *Year 1915* show in Moscow (Gordon [note 11], p. 870). For the versions of this painting, see Compton (note 12), pp. 186–87.

61 The similarities include the pose, the limited palette, the stripes of the prayer shawl and phylacteries (which echo those of the books in Altman's work), and the two white diagonal planes behind Chagall's Jew, which seem to vary the similar forms of the tilted table plane in Altman's work. It is not clear how Chagall knew this painting, which had been exhibited at the end of 1913, unless he saw a photograph of it, perhaps sent to him by Altman. See also Amishai-Maisels (note 3), pp. 83, 97 n. 68.

62 Meyer (note 4), pp. 224, 237, 243–44, 246, 258–63; nos. 234–50.

63 Etkind (1984) (note 17), pp. 216–17. Altman may have reacted to Chagall's return in his *Self-Portrait Sitting on a Roof* (*ibid.*, p. 216), which paraphrases a Chagall theme.

64 At the *Year 1915* show in April (Gordon [note 11], pp. 869–70), Altman exhibited his 1911 *Jewish Funeral*, and Chagall, three clearly Jewish themes, *Black and White*, *At Table*, and *Jews* (probably Meyer [note 4], p. 235; nos. 189, 192).

65 It is often mistakenly thought that the Jewish flowering was a response to the Revolution of 1917. For a list of the Jewish cultural organizations that opened in Petrograd in the last years of the Tsar's reign, see Bowlt (note 1), p. 47, and his essay in the present volume. Why Jewish culture was allowed such freedom in 1916 is a question that requires further research.

66 This name is occasionally given as the Society for the Encouragement of Jewish Art, which is a better description of its goals. However, the name on Altman's seal in both Russian and Hebrew is the Jewish Society for the Encouragement of Art (Bowlt, fig. 7). The use of Hebrew rather than Yiddish, and of "Hevrah Ivrit" (Hebrew Society) rather than "Hevrah Yehudit" (Jewish Society), indicates the JSEA's position in the disputes between the Hebrew-speaking Zionists and those who chose Yiddish to express their wish for Jewish autonomy in Russia (Simon Dubnov, *The History of the Jews*, rev. edn. [New York: Yoseloff, 1973], pp. 787–92).

67 See Wolitz (note 1), p. 29; Bowlt (note 1), pp. 47–50; Bowlt's essay in the present volume.

68 Thus in 1916, Chagall both took part in the JSEA's exhibition in April–May and exhibited Jewish themes at the *Jack of Diamonds* and *Modern Russian Painting* exhibitions at the end of the year (Gordon [note 11], pp. 894–95, 898), while Altman helped found the JSEA in the same month as he exhibited a formalist painting at the *0.10* show in Moscow (*ibid.*, p. 883) and took part in an exhibition of the World of Art (Vsevolod Petrov and Alexander Kamensky, *The World of Art Movement in Early 20th-Century Russia* [Leningrad: Aurora, 1991], p. 297). Lissitzky also showed with the World of Art in December 1916 and February and December 1917, as well as in the April 1917 JSEA show in Moscow (*ibid.*, pp. 297–98; Apter-Gabriel [note 25], p. 105). Moreover, Etkind ([1984] [note 17], p. 41) stated that Altman tried to become a member of the World of Art in 1916 and succeeded in 1918. He and Chagall joined the Union of Youth in 1917 and participated in the provisory committee uniting all the artists' groups after the February 1917 Revolution.

69 Bowlt (note 1), p. 48; Maxim Syrkin, "Evrei i iskusstvo," *Evreiskaya nedelya*, no. 26 (26 June 1916), p. 38; Gordon (note 11), p. 894. At the JSEA show, Altman exhibited a caricature-portrait of Sholem Aleichem (*Evreiskaya nedelya*, no. 22 [29 May 1916], p. 10), along with previously exhibited works and five items from *Jewish Graphics* termed "Ornaments to the Bible" (information courtesy of John Bowlt). These graphics may have been part of the 10 drawings for a Jewish alphabet that Etkind ([1984] [note 17], p. 217) claimed Altman did in 1916.

70 This stress on his "Jewish" nose is rare. He neutralized it in other self-portraits (e.g., see pl. 1; Etkind [1984] [note 17], p. 11; pl. 2). Efros stressed both this "Jewishness" and Altman's pride in a contemporary article on Jewish art ("Zametki ob iskusstve," *Novyi put*, nos. 48–49 [18 December 1916], pp. 61–62, trans. in Nicoletta Misler, "The Future in Search of Its Past: Nation, Ethnos, Tradition and the Avant-Garde in Russian Jewish Art Criticism," in *Tradition and Revolution* [note 1], p. 150). Etkind ([1984] [note 17], p. 37) believed that the sculptural shape on the side was inspired by the sofa in *Old Jew*.

71 Meyer (note 4), pp. 246, 253; nos. 251–52; *Tradition and Revolution* (note 1), nos. 143–44; Gordon (note 11), p. 898; Amishai-Maisels (note 3), pp. 83, 97 n. 76; Chimen Abramsky, "Yiddish Book Illustrations in Russia: 1916–1923," in *Tradition and Revolution* (note 1), pp. 61–62. The illustrations are close to his 1914–15 drawings (Meyer [note 4], pp. 220, 242, 249, 254–255, 270).

72 Meyer (note 4), pp. 246, 248; nos. 255–60; Compton (note 12), pp. 192–93; Amishai-Maisels (note 3), pp. 83–84. The folk sources of *Purim* are more apparent in the sketch, in which the figures in the background are tiny compared to the main foreground figure, as they are, for instance, in the *lubok*-like painting of David and Goliath (*Back to the Shtetl* [note 7], p. 101). The exact date and destination of these murals are open to question; Meyer (note 4), nos. 255–60, dates them 1916–18. Rachel Wischnitzer told of a project for pictures for school children in which Chagall and Lissitzky participated, seemingly in 1918 ("Jüdische Kunst in Kiew und Petrograd [1918-20]," *Der Jude* [1920–21], p. 356). Kasovsky (private communication) has found letters from Chagall confirming that he submitted both *Purim* and *Feast of the Tabernacles* to this project in December 1918.

73 Meyer (note 4), pp. 247, 250; Compton (note 12),p. 195; Amishai-Maisels (note 3), p. 84.

74 Amishai-Maisels (note 3), pp. 97–98 n. 81; Apter-Gabriel (note 25), p. 102; Lissitzky-Küppers (note 25), p. 19.

75 Kampf (note 1), p. 51. Lissitzky did not claim, as Wischnitzer later remembered (Rachel Wischnitzer, "From My Archives," *Journal of Jewish Art* 6 [1979], p. 8), that the trip had been inspired by the Jewish art exhibition in 1916, but made a derogatory statement regarding that show, stating that it was the end—not the beginning—of national Jewish art (Lissitzky [note 26], p. 9, trans. in *Tradition and Revolution* [note 1], p. 233). He also claimed that he had been to Druya ([note 26], pp. 3, 9, 12), then in Lithuania and close to the battlefront, an area it would have been impossible to visit just to document a synagogue, as can be seen by the arrest of Yudovin and Rechtman at the end of 1914

for spying (Abraham Rechtman, "The Jewish Ethnographical Expedition," in Judith C. E. Belinfante and Igor Dubov, eds., *Tracing An-sky Jewish Collections from The State Ethnographic Museum in St. Petersburg*, exh. cat. [Amsterdam, Joods Historisch Museum, 1992], p. 13). It is probable that Lissitzky went to Druya without Ryback in 1915 as part of An-sky's reflief mission to the Jews there. The mission also rescued Jewish art and artifacts (Lukin [note 36], pp. 34, 36), which would explain Lissitzky's comments on looking at books in the Druya Synagogue's attic, as well as his hesitation over the date of the trip to Mogilev (Lissitzky [note 26], p. 9; Apter-Gabriel [note 25], p. 102). It is unclear how Ryback met Lissitzky. Ryback could have become interested in Jewish art while in Kiev, as between 1912 and 1914 the An-sky expedition findings were there (Kantsedikas [note 37], p. 48 n. 22).

76 Lissitzky (note 26), pp. 5, 7–8, 11–12; *Tradition and Revolution* (note 1), nos. 17, 70 (identified by Apter-Gabriel); Wischnitzer (note 72), p. 354; Ruth Apter-Gabriel, "A Drawing Comes to Light: The Ceiling of the Mohilev Synagogue by Ryback," *Israel Museum Journal* 6 (Spring 1987), pp. 69–74. Lissitzky never explained how he made exact copies of paintings such as the zodiac lion, which were from the highest part of the dome, although his exactitude suggests that he copied photographs (see, for example, *Istoria evreev v rossii*, Istoria evreikogo naroda 11 [Moscow: Mir, 1914], pt 1. opp. p. 392; Z. Yargina, *Wooden Synagogues* ([Moscow: Image, ca. 1993], p. 21; pls. 57, 59–60). The reversal of function between Lissitzky and Ryback requires study. Given Lissitzky's constant drawing of buildings while in Darmstadt, it seems likely that Ryback's paintings are actually based on realistic depictions of these synagogues by Lissitzky.

77 Lissitzky-Küppers (note 25), p. 19; Apter-Gabriel (note 25), p. 102. Ryback's chronology is problematic. Two early works in the Ryback Art Museum, Bat Yam, give an idea of his style before the Mogilev trip. *First Meal by the River*, dated 1915, is a symbolist frieze with long, thin figures, some of which tend toward caricature; another painting, on the back of a cubist work (no. 29), depicts praying Jews in the Eastern European mode in a weak expressionist style.

78 This painting is on the back of a cubist nude (Ryback Art Museum, no. 35). The Steinhardt woodcut (Leon Kolb, *The Woodcuts of Jakob Steinhardt* [San Francisco: Genuart, 1959], nos. 10, 14) could have been bought in Germany by Lissitzky or Chagall. That German Expressionist woodcuts, including Steinhardt's, were known is shown by the cover of *Evreiskii mir* (*Literaturnye sborniki*) 1 (1918), which can be compared to Kolb, nos. 12, 21. For comparisons to Ryback's frame, see Lissitzky (note 26), pp. 7, 10, 12. Ryback may also have drawn on Jewish paper cuts (Regina Lilientalowa, *Święta Żydowskie w przeszości i Teraźniejszości* [Cracow: Nakadem Akademii Umiejętności, 1908], pl. 14), or he may have been trying for the effect Alexandra Exter achieved in her 1916 theater sketch (G.F. Kovalenko, *Aleksandra Ekster* [Moscow: Galart, 1993], p. 50).

79 *Tradition and Revolution* (note 1), nos. 122–26. One of the Jewish *lubki* Ryback collected, a *Simhat Torah* flag, appears in his *Still Life with Etrog* (1925; Jerusalem, Israel Museum). For a similar flag, see *ibid.*, no. 158. The soldiers are based on Russian *lubki* of St. George and on Haiduk depictions such as that illustrated in *Istoria evreev v rossii* (note 76), p. 89, the volume whose Mogilev and Kopys photographs (opp. p. 392, p. 394) inspired Ryback and Lissitzky to undertake their expedition (Wischnitzer [note 75], p. 8).

80 Wischnitzer identified the synagogue as that of Dubrovna (Rachel Wischnitzer-Bernstein, "Ha'amanuth ha'hadasha v'anahnu," *Rimon/Milgroim* 1 [1922], pp. 6, 17); this is also mentioned by Lissitzky ([note 26], p. 9). This painting and two others were reproduced and dated to specific months in 1917 (*ibid.*, pp. 4–5, 17). Given their very different styles and that dating to months was abnormal at the time, it is doubtful that all three were painted in the same year. Ryback may have been trying here to claim precedence over Chagall and Lissitzky. Moreover, the treatment of the Dubrovna Synagogue is very different from Ryback's 1918 renderings of it in the Pogrom series, while Lissitzky's depiction of it in 1918 at the bottom of the title page of

Yingl Tsingl Khvat seems midway between Ryback's Pogrom and the painting (*Tradition and Revolution* [note 1], no. 123; p. 180; Apter-Gabriel [note 25], p. 109). Ryback's possibly contemporary *Tombstones in a Cemetery* (Bat Yam, Ryback Art Museum) was also influenced by Chagall's *Cemetery* (see pl. 9).

81 Apter-Gabriel (note 25), pp. 107, 109. This kind of upheaval had already been present in Chagall's early experiments with cubism, e.g., in *The Dead Man* and *Flight* of 1911 (Meyer [note 4], nos. 66, 79). It was intensified by Lissitzky, who knew these Paris works, and is present in several of his graphics from 1917–18 (*Tradition and Revolution* [note 1], nos. 74 [2, 13, 15], 78, 79 [title page, 1]), including the woodcut discussed in the text. This disruptive motion can also be found in Aristarkh Lentulov's depictions of churches from at least 1913 (see G.G. Pospelow, *Karo Bube* [Dresden: VEB, 1985], pls. 100, 102). For the identification of Lissitzky's synagogue, see *Marc Chagall: The Russian Years 1906–1922*, exh. cat. (Frankfurt: Schirn Kunsthalle, 1991), p. 15. This woodcut proves that we are missing an important part of the story by not having Lissitzky's paintings of this period.

82 Abramsky (note 71), p. 61; Dubnov (note 66), p. 838. There is a marked difference between the styles of Jewish and Russian avant-garde book illustration. Even artists who worked for the avant-garde, such as Altman and Lissitzky, developed different styles for these different purposes.

83 I. Ryback and B. Aronson, "Di Vegn fun der Yidisher malerey," *Oifgang* 1 (1919), pp. 99–124, partially trans. in *Tradition and Revolution* (note 1), p. 229.

84 Altman (note 40); Bowlt (note 1), pp. 48, 53; B. Aronson, *Sovremennaya evreiskaya grafika* (Berlin: Petropolis, 1924), pp. 43, 65; see also note 71 above.

85 This scroll is sometimes called *The Legend of Prague*. See also Wolitz (note 1), p. 29; Abramsky (note 71), pp. 62–63; Apter-Gabriel (note 25), pp. 104–5. The composition of the title page, framed by two figures on architectural bases with other illustrations above and below, is very popular in Jewish book illustration (Roth [note 2], figs. 228, 235, 238), while friezes running along the top of a double-column page or through its center are also common (*ibid.*, figs. 195, 211).

86 Lissitzky (note 26); see also the sections for which there are no extant drawings in Yargina (note 76), pls. 59–60.

87 Stasov and Guenzberg (note 1), *passim*; Kantsedikas (note 37), *passim*, esp. pp. 54, 60, 72, 88–89, 115, 120. An-sky had a complete draft ready by the spring of 1917, when he visited Moscow to raise money for the book's publication. Efros had a copy of it in order to write a preface (*ibid.*, pp. 38–39), so Lissitzky could easily have seen it.

88 "Assyrian script" means square Hebrew letters (Abramsky [note 71], p. 63; Apter-Gabriel [note 25], p. 104). However, in 1915–17 both Lissitzky and Altman (Etkind [1984] [note 17], p. 148) stressed an "Assyrian" quality as suggesting Jewish art's ancient Oriental traditions in line with Stasov's theories.

89 Apter-Gabriel (note 36), p. 114; Robert Treat Paine and Alexander Soper, *The Art and Architecture of Japan* (Harmondsworth: Penguin, 1975), p. 216. The way Lissitzky sharpened the broad ends of his lines recalls both Japanese and Arabic calligraphy (*ibid.*; David Talbot Rice, *Islamic Art* [London: Thames and Hudson, 1965], figs. 46, 135, 188, 200, 204). The mixture of Near and Far Eastern art is in line with Russian ideas on the "Orient" discussed by Bowlt in this volume. Lissitzky may have used a *pinkas* page here, because the colophon states that the story is based on a *pinkas* from Prague (Apter-Gabriel [note 25], p. 104). Copying a book design also seemed to him a traditional Jewish way to create art (Lissitzky [note 26], p. 12). Since he saw his colophon design as the realization of a Jewish style, he repeated it in his logo for the JSEA exhibition in Moscow in 1917 (Bowlt [note 1], fig. 17; Apter-Gabriel [note 25], p. 105).

90 For the designs of several artists based on this motif, see Apter-Gabriel (note 36), p. 113. The source was not the *pinkas* suggested by Apter-Gabriel, but a lost Yudovin drawing, also the source for the deer on the inside front cover of his *Idisher Folks-Ornament*. The first *Had Gadya* series continues the strong, *lubok*-like colors of *Sikhes Kholin*, copies of which were

hand-colored, each in a different way (Lissitzky-Küppers [note 25], pls. 10, 16–19; *Tradition and Revolution* [note 1], p. 14).

91 This angular style had been present in his woodcut, but now penetrated his logo for the Yiddish publishing house (Apter-Gabriel [note 25], p. 108), as well as the houses at the bottom of some of the early *Had Gadya* designs (e.g., *Marc Chagall* [note 14], p. 67) and his cover to *Yingl Tsingl Khvat*, becoming more dominant in the rest of the illustrations for that book and in his *Sabbath in the Forest* of 1919 (*Tradition and Revolution* [note 1], p. 180; nos. 79, 83–84; Apter-Gabriel [note 25], pp. 109-10, 113).

92 A. Efros and Ya. Tugendkhold, *Iskusstvo Marka Shagala* (Moscow: Gelikon, 1918), opp. pp. 8, 30; Meyer (note 4), p. 133. For reproductions of Chagall's work in the Russian press, see, for example, Syrkin (note 12), pp. 43–46; Ya. Tugendkhold, "Mark Shagal," *Apollon*, no. 2 (February 1916), pp. 10-18. The appearance of his Paris works in this book proves that Chagall brought photographs of them to Russia in 1914.

93 Efros and Tugendkhold (note 92), p. 54, directly opposite Lissitzky's credit line for the logo. The change in style is especially evident when the goat in the first plate (Apter-Gabriel [note 25], pl. 16; p. 115) is compared to the tufted goat in the 1917 version (*Marc Chagall* [note 14], p. 67), which is based on tufted goats from a memorial page in An-sky's album (Kantsedikas [note 37], p. 95). The goat does not appear at all in the last plate of the earlier version (Lissitzky-Küppers [note 25], fig. 19).

94 Birnholz (note 25), pp. 27–30; Haia Friedberg, "Lissitzky's *Had Gadia'*," *Jewish Art* 12–13 (1986–87), pp. 292–303; Apter-Gabriel (note 25), pp. 111, 113–18.

95 Apter-Gabriel (note 25), pp. 118–21.

96 *Tradition and Revolution* (note 1), nos. 45–47, 50 (2), 58; Wolitz (note 1), pp. 36–37; Aronson (note 84), p. 45. Chaikov's adoption of Chagall's lack of proportions and folk quality in 1918 negated the scorn the Makhmadim artists, including Chaikov himself, felt for Chagall's primitive quality in Paris (Wolitz [note 1], p. 28). The debt to Altman's Jewish style is seen in the "tombstone" lion at the left; his cubist style influenced the light facets of the face; and the frames in the background recall his *Still Life*s (e.g., Etkind [1984] [note 17], pl. 13). Chaikov was also influenced in 1919 by Lissitzky's curvilinear forms and birds (*Tradition and Revolution* [note 1], p. 36; no. 48 [cover, 1, 3]). His ambivalent view of Judaism is seen in his drawing *Exile* of 1917 (Location unknown; see Aronson [note 84], p. 77).

97 Compare Aronson's original style (Aronson [note 84], pp. 19, 95) to his later adoption of Chagallesque features (*ibid.*, pp. 44, 57, 105).

98 This work is a variation on his painting of the shtetl with a goat in the foreground (Maxim Syrkin, "A.A. Manevich," *Evreiskaya nedelya*, no. 7 [14 February 1916], p. 48) and does not seem to depict the destruction of the ghetto as the title indicates. Whereas Manievich had been worried about pogroms since 1917 (witness his naturalistic *Rumor of a Pogrom* [1917; Ein Harod, Mishkan Le'Omanut, Museum of Art]), the present painting apparently received its name in the United States in an effort to explain the disruptive facets to a public for whom this was not a self-evident style (see *Abraham Manievich Memorial Exhibition*, exh. cat. [New York: Art Center, Congress for Jewish Culture, 1957], no. 7).

99 A. Efros, "Lampa Aladina," *Evreiskii mir (Literaturnye sborniki)* 1 (1918), pp. 297–319, trans. in Kantsedikas (note 37), pp. 7–15. This article appeared in Yiddish as "Vegn tzu der yidisher kunst," in *Kultur un Bildung*, nos. 2–3 (1920), pp. 45–52.

100 Ryback and Aronson (note 83), pp. 99–124, partially trans. in *Tradition and Revolution* (note 1), p. 229, and analyzed in Kampf (note 1), pp. 60–64; Wolitz (note 1), pp. 35–36.

101 Ryback and Aronson (note 83); Osborn's introduction to Altman (note 40), pp. 7–15; Kampf (note 1), pp. 61–62; *Tradition and Revolution* (note 1), pp. 230, 235–38.

102 Wolitz (note 1), pp. 31–36; Bowlt (note 1), pp. 53–54, 59 n. 68; Grigor Kasovsky, *Kultur-Liga Artists* (Image, forthcoming); *idem*, "Avangard, govoryashchii na idish: Sara Shor—khudozhnik kultur-ligi," *Zerkalo*, no. 104 (September 1993), pp. 22–28. The Kultur Lige was very active despite the war waging around Kiev,

which was accompanied by atrocious pogroms (Dubnov [note 66], pp. 840–44).

103 Wolitz (note 1), pp. 33, 35–36; Bowlt (note 1), p. 53; Meyer (note 4), pp. 266–72; Amishai-Maisels (note 3), pp. 84–85; Etkind (1984) (note 17), pp. 55, 57. Bowlt (note 1), pp. 53–54, stresses the later influence of Exter and Malevich in art schools with large numbers of Jewish students.

104 Bialik and Osborn (note 37), pp. 21–23, 72, 78–79, 81–82, 86, 90, 92–93, 95; pls. 8, 20, 68–69; Luba K. Gurdus, "The Forgotten Friendship: L.O. Pasternak and A.J. Stybel," Jewish Art Annual 1 (n.d.), unpag. Pasternak's involvement with this group from 1915 on replaced his bond with Tolstoy, who had died in 1910.

105 Altman planned to illustrate Efros's Russian translation of Lamentations (Evreiskii mir [note 78], p. 320), but did not do so. In the introduction to his Kultur Lige exhibition with Chagall and Shterenberg, he stated that he had little time to paint (Moscow, March–April 1922, unpag.). However, one of his Soviet stamp designs (Etkind [1984] [note 17], p. 47) utilizes the style and plant motif from his Jewish Graphics (pl. 10). Chagall did not participate in the July 1918 Exhibition of Paintings and Sculpture by Jewish Artists in Moscow, which included several Petersburg artists (e.g., Altman and Yudovin), as well as Ryback from Kiev and Lissitzky (listed without a city). Chagall also had no 1918–19 pictures in Russian shows in 1919–20 (Chagall [note 11], p. 37; Marc Chagall, "Letter to Pavel Davidovitch Ettinger 1920," in Marc Chagall [note 81], p. 74).

106 Etkind [1984] (note 17], pp. 46–48, 50, 55–56, 60–65, pls. 15–18; B. Arvatov, Natan Altman (Berlin: Petropolis, 1924), opp. p. 58.

107 Tradition and Revolution (note 1), p. 17; Apter-Gabriel (note 25), pp. 116–18. For form, composition, and color gradation, see Popova's 1918 paintings (Magdalena Dabrowski, Liubov Popova, exh. cat. [New York: Museum of Modern Art, 1991], pp. 61, 77–83); compare especially the shape in the top center of the last of these works and the lameds on Lissitzky's cover.

108 This design is intermediate between the first and final Had Gadya series. It also appears on Lissitzky's stamp for the Kiev Culture Fund (Kasovsky, [note 102]). It is weakly copied in Ryback's 1919 cover for Oifgang (Tradition and Revolution [note 1], p. 198).

109 Abramsky (note 71), p 65.

110 The Great Utopia: The Russian and Soviet Avant-Garde, 1915–1932, exh. cat. (New York: Solomon R. Guggenheim Museum, 1992), no. 204. This work is said to bear Lissitzky's signature under a relining. For comparisons to Popova and Exter, see Dabrowski (note 107), pp. 57, 77, 79; Kovalenko (note 78), pp. 29–30, 32–33; Jo-Anne Birnie Danzker et al., eds., Avant-garde & Ukraine [Munich: Villa Stuck, 1993], pp. 30–31.

111 Meyer (note 4), p. 272.

112 Dabrowski (note 107), p. 43; A.D. Sarabyanov and N. Guryanova, Neizvestnyi russkii avangard (Moscow: Sovetskii khudozhnik, 1992), p. 235. Most of the works of this series, which show clear affinities with works by Popova, remain unpublished. Works similar to Aleph-Beth bear dates between 1919 and 1921. It is most likely that they all date to Ryback's stay in Moscow in 1919–20.

113 Kampf (note 1), pp. 65–66; Meyer (note 4), pp. 305, 307; nos. 282, 297–98, 301, 307–08, 323–26; Amishai-Maisels (note 3), pp. 85, 87.

114 Chagall (note 6), pp. 142–43; Meyer (note 4), pp. 272, 277; Alexandra Shatskich (sic), "Chagall and Malevich in Vitebsk," in Marc Chagall (note 81), pp. 62–67; Chagall (note 105), pp. 73–75; Romm (note 14), pp. 39–41.

115 Avram Kampf, "Art and Stage Design: The Jewish Theatres of Moscow in the Early Twenties," in Tradition and Revolution (note 1), p. 127; Alexandra Shatskikh, "Marc Chagall and the Theatre," in Marc Chagall (note 81), pp. 76–80; idem, "Chagall e il rinnovamento del teatro ebraico," in Marc Chagall (note 14), pp. 51–52; Etkind (1984) (note 17), pp. 38, 193. For P. Shildknekht's sets, see Bakhrushin State Central Theater Museum brochure (Moscow, 1991), no. 1, and unpublished designs in that museum.

116 For major analyses of these murals, see Matthew Frost, "Marc Chagall and the Jewish State Chamber Theatre," Russian History 8, nos. 1–2 (1981), pp. 94–96; Shatskich (note 115), pp. 80–84; Avram Kampf, "Chagall in the Yiddish Theatre," in Marc Chagall (note 81), pp. 94–101; Ziva Amishai-Maisels, "Chagall's Murals for the State Jewish Chamber Theatre," in Chagall: Dreams and Drama, exh. cat. (Jerusalem: Israel Museum, 1993), pp. 21–39 (an unabridged, corrected version of the Frankfurt catalogue article). For a contemporary review, see Alexander Vetrov, "On Chagall," in Marc Chagall (note 81), p. 93.

117 Amishai-Maisels (note 116), pp. 31–34, 39; and comments added to the translations of this article in Chagall Bilder, Träume, Theater 1908–1920, exh. cat. (Vienna: Yidisches Museum der Stadt Wien, 1994), p. 55 n. 89; Marc Chagall (note 14), p. 75 n. 95; Etkind (1984) (note 17), p. 193.

118 Chagall (note 6), pp. 163–64; Abram Efros, Profili (Moscow: Federatsiya, 1930), p. 203.

119 Meyer (note 4), pp. 288, 292, 294; no. 309; Marc Chagall (note 81), pp. 102–03; nos. 141–45; Abram Efros, "The Artists of the Granovsky Theatre," in ibid., pp. 91–92; Frost (note 116), pp. 96–98; Kampf (note 115), pp. 131–32; idem (note 116), pp. 101–05; Amishai-Maisels (note 3), p. 89; Shatskikh (note 115), pp. 84, 86. There is a conflict of testimony over the set for the third play. The reference here is to Chagall's designs, which bear the inscription It's a lie.

120 Etkind (1984) (note 17), pp. 68–73; Arvatov (note 106), pp. 68ff.; Kampf (note 115), pp. 132–36; Aronson (note 84), p. 87; Konstantin Rudnitsky, Russian and Soviet Theater 1905–1932 (New York: Harry N. Abrams, 1988), pp. 72–73, 76, 80–81; Amishai-Maisels (note 3), pp. 90–91, 99–100. Both Chagall and Altman owed a debt to Exter's 1917 set designs for Salomé (Rudnitsky, pp. 31–32).

121 Max Osborn, "Marc Chagall," Zhar-ptitsa 1, no. 11 (1923), pp. 34–35. See photographs in Béatrice Picon-Vallin, Le Théâtre juif soviétique pendant les années vingt (Lausanne: Cité-Age d'Or, 1973); Shtrom, nos. 5–6 (1924), betw. pp. 88 and 89.

122 For the later development of the Yiddish theater, see Picon-Vallin (note 121). For Chagallesque sketches by Rabinovich, Falk, and Tyshler, see the Bakhrushin Museum brochure (note 115).

123 Meyer (note 4), p. 303; Kultur-Liga (Moscow, 1922), Chagall nos. 28–35. Altman's graphics here (nos. 4–6) are simply listed as "Graphics 1920–1921."

124 Abramsky (note 71), pp. 62–63; David Hofstein, Troyer (Kiev: Kultur-Liga, 1922); Amishai-Maisels (note 3), p. 100 n. 119; Meyer (note 4), nos. 307–08, 323–26; Yudovin and Malkin (note 44), pl. 28; Aronson (note 84), p. 19. Despite the Suprematist influence, Chagall's illustrations seem to have more in common with George Grosz's designs than with Suprematism (compare Hans Hess, George Grosz [New Haven: Yale University Press, 1985], figs. 70, 85).

125 Tradition and Revolution (note 1), pp. 232, 243; Lissitzky-Küppers (note 25), p. 22; Birnholz (note 25), pp. 139–44; Henryk Berlewi, "El Lissitzky in Warschau," in El Lissitzky, exh. cat. (Hannover: Kestner-Gesellschaft, 1965), pp. 61–63; Wischnitzer (note 80), pp. 4–6; Lissitzky (note 26), pp. 9–12. That he brought his Mogilev drawings to Berlin and published them in Rimon shows how much he was involved in Jewish art even after he invented his Prouns.

126 Etkind (1984) (note 17), p. 68; Meyer (note 4), pp. 313, 315, 318; Tradition and Revolution (note 1), p. 239. Aronson also published a book on Chagall there (Boris Aronson, Marc Chagall [Berlin: Razum, 1924]).

127 Marc Chagall, Mein Leben (Berlin: Cassirer, 1923); Issachar Ber Ryback, Shtetl (Berlin: Shveln, 1923). Ryback dated his drawings to 1917 to correspond to his trip to Mogilev, but Aronson, who was in close contact with him, dated them to 1922 when he reproduced them in 1924 (Aronson [note 84], pp. 61, 73, 81, 117). The Synagogue in this series is a variation on the Old Synagogue painting (see pl. 131).

128 Compare Altman's 1922 cover for Got der Fayer (Tradition and Revolution [note 1], p. 20) to his 1919 poster for the Con-

gress of the Workers and Farmers of the North (Etkind [1984] [note 17], p. 50); his 1923 cover for *Jewish Graphics* (*Tradition and Revolution* [note 1], no. 31) to his 1919 *Petrocommune* (Etkind [1984] [note 17], pl. 18); and his 1922 cover for *Kling Klang* (Aronson [note 84], p. 119) and the 1923 cover for *Oksn* attributed to Lissitzky (Abramsky [note 71], p. 66) to Lissitzky's 1919 cover for the Committee to Combat Unemployment (Lissitzky-Küppers [note 25], fig. 44). Also compare Lissitzky's play with letter sizes and shapes in his 1922 *Yingl Tsingl Khvat* cover (Apter-Gabriel [note 25], p. 122) to his 1920 sketch for the cover of *Community and Culture* (Lissitzky-Küppers [note 25], fig. 41). For Lissitzky's earlier attempt to modernize Hebrew letters, see his cover for *Kultur un Bildung*, nos. 2–3 (1920). See also Abramsky (note 71), p. 65; Apter-Gabriel (note 25), pp. 119, 124 n. 63; *Tradition and Revolution* (note 1), nos. 29, 32, 107 (with Russian letters).

[129] Apter-Gabriel (note 25), pp. 118–21; Amishai-Maisels (note 3), pp. 85, 98 n. 88. These letters can also be read as variations on two "l"s (echoing the two *lameds* he had used on the *Had Gadya* cover), set correctly or reversed as though in Hebrew. See also Lissitzky's 1922–23 cover for *White Russian Folktales* (Apter-Gabriel [note 25], p. 120), which has a variation on De Stijl works from 1917 on the back cover (Frank Elgar, *Mondrian* [London: Thames and Hudson, 1968], pp. 84–87; Allan Doig, *Theo van Doesburg* [Cambridge: Cambridge University Press, 1986], p. 67). Lissitzky began to collaborate with van Doesburg in April 1922 (Doig, pp. 134–38). Altman used an almost Bauhaus design in his 1923 memorial to Haim Cohen (Aronson [note 84], p. 107; Magdalena Droste, *Bauhaus 1919–1933* [Cologne: Benedikt Taschen, 1990], p. 105).

[130] Ilya Ehrenburg, *Shest povestei olegkikh kontsakh* (Moscow and Berlin: Gelikon, 1922); Lissitzky-Küppers (note 25), pls. 71–74. Since this book was a joint effort between artist and writer, and there are two plates for which there is no story, my analysis ignores Ehrenburg's stories to find the common denominator among the illustrations. For comparisons see *Robert Delaunay* (New York: Harry N. Abrams, 1969), pp. 67, 73; no. 68;

German Karginov, *Rodchenko* (London: Thames and Hudson, 1979), pl. 29; *El Lissitzky*, exh. cat. (Paris: Réunion des Musées Nationaux, 1991), pls. 29–30, 34; Lissitzky-Küppers (note 25), pls. 24, 27, 36, 87.

[131] Lissitzky-Küppers (note 25), pp. 55-58; pls. 230–35. Lissitzky's letters from Switzerland (*ibid.*, pp. 41–43) are in a folk style, and one of them (p. 41) could almost be a Chagall. These light sketches for Küppers's children show that Lissitzky remained tied to his Jewish background despite his involvement with international abstract art.

[132] Lissitzky's comment "One must belong on this side or on that—there is no mid-way" was made in 1928 as a revelation of 1918 (Lissitzky-Küppers [note 25], p. 325). It is usually thought to refer to his conversion to abstraction, but it is not true of his works before 1925, as he had worked on Prouns simultaneously with Jewish art and even produced abstract Jewish art. It *is* true of works done after his return to Russia; the "side" he chose was Communism, and under Stalin, he antedated his decision to the year after the Revolution.

[133] Etkind (1984) (note 17), pp. 74–80, 120–21, 140, 157, 220–23; pls. 22, 29–32; Etkind (1971) (note 17), pp. 90, 105–07.

[134] The only really new Jewish themes in Paris in the 1920s were *The Falling Angel* (a drawing is preserved in a private collection in Paris) and *Self-Portrait with Phylacteries* (Brussels, Musées Royaux des Beaux-Arts) (Meyer [note 4], nos. 369, 507). For the change in Chagall in 1930 and his trip to Palestine in 1931, see Ziva Amishai-Maisels, *Depiction and Interpretation: The Influence of the Holocaust on the Visual Arts* (Oxford: Pergamon, 1993), pp. 21–25, 182; *idem*, "Chagall et la terre sainte," in *Chagall méditerranéen*, exh. cat. (Andros: Fondation Goulandris, 1994), pp. 23–33.

[135] Ziva Amishai, "Chagall's Jerusalem Windows: Iconography and Sources," in *Studies in Art*, Scripta Hierosolymitana, vol. 24 (Jerusalem: Magnes, 1972), pp. 160–71, 181–82; pls. 28–30.

[136] *Tradition and Revolution* (note 1), pp. 239, 243; paintings in the Ryback Art Museum, Bat Yam, and Aronson Collection, Israel Museum, Jerusalem.

Alexandra Shatskikh

Jewish Artists in the Russian Avant-Garde

Thanks to the work of its avant-garde, artists all over the world looked to Russia for inspiration at the turn of the century. The movement lasted about 20 years, from the first exhibition of the Jack of Diamonds (Bubnovy valet) group in 1910 to the so-called Great Change (Stalin's forced industrialization and collectivization in agriculture in 1929). The Russian vanguard included artists of various national backgrounds. Kazimir Malevich (of Polish extraction), Vasily Kandinsky and Mikhail Larionov (Russian), Ivan Puni (Italian), Alexandra Exter and Alexander Archipenko (Ukrainian), Georgy Yakulov (Armenian), and the Jews Marc Chagall, Natan Altman, and El Lissitzky together made the reputation of Russian art.

In the case of vanguard artists of Jewish origin, one can discern distinct circumstances that justify giving them special consideration.[1] Though they were full-fledged participants in the Russian avant-garde, many Jewish artists were also immersed in issues of Jewish identity and deeply engaged in finding ways to develop a new Jewish art. The double nature of these artists was in evidence throughout the history of the Russian avant-garde. During this brief period, it is possible to distinguish several phases in their activities.

By the beginning of the 1910s, there were four centers of the Russian avant-garde, two in Russia—St. Petersburg and Moscow—and two in Europe—Paris, with its profusion of competing movements, and the more academic Munich. Though relatively close ties existed among the four cities, they also exhibited significant differences. It was in St. Petersburg rather than Moscow, for instance, that a secularized Jewish culture evolved, yet even there, the establishment of a community of new Jewish professional artists had few repercussions. Léon Bakst taught at Elizaveta Zvantseva's private school in St. Petersburg (where his students included Chagall, Alexander Romm, and Sofya Dymshits-Tolstaia), and the art schools of Mikhail Bernshtein, Yakov Goldblat, and Savely Zeidenberg trained many other artists of the avant-garde. But nothing was ever said in these schools (nor could it be) about the aims, characteristics, or concerns of Jewish art.

Among the figures in the first phase of the Russian avant-garde (the late 1900s and early 1910s), there were a number of Jewish artists in whose work Jewishness played no appreciable role. The art created by the St. Petersburg painter Iosif Shkolnik, for example, was of a piece with the formal experiments undertaken by everyone in the avant-garde.[2] Shkolnik's authority among artists in Russia's northern capital was due to his position as one of the founding members of the avant-garde artists' group Union of Youth (Soyuz molodezhi).[3] In the work of Vladimir Baranov-Rossine and Adolf Milman, too, there is no discernible trace of a Jewish consciousness.

Many in the Russian vanguard sought to go abroad to finish or continue their artistic training. For Jewish artists, a European education was frequently the only possible one, inasmuch as it was extremely difficult for residents of the Pale of Settlement to gain admission to institutions in Moscow and St. Petersburg. The overwhelming majority of the imposing corps of "Russian Parisians" came from the cities and small towns of the Pale. During this period, however, the vanguard artists saw themselves primarily as Russian artists. In their own eyes, and in the eyes of the European public, this commonality eclipsed the ethnic variety of Russia's multilingual, Euro-Asiatic empire. A series of articles written by Anatoly Lunacharsky in Paris in the first half of 1914 and published in the newspaper *Kiev Thought* (*Kievskaya mysl*) under the general heading "Young Russia in Paris" is instructive in this regard.[4] Lunacharsky's series contained essays on Chagall, David Shterenberg, Fibig, Sofya Levitskaya, Alexander Zholtkevich, and Iosif Teper. While the work of Chagall and Shterenberg is well known today, allowing us to judge for ourselves the approach of each to questions of Jewish identity, Teper's[5] case is unclear. If we are to believe Lunacharsky, Jewish culture and art were matters of some concern to Teper,[6] whereas Lunacharsky himself (and one could say the same of Yakov Tugendkhold, also living and writing in Paris at this time[7]) discerned no uniquely Jewish themes or particular Jewishness in the work of young Jewish artists in the years leading up to the First World War. Ossip Zadkine, Jacques Lipchitz, Chana Orloff, Mané-Katz, Oskar Meshchaninov, and numerous others thought of themselves as Russian artists, were members of the Académie Russe in Paris, and in the 1920s joined the Parisian Society of Russian Artists.[8] In Russia, their works were shown at exhibitions of the Jack of Diamonds and World of Art (Mir iskusstva) groups, as well as in the most radical shows (*Donkey's Tail*, *Target*, and *No. 4: Futurists, Rayonists, Primitives*). Altman, Chagall, Milman, Lev Zak, and other "Russian Parisians" played a significant role in Russian cultural life, had close ties with the vanguard painters there, and participated as Russian artists in French and international exhibitions. (Simultaneously, of course, they functioned at the very center of the Paris School, and more than a few

of them were acclaimed subsequently as modern European masters. However, in 1928, for example, at the *Exhibition of Modern French Art* in Moscow, the Russian section—organized by the artists themselves—included works by Chagall, Mikhail Kikoine, Pinchus Kremegne, Lipchitz, Mané-Katz, Chana Orloff, Issachar Ryback, Zadkine, and Zak, among some four dozen artists.[9]

This strong sense of Russian identity notwithstanding, it was in Paris, at the artists' residence La Ruche—where most of the "Russian Parisians" lived in the early 1910s—that they began to explore their Jewish identity.[10] Artists zealously seeking the roots of their art in past times and places were inevitably transformed into theorists of a new Jewish art. Heated theoretical discussions led to manifestly eclectic artworks. For example, the illustrations in the journal *Makhmadim*, published by the artists' group in Paris of the same name, were evidence of their creators' susceptibility to the influence of Jugendstil and predilection for stylization. An unprecedented stimulus to the development of a uniquely Jewish art came, paradoxically, from Chagall, a painter who disdained these late-night debates.[11] Among those who did participate, the intense discussions bore fruit for Altman, Iosif Chaikov, Shterenberg, and El Lissitzky (the latter was in Paris in 1912 and paid many visits to La Ruche to see his friend Zadkine). In the case of both Altman and Lissitzky, their interest in Jewish art was realized only

after their return to Russia. It is worth noting that Altman put his Jewish artistic experience to use in one of the shocks to conventional taste delivered by the Russian avant-garde: the decorative tailpiece of "Explodity" by Kruchenykh. Altman wrote out the vulgar word *shish* in "Hebraized" Cyrillic letters, thus creating transrational verse "in Hebrew" (fig. 1).[12]

The revolutions of February and October 1917, so it seemed initially, cleared an enormous space for the development of Jewish culture and art. In its early days, the new regime not only emancipated Russia's ethnic minorities but also granted full citizenship to all of the avant-garde artistic movements which had been denied their rights in Tsarist society. Vanguard artists received government support and themselves wielded a certain amount of power. Many of the key positions in the Fine Arts Department of the People's Commissariat for Education (Izo Narkompros) were held by Jewish artists in the avant-garde. However, it became increasingly clear that artistic opinion did not embrace the notion that national or ethnic groups had integral artistic styles.[13] There were no easy, commonly accepted answers to the questions "What is Jewish art?" and "What is modern Jewish art?" The organizers of exhibitions of Jewish art in Petrograd, Moscow, and Kiev resolved these issues by resorting to a single, inarguable criterion: the Jewishness of the artists' mothers and fathers. This was the principle according to which the large exhibitions of Jewish art held in 1916–20 were organized.[14] The works in these shows covered the entire spectrum of art, both Russian and European, of the period, including vanguard personalities who had previously made no point of their Jewishness—such as Baranov-Rossine, Nina Niss-Goldman, and Shkolniky—but who now responded sympathetically to the summons of their fellow Jewish artists.

Among the notable individuals in this period were many women. As a rule, they came from educated families living in St. Petersburg, Moscow, and the large provincial centers of the Pale: Kiev, Kharkov, Odessa, and Vitebsk. The sculptors Eleonora Blokh, Niss-Goldman (fig. 2), and Beatrisa Sandomirskaya and the painters Sofya Dymshits-Tolstaya, Polina Khentova, Nina Kogan, and Vera Shlezinger all became active in the late 1910s and early 1920s.[15] Blokh, Khentova, Niss-Goldman, Sandomirskaya, and Shlezinger participated in exhibitions of work by Jewish artists. Several of these women ultimately left Russia and settled in the West; the work of Khentova and Shlezinger, for example, was well received in the Western press. Others stayed on in the Soviet Union, and, as one would expect, their working lives were disrupted by the totalitarian

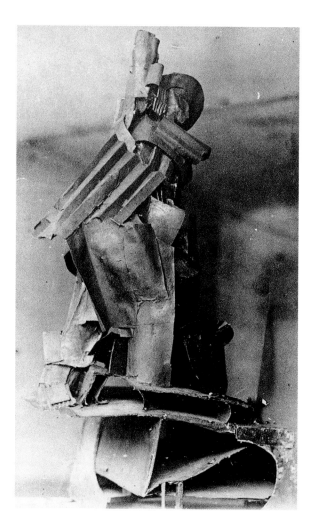

**Fig. 2
Nina Niss-Goldman
Composition, 1913/15
Papier-mâché
Destroyed**

Soviet regime. During the 1910s and 1920s, how-ever, almost all of them shared the artistic platform of the avant-garde. For example, the experimental work of Niss-Goldman, who lived in Paris between 1910 and 1915 and was associated there with Elie Nadelman and Chana Orloff, has much in common with that of Archipenko and Lipchitz. Her sculp-tures, like the works of Sandomirskaya, are marked by great power. Dymshits-Tolstaya experimented with painting on glass and collaborated with one of the giants of the Russian avant-garde, Vladimir Tat-lin, on his model for the *Monument to the Third International*, the most significant components of which were glass cubes, cones, and spheres. It was Dymshits-Tolstaya who was assigned to carry out the "elaboration of glass pieces" in this famous project, which had a powerful influence on ideas about the generation of form.

Young Jewish artists, who were both creators and theorists of the new art and who had served their apprenticeships in the various artistic van-guards, understood the barrenness of a path that ended in reproduction, imitation, and stylization. An exploratory stage led to the separating out of "purely

artistic Jewish form" and the search for a "Jewish element in art" (see pl. 7), described by Ryback as "painterly abstract sensations, revealed via the spe-cific material of perception."[16] The members of the Kultur Lige in Kiev, who were active proponents of the new Jewish art (and who included Boris Aron-son, Chaikov, Lissitzky, and Ryback), considered nonobjective art—outside subject matter and be-yond representation—as the most appropriate mir-ror of the Jewish way of thinking, taking their cue from the Second Commandment. Nonobjectivity (or geometric abstraction) was, of course, the most radical current in the Russian avant-garde, and Malevich was that current's most representative fig-ure. His Suprematist system divorced painting entirely from concrete images of the external world and sought to construct a new reality. Among Jew-ish artists, the messianism of the Russian avant-garde—exemplified by the Futurists, Malevich, Tat-lin, and the Constructivists—struck a deep chord.

The Russian vanguard's messianic ideas were inevitably linked with its wish to bring its discover-ies to all humanity, regardless of social and national differences. Avant-garde artists began to plan a uto-pian "new world," believing it possible to make peo-ple happy by merging art and life, by constructing reality according to the laws of aesthetic harmony. Many artists were initially inspired by their experi-ences designing decorations for Russian cities and villages on the first anniversary of the October Rev-olution; to them it seemed no more difficult to make objective facts into a "correct" and "just" reality than it had been to transform vast urban spaces into the-ater sets. In Petrograd, Altman turned Uritsky Square into an enormous stage for an exultant throng of people; his nonobjective, Suprematist-style decora-tions stood in jarring contrast to the baroque and classical buildings of the most imposing square of the former Russian Empire (Goodman, fig. 4). In Vitebsk, Chagall designed decorative panels for facades and roofs; the city's residents long remem-bered his unusual "flying Jews" and "green horses." Throughout the country, Jewish artists and sculptors were active in the creation of monuments under the aegis of Lenin's Plan for Monumental Propaganda; among them were Mikhail Blokh, Niss-Goldman, Isaak Mendelevich, Efim Ravdel, Sandomirskaya, Viktor Sinaisky, Solomon Strazh, and David Yaker-son. Not to mention the ubiquitous Altman, cre-ator of numerous reliefs and, by this time, one of the founders of artistic Leniniana, depictions of Lenin made during his lifetime which subse-quently became the basis for assembly-line-produced statues and busts and countless other compositions.

Fig. 3
El Lissitzky
Illustration
From Ilya Ehrenburg, *Six Tales with Easy Endings* (Moscow and Berlin: Gelikon, 1922)
Sackner Archive of Concrete and Visual Poetry, Miami

In the years following the Revolution, the avant-garde thought in terms of universal categories to which national or ethnic boundaries could only be compared as impediments. Logical, consistent, and strict adherence to the conceptions of nonobjective art led inevitably to the complete disappearance of traditional ethnic attributes of art, for the "pure" space and time that vanguard artists sought to harness could not easily be labeled as the property of any one ethnic or national group. The brothers Neemia and Natan Pevzner, renowned later as Naum Gabo and Noton Pevsner, were among the most uncompromising artists in the Russian vanguard. "Space and time were born for us today," they declared in their famous "Realistic Manifesto," written for a one-day exhibition in Moscow in August 1920. "Space and time are the sole forms from which life is constructed and, consequently, from which art should be constructed . . . The single aim of our artistic work is to realize our perceptions in the forms of space and time" (see ill. 29).[17]

Lissitzky's career is almost a textbook case of the influence of the new ideas about art and society. An ardent champion of Jewish art, an energetic member of the Kultur Lige, and the author of splendid books inspired by Jewish literary culture and avant-garde in spirit, Lazar Lisitsky (as he was born in Russia) was transformed into the internationalist El Lissitzky. With unusual fervor, he devoted himself to the elab-

oration and extension of Malevich's Suprematist ideas in Vitebsk, the city immortalized by Chagall.

Lissitzky played a unique role in the Russian avant-garde as the synthesizer of two apparently irreconcilable movements, Suprematism and Constructivism. Looking for ways to translate Suprematism from the planar surface to three dimensions, in 1919–20 he created his first Prouns (a term derived from the phrase "proekt utverzhdeniya novogo" [project for the affirmation of the new]; see ill. 70). The Prouns are the work of an architect who had seen in Suprematism the possibilities for a "grand style," a unique "Suprematist order."

Lissitzky's multiple talents made it natural for him to maintain contacts with artists with a variety of experimental tendencies and to exploit, as needed, the devices and means of different formal systems, paying no heed to the demarcations among them. His heedlessness was precisely what accounted for his unique integrating abilities. Lissitzky was even able to synthesize convincingly the artistic devices of Chagall and Malevich—two irreconcilable antagonists. His illustrations to Ilya Ehrenburg's *Six Tales with Easy Endings* (fig. 3)—including a paradoxical composite of "naive" drawings and Lissitzky's designs for *A Suprematist Tale about Two Squares*—are an obvious example.[18]

Lissitzky's synthetic approach, while appropriate to his time, was unusual; it was more characteristic of the era for artists to adhere to a single artistic system. Synthesizers were reproached by critics, theorists, and other artists for being omnivorous "stylizers" and "eclectics" who used alien elements in their work without rhyme or reason. Among the members of the avant-garde, Chagall's "chemistry" and Altman's complex, multifaceted production also had a synthetic quality. It was difficult to avoid the conclusion that therein lay an elusive, yet powerful attribute of Jewish thinking: the ability to fuse or unite diametrically opposed conceptions and artistic ideas into a convincing, enriching whole. Chaikov, Robert Falk, and Shterenberg also possessed this integrating ability in varying degrees, and it was the feature that many critics who followed trends in Jewish art discerned as fundamental in their work.[19]

All of the stages of Lissitzky's career were repeated, just a few years later, in those of a pleiad of artists whose initial allegiance had been to Jewish art. Ilya Chashnik, Lazar Khidekel, Iosif Meerzon, Tevel Shapiro, and Lev Yudin—Tatlin's future assistants in the planning of the *Monument to the Third International*[20]—began as grateful students of the Vitebsk patriarch Yehuda Pen (fig. 4). Most of them studied at the Vitebsk Popular Art Institute, which Chagall had created in 1918; their faith in figurative

Fig. 4
***Tatlin's Assistants in the Planning of the* Monument to the Third International (Former Pupils of Yehuda Pen), 1920**
(From left) Iosif Meerzon, Tevel Shapiro, Vladimir Tatlin, Sofya Dymshits-Tolstaya
Photograph
Private Collection

Fig. 4
***Tatlin's Assistants in the Planning of the* Monument to the Third International (Former Pupils of Yehuda Pen), 1920**
(From left) Iosif Meerzon, Tevel Shapiro, Vladimir Tatlin, Sofya Dymshits-Tolstaya
Photograph
Private Collection

art was unshaken until Malevich arrived in Vitebsk at Lissitzky's urging in November 1919. It was only a matter of weeks before he caused a complete turnabout in the minds and hearts of the young realist painters.[21] Abandoning figurative art (which, with its images from life, necessarily bore the imprint of particular national or ethnic modes of existence), they began to study (in Malevich's formulation) the "new systems in art," from Cubism to Suprematism. In 1920, the former students of Pen and Chagall organized the group known as Unovis with Malevich as their leader and theorist (fig. 5). The "denationalization" of art in Vitebsk did not, however, proceed without hindrance, for Malevich, who until now had said nothing about national issues, felt obliged to state in his manifesto "Affirmation of the New World" that

> self-determination regenerates the nation, which leads to the fracturing of our unified meaning, engendering a homeland, patriotism, and a fatherland, which all intelligent members of the nation must reject in the name of the supremacy of the oneness of humanity . . . every day must lead to the loss of all national distinctions, enriching the ranks of universal oneness . . . With this Affirmation of the New World I declare myself disengaged from nations and religious creeds; I belong to no nation and consider no language native; I follow the path of the supremacy of the unity of peoples in the spirit of dynamism and the language of the future.[22]

Fig. 5
***Malevich (center) and Members of Unovis En Route from Vitebsk to the First All-Russian Conference of Teachers and Students of Art in Moscow*, 1920**
Lissitzky, Kagan, Ermolaeva, Chashnik, Khidekel, Yudin, and Magaril are among those pictured
Photograph
Private Collection

The members of Unovis were intent not only on a revolution in painting but also on the transformation of theater, typography, architecture, and even political propaganda (they created numerous agitprop posters). And like their mentor, Malevich, they theorized. In the autumn of 1920, Chashnik and Khidekel—the most active of the group's members—issued the miscellany *Aero*, which contained projects and articles about the new art. Khidekel was the creator of numerous Suprematist paintings,

drawings, and projects (see ill. 48) and the author of many articles and theoretical investigations; subsequently, he turned all his energies to architecture. Chashnik, one of Malevich's most gifted followers, produced Suprematist paintings and reliefs that constituted unique models, projects, or laboratory tests for fantastic constructions anticipating the space age (see pl. 12). The ability to synthesize, in Chashnik's case, allowed him to combine the principles of Tatlin's counter-reliefs with the metaphysical revelations of Malevich's Suprematist paintings.

Many gifted women were members of the Unovis group. Vera Ermolaeva and Nina Kogan headed workshops at the Vitebsk school, and Fanya Byalostotskaya, Emma Gurovich, Elena Kabishcher-Yakerson, Anna Kagan, Evgeniya Magaril, and Tsiviya Rozengolts were among the students.[23] Although the fates of Ermolaeva and Kogan, both St. Petersburg natives, were different from those of their students, who came from Jewish families living in the Pale, at the Vitebsk school almost all were enthusiastic proponents of the new systems in art—even the 50-year-old Rozengolts made successful Cubo-Futurist paintings. In Vitebsk, Kogan staged one of the world's first performance pieces, which she called a "Suprematist ballet."[24] Malevich praised the power and mastery of Gurovich's drawings,[25] and students recalled his special regard for Kagan, whose works he placed next to his own in the Museum of Contemporary Art located at the Vitebsk Practical Art Institute (the school changed its

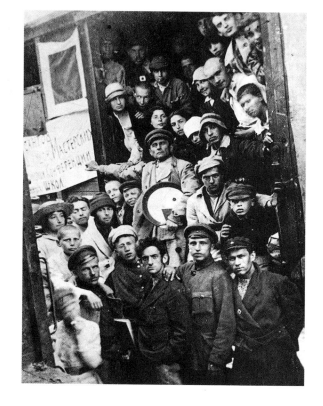

name in 1921) (see ill. 42).[26] Kagan's Suprematist compositions are notable for their unusual treatment of space; in contrast to the works of Chashnik, Khidekel, or Nikolai Suetin, with their "bottomless" black or red backgrounds, Kagan's pictures display a careful attention to the surface of the canvas, and she was a subtle and lively colorist. After Vitebsk, she worked under Malevich at the State Institute of Artistic Culture in Petrograd. In her work as an artist at the Leningrad State Porcelain Factory, she introduced new qualities into her geometric abstraction. Kagan's paintings and porcelain designs are a synthesis of Malevich's Suprematist lessons and elegant European Art Deco.

Vitebsk and its artistic life might also serve as a model for the final stage of the Russian avant-garde, when the formal and analytical movement was, in its turn, renounced. A number of Malevich's students, having mastered the new systems in art, were not satisfied with severe, imageless, speculative abstract production. They much preferred the example of the Cézannist Robert Falk, with his reverence for nature (see ill. 28).[27] Students who had once abandoned Pen and Chagall for Malevich now left Unovis and accompanied Falk to Moscow, to study with him at the Higher Artistic and Technical Studios (Vkhutemas); they included Roman Beskin, Mikhail Kunin, Dmitry Morachev, Efroim Volkhonsky, and Lev Zevin. The return to figurative art did not, however, mean the revival of earlier Jewish interests. Although

all of these young artists had been born in the Pale and had studied with Pen, investigations of Jewish identity did not concern them. Such issues had been influenced decisively by the belief, nurtured by the avant-garde since the Revolution, that what was international was advanced, progressive, and innovative and what was national was backward, antiquated, and obsolete.

The evolution of the generation of artists born in or around 1900 is an accurate mirror of the final period of vanguard art. The young artists trained at the Artistic and Technical Studios considered themselves disciples of such pillars of the Russian avant-garde as Exter, Malevich, Rodchenko, Tatlin, and Nadezhda Udaltsova. The Studios were an educational institution teeming with all possible artistic groupings. The Projectionists, a group formed in 1922, were among the most striking. After the October Revolution, the painter Solomon Nikritin, the group's theorist and organizer, studied in Exter's Kiev studio, where Isaak Rabinovich, Kliment Redko, Nisson Shifrin, and Alexander Tyshler also worked. After their move to Moscow and enrollment at the Studios, the Kiev friends—Nikritin, Redko, and Tyshler—organized the Projectionists with Alexander Labas, Sergei Luchishkin, Mikhail Plaksin, Nikolai Tryaskin, and Petr Vilyams. The group met at the Museum of Painterly Culture, one of Moscow's centers for the analytical study of art; Nikritin was chairman of the Research Division at the museum, of whose Art Council Labas, Tyshler, and Vilyams were members. In December 1922, the Museum of Painterly Culture was the site of the Projectionists' first exhibition, which profoundly impressed no less a critic than Tugendkhold, who saw a promising beginning in the young artists' investigations of color.[28] The formal and analytical character of their canvases showed these recent graduates of the Studios to be worthy inheritors of their renowned teachers.

The Projectionists, nurtured by the avant-garde, offered their own variant of the new art at the *First Discussional Exhibition of Associations of Active Revolutionary Art* in Moscow in May 1924.[29] In addition to the collective entries of eight competing artists' groups, this exhibition featured a number of works by Chaikov, exhibiting on his own. An older artist and a teacher at the Studios, Chaikov sympathized with the young artists; the works he showed illuminated the profound changes that had occurred in the artistic vision of this former Kiev resident and Kultur Lige member. Chaikov's development was in some respects similar to, and in other respects different from, that of his colleague Lissitzky. Once an ardent supporter of Jewish renewal (fig. 6), Chaikov

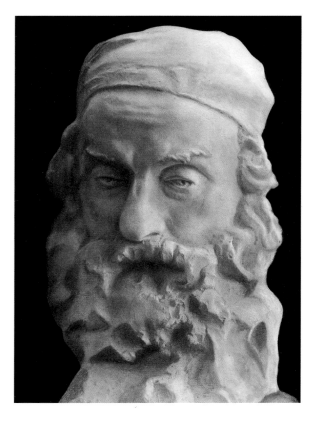

Fig. 6
Iosif Chaikov
Head of an Old Jew, 1913
Plaster, h: 13³/₄ in. (35 cm)
Private Collection, Moscow

became an equally ardent champion of a nationless "new world" and made expressive, vaguely Constructivist sculptures, which he showed at the *First Discussional Exhibition* (fig. 7; see pl. 13). In his way, Chaikov was a logical and consistent artist, for, having at one time fully subscribed to the new artistic thinking, he met the growing aggression of official Communist ideology by developing in the direction it demanded, accepting without reservation the idea that the Soviet state genuinely incarnated the "new world."

**Fig. 7
Iosif Chaikov
Bridge Constructor, 1921
Wood and papier-mâché
Destroyed**

The Projectionists took their name from theories elaborated by Nikritin, who was also the author of the Projectionist declaration that appeared in the exhibition catalogue.[30] The group maintained that the artist should produce not things but "projections" (that is, plans, models, and ideas); using such a "projection" as a prototype, anyone could then produce a finished artwork. As students, the Projectionists had organized unusual theatrical spectacles (it should be noted that since the era of World of Art, the theater had been the focal point for those interested in the notion of a *Gesamtkunstwerk*). The performances of the Projectionist Theater, directed by Nikritin, combined a peculiar kinetic art, *zaum* poetry, pantomime, and the "concrete" music of iso-

lated sounds and onomatopoeia. As was to be expected, Communist Party and proletarian critics took a strongly negative view of them.[31]

The works shown by the Projectionists in the *First Discussional Exhibition* force us to acknowledge them as precursors of a number of artistic trends of the latter half of the century. Nikritin, for instance, exhibited charts, blueprints, tables, and explanatory texts presenting Projectionism as both a method and an object of representation. Alongside these, he also exhibited a naturalistically painted portrait with a notice saying "I am exhibiting this as a demonstration of my professional skill, which I reject because I consider it socially reactionary."[32] The painter, according to Nikritin's theories, had to cede to the Projectionist. It requires little effort to substitute "concept" for "projection," "Conceptualist" for "Projectionist."

Projectionism was the contribution Nikritin and his friends made to the movement in order to introduce, as the slogan put it, "art into life." Unlike the productivists and Constructivists, however, who wanted to fashion a physical environment for the "new man," the Projectionists chose the spiritual realm, maintaining that the creative abilities of every individual had to be awakened first. Even Nikritin's later work was inspired by the desire to restore the artist's role in society as philosopher and prophet. Possessing an irrepressible artistic energy and immersed in existential dilemmas, Nikritin painted canvases at glaring odds with the ever-solider totalitarian regime. The naked emotion of his series of screaming women (see pl. 20), the somber, Kafkaesque atmosphere of *People's Court* (Moscow, State Tretyakov Gallery), and the metaphysical pathos of *The Old and the New* (Nukus, Uzbekistan, State Museum of Arts of Caracalpukskoi Autonomic Republic) are such that one can only agree (except for the word "class") with the verdict of one of Nikritin's persecutors: "It is a class attack, inimical to . . . Soviet power."[33] Nikritin was lucky that the merciless inquisitions he endured at the hands of officials did not result in the usual sentence; only his name vanished for many decades from the history of Soviet art.

The Projectionist artists, with the exception of Nikritin, formed the nucleus of a new group, the Society of Easel Painters (OST), which held its first exhibition in April 1925. In the early years of the Soviet Union, rejection of easel pictures had been a by-product of the Productivist and Constructivist renunciation of painting as such. Now, among the members of the Society, the easel painting found new adherents. In the hierarchy of artistic forms, these young artists considered the easel painting to

be the "queen of art," the quintessence of art's comprehension and reformation of the world. To some degree, the figurative paintings of the Society's artists represented a reaction against the impersonal, anti-psychological, dehumanizing side of the radical avant-garde. Yet, the uncompromising stance of the new easel painters was just as radical: to these students trained in nonobjectivity, the image—created by traditional means—was the highest form of art. Everywhere in Europe in the 1920s there was a return to a realistic, figurative art, and the Society's artists were part of this general trend (modified, of course, by the particular features of Soviet social life).

David Shterenberg, the former head of the Fine Arts Department of the People's Commissariat for Education , was elected president of the Society of Easel Painters. He had always been a supporter of easel painting, considering it a bulwark of cultural values and professional skill. Shterenberg's purist still lifes and compositions joined the lessons of his years in France with techniques tracing their origins to the most radical innovations of the Russian avant-garde. His focus on the physical qualities of painted texture was evidence of attention to Tatlin's "culture of materials," while the purity and vacantness of large colored areas of his canvases recalled the geometrical severity of Suprematism. His work, which manifests all of the traditional virtues of easel painting, was rightfully a banner for the Society (see ill. 113).

Among the Society's members, Labas and Tyshler were painters of the first magnitude. Schooled in the formal and analytical techniques of the avant-garde, both artists returned to figurative painting capable of expressing diverse and complex ideas rooted in numerous spheres of human culture. In his canvases, Labas poeticized the new urban, technological way of life and was not afraid to make symbolic and metaphysical generalizations (see pl. 23). From the avant-garde he inherited a bias toward novelty as an inarguably positive, progressive phenomenon, and his delight in the age of air travel

recalls the enthusiasm of the Russian and Italian Futurists for technology and the machine. Strictly painterly aims—the incarnation of movement and of rhythm, the reproduction of the enormous panorama that opens out during the flight of man-made birds—shaped Labas's individual manner. The elegance, lightness, and sketchiness of his lines and the "good taste" of his color combinations bespeak his allegiance to the French tradition, which assigned a high value to colorism.

Tyshler occupied a unique place in the Society, as well as in all of Soviet art. Exhibiting with the Projectionists in the *First Discussional Exhibition*, he showed both analytical compositions (such as *Color—Formal Construction of the Color Red* [Moscow, State Tretyakov Gallery] and *Color—Dynamic Tension in Space* [Moscow, Private Collection]) and paintings of a different cast, whose enigmatic character, emotionality, fantasy, and expressiveness foretold his future work. While Tyshler was a member of the Society, his talent bloomed freely and profusely. As a mythologizer, he can be compared only with Chagall, an artist whom he idolized. (It was Tyshler who, at no small danger to himself, saved Chagall's murals for the State Jewish Theater. When the theater was closed in 1950, Tyshler personally delivered the murals to the State Tretyakov Gallery.) Tyshler's production, like Chagall's, grew out of his impressions as a young boy, son of a modest Jewish craftsman living in the Pale of Settlement. A visionary and fantasist, Tyshler was able to combine irrational, intuitive, and constructive principles in his magical paintings (see ill. 121); in his canvases, drawings, and lithographs, wisdom and childish naiveté, light humor and tragedy, and sly irony and sorrow are fully and happily conjoined. To a significant degree, it was Tyshler's Jewishness that led to his becoming the most persecuted member of the Society of Easel Painters (although others did not escape unscathed).

As the 1920s progressed, politics and art became intertwined more often, and more closely. As inheritors of the avant-garde who only obeyed artistic laws, the members of the Society became a convenient target, accused of opposition to the Revolution and the dictatorship of the proletariat. Officially, the group existed until 1932, yet it held no exhibitions after 1928; in January 1931, internal conflicts caused the group to split. Some artists who saw their calling as promoters and transmitters of Communist Party ideology left to form the Brigade of Artists (Izobrigada).[34] Brigade members denounced the "formalist deviations" of their former friends and comrades from the Society of Easel Painters more zealously than did the Society's longtime enemies among the realists.[35] Shterenberg, Labas, and Tysh-

Artist Unknown
Performance of *King Lear*,
Goset, Moscow, 1935
Private Collection, Moscow

ler remained in the Society (and were among the group's new leaders) along with 25 other artists. One of the new members was Lev Zevin, a Vitebsk native counted by all his teachers—Pen, Chagall, Malevich, and Falk—as among their best pupils.[36]

Only the staunchest Jewish members of the avant-garde managed to survive the "Egyptian captivity" of Socialist Realism, the official artistic style of Soviet totalitarianism. One would like to think that for Falk, Nikritin, and Tyshler—whose individuality could not be crushed by the state—existence was somehow made easier by the Jewish people's history of survival and covert opposition, their ability to preserve their integrity in seemingly hopeless circumstances. The artistic legacy of the Soviet era is now described simplistically and schematically as the "great utopia" of totalitarian art—making all the more valuable the "other art," an art of resistance created by artists who under a totalitarian regime betrayed neither themselves nor their destiny.

Alexandra Shatskikh

is a research fellow at the Russian Institute of Art Studies, Moscow.

Notes

[1] In June 1987, the Israel Museum in Jerusalem devoted an exhibition, curated by Ruth Apter-Gabriel, to the contribution of Jewish artists to Russian art. See Ruth Apter-Gabriel, ed., *Tradition and Revolution: The Jewish Renaissance in Russian Avant-Garde Art, 1912–1928* (Jerusalem: Israel Museum, 1987).

[2] Iosif Solomonovich Shkolnik (1883–1926) was a painter, graphic artist, stage designer, and arts administrator. He studied at the Odessa Art Institute and at the Higher Art School of the St. Petersburg Academy of Arts. In 1908 Shkolnik joined the Triangle group created by Nikolai Kulbin, an advocate of new trends in art. In late 1909, a number of the more active members of the group, including Shkolnik, left Triangle and, in February 1910, formed the Union of Youth group. Shkolnik was this group's secretary, the editor of a series of publications, and the author of articles in two Union of Youth miscellanies (both published in St. Petersburg in 1912). Among his best-known works was his stage design (in collaboration with Pavel Filonov and Olga Rozanova) for the tragedy *Vladimir Mayakovsky*, performed in St. Petersburg in December 1913, in "the world's first Futurist theater." In 1917 Shkolnik played a major role in the organization of the Union of Art Workers in Petrograd. In 1918 he became a member of the Fine Arts Department of the People's Commissariat for Education and headed the stage design section; in 1920, the section was transformed into the Institute of Decorative Art, and Shkolnik became its director. From 1919, he taught a design class at the State Free Art Workshops in Petrograd. A leading figure in the St. Petersburg avant-garde, his work is represented in the collections of the State Russian Museum, St. Petersburg, and State Tretyakov Gallery, Moscow.

[3] Union of Youth (1910, 1917) was a vanguard artists' group in St. Petersburg whose members included David and Vladimir Burlyuk, Filonov, Malevich, Rozanova, Shkolnik, Tatlin, and others. Three issues of a miscellany bearing the group's name were published during 1912–13. The group's exhibitions represented the full range of vanguard trends.

[4] The "Young Russia in Paris" series appeared on 6 February (no. 37), 14 March (no. 73), 10 April (no. 98), 7 May (no. 124), 15 June (no. 165), and 6 July (no. 183).

[5] During the 1910s, Iosif Naumovich Teper (1886–after 1921) lived in Paris, participating in the artistic life of the Russian community. He traveled to Palestine. After the Revolution, he settled in Moscow, where he was active in the Moscow branch of the Jewish Society for the Encouragement of the Arts. He showed his work at exhibitions of Jewish artists and worked for the People's Commissariat for Education.

[6] In his article, Lunacharsky noted that Teper "spent a period of time in Palestine" and also described several works completed there, including "a landscape made near Jerusalem." See A.V. Lunacharsky, "Teper," in *Ob iskusstve* (Moscow: Iskusstvo, 1982), vol. 2, pp. 39–42.

[7] See Nicoletta Misler, "The Future in Search of Its Past: Nation, Ethnos, Tradition and the Avant-Garde in Russian Jewish Art Criticism," in *Tradition and Revolution* (note 1), pp. 150–52.

[8] On the Académie Russe in Paris and its members, see A. Shatskikh, "Russkaya akademiya v Parizhe," *Sovetskoe iskusstvoznanie* 21 (1986), pp. 352–65; *idem*, "Masterskie Russkoi akademy v Parizhe," *Iskusstvo* 7 (1989), pp. 61–69.

[9] In both the exhibition and the catalogue, the artists used the Russian forms of their names. See *Sovremennoe frantsuzskoe iskusstvo. Katalog vystavki*, exh. cat. (Moscow: Gosudarstvennyi muzei novogo zapadnogo iskusstva, 1928).

[10] On the "Russian Parisians" at La Ruche, see Jacques Chapiro, *La Ruche* (Paris: Flammarion, 1960), p. 77.

[11] On Chagall's position, see Jerzy Malinowski, *Grupa "Jung Idysz" i zydowskie srodowisko "Nowej sztuki" w Polsce, 1918–1923* (Warsaw: Polska Akademia Nauk, 1987), p. 67.

[12] A. Kruchenykh, *Vzorval* (St. Petersburg: EUY, 1913). Altman's illustration appeared in the second, expanded edition of the book.

[13] In January 1918 in Petrograd, the All-Russian Fine Arts Department was created under the aegis of the People's Commissariat for Education. David Shterenberg became head of the department; Altman, Vladimir Baranov-Rossine, and Shkolnik were among the members of its art board. Tatlin headed the Moscow branch of the department, and in 1918–19 the Moscow art board included Sofya Dymshits-Tolstaya, Robert Falk, and others.

[14] The first such exhibition was held in April 1916 in Petrograd. It was organized by the Jewish Society for the Encouragement of the Arts, which had also mounted two Moscow shows entitled *Exhibition of Paintings and Sculpture by Jewish Artists* in Moscow (the first in April 1917, the second in July–August 1918). In Kiev the Kultur Lige sponsored a single exhibition, in February–April 1920. The final such show was of work by Altman, Chagall, and Shterenberg and was organized by the Moscow branch of the Kultur Lige in March–April 1922.

[15] Eleonora Abramovna Blokh (1881–1943) was a sculptor who studied at the school of the St. Petersburg Society for the Encouragement of the Arts and at the Paris studio of O. Rodin (1898–1905). She later lived and worked in the Ukraine and was a professor at the Kharkov Art Institute. Nina Ilinichna Niss-Goldman (1893–1989), also a sculptor, was trained in a private studio in Kiev and from 1911 to 1915 lived in Paris, where she studied sculpture at the Académie Russe. Niss-Goldman returned to Russia in 1915. In Rostov-on-Don, she participated in projects executed under the Plan for Monumental Propaganda. From 1925 to 1930, she taught at Vkhutemas/Vkhutein. She was a member of the Society of Russian Sculptors from 1926 to 1931. Another sculptor, Beatrisa Yurevna Sandomirskaya (1897–1974), also studied at the school of the Society for the Encouragement of the Arts and, briefly, at the Free Art Studios in Moscow. She worked on many projects under the Plan for Monumental Propaganda and from 1926 to 1931 was a member of the Society of Russian Sculptors. For more about her, see I. E. Svetlov, *Beatrisa Sandomirskaya* (Moscow: Sovetskii khudozhnik, 1971). Polina (Pola) A. Khentova (?–1933), a painter and book designer, received her first art lessons from Yehuda Pen in Vitebsk, her hometown. Having graduated from the Brussels

Academy, she returned to Russia on the eve of the First World War and exhibited there with World of Art (Petrograd, 1917) and the Society of Moscow Artists (Moscow, 1918), as well as in the *Exhibition of Paintings and Sculpture by Jewish Artists* (Moscow, 1918). Khentova lived and exhibited in Berlin, Paris, and London. The graphic artist and illustrator Nina Osipovna Kogan (1889–1942) was born in St. Petersburg. From 1911 to 1913, she studied at the Moscow Institute of Painting, Sculpture, and Architecture, and from 1919 to 1922, she taught at the Vitebsk Popular Art Institute. Kogan was a member of Unovis. In 1922 she moved to Moscow, where she worked at the Museum of Painterly Culture; in the mid-1920s, she moved to Leningrad. Finally, Vera N. Shlezinger (Roklina) (1896–1934) was a painter who participated in a number of Moscow exhibitions in 1918–19. In the early 1920s, she moved to France, and from 1922 she exhibited frequently there.

16 B. Aronson and I. Ryback, "Put evreiskoi zhivopisi," quoted in G.I. Kazovsky, "Evreiskoe iskusstvo v Rossii, 1900–1948: Etapy istorii," *Sovetskoe iskusstvoznanie* 27 (1991), p. 247.

17 The "Realistic Manifesto," which expressed opposition to Cubism and Futurism, was prepared for the one-day *Exhibition of the Painting of Natan Pevsner, the Sculpture of N. Gabo, and the School of Pevsner: Gustav Klutsis,* held on Tverskoy Boulevard in Moscow on 15 August 1920.

18 Ilya Erenburg, *6 povestei o legkikh kontsakh* (Moscow and Berlin: Gelikon, 1922).

19 In the late 1910s, in works on both individual artists and general problems of the ethnicity of art, Abram Efros, Maxim Syrkin, and Yakov Tugendkhold devoted much attention to this issue. See Misler (note 7), pp. 148–50.

20 Iosif Alexandrovich Meerzon (1900–1941), born in Vitebsk, studied with Yehuda Pen and, later, at the Moscow Institute of Painting, Sculpture, and Architecture. After the Revolution, he worked under Chagall, designing holiday decorations for Vitebsk. In 1919, he studied with Malevich at the Second State Free Art Studios in Moscow. During 1919–21, he assisted Tatlin in his work on the *Monument to the Third International.* In 1927, Meerzon graduated from the architecture department of the Higher Artistic and Technical Institute of the Leningrad Academy, where he taught during the 1930s. Meerzon was killed in action during the Second World War. Tevel Markovich Shapiro (1898–1983) also studied with Pen and at the Moscow Institute. In 1919, he studied with Malevich at the Second State Free Art Studios. Like Meerzon, he assisted Tatlin on the *Monument to the Third International* during 1919–21.

21 On Malevich's invitation to, and arrival in, Vitebsk, see A. Shatskikh, "Malevich v Vitebske," *Iskusstvo* 11 (1988), pp. 38–43.

22 K. Malevich, "UNOM I [Utverzhdenie novogo mira]," *Almanakh Unovis No. 1* (Vitebsk, 1920), fund 76/9, p. 10, V, Manuscript Division, State Tretyakov Gallery, Moscow.

23 Fanya Yakovlevna Byalostotskaya (1904–1980) was an architect who studied at Vitebsk. Emma Ilinichna Gurovich (1899–1980) was a graphic and applied artist who later studied at the Higher Artistic and Technical Institute of the Petrograd Academy and at the Higher Artistic and Technical Institute (Vkhutein) in Moscow. She worked as a textile artist. Elena Arkadevna Kabishcher-Yakerson (1903–1990) studied in Robert Falk's workshop at the Higher Artistic and Technical Studios (Vkhutemas). After Vitebsk, Evgeniya Markovna Magaril (1902–1987) studied with Mikhail Matyushin at the Petrograd Academy. Finally, Tsiviya (Klara) Abramovna Rozengolts (1870–1961) was a teacher and follower of Malevich who created a number of Cubo-Futurist works now in a private collection in Moscow. She was the stepmother of Arkady Rozengolts, a prominent social and Party activist in the USSR who was sent to a prison camp in 1938.

24 The scenario and stage design for this "ballet" appeared in *Almanakh Unovis No. 1.* The first and only staging was in Vitebsk, on 6 February 1920, following a performance of *Victory over the Sun.* Both productions were prepared by teachers and students at the Vitebsk Popular Art Institute (including Ermolaeva, Kogan, Malevich, L. Tsiperson, and L. Zuperman).

25 Malevich's reactions to Gurovich's work were noted by Lev Yudin in his diary (Manuscript Division, State Saltykov-Shchedrin Public Library, St. Petersburg, fund 1000; Manuscript Division, State Russian Museum, St. Petersburg).

26 Malevich's high opinion of Kagan's work was related to me by the architect Moisei Lerman (1905–1993), who had been a student at the Vitebsk Popular Art Institute, and by the artist Konstantin Rozhdestvensky (b. 1906), formerly Malevich's student and assistant, as well as Kagan's colleague at the State Institute of Artistic Culture.

27 Falk came to Vitebsk for the first time in 1921, to visit the parents of his wife and pupil, the artist Raisa Idelson (who had been born there). He was offered a studio at the Vitebsk Practical Art Institute. Despite the divergence of their artistic views, Falk and Malevich found a common language, and Malevich did not object when many of his pupils chose to study with Falk and, eventually, to follow him back to Moscow.

28 Ya. Tugendkhold, "Vystavka v Muzee zhivopisnoi kultury," *Izvestiya,* 10 January 1923.

29 On the Projectionists, see Irina Lebedeva, "The Poetry of Science: Projectionism and Electroorganism," trans. Walter Arndt, and Charlotte Douglas, "Terms of Transition: The *First Discussional Exhibition* and the Society of Easel Painters," in *The Great Utopia: The Russian and Soviet Avant-Garde, 1915–1932,* exh. cat. (New York: Solomon R. Guggenheim Museum, 1992), pp. 451–65.

30 *1-ya diskussionnaya vystavka obedinenii aktivnogo revolyutsionnogo iskusstva. Katalog,* exh. cat. (Moscow: Mospoligraf, 1924).

31 The productions, and reactions to them, are described in V. Kostin, *OST (Obshchestvo stankovistov)* (Leningrad: Khudozhnik RSFSR, 1976), pp. 18–20, and in S.A. Luchishkin, *Ya ochen lyublyu zhizn. Stranitsy vospominanii* (Moscow: Sovetskii khudozhnik, 1988), pp. 79–83.

32 *1-ya diskussionnaya vystavka* (note 30), p. 11.

33 These words were spoken by Fridrikh Lekht on 10 April 1935. See Douglas (note 29), p. 463.

34 Sergei Luchishkin, Yury Pimenov, Petr Vilyams, and Ekaterina Zernova were among those who joined the Brigade of Artists. Luchishkin later recalled:

> We tried to develop what we had learned from the experiments of our teachers—Kandinsky, Malevich, Rodchenko, Popova, Udaltsova, and others—and, above all, to link it with our revolutionary consciousness so as to make art an active fighter in the construction of the new social order. In practice, however, such art proved hopelessly weak and incapable of achieving our chief goals ([note 31], p. 70).

35 These included the Association of Artists of the Revolution (1922–28), known until early 1928 as the Association of Artists of Revolutionary Russia (AKhRR, AKhR), and the Russian Association of Proletarian Artists (RAPKh; 1931–32). These groups were against avant-garde trends in art and laid claim to being the leading artistic-political organizations in the USSR.

36 Lev Iakovlevich Zevin (1903–1941) joined Unovis (Malevich wrote a brief article entitled "Lev Zevin," which is now in the Malevich archives of the Stedelijk Museum, Amsterdam), but left Vitebsk for Moscow with Falk. Falk, who considered him one of his most gifted students, painted Zevin's portrait in the early 1920s (Yaroslavl Art Museum). A member of the groups Growth and Thirteen, Zevin joined the Society of Easel Painters late in its existence. He was killed in action during the Second World War.

Boris Groys

From Internationalism to Cosmopolitanism: Artists of Jewish Descent in the Stalin Era

Between 1932 and 1934, several substantial shifts occurred in Soviet culture that signaled a transition from the avant-garde period of the 1920s to the culture of the Stalin era. Most importantly, the notion that the art of the "new Soviet age" must differ radically from that of previous ages was the first theory to lose favor under Stalin. In the first half of the 1930s, the slogan "dictatorship of the proletariat" was replaced by the slogan "all-peoples' society," and the proletariat itself was eventually renamed, more modestly, "the working class." Correspondingly, the notion of "proletarian ideology" (*proletarskaya ideinost*) was replaced by that of "spirit of the people" (*narodnost*); art now not only was obliged to express the ideology of the proletariat but also had to be "familiar and comprehensible to the whole nation." In practice, this meant rehabilitating the art of the past, whose time-approved forms now had to serve a new, socialist approach as well. But the old forms had to be given new content, and this meant a requirement for "adherence to Party principles" (*partiinost*). Instead of depicting life as it was, art was now obliged to depict life as it was being shaped in the Soviet Union by the ruling Communist Party in accordance with Marxist-Leninist ideology (fig. 1).[1]

This triad—"spirit of the people," Party adherence, and ideological correctness—became central

for Stalinist culture, being intended to provide the basis for "depicting life in its Revolutionary development." The official beginning of the Stalin era in Soviet Russia was the famous Resolution of 23 April 1932, which ordered the disbanding of all artistic and literary associations. At the First Congress of the Union of Writers in 1934, a corresponding artistic doctrine was proclaimed under the label "Socialist Realism" as the sole and obligatory method for all Soviet art. This unity of method was reinforced over the next few years as unions of Soviet artists, architects, cinematographers, and so on were created on the model of the Union of Writers. Stalin's cultural policy, which put an end to the various art groups' struggle for dominance and which subjected art to the direct control of the Party, was to a certain extent the natural outcome of this struggle. The artistic pluralism of the 1920s was understood, even by those who contributed to it, to be nothing more than a transitional period in the quest for a single socialist aesthetic, which artists or theorists might imagine in their own ways (fig. 2).

Since artists of Jewish descent were active in virtually all the art groups of the 1920s, whatever fate befell them in the Stalin era was determined primarily by how this or that group was evaluated according to Stalin's cultural policy, to what extreme a group might be condemned and persecuted, and how quickly individual artists might reinvent themselves to blend into the general picture of Stalinist art or remove themselves from active social involvement. In this regard, the fate of Jewish artists and critics was no different from that of other Soviet artists in this period.

The rehabilitation of traditional art forms did, however, have one aspect that reflected specifically on the situation of Jewish artists, since it also meant a return to national traditions. Socialist Realism was officially defined as an art "national in form and socialist in content." But in reality, the rehabilitation of national elements in art was selective, following Lenin's theory of "two cultures within a single national culture." Lenin had distinguished between "the elements of democratic and socialist culture present . . . in every national culture"[2] and the "dominant culture" of "bourgeois nationalism"[3] to which these elements were opposed. The criterion for evaluating a particular artist's work was nothing other than the determination of which national tradition that work perpetuated, the "progressive" (socialist) one or the "reactionary" (bourgeois) one. Since official ideology was concerned primarily with combatting "the nihilistic relationship to the national cultural heritage" that was ascribed to avant-garde artists and theorists, each individual artist was faced with

two mutually contradictory demands: to remain faithful to his or her own national tradition (so as not to be accused of "national nihilism") while avoiding the trap of "bourgeois nationalism." The fact that "dialectical materialism" allowed Stalinist ideologues to make mutually contradictory assertions regarding single issues made it possible for them to accuse their victims of both "national nihilism" and "bourgeois nationalism," thus making retreat impossible.

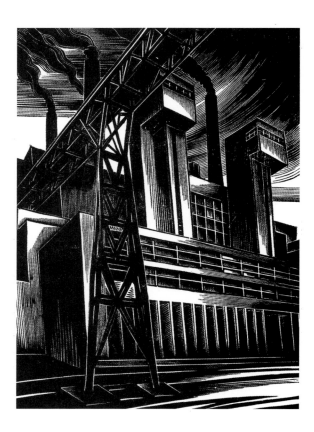

Fig. 2
Solomon Yudovin
Factory, ca. 1932
Woodcut on paper,
$8^3/_4$ x $6^3/_4$ in.
(22 x 17.1 cm)
Brodsky House Museum,
St. Petersburg

This total ideological indefensibility made every artist vulnerable. In the case of Jewish artists, there was added to this fundamental indeterminacy another indeterminacy relating only to "persons of Jewish nationality." Was it or was it not possible to regard Jews as a separate nation alongside all other nations? What did it mean for a Jewish artist's work to be "national in form?" Stalin had formulated his own definition of a "nation" in his 1913 essay "Marxism and the National Question." This essay was primarily devoted to the fight against the Jewish Bund party, which had required national and cultural autonomy for the Jewish population of Russia. Stalin argued that the criteria for defining a nation were, above all, unity of territory, language, and economic activity and, only secondarily, cultural and psychological unity. On these grounds, he denied Jews the right to be considered a nation, calling Yid-

dish nothing but "jargon." He saw the Bund's call for national and cultural autonomy as a manifestation of pure bourgeois nationalism aimed at dividing the workers' movement.[4]

Jews in Stalin's Soviet Union found themselves, then, in an especially difficult predicament. On the one hand, in the famous fifth item of the internal Soviet passport that had been introduced in 1933, the word "Jew" stood as the designation of their nationality, just as others had the words "Russian," "Ukrainian," or "Tatar" in their passports. Moreover, in 1934, the Jewish Autonomous Oblast had been established in Birobidzhan, on the Chinese border, in order to give Jews their own "unity of territory." In this sense, they were officially recognized as a separate nation.[5] However, Jews could not appeal to their national culture with the same assurance as representatives of other peoples, for according to Stalin's theory, that national culture was bourgeois rather than "democratic and socialist." Jewish artists, therefore, were unable to fulfill completely Socialist Realism's fundamental requirement of combining national form with socialist content; although the use of Yiddish was permitted in certain cultural contexts, such activities were marginal and were undertaken as a rule by Jewish intellectuals inclined toward Communism who had particularly distinguished themselves in the battle against Jewish cultural tradition.[6] Almost the only recourse for Jewish artists, then, was to continue to emphasize their internationalism, despite the risk of being accused of a nihilistic relationship to national tradition.[7] In fact, the overwhelming majority of artists and critics of Jewish descent who took part in post-Revolutionary Soviet culture were enthralled by the internationalism of Communist ideology, which promised them a way out of their isolation without having to assimilate into Russian culture.[8] Communism promised a new society in which all forms of nationalism, including Russian nationalism, would be overcome. This appeal to the Communist ideal initially put Jewish intellectuals in an advantageous social position, which they often exploited to criticize Russia and the Russians. For example, the Jewish critic Osip Beskin, famous for his orthodox Soviet polemics against avant-garde aesthetics, also unleashed an attack against traditional Russian religious fanaticism and the "diehard anti-Semitism of the Russian peasantry."[9] Ironically, Beskin wrote during the period of terror against the peasantry that was unleashed under the guise of the collectivization of the countryside and that cost that countryside many millions of innocent victims. Some of his articles serve as good illustrations of both the hopes many Jewish intellectuals placed in the internation-

Fig. 3
Boris Iofan, A. I. Baranskij,
Ja. B. Belopolsky, G. Krasin,
A. Korobko, S. D. Merkurov,
V. A. Andreev, and I. Lednev
*Maquette for Palace of
Soviets*, variant from
1942–43; wood,
$33^{3}/_{4} \times 47^{5}/_{8} \times 33^{1}/_{2}$ in.
(85.5 x 121 x 85 cm)
Private Collection

Fig. 4
Evgeny Katsman
Kalyazin Lace Makers, 1928
Pastel on paper, 36 x 56 in.
(91 x 142 cm)
State Tretyakov Gallery,
Moscow
© 1995 VAGA, New York

alism of the Soviet regime and the position of intellectual complicity into which those hopes seduced them.

Other members of the Jewish intelligentsia sought new strategies for survival. One of the most common of these was to appeal to the notion of "the friendship of nations" (*druzhba narodov*), which to some degree perpetuated the internationalism of the previous period. The most successful example of such a strategy is provided by the career of Boris Iofan, perhaps the most influential and representative architect of the Stalin era. Iofan is known primarily

as the designer of the Palace of Soviets, a building that was from the start officially intended to embody most consistently and fully Stalinist aesthetic principles (fig. 3). In 1931, his design was chosen as a finalist in an open international competition. In 1932–33, in a series of closed competitions, it was accepted as the basis for subsequent work on the building, work that continued at least until the start of the Second World War and was not entirely abandoned even after the war's conclusion.[10] Although the Palace of Soviets was never actually built, Iofan's design fulfilled its primary task: to be the most consummate example of the Stalinist aesthetic (see pl. 22; ill. 37). It became a prototype for the whole of Soviet architecture and especially for the architects who designed the postwar high-rise buildings that by and large defined the Moscow cityscape. Iofan's design also influenced Soviet film, painting, sculpture, and even literature. Another of his buildings played an important role in establishing Stalinist style: the Soviet Pavilion at the 1937 Universal Exposition.[11]

Iofan, who spent 10 critical years in Italy (1914–24), had an international orientation from the very beginning. However, he was not in the least interested in creating an international modernist style in the spirit of the Bauhaus. The Palace of Soviets was not supposed to mark a break with national traditions, but to act as a summation of the best that had been created by various national traditions throughout world history. "Russian" architectural elements, then, were to stand on a par with those of ancient Greece, Egypt, Babylonia, the baroque, and so on. The quest for a single "extra-national" style was replaced, then, with a radical eclecticism that proved to be universalist as well, for it was prepared to include on an equal footing the most diverse national traditions, subjecting all of them to a single socialist content. This artistic strategy perfectly matched the imperialistic nature of Stalinist culture, which was always ready to incorporate the rest of the world as yet one more "Soviet Socialist Republic." Iofan—a Jew—managed to find a place for himself in Stalinist culture precisely as a spokesman for this socialist, imperialist eclecticism, which in a curious way resembled the fundamental eclecticism of Jewish culture, making reference to the various cultures in the midst of which Jews have lived throughout the ages even as it remained faithful to its own content.

A more naive, but therefore more obvious example of the strategic use of the "friendship of nations" idea can be found in the work of the artist Grigory Shegal, who strove to paint pictures that depicted, as he said, "the brotherhood of the peo-

ples of our country, and the cultural and economic growth of formerly backward nations."[12] Already by the end of the 1920s, Shegal had on his own initiative begun traveling to distant parts of Russia and to the national republics; such trips later became obligatory for Soviet artists.[13] The result of Shegal's trips can be discerned in such paintings as *A New Comrade* (1931–32)—which shows a young Kazakh man going down into a mine shaft, where he is greeted by an elderly Kazakh and a young Russian woman—and *The Conscription of Mountain Youth [into the Red Army]* (1932). Shegal's best-known work, *Leader, Teacher and Friend*, shown at the renowned *Industry of Socialism* exhibition in 1939, depicts Stalin attending the Second Congress of Collective Farm Shock Workers (see ill. 107). He is listening to a speech being made by a young Uzbek woman, and other Soviet nationalities are represented in the auditorium as well. These officially "permissible" Kazakhs and Uzbeks, whose faces show their non-Russian origins, are clearly substitutes for the artist's own Jewishness, which he preferred not to demonstrate, integrating it into the neutral and universal "friendship of nations" idea. The same thing was done by the photographer Georgy Zelma, who made a point in his photographs of depicting the construction of socialism by representatives of various nationalities (see pl. 17).[14]

The artist who deviated the most from this cautious strategy was Evgeny Katsman, who in 1922 was one of the founders of the Association of Artists

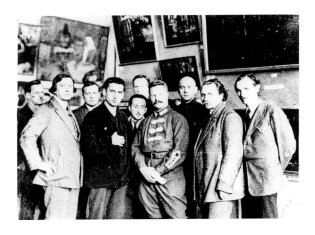

of Revolutionary Russia (AKhRR). As a young man, he had been associated with Marxist youth organizations, though his aesthetic sympathies lay much closer to the Russian realist school known as the Wanderers (Peredvizhniki), in whose last exhibition he took part. Katsman's ability to combine traditional realist aesthetics with Communist convictions proved to be optimal for the culture of the Soviet age (fig. 4). The main criterion for the activity of AKhRR artists became its immediate ideological and propagandistic influence on the masses in the Soviet context (see ill. 46). The criterion of historical innovation, important for the avant-garde, became secondary, replaced by the criterion of immediate effectiveness (see pl. 25).[15] Katsman played a central role in the development of this new aesthetic of effectiveness. In his famous article "Let Them Answer," addressed to "left-wing" avant-garde artists, he wrote:

> "Left-wing" artists enjoyed great power. The administration of art affairs for the whole of the vast U.S.S.R. was in their hands . . . But what did these "left-wing" artists give us? Nothing, or next to nothing . . . There are artists of the masses, and then there are artists of tiny little art groups. The realists are artists of the masses. AKhRR artists are artists of the masses of workers and peasants.[16]

As the secretary general of the AKhRR (where he was, by the way, one of a very few Jews), Katsman proposed the well-known slogan "heroic realism," a forerunner of Stalin's "Socialist Realism." In May 1926, the AKhRR also organized an exhibition entitled *The Life and Customs of the Peoples of the USSR*, a forerunner of the "friendship of nations" idea. Unlike many other leaders of "proletarian" art groups, Katsman remained a recognized Soviet artist until the end of his life, although—despite his persistent demonstration of political loyalty—he never managed to attain a leading position.

The only Jewish artist to reach the pinnacle of official Soviet success was, it is fair to say, Isaak

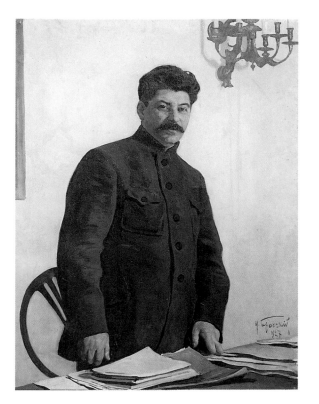

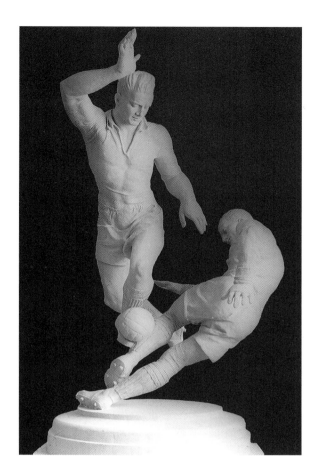

Brodsky, who was hardly inclined to political rhetoric and who tended to remain outside the battles among the art groups of the 1920s. Brodsky, a well-known academic artist even before the Revolution, painted the portraits of Lenin which essentially became the foundation of all Lenin iconography (see pl. 27), but he also painted many other high-ranking Party officials, with whom he maintained personal relations as well (fig. 5). He was especially close to Voroshilov, the head of the Red Army and an influential member of the Politburo, who acted unwaveringly as his protector (see ill. 11). Moreover, Brodsky hosted something like a salon in his home that was frequented by many influential people of the time, and he also acquired a significant collection of art. He thus can be seen as a sort of court artist of Stalin's empire. Brodsky did not attempt to put forward any independent ideas that might at any moment have come into conflict with the official Party line, and it was this strategy that proved most effective for making a career in Stalinist culture.

From 1934 until his death, Brodsky held the key post of director of the Academy of Arts. His exceptionally privileged position is indicated by the fact that, unlike the vast majority of other Soviet Jewish artists, he actually stressed his Jewish background, citing it as the reason for his loyalty to the Soviet regime. Thus, in his memoirs, which were published in 1940, right after his death, he wrote: "I was already a recognized artist, and my works had received high acclaim abroad, but in Tsarist Russia I was never forgiven for being a Jew . . . The cruel la-

bel *zhid* followed me for many long years. My Jewishness never ceased to upset people, some of them highly educated."[17] Later, Brodsky recalled how the Tretyakov Gallery refused to buy his work simply because he was Jewish. He concluded his autobiography with the following statement: "The Party and the government have expressed their confidence in me . . . I am happy in the knowledge that my creative work was useful, if only in some small degree, to the common cause of building socialism."[18]

But not all Jewish artists viewed their backgrounds as Brodsky did, as nothing but an obstacle to a "normal" artistic career. They tried to make use of the chinks in Stalin's cultural policy by treating Jewish national motifs within the framework of a legitimate interest, allowed by the censor, in one's national tradition. Thus, Iosif Chaikov made a relief with the programmatic title *Jews on the Land* (1929; Moscow, State Tretyakov Gallery) and cast sculptural portraits of the leading figures of Jewish culture, including in the 1940s a portrait of the Yiddish poet Leib Kvitko, who later perished. But, typically, not even Chaikov was able to avoid the usual strategy; in 1954, he made statues symbolizing the 16 republics for the *Friendship of Nations* fountain at the entrance to the *Exhibition of the Achievements of the People's Economy* (fig. 6).[19]

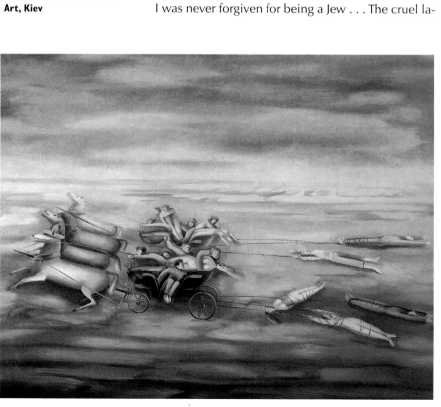

Among the niches open to Jewish artists at this time, the most important were in the fields of book illustration and theatrical design, which were subject to weaker censorship than the "high" arts of painting and sculpture (fig. 7). These media therefore served as a refuge not only for many "formalists," such as Tatlin, but also for many Jewish artists with an interest in Jewish thematics. A career in book illustration, for example, allowed Solomon Yudovin to treat Jewish themes even in the 1930s and 1940s by illustrating such works as Lion Feuchtwanger's novel *Süss the Jew*. After 1933, Alexander Tyshler took part in official exhibitions almost exclusively as a theater designer or book illustrator. During this time, he collaborated with such leading figures of Yiddish culture as the poet Peretz Markish and the director Solomon Mikhoels; from 1941 to 1949, Tyshler was the principal designer for the State Jewish Theater (Goset). In 1945, he received the Stalin Prize—at the time, the highest official award an artist could receive—for his setting of E. Shneer's play *Freylekhs* at the theater. Also working there was the renowned painter Robert Falk, who after his return from France in 1937 had virtually no exhibition opportunities. Both Tyshler and Falk were constant targets of official "antiformalist" criticism, but even so they were never subjected to any direct repres-

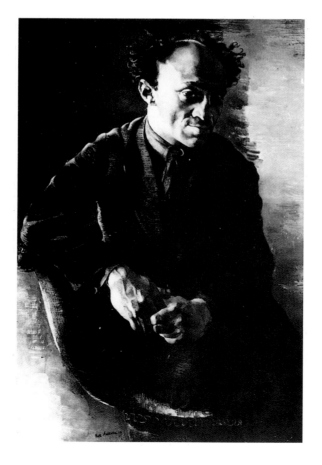

sion and continued to be able to work for themselves and their friends. In doing this, they anticipated the type of behavior practiced by the "unofficial culture" of the post-Stalin era.

Such niches of Jewish culture suffered a sharp reduction in scope, or disappeared entirely, as new political campaigns were launched against the surviving members of the cultural intelligentsia soon after the end of the Second World War. The growth of Russian nationalism—which Stalin had encouraged during the war as an additional means of mobilizing the people against the enemy—along with a deep fear of Western influence and the creation of the State of Israel resulted in repression, which took the form primarily of a battle against "cosmopolitanism" (as the former "internationalism" was now known). Jewish members of the intelligentsia became the main (though not the only) target. As Andrei Zhdanov, the instigator of these campaigns, wrote: "Internationalism is not born on the basis of the reduction and impoverishment of national culture. On the contrary, internationalism is born where national art flourishes. To forget this truth means to lose the guiding line, to lose one's own face, to become a rootless cosmopolitan."[20] Jews, and especially theater, literary, and art critics of Jewish descent, proved to be easy prey in the battle against "the insufficient appreciation of the achievements of Russian and Soviet culture," the more so since a parallel repression of Jewish cultural figures working in Yiddish had been launched under the banner of a battle with "bourgeois Jewish nationalism," which was found to be in the service of "world Zionism" and "American imperialism."[21]

The main victim of this anti-Semitic campaign was the Jewish Anti-Fascist Committee (EAK), which was headed by the popular State Jewish Theater actor and director Solomon Mikhoels (fig. 8) and which included virtually all the best-known Yiddish cultural figures such as Peretz Markish, Itzik Feffer, and Leib Kvitko. The pretext for the attack was a letter sent in 1944 by a group of the committee's leaders to Stalin proposing the establishment of a Jewish socialist republic in the Crimea. In 1948, as the Cold War was developing and following the formation of the State of Israel, this letter was pulled out of the archives and interpreted as an attempt to tear the Crimea away from the Soviet Union. As a result, a secret police operation took place that led rather quickly to the assassination of Mikhoels[22] and, later, to the deaths of dozens of leading Jewish cultural figures who had worked with the committee—the only legal Jewish association in the Soviet Union throughout all these years—and the closing of nearly all Jewish cultural institutions. Subsequently, the

affair became the main battlefield within the highest ranks of the Party, finally developing into the infamous "Doctors' Plot."[23]

Due to the political climate, the campaign in the Soviet press against "cosmopolitans" and "Jewish bourgeois nationalists" rather quickly reached a level of hysteria which seemed unusual even by the standards of Soviet cultural practice. Here are some examples of the critical pronouncements of the time:

> In the "works" of such "critics" as Ya. Tugendkhold, N. Punin, A. Efros, and I. Matsa, and in the critical observations of their brother-in-arms O. Beskin, not only is the Russian national school of painting disparaged, but its historical significance in world art, its ideological strength, its national character and high artistic value are denied.[24]

> These rootless, tribeless people have decided that they have "good taste" and have announced that they are striving for the aesthetic improvement of our art . . . The aesthete, the snob, has no homeland, for in denying the ideological dimension and the national character of art, he denies the national foundations of creativity, and he denies true Bolshevik humanism.[25]

> What possible notion can Gurvich [a Jewish theater critic] have concerning the national character of the Russian Soviet man? . . . Whoever looks at our life from the outside, with the fish eyes of the disinterested observer, must inevitably lag behind.[26]

> The favorite tactical device of cosmopolitan critics is double-dealing. They usually disguise their anti-patriotic positions with lots of talk about raising the level of "artistic mastery" and the "quality" of Soviet art. The greatest zealot of the lot is that double-dealer Osip Beskin.[27]

Thus, even Beskin fell victim to the anti-cosmopolitan campaign in as much as he was a Jew and his criticism of "formalists" was not crude or indiscriminate enough. In the official Soviet press, such terms as "rootless cosmopolitan," "double-dealer" and "man with fish eyes" soon became widespread synonyms for Jewish intellectuals.

Having begun with an enthusiasm for Communist internationalism, in which, as in the Christianity of the Apostle Paul, "there is neither Greek nor Jew," and having hoped to find a homeland there, Soviet intellectuals of Jewish descent now perished alongside this same internationalism. They seemed unaware that in the eyes of others they were still Jews no matter what, and that their appeal to internationalism seemed to the authorities to be nothing more than a mask that had to be ripped off so as to disclose their true faces. It was inevitable that Stalinist culture, which strove to incorporate all possible national traditions and forms so as to subject them to

its own "socialist content," would see the Jews as a dangerous double just as capable of giving their own "Jewish content" to the diverse national cultures in whose midst Jews had been found historically and in whose development they had played an active part. Individual Jews managed to escape this logic only through good luck.

Indeed, one can say that Jewish artists in the Stalin era were on the whole very lucky, since the extent of repression among artists was, generally speaking, incomparably less than in any other cultural group.[28] Russian culture is, by and large, extremely literary and not very visual, so art was not the focus of the authorities' attention and did not provide the main arena for ideological battles. Literature did that. The typical fate of artists living in the Soviet Union was, then, surprisingly benign; most of them died in their beds, which for the time was an exceptional achievement. It is possibly for this reason that visual art became such an important factor in the cultural opposition of the post-Stalin era.

Boris Groys
is Professor of Philosophy and Aesthetics at the Staatliche Hochschule für Gestaltung, Karlsruhe.

Special thanks to Ekaterina Diogot.

Notes

[1] On the transition from an avant-garde ideology to Stalinist cultural policy, see Boris Groys, *The Total Art of Stalinism: Avant-Garde, Aesthetic Dictatorship, and Beyond* (Princeton: Princeton University Press, 1992).

[2] V.I. Lenin, *On Culture and Cultural Revolution* (Moscow: Progress Publisher, 1970), p. 43.

[3] *Ibid.*, p. 44.

[4] I.V. Stalin, "Marksizm i natsionalnyi vopros," in *I.V. Stalin*, vol. 2 (Moscow: Foreign Languages Publication House, 1946), pp. 294ff. Specifically about the Jews, Stalin wrote that they were a "paper nation" in that they lacked a unity of territory and language and were characterized only by an "ossified religious tradition" (pp. 300–01).

[5] The Jewish population of Birobidzhan, despite the best efforts of the authorities, never grew to more than a few thousand, and the whole project ended in failure. See S. Shvarts, "Birobidzhan: Opyt evreiskoi kolonizatsii," in Ya.G. Frumkin, G.Ya. Aronson, and A.A. Goldenweiser, eds., *Kniga o russkom evreistve* (New York: Union of Russian Jews, 1960), pp. 160–203. The official definition of Jews as a nation in Stalinist Russia was in a certain sense unique in that Jews were most often viewed as a religious group. See Tsvi Gigelman, "Formirovanie evreiskoi kultury i samosoznanya v SSSR: Gosudarstvo v roli sotsialnogo inzhenera," in *Istoricheskie sudby evreev v Rossii i SSSR: Nachalo dialoga* (Moscow: Evreiskoe istoricheskoe obshchestvo, 1992), pp. 15–27.

[6] On the Jewish intelligentsia's role in fighting its own cultural traditions under the banner of "the dictatorship of the proletariat on Jewish streets," see G. Aronson, "Evreiskii vopros v epokhu Stalina," *in Kniga o russkom evreistve* (note 5), pp. 134–35.

7 In his famous letter "The National Question and Leninism" (1929), Stalin raised a decisive objection to internationalism, which he understood as a program aimed at eradicating national differences, and insisted on the existence of nations within the context of socialism: "You know, of course, that the policy of assimilation is absolutely excluded from the arsenal of Marxism-Leninism, as being an anti-popular and counter-revolutionary policy, a fatal policy." See I.V. Stalin, "Natsionalnyi vopros i leninism," in *I.V. Stalin,* vol. 11 (Moscow, 1954), p. 362.

8 The desire to overcome their Jewishness was also typical of writers in the Stalin era who did not necessarily espouse the official ideology. For instance, Boris Pasternak, an ethnic Jew, called in his novel *Doctor Zhivago* for the renunciation of Judaism in favor of Christian universalism. An analysis of his views may be found in D. Segal, "Pro domo sua: The Case of Boris Pasternak," *Slavica Hierosolymitana* 1 (1977), pp. 199–255.

9 O. Beskin, "Rosseyane," *Revolyutsya i kultura* (Moscow), no. 18 (1928), pp. 34–43.

10 On the evolution of Iofan's design for the Palace of Soviets, see Peter Noever, ed., *Tyrannei des Schönen: Architektur der Stalin-Zeit,* exh. cat. (Vienna: Österreichisches Museum für Angewandte Kunst, 1994), pp. 151ff. For a description of the design phases, see Christian Borngräber, "Der Sowjetpalast im Zentrum von Moskau," in *Die Axt hat geblüht... Europäische Konflikte der 30er Jahre in Erinnerung an die frühe Avantgarde,* exh. cat. (Kunsthalle Düsseldorf, 1987), pp. 417–25.

11 On Iofan's designs for the Soviet Pavilion at the 1937 Paris World's Fair, see *Tyrannei des Schönen* (note 10), pp. 141–42. For a description of the pavilion, see M.C. Zopff, "Ein Rundgang im Sowjetischen Pavillon der Weltausstellung 1937 in Paris," in *Die Axt hat geblüht...* (note 10), pp. 426–29.

12 As quoted in Sofya Razumovskaya, *Grigory Mikhailovich Shegal* (Moscow: Sovetskii khudozhnik 1963), p. 51.

13 Similar trips were organized to Birobidzhan and to the Jewish national regions of the Ukraine, the Crimea, and the Caucasus, resulting in the exhibition *The Jewish Autonomous Oblast and the Jewish National Regions in Painting and Graphics,* which took place in Moscow in 1931. See Gr. Kazovsky, "Evreiskoe izobrazitelnoe iskusstvo v Rossii (1900–1948): Etapy istorii," in *Istoricheskie sudby evreev* (note 5), p. 301.

14 Zelma's Central Asian photographs are, in this sense, typical. See *Russische Avantgarde im 20. Jahrhundert: Von Malewitsch bis Kabakov: Die Sammlung Ludwig,* exh. cat. (Cologne: Kunsthalle, 1993), pp. 230–31; no. 66.

15 See E.A. Katsman, "Kak sozdavalsya AKhRR" [Moscow, 1925], in *Zapiski khudozhnika* (Moscow: Izd-vo Akademy khudozhestv SSSR, 1962).

16 E.A. Katsman, "Pust otvetyat," *Zhizn iskusstva,* no. 27 (6 July 1926), p. 7.

17 I.I. Brodsky, *Moi tvorcheskii put* (Moscow and Leningrad: Iskusstvo, 1940), p. 63.

18 *Ibid.,* p. 110.

19 For more on Chaikov's work, see A. Romm, "O tvorchestve Iosifa Chaikova," *Iskusstvo* (Moscow), no. 3 (1933); V. Keller, "Iosif Chaikov," *Iskusstvo* (Moscow) (1949).

20 As quoted in an editorial in the newspaper *Sovetskoe iskusstvo,* no. 18 (1 May 1948), p. 1106.

21 Jews accounted for approximately 70 percent of all individuals who suffered from anti-cosmopolitan persecution, as is shown in the statistical table in G.S. Batygin and I.F. Devyatko, "Evreiskii vopros: Khronika sorokovykh godov, Chast pervaya," *Vestnik Rossiiskoi akademii nauk* 63 (1993), p. 65. In many cases, this percentage corresponds to the general percentage of Jewish participation in the cultural life of the period, especially in the area of literary, theater, and art criticism, which became the main arena for persecution.

22 The assassination of Mikhoels and his companion V. Golubov on 13 January 1948 was reported as an automobile accident in which the two men were run over. Mikhoels was buried with honors. Only in 1953 was he posthumously "revealed" to have been "a bourgeois nationalist" and stripped of all awards and titles. For the details of his assassination, see A. Borshchagovsky, *Obvinyaetsya krov* (Moscow: Izdatelskaya gruppa "Progress", 1994), pp. 3ff.

23 There have recently been a number of new publications on the Jewish Anti-Fascist Committee affair, most importantly the chapter "The Jews: California in the Crimea" in the memoirs of Pavel Sudoplatov, the head of Stalin's international terrorist network. Here, the entire anti-Semitic campaign of the 1940s and 1950s is described in detail from the perspective of the then leadership of the organs of repression. See Pavel Sudoplatov and Anatoli Sudoplatov with Jerrold L. and Leona P. Schecter, *Special Tasks* (New York: Little, Brown and Co., 1994), pp. 285–309. *Obvinyaetsya krov* by Borshchagovsky (note 22), a victim of the anti-cosmopolitan campaign, presents the letter about the Crimea as an act of provocation by the authorities (see pp. 132ff.).

24 A. Gerasimov [then president of the Academy of Arts], "Za boevuyu teoriyu izobrazitel nykh iskusstv," *Sovetskoe iskusstvo,* no. 2 (8 January 1949), p. 1142.

25 From the editorial "Kritika, vrazhdebnaya narodu," in *Sovetskoe iskusstvo,* no. 6 (5 February 1949), p. 1146.

26 From the editorial "Ob odnoi antipartiinoi gruppe teatralnykh kritikov" [*Pravda*], in *Sovetskoe iskusstvo,* no. 5 (29 January 1949), p. 1145.

27 P. Sysoev and V. Veymarn, "Protiv kosmopolitizma v iskusstvoznanii," *Sovetskoe iskusstvo,* no. 10 (5 March 1949), p. 1150.

28 Only eight artists became direct targets in the campaign against cosmopolitanism, and only three of them were Jews, in comparison with, for instance, a hundred and fifty-five critics, of whom a hundred and three were Jews. These statistics are from Batygin and Devyatko (note 21), p. 65.

Viktor Misiano

Choosing To Be Jewish

Starting around the mid-1950s, Russian Jewish identity took on an extremely contradictory character, culturally and aesthetically as well as ethnically. On the one hand, public consciousness continued to be defined and shaped by the machinery of ideology. Despite being incomparably less rigid than they had been under Stalin, the aesthetic norms—iconographic, thematic, and linguistic—of Socialist Realism retained their universally binding status. On the other hand, the monolith of official culture was undermined as aspects of the individual and the specific—including such phenomena as nationalism—emerged inexorably. Although there was a ritual quality to the "otherness" of the regional artistic schools—the Caucasian (that is, Armenian and Georgian), for instance, or the Baltic (Estonian in particular)—there is no question that all of these schools acquired alternative aesthetic values and at the same time defined the area available for the legal and authentic realization of national identity. It is important to understand that Jews were unable to take full advantage of these opportunities.

One reason for this was the absence in the Soviet Union of any strong institutional or political support for Jewish identity. The existence of a Jewish state outside its borders (as well as the political tension between the two countries) made it inevitable that Jewish identity in this period—as an entity laying claim to confessional and cultural articulation—also implied laying claim to emigration. It is no coincidence that the chief political backing of Soviet Jewry at this time—the support of the diaspora and of world opinion—was focused on protecting the right of Soviet Jews to emigrate. It was because of this that those Jews who proposed to remain and work as artists within the borders of the Soviet Union found a completely different channel for their national identity.

While artists who were Jews were common, there was an almost total absence of what one might call "Jewish artists." If, in the context of Soviet culture as a whole, the notion of, for instance, an "Armenian artist" can be accepted as legitimate because it implies the existence of an Armenian artistic school—created by the people's combined efforts to consciously and purposefully build up art that is Armenian—then no project for Jewish art in Russian artistic culture arose at this time. An artist had only to propose the creation of a purely Jewish art to find that this proposal inevitably conjured up pretensions to the perspective of an Israeli artist. A

Jewish identity nonetheless existed, albeit without definite form. This identity manifested itself—at times unperceived by the artists themselves—in certain deeply rooted attitudes, in a basic mindset handed down via a specific sensibility. If you were to find yourself, for example, among the Sretensky Boulevard artists—Ilya Kabakov, Vladimir Yankilevsky, Eduard Shteinberg, Viktor Pivovarov, Erik Bulatov—you would always know that those persons present were Jews.

The very existence of the Sretensky Boulevard group, a kind of fellowship of Jewish artists, reveals the first significant characteristic of Russian art with Jewish origins. Despite the absence of a ghetto tradition, despite the long-previous abolition of the Pale of Settlement, and despite assimilation to a large extent under Soviet rule—despite all this, the Jewish intelligentsia continued to consolidate, to isolate itself, to form closed communities. To some degree, this was a feature of the Russian intelligentsia in general and could be blamed on the regime's repressiveness and anti-intellectuality. The tradition of an intellectual dynasty in opposition to officialdom, as a position from which genuine thought and values could be pursued, has existed in Russian society since the end of the eighteenth century—in other words, since the Russian intelligentsia first appeared. And yet, the Russian intellectual's traditional isolation from the social context, from what was known as "the people," was invariably perceived by him or her as a burden, as a moral flaw. From this, therefore, stemmed the same intellectuals' persistent yearning to transcend their own isolation, either directly—via Tolstoyanism, "going to the people," etc.—or metaphorically via creative work, which was seen as a reflection of the life of society, the embodiment of the suffering and aspirations of the people.

This tendency to identify directly with an external social mentality has not appeared among modern artists of Jewish extraction. Quite the reverse, they have tended instead to glorify their own isolation and to romanticize the small, closed circle, the "little ghetto." This tendency goes back to Marc Chagall, to his mythicized "Little Jerusalem" and to his view of the artist's function as the creator of a poetic Promised Land. This tradition was continued in Alexander Tyshler's lyrical apologia for "outsider" human communities: tramps, circus performers—and artists. This approach was developed even more directly in Anatoly Kaplan's straightforward depiction of the life of Jewish communities. The work of Robert Falk and of his original disciple, Vladimir Weisberg—with its characteristic intimacy and attempts at a phenomenological depiction of the

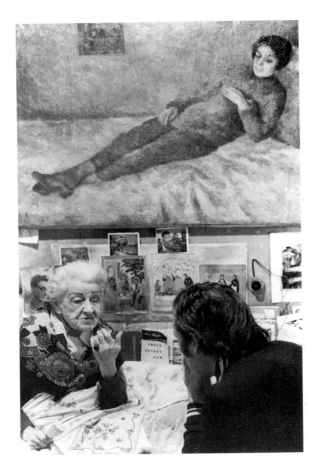

Igor Palmin
*Alexandra Granovskaya
with Robert Falk's Portrait
of Her,* 1979
Photograph, 10 x 6³/₄ in.
(25.4 x 17.1 cm)
Courtesy Igor Palmin,
Moscow

ordinary "living world"—can be seen as another form of this apologia for isolation (see ill. 123).

It is essential to note that these classic Russian artists of the Soviet era, Tyshler and Falk, succeeded in glorifying isolationism not only in their work, but in their own lives. Both played an exceptionally important role for the younger generation of artists who began working during the liberalization of the Soviet regime following the death of Stalin in 1953. Enduring several decades in voluntary exile, they preserved and handed down to the younger generation the fundamentals of early twentieth-century artistic culture—in other words, the art of the era of the great Russian avant-garde, consigned to oblivion under the crushing dogmas of official aesthetics. Almost every founding figure of the new Russian art of the last three decades paid their homage to Tyshler and Falk (see ill. 27), making their ways through the aura of forbiddenness and dissidence that attended visits to the private studios of these two elderly artists. Their personal and creative isolation was poetically suggestive and was perceived as confirmation of the highly ethical character of their art.

If Tyshler and Falk were the existential realization of the paradigm of the "eternal Jew," then the realization of the paradigm of the "little ghetto" became, practically speaking, an entire tradition of

Muscovite art, inspiring its truly unique and continuing obsession with forming artistic groups and societies. These societies lacked any kind of socioeconomic motivation (none were legally constituted associations or unions). Two things united their members: the emotional closeness resulting from their own distancing from their social surroundings, and the fact that most were Jews. It was also natural, therefore, that artists of other backgrounds—even those who felt an aesthetic kinship with the members of these groups—were less deeply connected to them. The urge of other artists to distance themselves was less organic; without being conformist, they were incomparably more mobile and open within Soviet society. The artists Dmitry Prigov, Boris Orlov, and Vyacheslav Lebedev, for example—who in the 1970s carried on a creative dialogue with the Sretensky Boulevard group, with the future practitioners of Sots Art, and with the group known as Collective Actions—nonetheless never joined these associations and also did not consider it necessary to form their own group. On the contrary, their exceptional social activism was extroverted rather than introverted, aimed within the huge, official Union of Soviet Artists, where they launched the action of debate through exhibitions—action which, despite the fact that it went through the legal motions, shook the foundations of Soviet aesthetic officialdom.

One can, of course, interpret the urge to form artistic groups as an effort to unite in the face of official culture, but it also had typically Russian roots in the much-touted phenomena of *sobornost* (the old Russian local ecumenical councils), "peasant communes," and "collectivism." In an artistic context, however, these features of the Russian mentality meant only that the associations turned out to be too large and too universalist—so ecumenical, indeed, as to be, finally, unstable and ephemeral. If the motive for coming together was purely aesthetic, based on a common artistic program, the groups were fragile and had few members. In groups with a Jewish element, the isolationist aim became clearer and more acknowledged in direct proportion as Jewish identity declared itself more and more openly in Soviet society.

The Sretensky Boulevard group, which formed at the beginning of the 1970s, was far more united and elitist than the bohemian, open-ended Lianozovo Group that had appeared in the mid-1950s and that had included Oscar Rabin, Lev and Evgeny Kropivnitsky, Lidiya Masterkova, Vladimir Nemukhin, and others (see ill. 94). At the end of the 1970s, the conceptualist group Collective Actions (Andrei Monastyrsky, Igor Makarevich, Elena Elagina, Georgy Kizivalter, etc.) was seen as a secret order or

sect, surrounded by a tiny circle of comrades-in-arms. Its artistic activity was reduced to an endless series of performances by its members in the bosom of nature before a group of dedicated spectators that barely changed over the course of many years (fig. 1). The currently active group of young artists called Medical Hermeneutics (Pavel Peppershtein, Sergei Anufriev, and Yury Leiderman) cultivate an art of anonymity whose isolationism has led to escapism. The characteristic term *noma* that appeared in the young "hermeneuticists'" theoretical compositions denoted the whole tradition of conceptually

oriented Muscovite underground art, practically speaking all artists from Ilya Kabakov and Monastyrsky up to Medical Hermeneutics itself. In their texts, the work of well-known artists appears not so much as a living, spontaneous process as a kind of talmudically abstract and biblically epic construction. Thus, the paradigm of the "little ghetto" acquired, in the concept of the *noma*, its ontological justification and metaphysical status.

One principle that came to characterize the concept of the "little ghetto" was not so much its realization in the forms of direct representation, illusionary reconstruction, or living incarnation as its thematicization, its interpretation as self-evaluative experience. A central creative theme of a number of Jewish artists—and of some of the most important Russian artists, too—became the problem of the boundaries between particular and general, unique and universal, closed and open. In the work of Yankilevsky and Kabakov, this was especially apparent in the image of a cupboard as a metaphor for a private, isolated existence cut off from the limitless outside world. The actual structure of Yankilevsky's works, based on the triptych or polyptych (fig. 2), implied that some parts of a composition embodied the idea of a private, closed existence, while others implied the reverse, the limitless outside world. Here, the problem of boundaries took on dramatic forms. With Kabakov, we can see a metaphysical apologia for private existence, which must be lived through to its conclusion because it is the only route to the universal: a transcendent luminescence reaches the eyes of his protagonists only through an ordinary object of everyday life (fig. 3). The work of Erik Bulatov, in turn, can be seen as a phenomenological exploration of the boundaries between inner and outer, between the individual's personal experience and the leveling experience of the general and impersonal (see ill. 16). Here, the boundary becomes the governing motif of the work of art, embodied in the lines of the horizon, the emotional contours of the object, the surface of the painting itself (fig. 4). A very typical way of realizing this isolated identity is a tendency to reveal the universal within the individual—generality within subjectivity—using the strategy of the mystic. This strategy, highly prevalent in the work of Jewish artists, also runs through the entire history of Russian artistic culture, linking artists of completely separate generations. Among these, for example, are Dmitry Lion, Pivovarov (see ill. 91), and Kabakov—and the tradition undoubtedly goes back to the art of Chagall (see ill. 18).

Another feature specific to Jewish artists in Russia flows naturally out of those preceding—that is,

Fig. 1
Collective Actions
Ten Appearances, 1981
Performance, Moscow

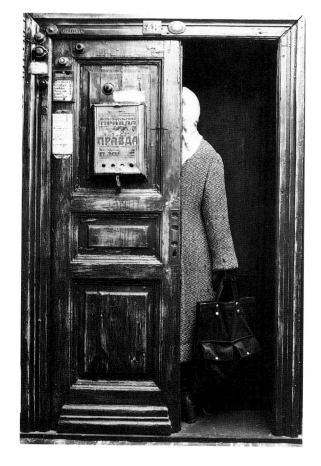

Fig. 2
Vladimir Yankilevsky
Pentaptychon No. 2
(Adam & Eve), 1980
Mixed media construction,
6 ft. 4⁵/₈ in. x 36 ft. 9 in. x 1 ft.
(1.9 x 11.2 x .3 m)
Jane Voorhees Zimmerli Art
Museum, Rutgers, The State
University of New Jersey,
New Brunswick, The
Norton and Nancy Dodge
Collection of Nonconform-
ist Art from the Soviet
Union

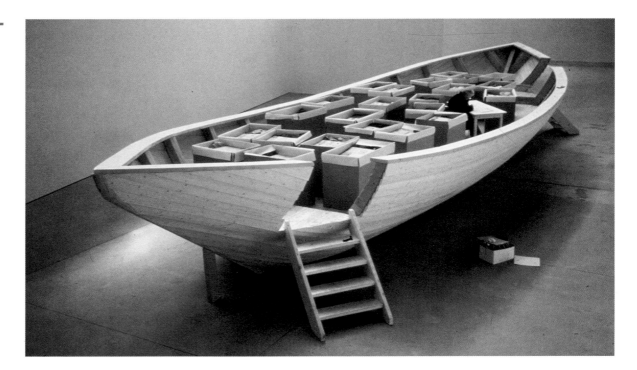

the specific perception of external reality which results in a consciousness that seeks distance and self-isolation. Such a consciousness unquestionably experiences the texture of life with extraordinary intensity and is especially effective in its analysis of the external signs of reality. In other words, to use a term once applied to the Russian Jewish writer Isaak Babel, it may be said that this kind of consciousness is realized in "the feeling description of the relief of life." What is at issue here is not intellectual superficiality, but the contempt for those efforts to identify oneself with reality, to penetrate "its unknown depths," so typical of the Russian creative temperament.

An intensely emotional depiction of reality was intrinsic to the Lianozovo Group, which stood at the source of alternative Muscovite culture. The main motif in Oscar Rabin's work became the black prison camp barracks that surrounded the village of Lianozovo, outside Moscow, where the members of this creative group gathered at an old dacha (see ill. 95). The notion of texture was expressed quite literally, as if the paint-encrusted surface of the canvas was imitating the bumpy surface of the log buildings. The texture itself intensified the emotional meanings—and, through them, the social meanings—of the works. The next step, which followed naturally from this sensuous depiction through texture, was the disclosure of the heraldic, symbolic nature of reality. Rabin was the first to take this step, with his *Passport*, a classic work of Russian art, in which he reproduced, in a style reminiscent of Pop Art, his own identity card turned back to front (see ill. 93).

The artist Mikhail Roginsky evolved analogously but far more radically. Starting with stylized Moscow landscapes, he moved on to create not just one (perhaps unintentionally) but a whole series of proto-Pop works that were fragmentary reproductions of objects of everyday reality—a tiled kitchen wall, an apartment door, a primus stove, and so forth (see ill. 97). The artists who developed this Russian variant of New Realism most consistently, at the same time as Roginsky, were Boris Turetsky and Yury Zlotnikov (in an early stage of his career), both of Jewish origin. This "new objectivism" vividly exposed its genetic ties to the textural studies of the

93

period that preceded it: the paint surface itself intensified its own representation of motifs from the outside world. These works, reproducing store windows (in Zlotnikov's case) or people seen on Moscow's subway (in Turetsky's), convey the experience of a consciousness aloof from reality—at times violently recoiling from it.

The next stage in the mastery of this problem of surface is typified in the work of Bulatov, for whom the problem of how things are perceived became central. "The refusal to penetrate a thing, but to remain on its surface" is Bulatov's leitmotiv. The contours of objects in his work are stained with a representation of the color spectrum, and thus what we see in his paintings is not the actual image of reality, but only its optical membrane. For Bulatov, the act of seeing is the basic principle. The element of light, defining as it does the phenomena of the visible world, carries with it a substantively ontological character (see pl. 41). From this idea stems the exceptional importance of the painting process in the reconstruction of the world of objects. The world can be grasped only when it has undergone a concentrated process of molding visual experience and organizing it in a purposeful, willed fashion. Thus, in the art of Bulatov the experience of observation, estranged from contemplation, acquires a global, existential sense, as if constructing a whole world. It should also be noted that Bulatov's work epitomizes another typical Muscovite art tradition, defined, to a great extent, by Jewish artists: the deeply felt phenomenological analysis of visual perception and exploitation of reductionist processes seen in the ascetic still lifes of Vladimir Weisberg (see ill. 124). Bulatov was drawn, in turn, through his connection to another artistic tradition, that of Rabin and Roginsky, to social questions. Through analysis of ordinary perception, he came to work with the production of political propaganda on a

large scale. It was Bulatov's propaganda pieces that became the inspiration for a number of artists whose work had a much more significant impact on Russian art of the postwar period—work known as Sots Art.

Vitaly Komar and Alexander Melamid introduced the term "Sots Art" to describe a strategy of manipulation and appropriation of official Soviet symbols, iconography, and graphic styles. In addition to Bulatov, Kabakov, Alexander Kosolapov, and Leonid Lamm—all Jewish artists—were also involved in developing the strategy. Their approach introduced completely new emphases into the experience of observation from afar. Sots Art, after all, is nothing but another example of an apologia for the meaningfulness of the external appearance of phenomena, since at its heart lies the conviction that the deconstruction of official ideology is possible through the manipulation of its external attributes (see ill. 61). The work of artists such as Orlov, Rostislav Lebedev, and Dmitry Prigov also has close ties with the poetics of Sots Art, although distinctions between the two groups of artists are extremely significant. In essence, this has to do with the interpretation of the external reality that is appropriated. What is important in the work of Orlov, Lebedev, and Prigov is that it is never appropriated literally. Their borrowing of official symbolism is only partial, involving isolated elements made into conglomerations of images that appear as metaphors rather than as authentic "givens." By contrasting this work with Sots Art, it becomes clear that it is Jewish artists who, possessing the advantage of an estranged perception, have absorbed most intensely the aesthetic expressiveness of Soviet ideological and social reality in all its nakedness. Paradoxically but typically, the Sots artists have produced their most significant work outside Russia.

If we recognize that being closed off and distanced have been characteristic features of Jewish experience, then another feature of Jewish art suggests itself: an on-going tendency to conquer self and go beyond self-assigned limits. Such work invariably strives toward universalism, toward universal horizons, and carries within itself the paradigm of the utopian dreams of shtetl dwellers. Among a number of artists, this striving is revealed in emotional form, in an unusually powerful spiritual impulse that seems poised to comprehend the universe. These artists also lean to a large degree on the tradition of Chagall, whose work, as is often remarked, is deeply rooted in the Hasidic experience (see ill. 17). The most typical individuals are Yury Zlotnikov and Dmitry Lion (see ill. 67), both romantic artists whose abstract works, in contrast to

Artist Unknown
Artists in First Uncensored Perestroika Exhibition,
ca. 1985
Photograph, 6¹/₂ x 9³/₄ in. (16.5 x 24.8 cm)
Collection Grisha Bruskin, New York

the lyrical abstractionism of purely Russian artists such as Vladimir Nemukhin, Vladimir Naumts, and so on, completely lack a harmonizing basis, but celebrate mystical ecstasy and exultation.

The language of abstract painting, however, allows universalist yearning to be realized in other ways. In the early 1950s, Zlotnikov laid the foundations of nonfigurative geometric imagery in his famous Signals series, purely painterly compositions that were utopian in their world-transforming communication and cosmopolitan in their imagery. On a parallel course, Boris Turetsky also turned to the language of painterly archetypes, linking it to the possibility of describing "everything" and the total exhaustion of existence (see ill. 118). Characteristically, the third of the Moscow artists to develop an abstract, geometric imagery at this time, Mikhail Chernyshev, lacking any Jewish connection, appeared completely free from ties to universalist abstraction. His work, based on the notion of art as a concrete act of communication, moved in the direction of Pop Art and socially oriented performance.

The understanding of art as the search for an ontology, and of works of art as a microcosm, a model of existence, is the driving force behind the Moscow art scene today. At its source lie the monumental productions of Ernst Neizvestny, invariably aiming for utopian, unrealizable projects that aspire to a universal synthesis of the history of humankind (fig. 5). This tendency to universalism—although more in the form of an anti-utopia than that of a utopia—has emerged in Kabakov's mature installations, in which the mind of society is present in all its layers, from the garbage of human existence to the divine light. The work of this artist, like any deconstructionist strategy, is doomed, ultimately, to being

rooted in the object being deconstructed. Thus, having set himself the task of conquering the Soviet ideological myth, Kabakov nonetheless inevitably—although completely consciously—has made the Soviet ideological myth immanent in his art. Lastly, the aim of creating a universalist language of description is present even in the title of Grisha Bruskin's *Lexicons* cycle, in which the emblems of Soviet officialdom are linked to the symbols of Jewish mysticism (see pl. 46); thus, two languages, universalist by definition, are linked to produce another, meta-universalist linguistic construction (see ill. 12). Clearly, this inclination toward a possibility of universal depiction is the natural reverse of a predisposition to distancing and closing oneself off. Only by alienating oneself from a phenomenon is one able to produce an independent structural model; only when one is closed off from "everything" can one discover the urge to depict that "everything" exhaustively.

One final characteristic of the Russian artistic mentality colored by its Jewish roots should be mentioned: a consciousness inclined to experience the texture of objects of a foreign reality with special intensity and to identify with it—in other words, to experience "another's as one's own." This characteristic is particularly clear in the work of Vladimir Yakovlev, an astonishingly organic artist who, without trace of mannerism, has appropriated the imagery of children's art. Yakovlev found himself in alignment with two other artists of the generation of the 1960s, Anatoly Zverev and Vyacheslav Kalinin, both leaning toward neo-expressionism. Zverev's relaxed, painterly mastery was entirely free of stylization, while Kalinin, although unusually interested in appropriation and "migrating" through styles from naive to Dutch painting, nonetheless did not identify with any one borrowed style and continually emphasized the fictitiousness and lack of authenticity of his models. In other words, one of Yakovlev's former comrades-in-arms was not inclined to turn to an "other," while the second, though he did turn to that "other," was not inclined to accept it as "his own."

A number of other artists produced work that exploited an existing stylistic or linguistic model. The work of Eduard Gorokhovsky is based entirely on the manipulation and wholehearted reworking of other styles (see ill. 34). Eduard Shteinberg's work is built on the experience of Suprematist imagery (see ill. 108). Viktor Pivovarov demonstrates an exceptional stylistic mobility and omnivorousness combined with a rare ability to take on radically differing styles and languages without losing his artistic identity (see ill. 92).

Fig. 5
Ernst Neizvestny
Tree of Life, 1968–76
Ink on paper, 12 x 19¹/₂ in.
(30.5 x 49.5 cm)
Collection of the Artist,
New York

Of course, the practitioners of Sots Art propounded a very particular type of identification with the opposition, not without paradox. Bulatov experienced this process of recognizing "another's as one's own"—that is, revealing one's own complicity in the official ideology, one's inability to isolate oneself completely from the surrounding mind of society—as a drama. Putting the symbols of Soviet propaganda on his canvases is at bottom an act of exorcism; it is as if he extracts them from his subconscious, brings them to the surface, and, by this act, liberates himself from them. For Komar and Melamid, the identification with the ideological "other" also performed a liberating, prophylactic function (see ill. 51). In essence, *Sometime in Childhood I Saw Stalin* (New York, Museum of Modern Art) points the finger directly at their own—and everyone else's—participation in the life around them. It is also deeply lyrical. From the distance of emigration, the "other" Soviet official aesthetic is perceived as something very intimate—"one's own."

Kabakov, sharing the paradoxes of the Sots artists' identification with Soviet reality, proposed within this strategy a device that has become widespread, the so-called "character piece" (brilliantly realized by Komar and Melamid as well as others). This strategy results in the summoning up of a fictitious character, by whom the work of art is created. This person is, more often than not, a *khalturshchik*—a hack worker or semiprofessional artist who comes forward as the bearer of some kind of Soviet experience. In this way, the strategy of experiencing "another's as one's own" takes on an extremely radical form: the "other," the opposition, is admitted within the limits of one's identity. This splitting of identity—this understanding of how problematic and relative any statement with a claim to integrity and internal completeness must be—lay at the heart of the poetics of Moscow conceptualism as it was realized in the work of Monastyrsky, Pivovarov, Yury Albert, Medical Hermeneutics, and others. The matter at hand was the search for an adequate ethical position and the rejection of didactic moralizing. This position matured in the early 1970s amid the triumphant ethical zeal of the time for denunciation and re-denunciation; it attempted to expose, as far as possible, the ephemerality of any claims to the right to be judged by a higher authority or an impartial court. The problem of ethics became an individual affair, offering what amounted to a strategy of personal salvation. Thus, we return to the starting point of our analysis: the urge among artists and intellectuals of Jewish extraction to make their spiritual experience intimate and private.

The complex, many-sided identity distinguishing Russian Jewry in the final decades of the Soviet Union's existence determined its particular and unique place in the social and cultural context. The absence for Jewry of any set geographic borders or political support, the Jews' unalterable striving for a way leading beyond their own limits to some universalist perspective, their readiness to identify with something outside themselves, lent them a kind of meta-position in the context of the Soviet nations despite the latter's possession of geographic frontiers and autonomous political institutions. The result was that this Jewish identity became the only adequate ideology of utopia and universalism in the entire country. In other words, Jewish identity was the only true *Soviet* identity—in the full sense of the word—that is, not Russian, which would not have been adequate, and not purely Jewish, which would have been out of place. It is because of this that Kabakov—the most renowned Russian artist of our time—has every reason not to return to the new, postcommunist Russia, considering himself to be a citizen of another country and a *Soviet* artist. At the same time, Jewish identity, capable of omnivorousness and of self-transcendence, has shown itself open to outside experiences and values and thus has undermined official dogma and Soviet xenophobia. Russian Jewry, with its bent for distancing itself, took upon itself the role of leader in forming a critical position in relation to Soviet reality. This is why Jewish identification of self in the Soviet context stands not so much for an ethnic or confessional identity as for a cultural one—and, above all, an ethical and political one. This is why it is not merely those who are born Jewish who have identified themselves in recent years with Jewishness, but all those at the boundaries of the repressive Soviet regime with a claim to spiritual and individual autonomy. Since Stalin's death, being Jewish has not been an ethnic reality, but an ethical choice.

Viktor Misiano
is a director of the Contemporary Art Centre, Moscow, and Editor-in-Chief of *Moscow Art Magazine*.

Plates

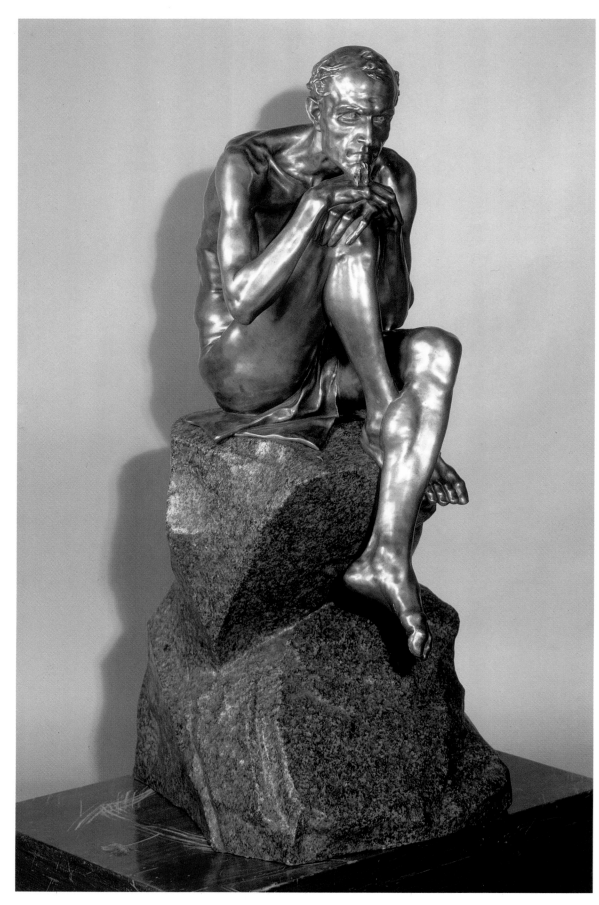

Plate 1
Mark Antokolsky, *Mephistopheles*, ca. 1880

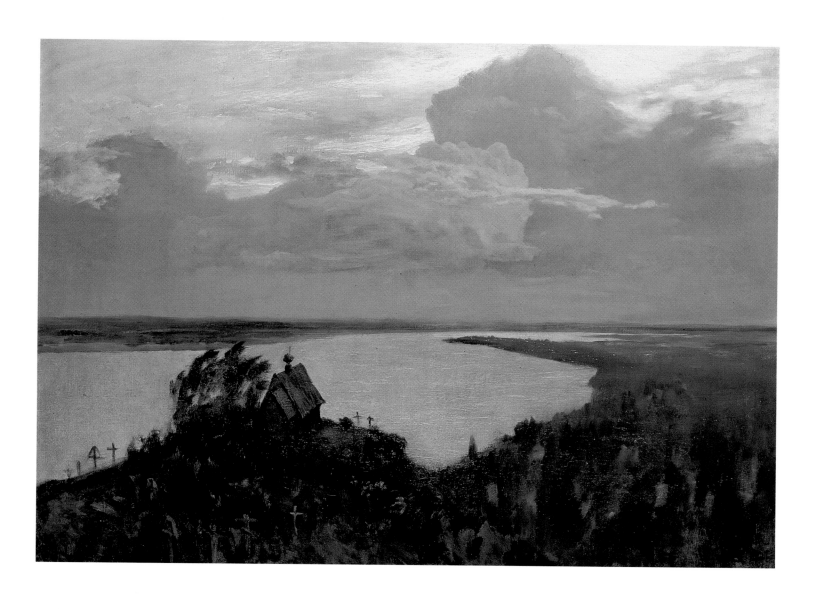

Plate 2
Isaak Levitan, *Study for Above Eternal Peace*, 1894

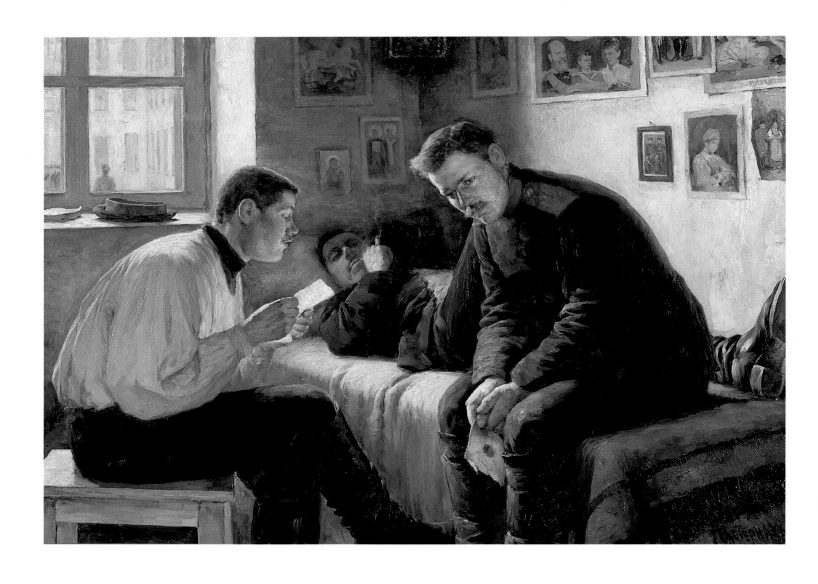

Plate 3
Leonid Pasternak, *News from the Motherland*, 1889

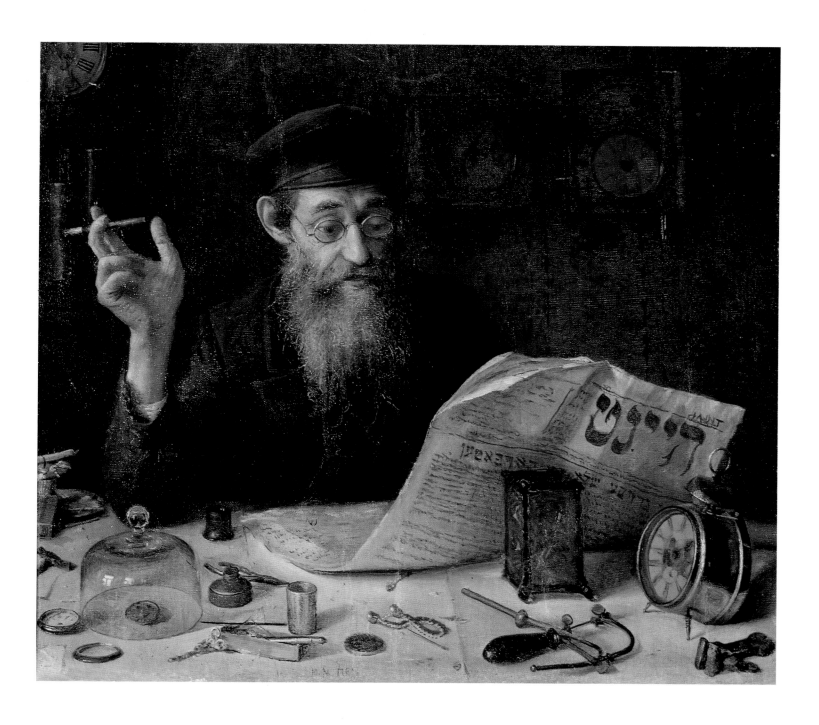

Plate 4
Yehuda Pen, *The Watchmaker*, 1914

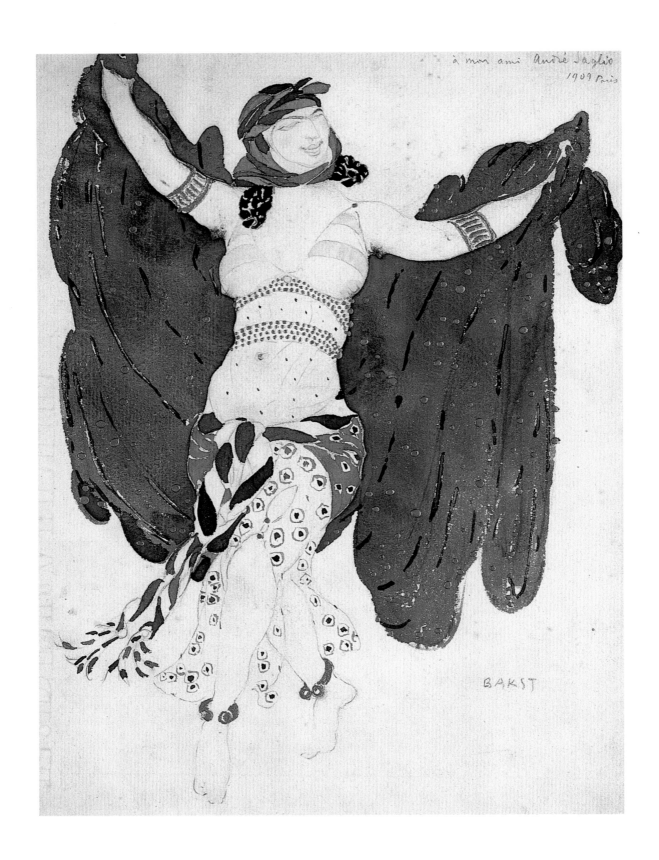

à mon ami André Saglio
1909 Paris

BAKST

Plate 5
Léon Bakst, *Syrian Dancer* (Costume Design for *Cleopatra*), 1909

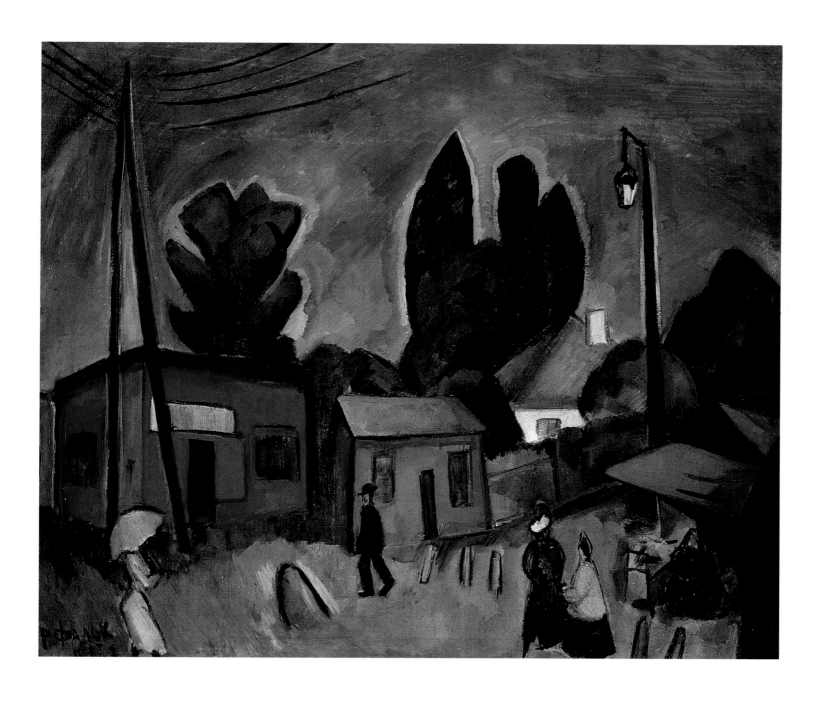

Plate 6
Robert Falk, *Environs of Moscow*, 1912

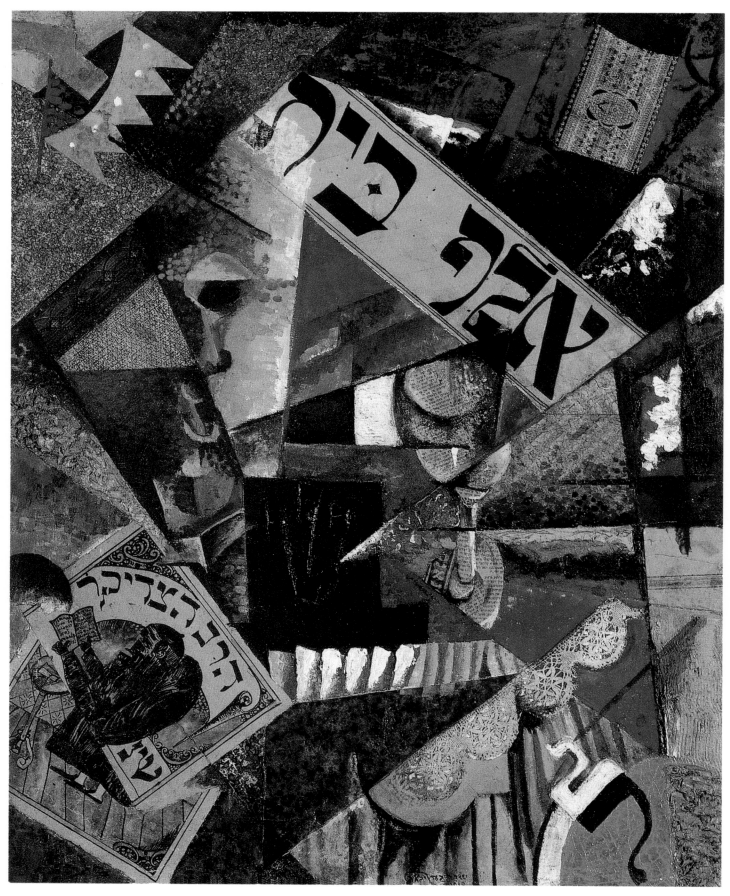

Plate 7
Issachar Ryback, *Aleph–Beth*, 1918

Plate 8
El Lissitzky, "Then Came a Fire and Burnt the Stick" from *Had Gadya Suite*, 1919

Plate 9
Marc Chagall, *The Cemetery*, 1917

Plate 10
Abraham Manievich, *Destruction of the Ghetto, Kiev*, 1919

Plate 11
Lazar Khidekel, *Suprematist Concentric Circles*, 1921

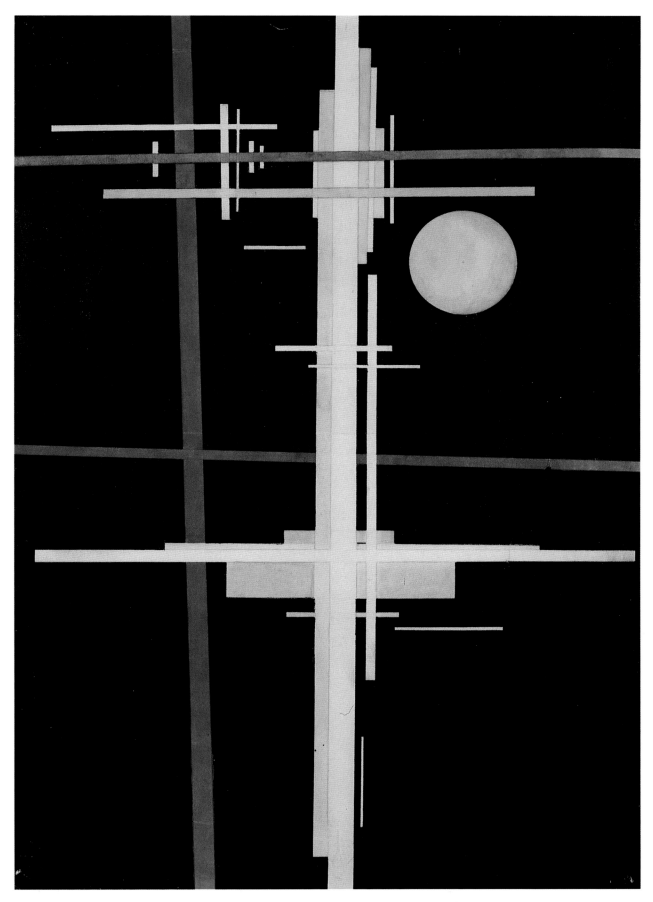

Plate 12
Ilya Chashnik, *Suprematist Composition*, 1926–27

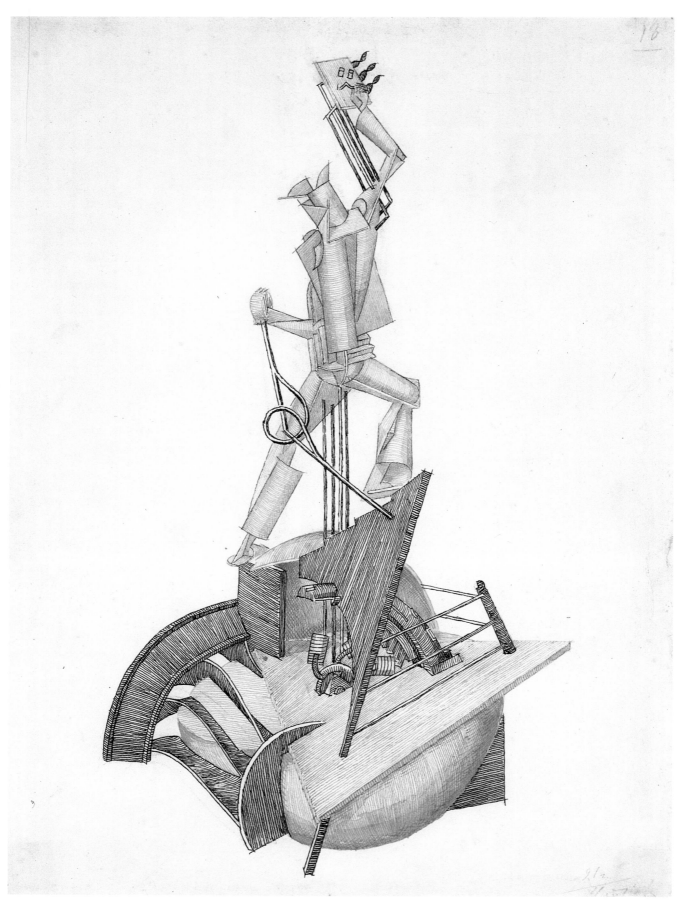

Plate 13
Iosif Chaikov, *Electrifier*, 1921

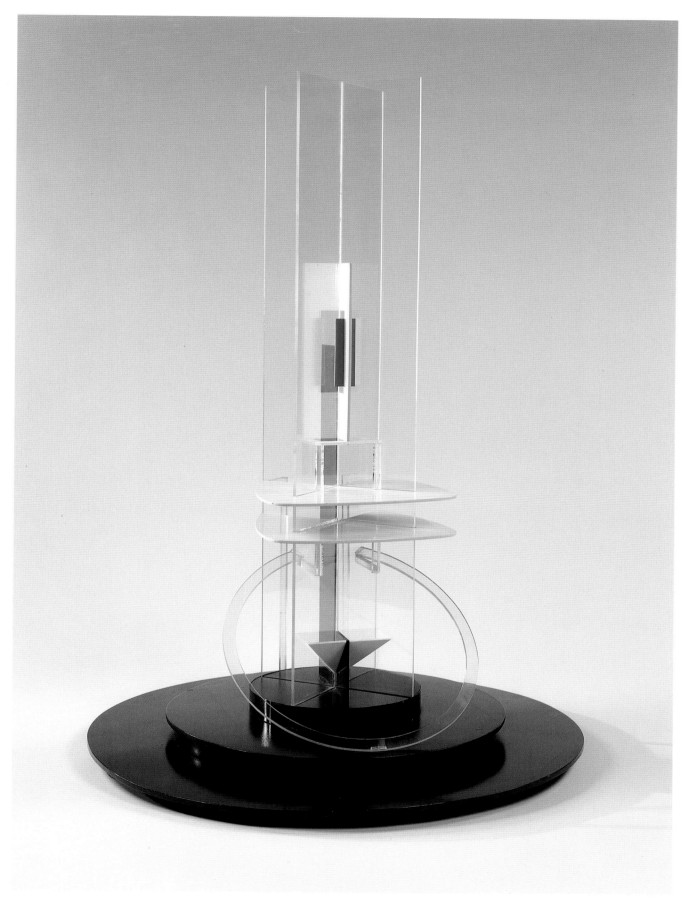

Plate 14
Naum Gabo, *Column*, ca. 1923

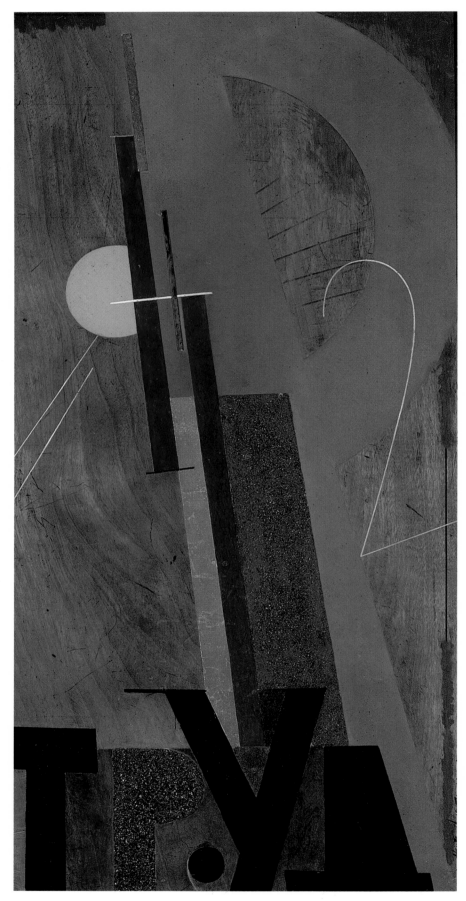

Plate 15
Natan Altman, *Russian Labor*, 1921

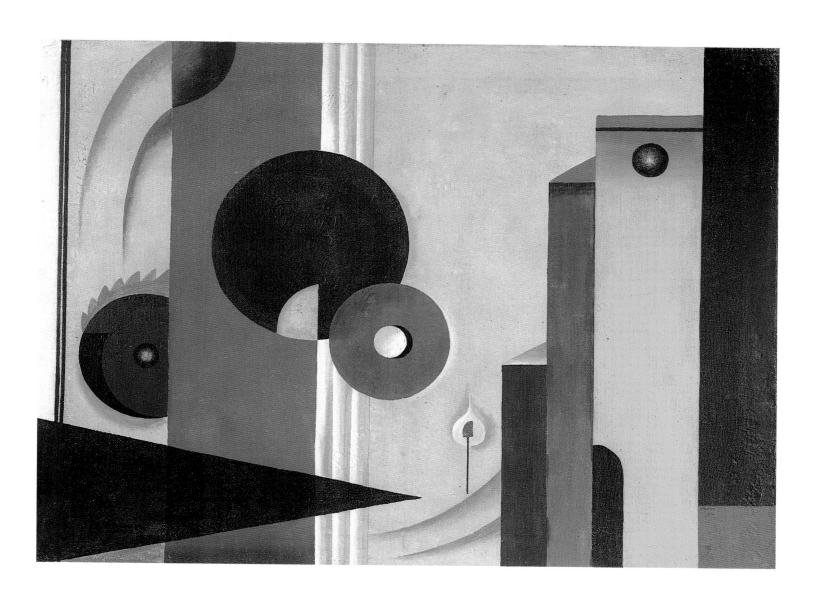

Plate 16
Anna Kagan, *Suprematist Architectonic Composition*, 1926

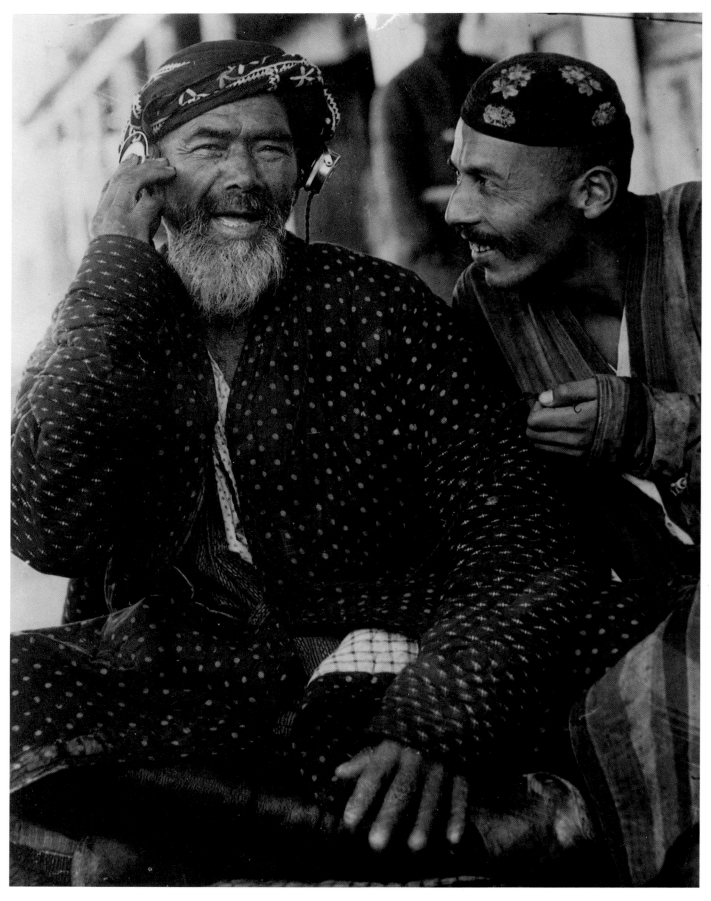

Plate 17
Georgy Zelma, *The Voice of Moscow, Uzbekistan*, 1925

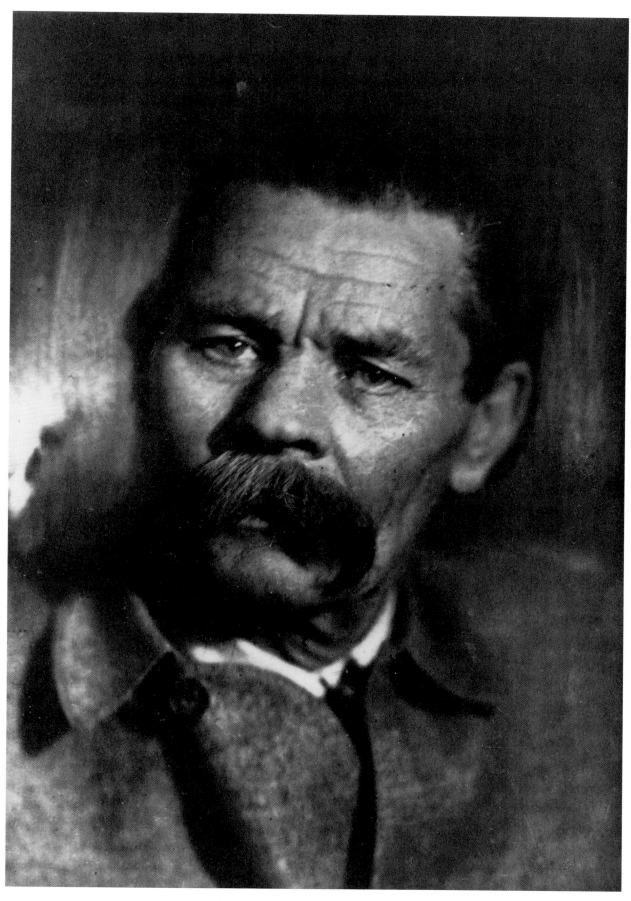

Plate 18
Moisei Nappelbaum, *Maxim Gorky*, 1927

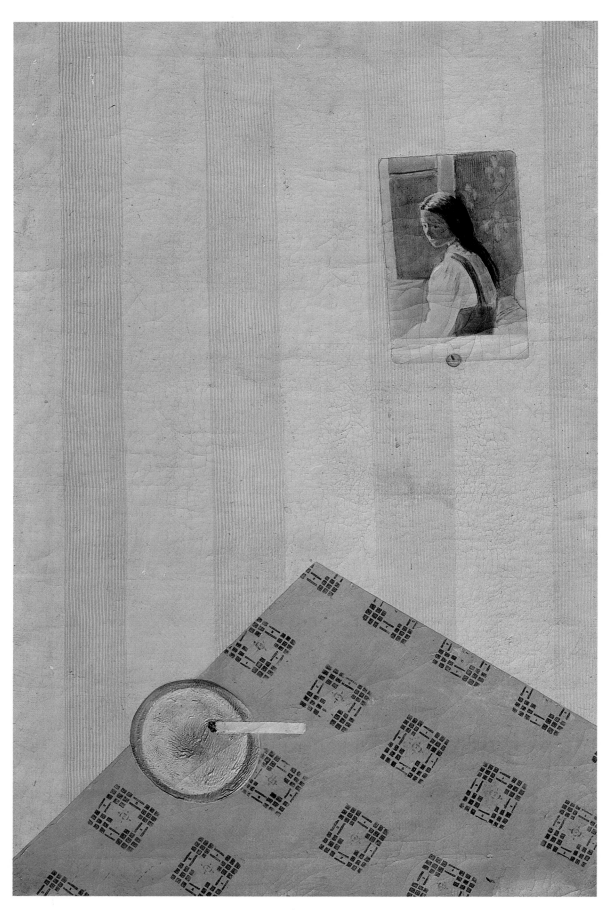

Plate 19
David Shterenberg, *Still Life with Picture on Wall*, ca. 1925

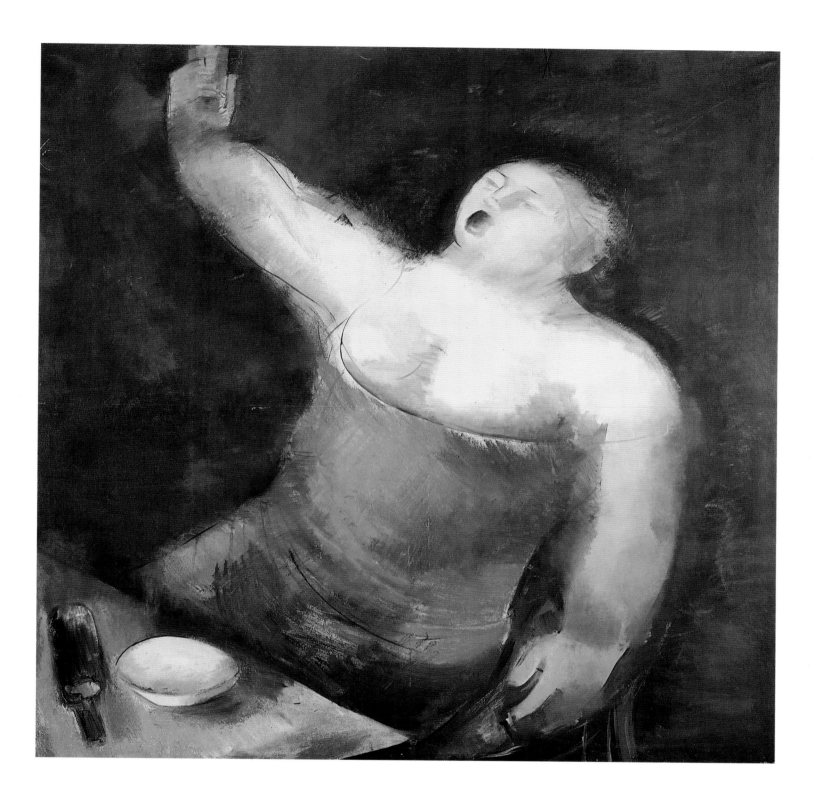

Plate 20
Solomon Nikritin, *Screaming Woman*, 1928

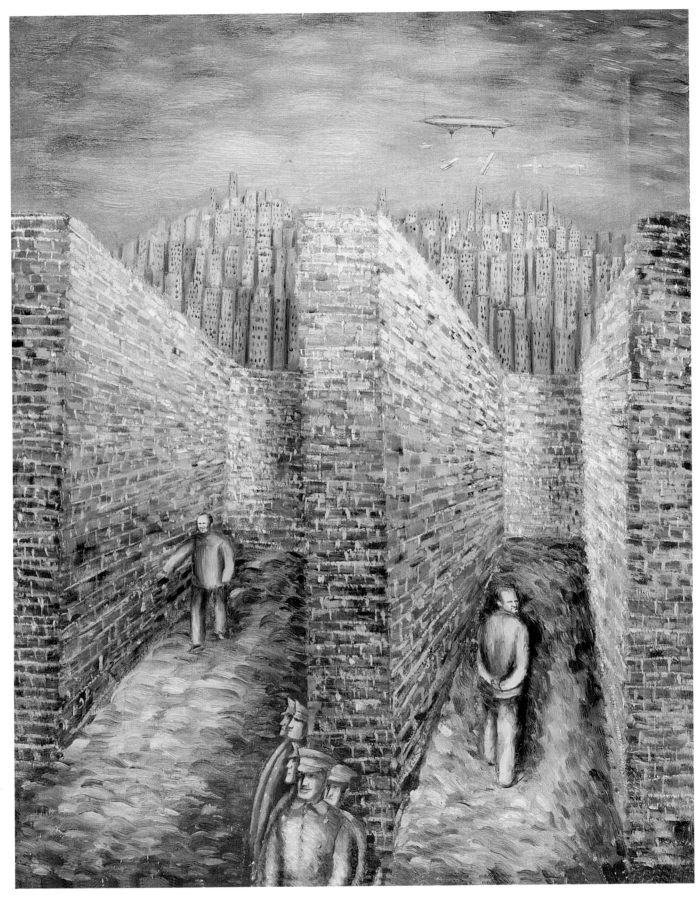

Plate 21
Alexander Tyshler, *Sacco and Vanzetti*, 1927

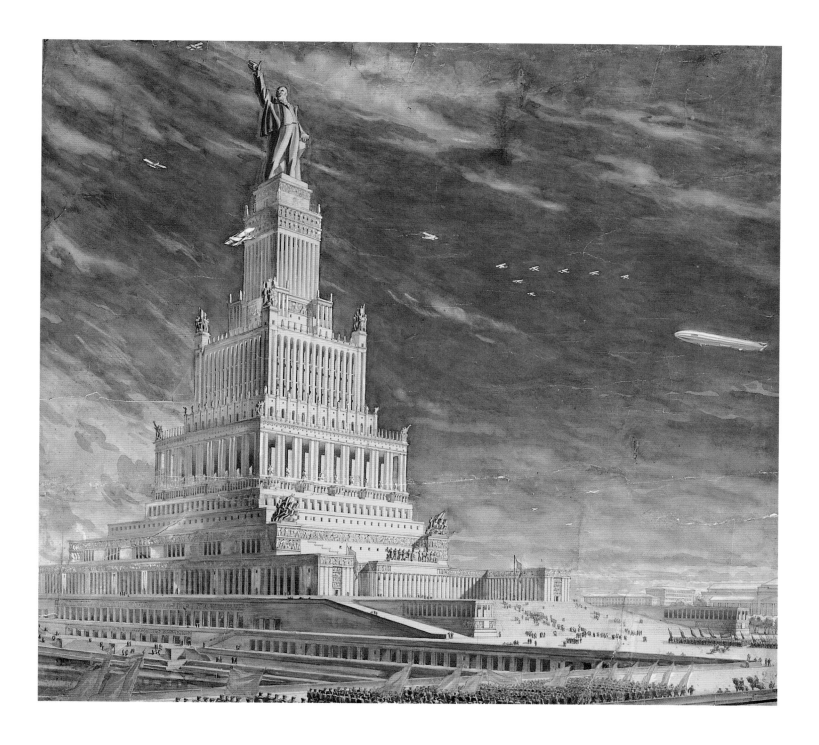

Plate 22
Boris Iofan with B. Shchuko and V. Gelfreikh, *Perspective for the Palace of Soviets, Moscow* (Competition Project), 1933

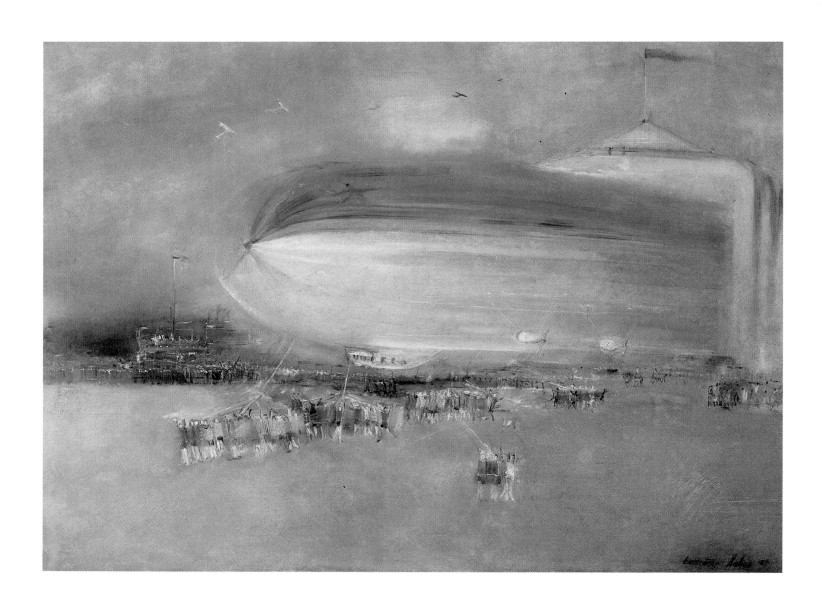

Plate 23
Alexander Labas, *The First Soviet Dirigible*, 1931

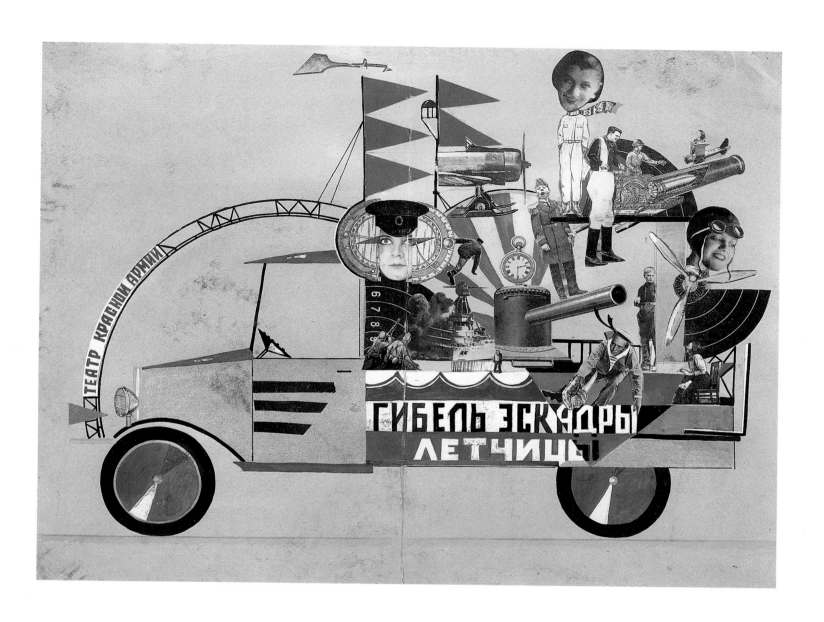

Plate 24
Solomon Telingater, *Design for Decoration of Red Army Theater Truck*, 1932

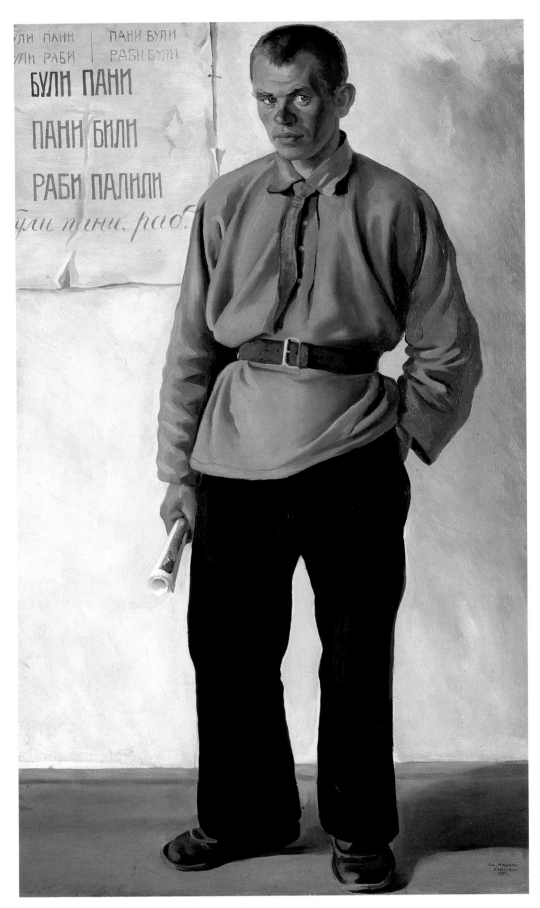

Plate 25
Evgeny Katsman, *Village Teacher*, 1925

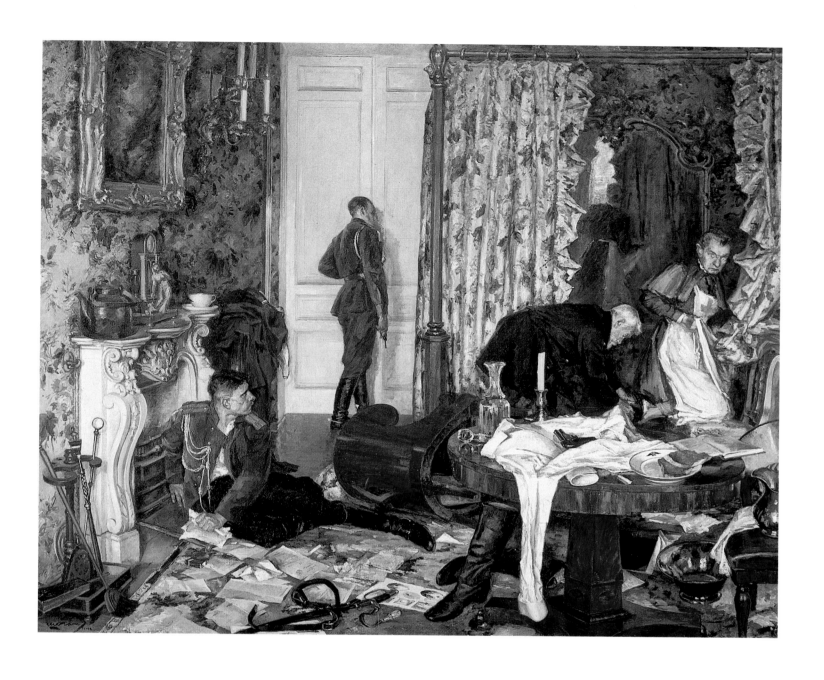

Plate 26
Grigory Shegal, *Kerensky's Flight from Gatchina in 1917*, 1936–38

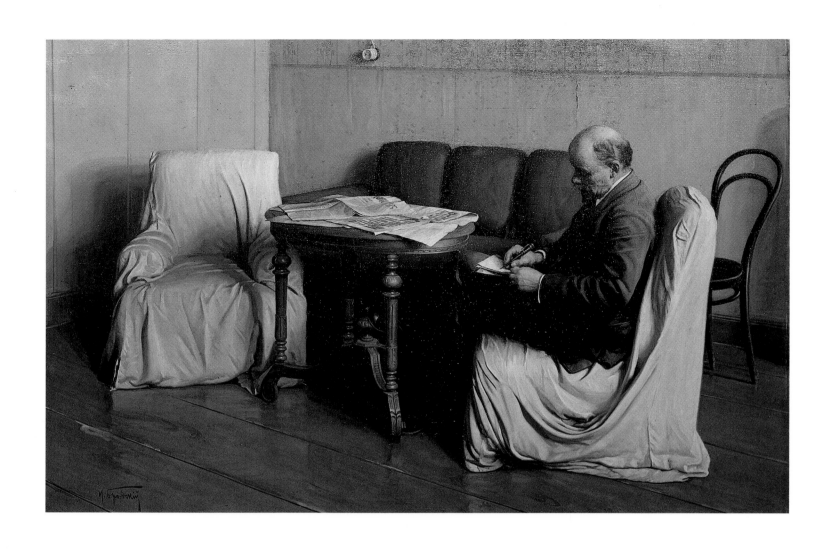

Plate 27
Isaak Brodsky, *Vladimir Ilich Lenin at the Smolny Institute,* 1937

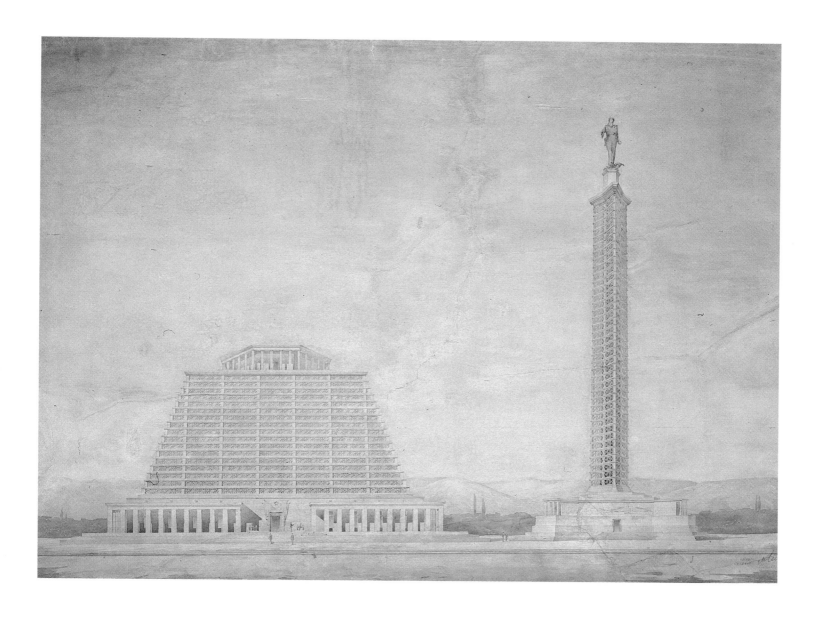

Plate 28
Moisei Ginzburg, *Project for the Rebuilding of Downtown Sevastopol—Twice-Defended Square*, 1943

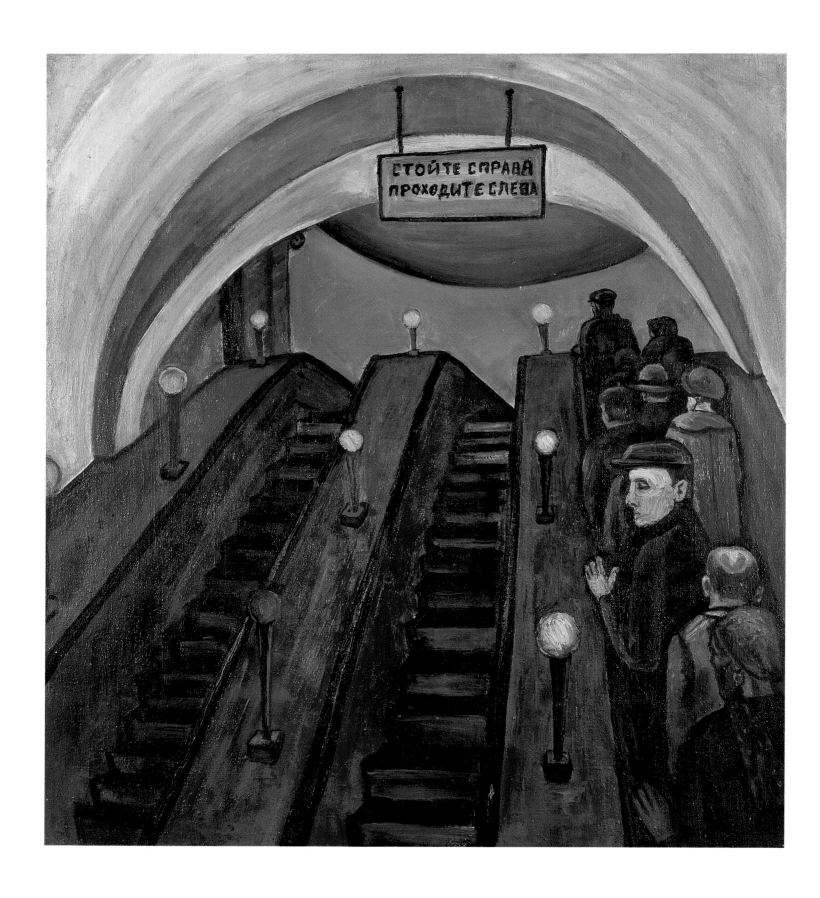

Plate 29
Mikhail Roginsky, *Metro*, 1962

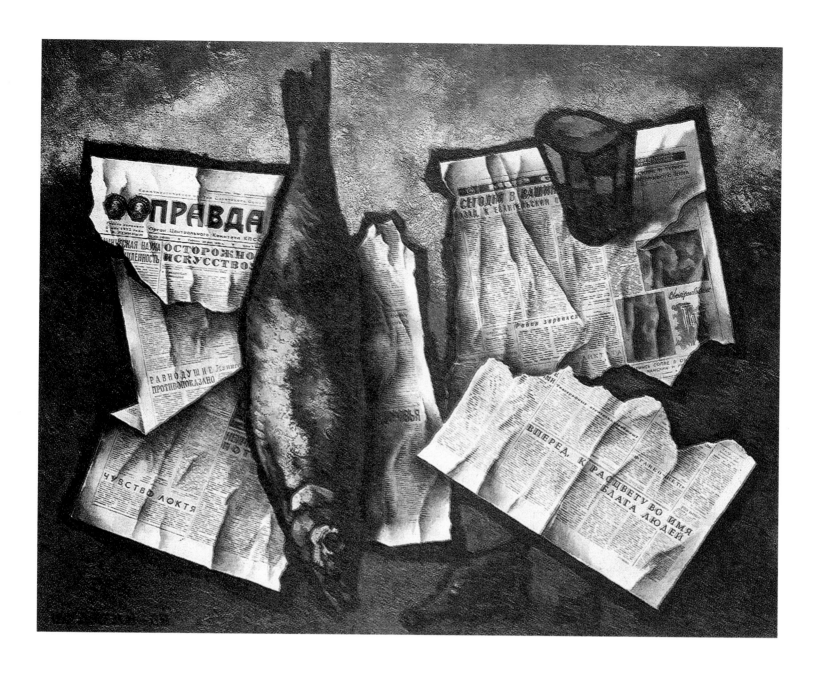

Plate 30
Oscar Rabin, *Still Life with Fish and Newspaper "Pravda" 7*, 1968

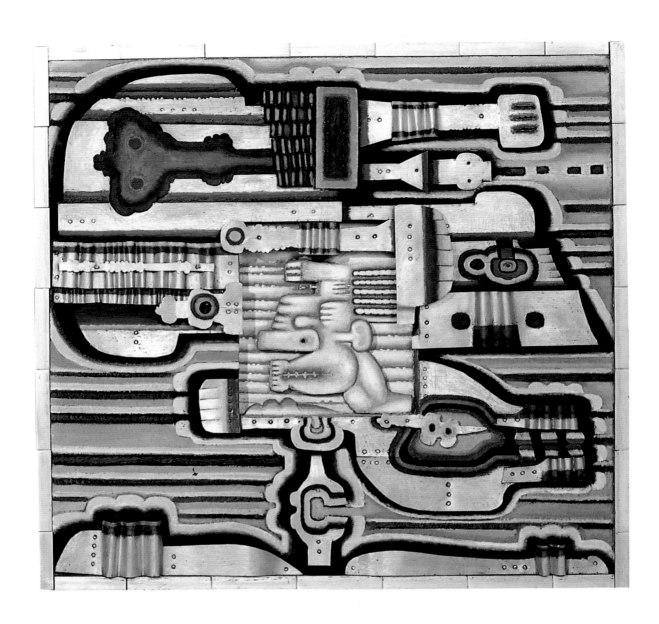

Plate 31
Vladimir Yankilevsky, *Triptychon No. 4* (detail), 1964

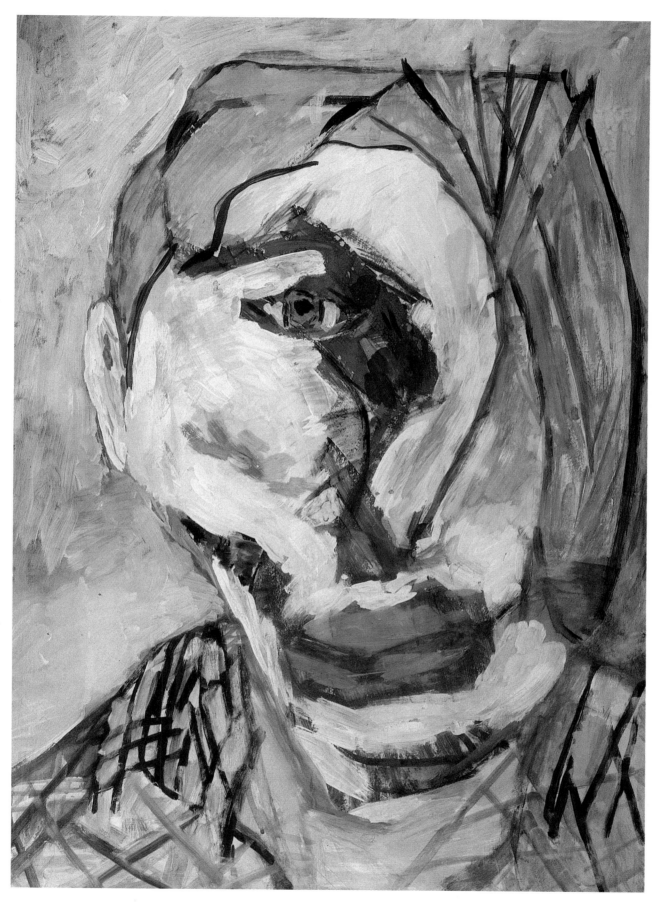

Plate 32
Vladimir Yakovlev, *Portrait of Boris Pasternak*, 1974–77

Plate 33
Oleg Tselkov, *Still Life*, 1965

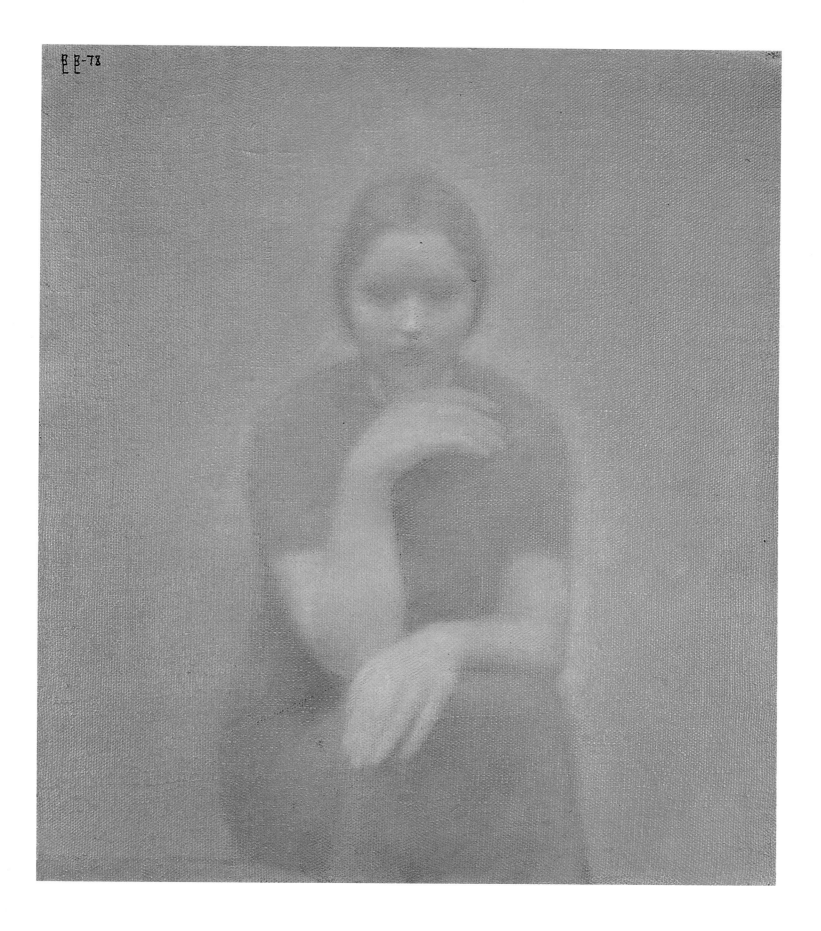

Plate 34
Vladimir Weisberg, *Portrait of Olga Kikina*, 1978

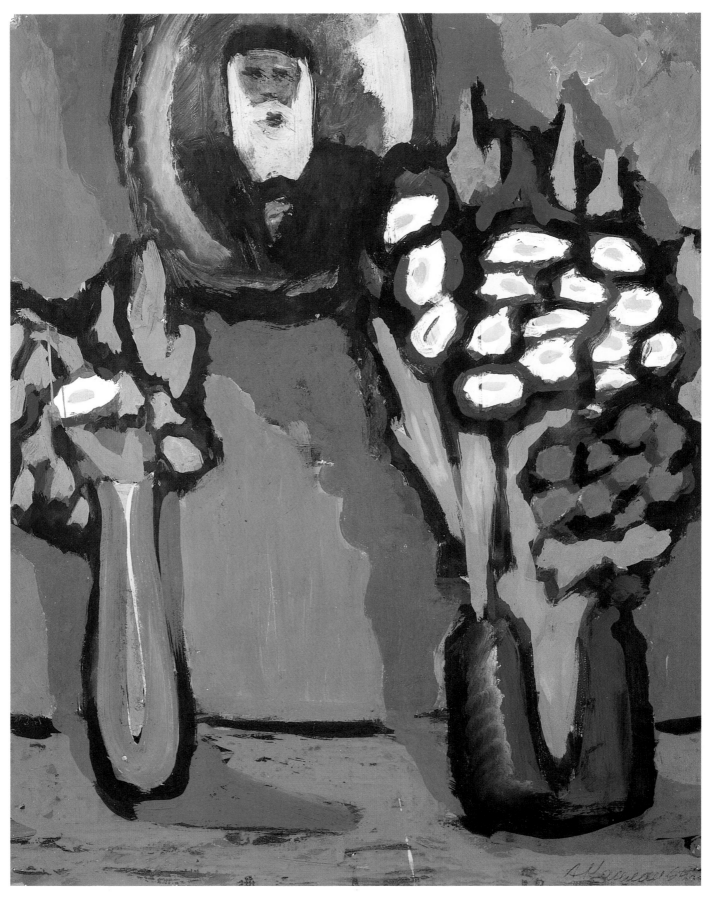

Plate 35
Anatoly Kaplan, *Flowers and Portrait*, 1964

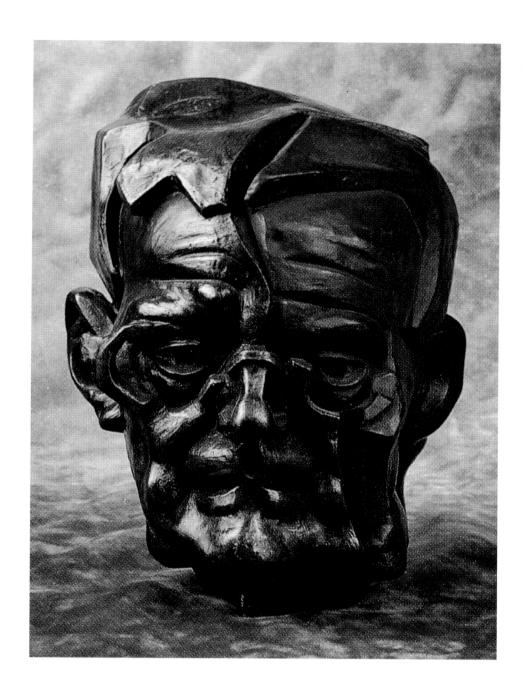

Plate 36
Ernst Neizvestny, *Dmitry Shostakovich*, 1976

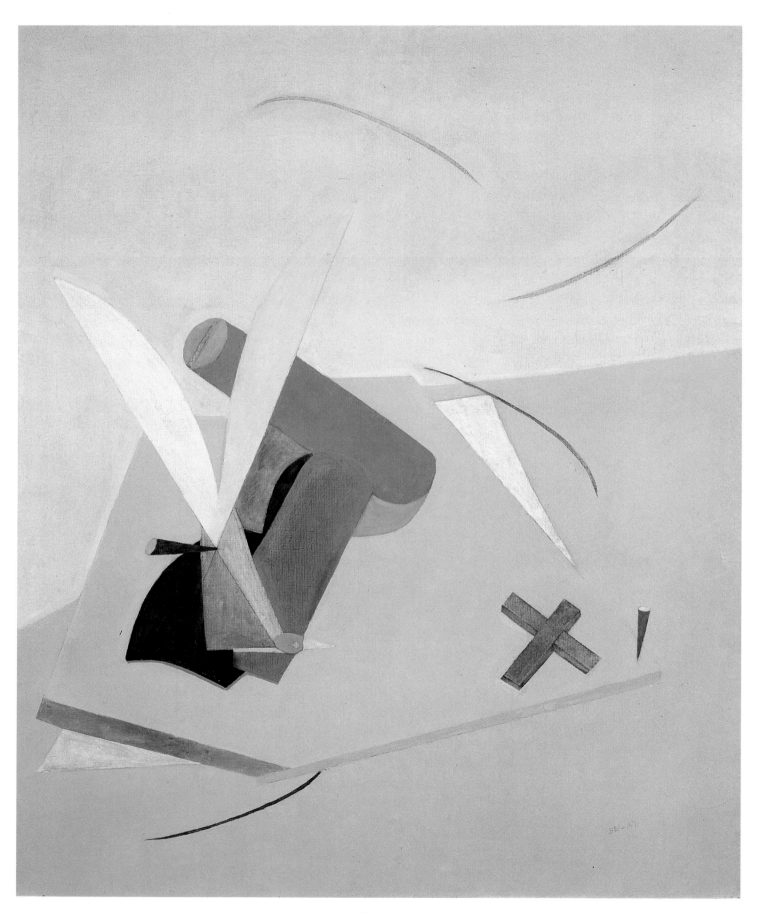

Plate 37
Eduard Shteinberg, *Abstract Composition*, 1969–70

Plate 38
Alexander Kosolapov, *Aurora*, 1973

Plate 39
Ilya Kabakov, *Answers of an Experimental Group*, 1970–71

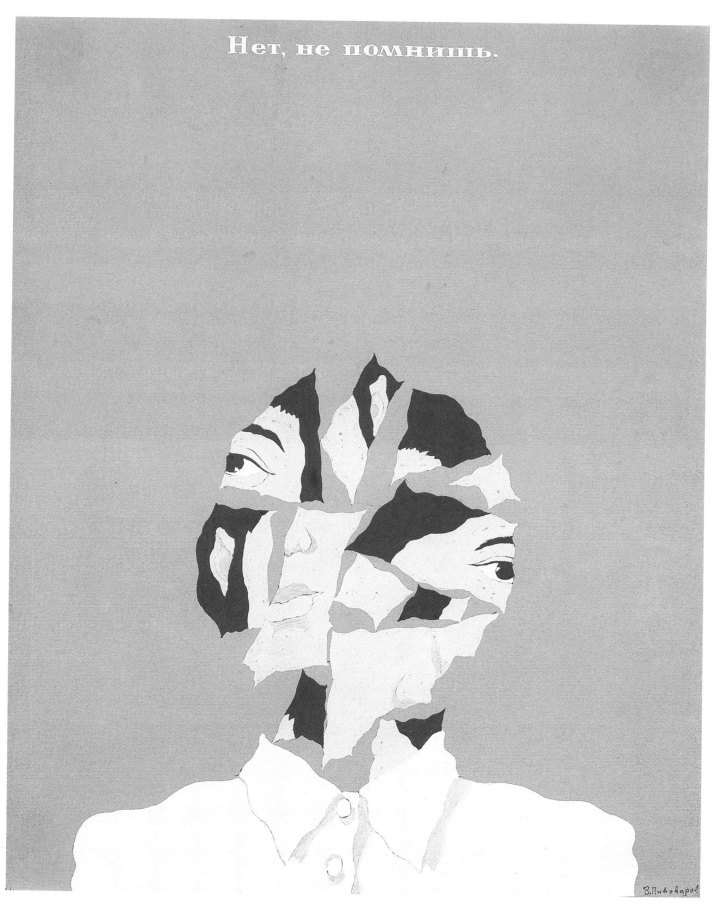

Нет, не помнишь.

Plate 40
Viktor Pivovarov, *No, You Don't Remember* (from *Do You Remember Me?*) 1975

Plate 41
Erik Bulatov, *Welcome*, 1973–74

Plate 42
Vitaly Komar and Alexander Melamid, *Factory for the Production of Blue Smoke*, 1975

Plate 43
Boris Mihailov, *May Day Parade* (from *Sots Art Series I*), 1975

Plate 44
Eduard Gorokhovsky, *Spiele (Games)*, 1983, from a series of 9 works

Plate 45
Leonid Lamm, *Assembly Hall* (from *Butyrka Prison Series*), 1976–86

Plate 46
Grisha Bruskin, *Alefbet—Lexicon No. 4*, 1988

Biographies
of the Artists

Natan Isaevich
Altman
Vinnitsa 1889–
1970 Leningrad

From the outset of his career, Altman was involved in most aspects of Jewish national expression, and his work reflects the various contradictory movements that were part of the Moscow/St. Petersburg visual tradition. In Paris from 1910 to 1912, he associated with the Makhmadim; after moving back to Russia, he sketched tombstone reliefs in Shepetkova cemetery in Volhynia and published cubist versions of those sketches. In addition to exhibiting with the Union of Youth and the World of Art, his self-portrait, *Head of a Young Jew* (see ill. 1), exhibited in the fifth Jack of Diamonds exhibition in Moscow, was admired as an attempt to express Jewish national identity utilizing a contemporary style. He continued to submit works to the Salon des Indépendants in Paris and also contributed to the Futurist exhibition *0.10* in Petrograd. In 1916, he became a founding member of the Jewish Society for the Encouragement of the Arts in that city. Altman eagerly supported the Bolshevik Revolution and the new government as a member of Izo Narkompros during 1918–21. In 1919, he became a leading member of the Communist Futurists (Komfut) in Petrograd, where he worked on Lenin's Plan for Monumental Propaganda. He created a number of agitprop decorations, some for porcelain in collaboration with Mikhail Adamovich. His most striking public design was an ambitious scheme for Uritsky Square, Petrograd, for the first anniversary of the Bolshevik Revolution (Goodman, fig. 4). Altman taught at Svomas from 1918 to 1920, and in 1920 he made a series of sketches of Lenin and two bas-

reliefs commissioned by the government. Ten of these sketches published in 1921 formed the basis for many subsequent works of art. Altman's interpretation of Constructivism emerged in his nonfigurative paintings of the early 1920s (see pl. 15) and in his designs and decorations for the Habimah Theater and for Goset, Moscow, including designs for Semyon An-sky's 1922 production of *The Dybbuk* (see ill. 3). Altman mingled decorations taken from Jewish folk and religious art with geometric planes suspended from the theater flies. He adopted a more extreme Constructivist style for Alexander Granovsky's Goset production of Carl Gutzkow's *Uriel Accosta* (1922). He took part in the *Erste russische Kunstausstellung* in Berlin in 1922 and in the same year exhibited with Chagall and Shterenberg in the *Exhibition of the Three* in the Soviet Union. Altman accompanied Goset on its European tour in 1928. Returning to the USSR in 1931, he once again designed sets for Moscow theaters. He took part in the *Exhibition of Contemporary Art of Soviet Russia* in 1929 and in 1932 was included in *Artists of the RSFSR over the Last 15 Years* in Leningrad. In 1937, Altman was awarded a gold medal at the Exposition Universelle in Paris, and the following year he was given a solo exhibition in Moscow. Commissions came slowly during the 1940s and 1950s, but Altman remained active. His reputation was rehabilitated, and in 1968 he was named Honored Arts Worker. Solo exhibitions in Leningrad were held in 1938, 1940, 1941, 1961, 1964, and 1968.

Selected Bibliography

Arvatov, Boris. *Natan Altman.* Berlin: Petropolis, 1924.

Efros, Abram. *Profili.* Moscow: Federatsiya, 1930, pp. 247–88.

Etkind, Mark. *Natan Altman.* Moscow: Sovetskii khudozhnik, 1971. Rev. edn. Dresden: Verlag der Kunst, 1984.

Lozowick, Louis. "The Art of Nathan Altman." *Menorah Journal,* no. 12 (1926), pp. 35–36.

Molok, Yury. "Kak v zerkalo glyadela ya trevozhno . . ." *Akhmatovskii sbornik 1.* Paris: Institut National d'Etudes Slaves, 1989, pp. 43–52.

Osborn, Max. *Evreiskaya grafika Natana Altmana.* Berlin: Petropolis, 1923.

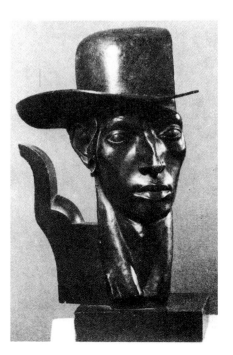

Ill. 1
Natan Altman, *Head of a Young Jew,* 1916

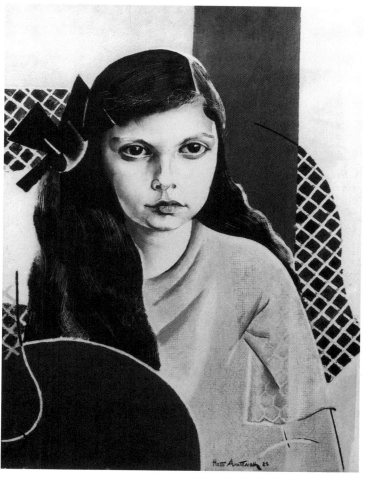

Ill. 2
Natan Altman, *Portrait of Silviya Grinberg*, 1923

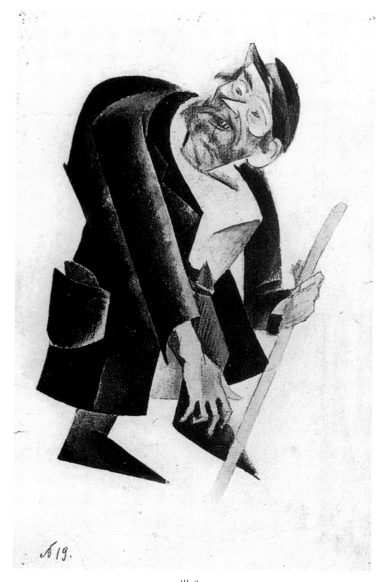

Ill. 3
Natan Altman, *Male Beggar* (Costume Design for *The Dybbuk*), 1920

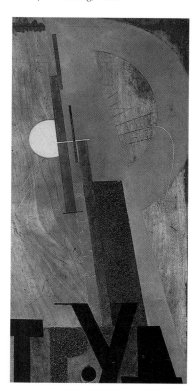

Plate 15
Natan Altman, *Russian Labor*, 1921

Mark Matveevich
(Mordukhai Matysevich)

Antokolsky

Vilna 1842–
1902 Bad Homburg

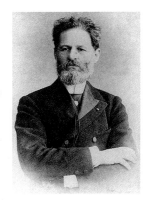

Antokolsky was the first internationally known Russian Jewish artist and the first Jewish student to be accepted at the Imperial Academy of Arts, St. Petersburg. Having been apprenticed to a woodcarver, his carvings of Christian figures attracted the attention of the wife of the governor-general of Vilna Province. With her assistance, Antokolsky traveled to St. Petersburg, where he received a stipend from Baron Horace Guenzberg to attend the Academy of Arts. In 1864, Antokolsky executed carvings of Jewish artisans and professionals, and for his final project, he carved a bas-relief, *Attack of the Inquisition on the Jews*, showing a raid on a secret Passover Seder in Spain. Disappointed by criticism of this work, he never again dealt explicitly with Jewish subjects, turning instead to Russian historical themes and exhibiting in 1870–71 in the first exhibition of the Wanderers. Tsar Alexander II commissioned Antokolsky's sculpture of Ivan the Terrible (see ill. 4) for the Hermitage collection; for this work the artist was awarded the title of Academician, thereby establishing his reputation in Russia. Anto-

kolsky initially left his homeland due to illness and to escape anti-Semitic attacks. During his years in Rome (1871) and Paris (1877), he corresponded regularly with the critic Vladimir Stasov, and with his closest student, sculptor Ilya Gintsburg, concerning the importance of developing a Jewish national school of art in order to raise the level of art among Jews. In 1878, Antokolsky won a gold medal at the Exposition Universelle in Paris, and in 1893 he was named a full member of the Imperial Academy of Arts. Although Antokolsky never returned permanently to Russia, he visited periodically and published articles in Russian journals. He urged Jewish artists to concentrate on handicrafts in order to express their Jewishness, make a living, and achieve some mobility. In 1900, Antokolsky was again awarded a gold medal at the Exposition Universelle. In 1902, a Jewish school, an industrial society, and a museum were established in Vilna in Antokolsky's name. Posthumous exhibitions of his work were held in Moscow and Leningrad in 1937.

Selected Bibliography

Aranovich, Feliks. *Nadgrobie Antokolskogo: Povest ob utrachennom i zaimstvovannom.* Ann Arbor: Ermitazh, 1982.

Kuznetsova, Eva V. *Mark Matveevich Antokolsky, 1843–1902.* Leningrad: Khudozhnik RSFSR, 1986.

———. *M. M. Antokolsky: Zhizn i tvorchestvo.* Moscow: Iskusstvo, 1989.

Lebedev, Andrei K., and Genrietta K. Burova. *Tvorcheskoe sodruzhestvo: M. M. Antokolsky i V. V. Stasov.* Leningrad: Khudozhnik RSFSR, 1968.

Rajner, Miriam. "Mark Antokolsky: The First Russian Artist in the Awakening of Jewish National Art in Russia." *Jewish Art* 16–17 (1990–91), pp. 99–106.

Stasov, Vasily V., ed. *Mark Matveevich Antokolsky: Ego zhizn, tvoreniya, pisma i stati.* St. Petersburg and Moscow: Volf, 1905.

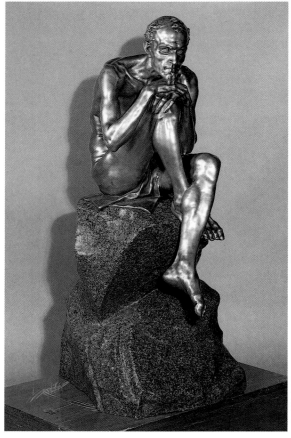

Plate 1
Mark Antokolsky, *Mephistopheles*, ca. 1880

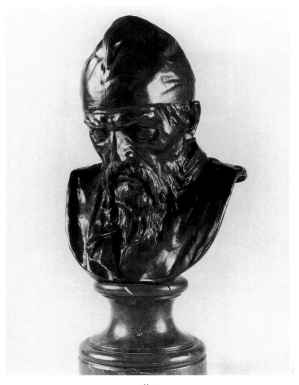

Ill. 4
Mark Antokolsky, *Head of Ivan the Terrible*, ca. 1880

Ill. 5
Mark Antokolsky, *Spinoza,* ca. 1882

Léon
Bakst
(Lev Samoilovich
Rozenberg)
Grodno 1866–
1924 Paris

During his lifetime, Bakst designed over 80 opera, ballet, and theater productions for companies in Russia. Following his initial period of artistic activity there, his innovations in ballet were linked to his association with Diaghilev's Ballet Russes in Paris. Bringing a fresh vision to set and costume design, Bakst introduced freedom and expressiveness to dance costumes that revealed the body and evoked the Orient and antiquity in vibrant colors and flowing cut. After he won a prize in an art contest at the age of 12, his wealthy parents contacted Antokolsky, hoping that he would discourage Bakst from an artistic career. Antokolsky was convinced that the boy's drawings showed promise, and in 1884 Bakst was admitted to the Imperial Academy of Arts in St. Petersburg. He began his career as a realist, submitting to the academy a painting of an aging, disheveled Madonna drawn from sketches made in the Jewish ghetto. The judges rejected his work, and he was expelled. It was Bakst's travels abroad and his association with the World of Art (which he helped found in 1898) that led him toward a more decorative painting style. Through Alexander Benois, he made contacts that led to important portrait commissions in Russia (see ill. 8). Between

1901 and 1908, he received commissions to design sets and costumes for plays by Sophocles and Euripides in which he introduced archaic Greek motifs (see ill. 6). In 1902, he was the designer for the pantomime *Le Coeur de la marquise* at the St. Petersburg Hermitage Theater. In 1906, he was awarded the Légion d'Honneur and from 1906 until 1909 taught at the Zvantseva School of Art in St. Petersburg. Encouraged by his trip to Greece and Crete in 1907, he began his many collaborations with Diaghilev on productions for the Ballets Russes; some of his most brilliant work was accomplished during the period of this collaboration (see pl. 5). Although Bakst had become a Lutheran when he married in 1903, he reverted to Judaism in 1910, the year of his divorce. After 1910 he lived mainly in Paris; his application for renewal of a permit to reside in St. Petersburg was rejected in 1912 because of his identity as a Jew. In 1914, he was elected a member of the Academy of Arts, thus acquiring the right to reside freely in Russian cities; however, war prevented him from returning, and he remained abroad permanently. He broke with Diaghilev in 1921, but continued as an independent designer until the end of his life.

Selected Bibliography

Alexandre, Arsène. *The Decorative Art of Léon Bakst.* Trans. Harry Melvill. New York: Dover, 1972.

Golynets, S.V. *Lev Bakst.* Moscow: Izobrazitelnoe iskusstvo, 1992.

Levinson, André. *Bakst: The Story of the Artist's Life.* New York: B. Blom, 1971.

On Stage: The Art of Léon Bakst. Exh. cat. Jerusalem: Israel Museum, 1992.

Pruzhan, Irina N., ed. *Léon Bakst: Set and Costume Designs, Book Illustrations, Paintings and Graphic Works.* Trans. Arthur Shkarovski-Raffe. New York: Viking, 1987.

Schouvaloff, Alexander. *Léon Bakst: The Theatre Art.* London: Sotheby's Publications, 1991.

Spencer, Charles. *Leon Bakst.* London: Academy Editions, 1973.

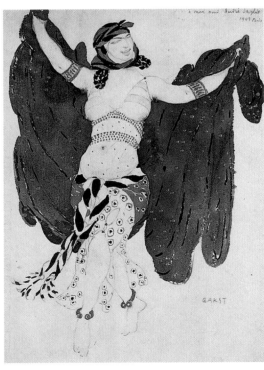

Plate 5
Léon Bakst, *Syrian Dancer*
(Costume Design for *Cleopatra*), 1909

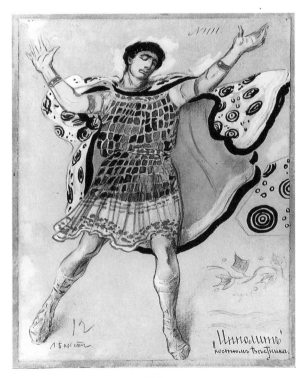

Ill. 6
Léon Bakst, *Messenger*
(Costume Design for Euripides' *Hippolytus*), 1902

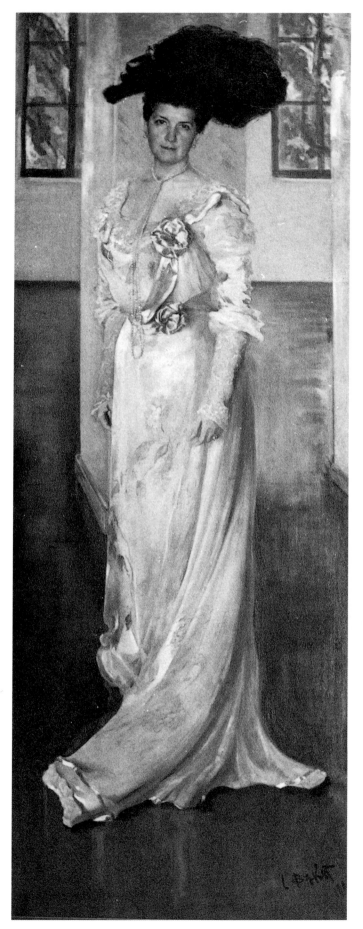

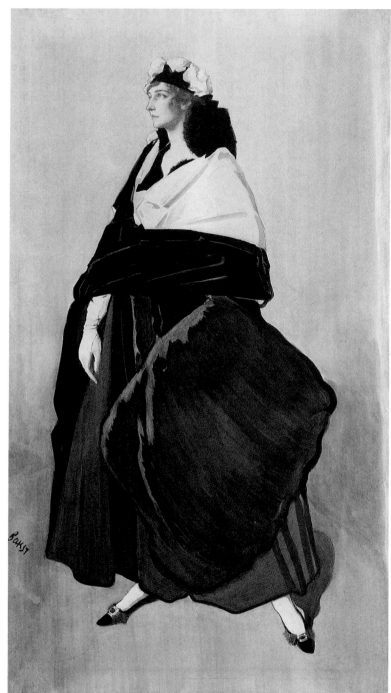

Ill. 7
Léon Bakst, *Ida Rubinstein,* 1910

Ill. 8
Léon Bakst, *Countess M. Keller,* 1902

Isaak Izrailevich
Brodsky
Sofievka 1883/34–
1939 Leningrad

Selected Bibliography

The Aesthetic Arsenal: Socialist Realism under Stalin. Exh. cat. New York: Institute for Contemporary Art, P. S. 1 Museum, 1993.

Brodsky, I. A. *I. I. Brodsky.* Moscow: Izobrazitelnoe iskusstvo, 1973.

———. *Isaak Izrailevich Brodsky.* Moscow: Sovetskii khudozhnik, 1956.

———, and M. P. Soleonileov. *Pamiati I. I. Brodskogo: Vospominaniya, dokumenty, pisma.* Leningrad: Khudozhnik RSFSR, 1959.

Brodsky, I. I. *Moi tvorcheskii put.* Leningrad: Iskusstvo, 1940; 2nd edn. Khudozhnik RSFSR, 1965.

Brodsky was a forefather of Socialist Realism, famous for his iconic portrayals of Lenin and his idealized, carefully crafted paintings dedicated to the events of the Civil War and Bolshevik Revolution of 1917. From 1902 to 1908, he studied with the great genre and history painter Ilya Repin at the Imperial Academy of Arts in St. Petersburg. Brodsky was known before the Revolution for his observant salon portraits (see ill. 9) and landscapes, exhibiting from 1904 with the Wanderers and the World of Art. Throughout his career, he maintained the academic standards he absorbed as a student; thus he was able to reinstate traditional methods and styles of painting at the reformed All-Russian Academy of Arts, Leningrad. Throughout his career, Brodsky openly acknowledged his Jewish heritage, and he was briefly involved in activities of the Jewish renaissance. In 1916, he became a member of the Jewish Society for the Encouragement of the Arts in Petrograd, contributing to both the Petrograd *Exhibition of Jewish Artists* and the Moscow *Exhibition of Paintings and Sculpture by Jewish Artists* in 1917–18. Mentioning incidents of pre-Revolutionary anti-Semitism in his memoirs, he acknowledged the Soviet regime for recognizing him and his work. A member of AKhRR from 1924 through 1928, Brodsky painted numerous sympathetic portraits of Lenin from life and had no difficulty conforming to Bolshevik dictates. Ambitious in scale, composition, and theme, these portraits were regarded as landmarks. Their meticulous execution, based on research, sketches from life, and documentary photographs (a technique labeled "Brodsky-ism" by the artist's critics) caused Brodsky to be ejected from the AKhRR even though he was highly regarded by Stalin and members of the arts administration. During the 1930s he contributed to numerous exhibitions and had several solo shows (see pl. 27). In 1932, Brodsky was named Honored Arts Worker of the RSFSR. He was named Professor (1932–39) and then—his final accolade—Director (1934–39) of the All-Russian Academy of Arts, Leningrad. In 1933, Brodsky was invited to join Alexander Gerasimov and Katsman to meet with Stalin and Kliment Voroshilov (see ill. 11) to discuss the Socialist Realist method. In 1937, Brodsky won a gold medal at the Exposition Universelle in Paris. In 1949, his apartment was opened as a memorial museum.

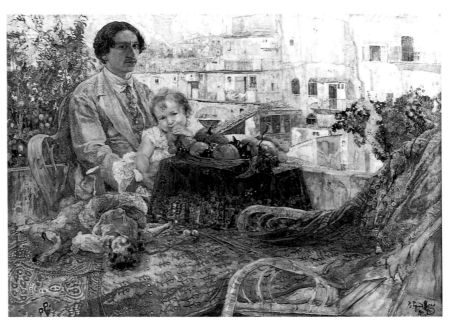

Ill. 9
Isaak Brodsky, *Self-Portrait with Daughter*, 1911

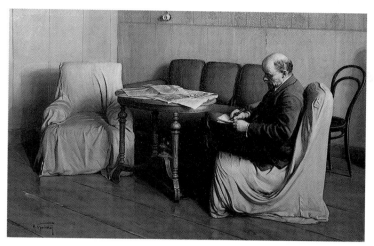

Plate 27
Isaak Brodsky, *Vladimir Ilich Lenin at the Smolny Institute*, 1937

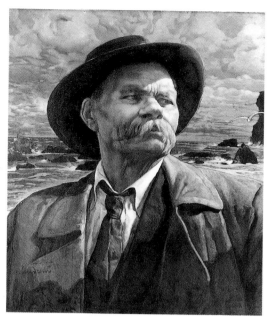

Ill. 10
Isaak Brodsky, *Portrait of Maxim Gorky*, 1936

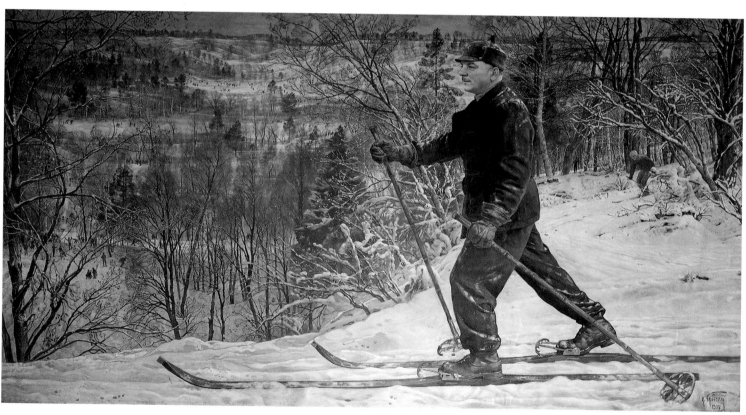

Ill. 11
Isaak Brodsky, *Kliment Voroshilov Skiing*, 1937

Grisha (Grigory
Davidovich)
Bruskin
Moscow 1945;
lives in New York

Bruskin was one of the few contemporary Soviet Jewish artists who produced work with explicit Jewish content while at the same time exploring the iconography of Socialist Realism in other work. After his 1968 graduation from the Art Department of the Moscow Textile Institute and his first (1976) solo exhibition at the Central Artists' House, Moscow, his work ran afoul of official censors. His 1983 Vilna solo exhibition was closed by the authorities after 10 days "for Zionist ideology," while his 1984 solo exhibition at Moscow's Central House of Workers in the Arts was closed on opening day. However, Bruskin's Alefbet series, which he began in the 1980s, reflects a poetic and mystical, rather than an explicitly religious, orientation. Typically, each canvas is divided into cells, each of which contains a supernatural figure or figures, which are Bruskin's interpretations of themes found in the Torah or Kabbalah. He has referred to the link between figure and text as indirect; neither is meant to serve as an explicit representation of the other, but rather as a general illumination of hidden symbolism. In the Léxicon series (see pl. 46), Bruskin applied a similar formal approach. As a commentary on the generic images of Soviet monumental art encouraged by the Communist regime, his ironic stock figures, or "heroes," derived from sculptures that filled the parks during his childhood, function as words or signs in Bruskin's constructed language (see ill. 12). While there is no hierarchy among them, the accessories or attributes they clutch are derived from life, identifying them and suggesting identities for the figures in the Alefbet paintings. In 1988, Bruskin achieved international fame when the Fundamental Lexicon brought the record price at the auction of Russian art organized by Sotheby's in Moscow. Shortly thereafter, he emigrated to New York, where he continues to express his reactions to the human condition in a totalitarian society. He has had solo exhibitions at the Marlborough Gallery in New York (1990–94) and in Moscow, at the State Pushkin Museum (1993).

Selected Bibliography

Grisha Bruskin. Exh. cat. New York: Marlborough Gallery, 1994.

Grisha Bruskin. Exh. cat. San Francisco: Alexander Meyerovich, 1994.

Grisha Bruskin: Paintings and Sculpture. Exh. cat. New York: Marlborough Gallery, 1990.

"The Journal *Word* Interviews Grigory Bruskin the Painter." *Word/Slovo* (1989), pp. 86–93.

Levkova-Lamm, Innesa. "Words of the Prophets." *Contemporanea International Art Magazine* 2 (January–February 1989), pp. 3, 49–53.

Peschler, Eric A. "Grisha Bruskin." In *Künstler in Moskau.* Zurich: Edition Stemmle, 1988, pp. 144–152.

Plate 46
Grisha Bruskin, *Alefbet—Lexicon No. 4*, 1988

Ill. 12
Grisha Bruskin, *Birth of the Hero*, 1985–88,
from a series of 15 works

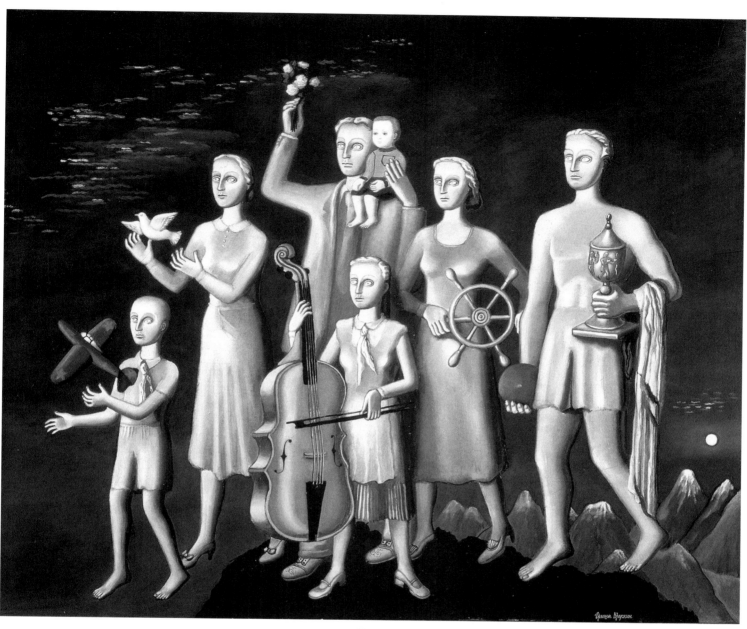

Ill. 13
Grisha Bruskin, *Memorial*, 1983

Erik Vladimirovich
Bulatov
Sverdlovsk 1933;
lives in Moscow
and Paris

Bulatov is a leading member of the older generation of nonconformist artists. Many of his canvases incorporate official Soviet slogans and propaganda, as well as common phrases in large Cyrillic or Roman block letters, which are superimposed over commonplace scenes in a manner reminiscent of postcards or illustrations in travel brochures (see pl. 41). Although Bulatov graduated in 1958 from Moscow's Surikov Institute of Arts, he had actually begun exhibiting his work two years earlier, having been included in the 1957 *International Exhibition of Young Artists* for the Sixth World Festival of Youth and Students in Moscow. By 1959 he had begun to illustrate books, mainly for children. His 1965 exhibition with Viacheslav Kalinin at the Kurchatov Institute of Nuclear Physics in Moscow was closed by the authorities after an hour. Bulatov exhibited with Kabakov in 1968 at the Blue Bird Café in Moscow. While he was studying to be an illustrator, he and his friend Oleg Vasiliev sought alternatives to their classes at the Surikov Institute. Bulatov claimed that his acquaintance with veteran artists Vladimir Favorsky and Falk had a decisive impact on his creative development. The letters or texts in his paintings created a boundary between the foreground—the viewer's real space, a world that was pervaded by Soviet ideology—and the space "beyond" the picture plane, a space synonymous with freedom. Growing up amid conditions of severe restriction, Bulatov felt that his art provided a "possible way out," a means of expressing the discrepancy and tension between official language and unofficial life While he made use of the Socialist Realist style, it was always in the service of his own vision (see ill. 16). The irony in his renderings was clearly understood by the Soviet authorities, and from the late 1960s until the 1970s he was prohibited from exhibiting (see ill. 15). Since 1973, when he was included in *Russian Avant-Garde, Moscow-73* at the Galerie Dina Vierny, Paris, and 1986, when he began to exhibit at the Phyllis Kind Gallery, Chicago, Bulatov has been included in numerous group exhibitions in Russia and abroad. In the work of the last two decades, his commentary has become less overtly topical. Through his repetition of text and image, he exposes the sterility of an inescapably politicized environment and of exhausted official painting. In 1989, a solo retrospective exhibition organized by the Kunsthalle Zurich traveled in Germany, concluding at the Centre Georges Pompidou, Paris. In that same year, a further solo exhibition began its tour of England and the United States at the Institute of Contemporary Art, London, and in 1990 an exhibition of Bulatov's work was organized by the Stedelijk Museum, Amsterdam.

Selected Bibliography

Erik Bulatov. Exh. cat. London: Institute of Contemporary Art, 1989.

Eric Bulatov/Oleg Vassilyev. Exh. cat. New York: Phyllis Kind Gallery, 1991.

Groys, Boris. "Interview with Erik Bulatov." *A-Ya* 1 (1979), pp. 26–33. (In Russian and English.)

Peschler, Eric A. "Erik Bulatov." In *Künstler in Moskau.* Zurich: Edition Stemmle, 1988, pp. 90–98.

Taylor, Sue. "Beyond the Picture Plane." *Art in America* 78 (March 1990), pp. 172–75, 219.

Tupitsyn, Magarita. "*Sots Art*: The Russian Deconstructive Force." In *Sots Art.* Exh. cat. New York: New Museum of Contemporary Art, 1986, pp. 4–15.

Ill. 14
Erik Bulatov, *Red Horizon*, 1971–72

III. 15
Eric Bulatov, *Brezhnev in the Crimea*, 1981–85

Plate 41
Erik Bulatov, *Welcome*, 1973–74

III. 16
Erik Bulatov, *People in the Countryside*, 1976

Marc
Chagall

(Moisei Zakharovich
Shagal)
Vitebsk 1887–
1985 St. Paul-de-Vence

Selected Bibliography

Amishai-Maisels, Ziva.
"Chagall's Jewish In-Jokes."
Journal of Jewish Art 5
(1978), pp. 76–93.

Chagall, Marc. *My Life.*
New York: Orion Press,
1960; London: Peter Owen,
1965; Oxford and New
York: Oxford University
Press, 1989; New York:
Da Capo Press, 1994.

Compton, Susan. *Chagall.*
Exh. cat. London: Royal
Academy of Arts, 1985.

Kamensky, Alexander A.
*Chagall: Periode russe et
soviétique 1907–1922.*
Trans. Joelle Aubert-Yong.
Paris: Editions du Regard,
1988. (English and German
editions also exist.)

*Marc Chagall and the Jewish
Theater.* Exh. cat. New
York: Solomon R. Guggen-
heim Museum, 1992.

*Marc Chagall: Oeuvres sur
papier.* Exh. cat. Paris:
Centre Georges Pompidou,
1984.

Meyer, Franz. *Marc Chagall:
Life and Work.* Trans. Ro-
bert Allen. New York: Harry
N. Abrams, 1964.

Misler, Nicoletta, ed. *Marc
Chagall: Gli anni russi
1908–1922.* Exh. cat. Flor-
ence: Palazzo Medici Ric-
cardi, 1993.

Petrova, Evgeniya N., *et al.,*
eds. *Chagall e il suo mondo.*
Exh. cat. Comune di Bari,
1994.

Sarabyanov, Dmitry Vladi-
mirovich. *Mark Shagal.*
Moscow: Izobrazitelnoe
iskusstvo, 1992.

Chagall spent 12 years of his career in Russia and the Soviet Union. In 1906, he attended Pen's school in Vitebsk, and in 1908, studied with Bakst at the Zvantseva School of Art. In 1910, with a stipend from his patron, Maxim Viniver, Chagall traveled to France, where he lived until 1914. During this period, his work was included in the Salon des Indépendants (1911–14) and the Salon d'Automne and shown with the Donkey's Tail (1912). He associated with the émigré population at La Ruche and maintained contact with Russian art circles. Chagall derided the efforts of the Makhmadim to develop a modern Jewish style, even as he himself was producing a body of work dealing with shtetl life and other Jewish themes. After returning to Moscow, he was forced by war to stay in Russia for a time and entered a productive period in his career, contributing to many exhibitions (*Jack of Diamonds*, Moscow, 1916; *World of Art* 1919, 1922); he was recognized increasingly as a major figure of the Russian avant-garde (see pl. 9). The circumstances of his personal life (he married and became a father in 1915–16) contributed to Chagall's style and themes during his final Russian period (1914–22) (see ill. 18). He took part in the *Exhibition of Jewish Artists* in Petrograd (1917) and, the following year, the *Exhibition of Paintings and Sculpture by Jewish Artists* in Moscow. In 1918 he was appointed Art Commissar for Vitebsk and founded and directed the Vitebsk Popular Art Institute, where he taught many devoted students until his rivalry with Malevich forced him, in 1920, to depart for Moscow. Having received an invitation from Alexander Granovsky and Abram Efros to design for the newly established State Jewish Theater, his first works were a series of murals on canvas designed to cover portions of the ceiling and walls. These paintings and his later costume and set designs represented attempts to combine all aspects of the theater into an integrated whole and contain many Yiddish puns and literary references. Chagall's last exhibition in Russia was the *Exhibition of the Three* with Altman and Shterenberg in 1922; during that year Anatoly Lunacharsky provided him with a passport to travel to Lithuania and from there, permanently, to the West. He lived first in Berlin, where he participated in the *Erste russische Kunstausstellung* (1922), before settling in France in 1924. Chagall returned to the Soviet Union only once, in 1973, to sign and date his murals, which had been preserved by fellow artists and which were not seen again until 1990.

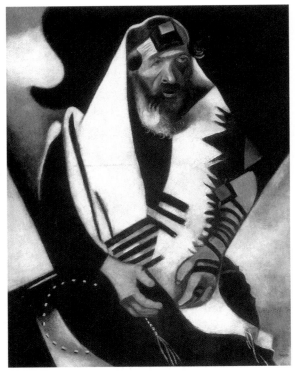

Ill. 17
Marc Chagall, *The Praying Jew (The Rabbi of Vitebsk)*, 1923

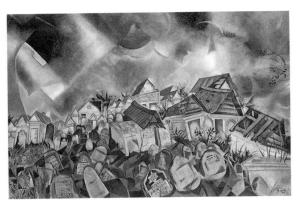

Plate 9
Marc Chagall, *The Cemetery*, 1917

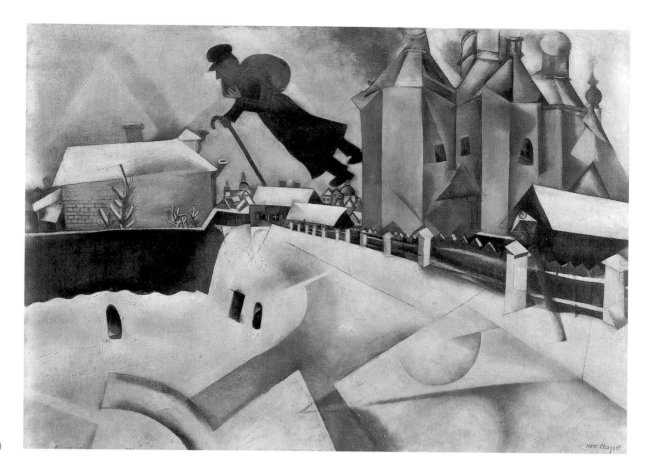

Ill. 18
Marc Chagall
Over Vitebsk, 1915–20
(after a painting of 1914)

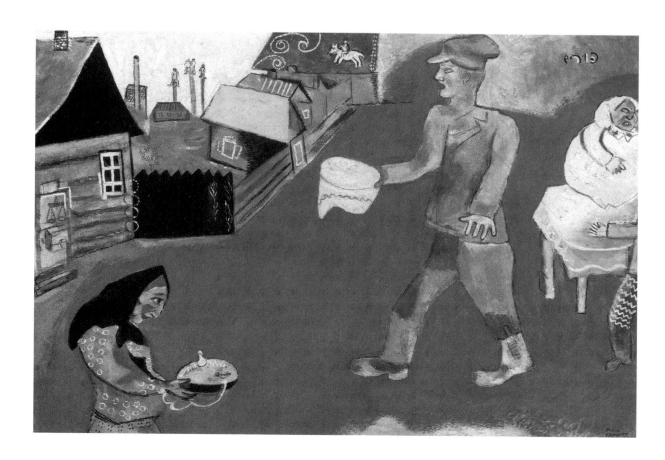

Ill. 19
Marc Chagall
Purim, 1916–18

Iosif Moiseevich
Chaikov
Kiev 1888–
1986 Moscow

Chaikov, who was one of the most active promoters of the Jewish national art movement, wrote the first book on modern sculpture in Yiddish and gained distinction among the experimental sculptors of the early Soviet period before turning to Socialist Realism. Having grown up with his grandfather, a deeply religious scribe, in 1908 Chaikov was apprenticed to a Kiev engraver. He attracted the attention of the sculptor Naum Aronson, who helped him obtain a scholarship to travel to Paris, where he associated with artists of La Ruche and other Jewish sculptors. He became involved with the Makhmadim, and his illustrations in their journal portrayed Jewish subjects in a contemporary style influenced by Art Nouveau (see Stanislawski, fig. 4). Chaikov returned to Russia in 1914. After the Revolution, he worked simultaneously on developing a Jewish national style as well as a post-Revolutionary Soviet art. In Kiev, he was active in the Kultur Lige, illustrating Yiddish books for Moscow and Kiev authors, teaching sculpture in the Kultur Lige studios, and sponsoring their only exhibition of Jewish artists in Kiev. In 1920, while there, he contributed to the *First Jewish Art Exhibition of Sculpture, Graphics, and Drawings*. Concurrently, he taught at Vkhutemas in Moscow, where a number of Jewish students attended his classes. In statements made in *Sculpture* (1921), he rejected both ethnographic content and folkloric or primitivist styles, anticipating the invention of new expressive forms arising from the unique situation of Jews in the modern world. He traveled to Berlin to view the 1922 *Erste russische Kunstausstellung* and, in 1924, contributed to the *First Discussional Exhibition of Associations of Active Revolutionary Art* in Moscow. During the early 1920s, his style was Constructivist (see pl. 13); by the late 1920s, however, Chaikov had become less interested in both abstraction and the Jewish national art movement, accepting Socialist Realism and devoting himself to promoting the new Soviet society (see ill. 22). During his early years in Kiev, he had created designs for monuments and memorials under Lenin's Plan for Monumental Propaganda. From the 1930s on, he was active as a monumental sculptor, recognized particularly for his depictions of athletes. One of the most acknowledged of Soviet sculptors, Chaikov had a number of solo exhibitions in Moscow (1948, 1959, 1979). He was awarded the Medal for Valiant Labor in the Great Patriotic War in 1946 and the Jubilee Medal for Valiant Labor in 1970, having been named Honored Arts Worker of the RSFSR in 1959.

Selected Bibliography

Abramsky, Chimen. "Yiddish Book Illustrations in Russia: 1916–1923." In Ruth Apter-Gabriel, ed. *Tradition and Revolution: The Jewish Renaissance in Russian Avant-Garde Art, 1912–1928.* Exh. cat. Jerusalem: Israel Museum, pp. 61–70.

Bowlt, John E. "Rodchenko and Chaikov." *Art and Artists* 11, no. 7 (1976), pp. 28–33.

Iosif M. Chaikov. Exh. cat. Moscow: Union of Soviet Artists, Sovetskii Khudozhik, 1979.

Shmidt, I. *Iosif Chaikov.* Moscow: Sovetskii khudozhnik, 1977.

Wolitz, Seth L. "The Jewish National Art Renaissance in Russia." In Ruth Apter-Gabriel, ed. *Tradition and Revolution: The Jewish Renaissance in Russian Avant-Garde Art, 1912–1928.* Exh. cat. Jerusalem: Israel Museum, pp. 21–42.

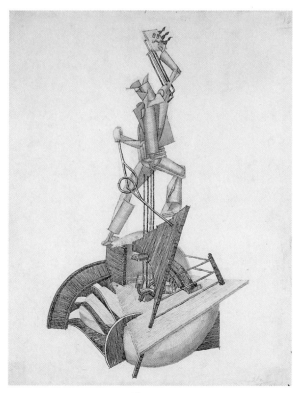

Plate 13
Iosif Chaikov, *Electrifier*, 1921

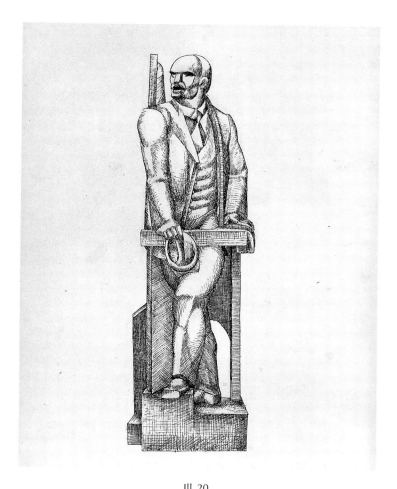

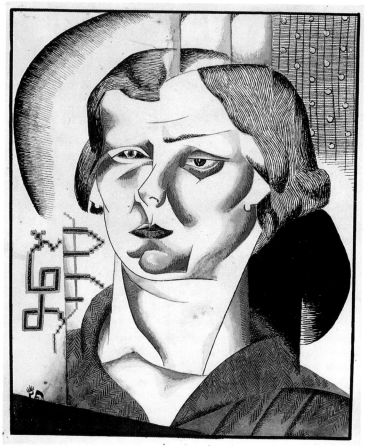

Ill. 20
Iosif Chaikov, *Lenin the Orator*, 1927

Ill. 21 (top right)
Iosif Chaikov, *Portrait of a Woman*, 1921

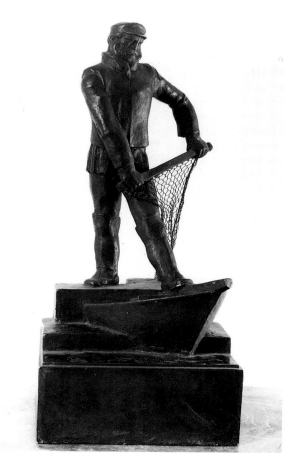

Ill. 22
Iosif Chaikov, *Fisherman*, 1926

Ilya Grigorevich
Chashnik
Lyucite, Eastern
Latvia, 1902–
1929 Leningrad

One of a group of outstanding young Jewish artists in Vitebsk who were galvanized by the teachings of Malevich, Chashnik's graduation paper for the Vitebsk Popular Art Institute was one of the few theoretical texts to expand the concepts of Suprematism. Having studied drawing with Pen in Vitebsk in 1917, Chashnik went on to study with Chagall at the Vitebsk institute, where he associated as a student with Lev Yudin, Nikolai Suetin, Nina Kogan, Khidekel, and Lissitzky. When Malevich joined the faculty at Vitebsk, Chashnik became one of his closest collaborators. In 1920, he was a founding member of Unovis, exhibiting with them at Vkhutemas in Moscow. Between 1919 and 1921, Chashnik developed a unique style characterized by the use of elements floating on fields of color. He applied Suprematist ideas to various disciplines and media, such as the theater, typography, architecture, and even political propaganda. His thesis, "The Suprematist Method," discussed, among other things, time, the significance of color, and a theoretical basis for dimensional expansion of Suprematist compositions (see ill. 24). After graduation in 1922, when some of the Unovis people left Vitebsk, Chashnik moved to Petrograd, where he assisted Malevich at the Museum of Artistic Culture with his architectural designs and produced variations of his own Suprematist conceptions in painting. He also began to apply Suprematist designs to utilitarian objects, the most successful of which were ceramics and textiles created in collaboration with Suetin for the Lomonosov State Porcelain Factory (see ill. 25). Many of these ceramics quoted Suprematist paintings and drawings. Chashnik contributed to the 1923 *Exhibition of Petrograd Artists of All Trends* and was represented in the 1925 *Exposition Internationale des Arts Décoratifs et Industriels Modernes* in Paris. He worked as a researcher at the Decorative Institute in the laboratory headed by Malevich, as well as on his own architectural models. With Suetin and Khidekel, he also worked in the architectural studio of Alexander Nikolsky. At the age of 27, Chashnik died of appendicitis. His art was posthumously exhibited at the 1932 jubilee exhibition *Artists of the RSFSR over the Last 15 Years* in Leningrad.

Selected Bibliography

Ilja G. Tschaschnik (1902 Ljucite–1929 Leningrad). Exh. cat. Kunstmuseum Düsseldorf, 1978.

Ilya Chashnik and the Russian Avant-Garde: Abstraction and Beyond. Exh. cat. Austin: University of Texas, The Archer M. Huntington Gallery, 1981.

Ilya Grigorevich Chashnik Lyucite/1902–Leningrad/ 1929: Watercolors, Drawings, Reliefs. Exh. cat. New York: Leonard Hutton Galleries, 1979.

Malevich, Suetin, Chashnik. Exh. cat. New York: Leonard Hutton Galleries, 1983; Cologne: Galerie Gmurzynska, 1992.

Rakitin, Vassili: *Suprematisti russi degli 20: Suetin, Chashnik, Leporskaja.* Milan: Fabbri, 1991.

Sarabyanov, Dmitry Vladimirovich, and Alexandra Semenovna Shatskikh. *Malevich.* Moscow: Iskusstvo, 1993.

The Suprematist Straight Line: Malevich, Suetin, Chashnik, Lissitzky. Exh. cat. London: Annely Juda Fine Art, 1977.

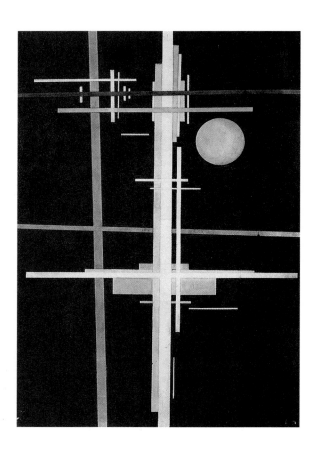

Plate 12
Ilya Chashnik, *Suprematist Composition*, 1926–27

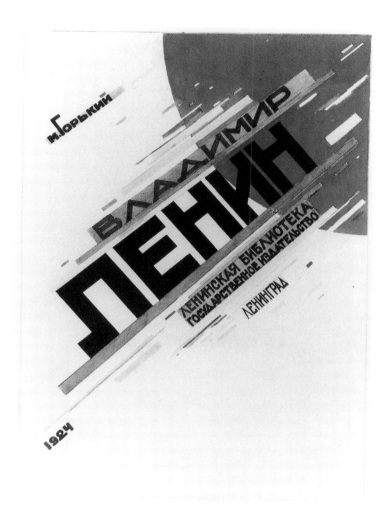

Ill. 23
Ilya Chashnik, *Maxim Gorky—Vladimir Lenin*, 1924

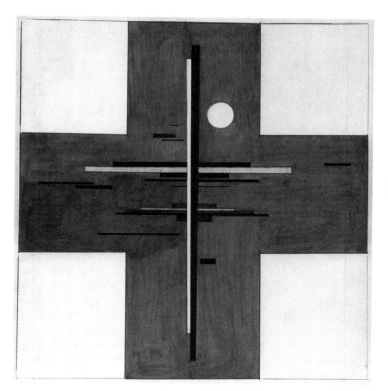

Ill. 24 (left)
Ilya Chashnik, *Suprematist Cross*, 1922

Ill. 25
Ilya Chashnik, *Suprematist Soup Tureen and Lid*, 1923

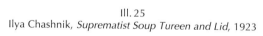

Robert Rafailovich
Falk
Moscow 1886–
1958 Moscow

Falk's early paintings were influenced by Cézanne and by the style of Post-Impressionism practiced by his Moscow teachers. He joined with artists of similar orientation in 1910 to found the Jack of Diamonds group, exhibiting frequently with them (see ill. 26). Falk was known for the stability of his compositions and his harmonious, restrained use of color. In 1911, he became a member of the World of Art, and during the late 1910s, he adopted a sharper, cubist style, with flashes of Fauve color (see pl. 6). His early work was included in the *Exhibition of Paintings and Sculpture by Jewish Artists* (1918) in Moscow. After the Bolshevik Revolution, Falk taught painting at Svomas and Vkhutemas/Vkhutein (1921) in Moscow, where a number of Jewish artists attended his classes. He also taught for a few months in 1921 at the Vitebsk Popular Art Institute, from which he returned to Moscow with several dedicated students. In 1922, Falk contributed to the *Erste russische Kunstausstellung* in Berlin, and in 1924 he had a solo exhibition at the State Tretyakov Gallery in Moscow. Falk began his work in the theater in 1925 with stage and costume designs for productions at the Goset and Habimah theaters in Moscow. That same year he was again the subject of a solo exhibition at the State Tretyakov Gallery.

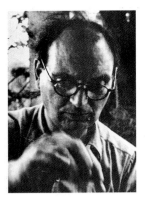

During 1926–28, he exhibited with AKhRR. Falk joined the Goset troupe during their European tour (1928–37) and met Altman and Chaim Soutine in Paris during that period. He was represented at both the 1928 Salon d'Automne, Paris, and the Venice Biennale. Following his return to Moscow, he designed sets for Goset (1940–41), as well as for Jewish theaters in Belorussia, until they were closed in 1948. Falk spent the war years in Samarkand, whose art and architecture influenced his work. During the Socialist Realist years, Falk was perceived as an aloof, intellectual artist, although he contributed to the *All-Union Art Exhibition* in Moscow in 1946. That same year, he was criticized as a result of the first Zhdanov decree. He was not allowed to exhibit from 1947 to 1957, and association with him was risky. Falk worked in private, producing portraits and "philosophical landscapes" during the 1940s and 1950s; in 1950 he had a solo exhibition sponsored by MOSSKh. During the 1950s, he was a major influence on the rising generation of nonconformist artists. After his death, his widow organized weekly showings of his work in his former studio, and in 1972 there was an exhibition of his work in the State Russian Museum, Leningrad.

Selected Bibliography

Basner, Elena. *Robert Falk: Zhivopis i grafika iz muzeev i chastnykh sobranii.* Exh. broch. St. Petersburg: State Russian Museum, 1992.

Besançon, Alain. "R. R. Falk (1886–1958)." *Cahiers du monde russe et soviétique* 3, no. 4 (1962), pp. 564–81.

Sarabjanow, Dimitrii. *Robert Falk.* Dresden: VEB Verlag der Kunst, 1974.

Shchekin-Krotova, A. V., ed. *R. R. Falk: Besedy ob iskusstve, pisma, vospominaniya o khudozhnike.* Moscow: Sovetskii khudozhnik, 1981

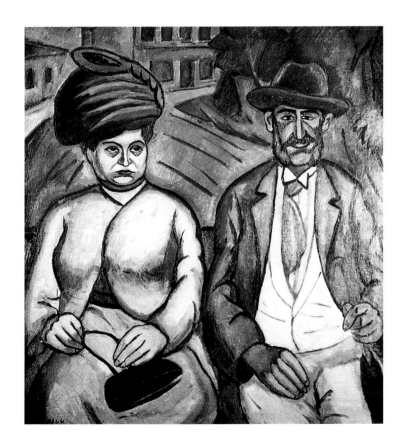

Ill. 26
Robert Falk, *Portrait of My Parents,* 1911

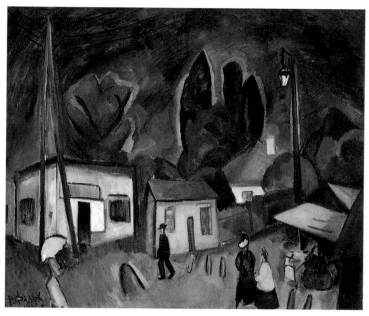

Plate 6
Robert Falk, *Environs of Moscow*, 1912

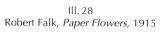
Ill. 28
Robert Falk, *Paper Flowers*, 1915

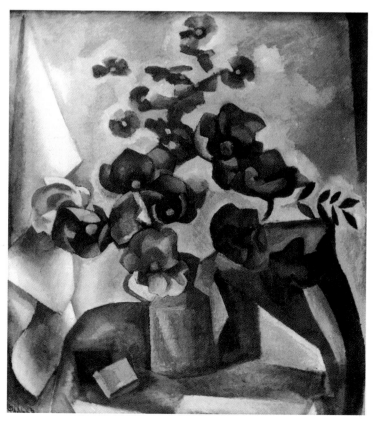

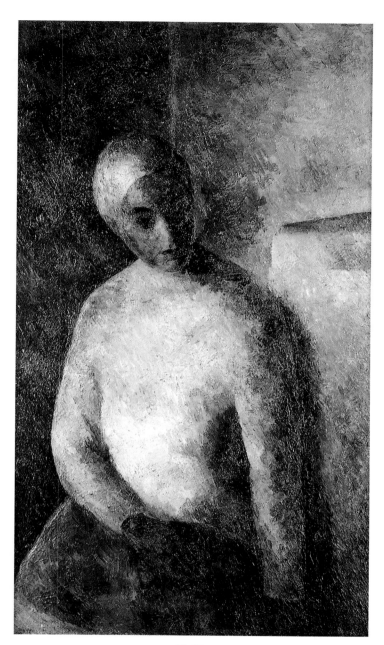

Ill. 27
Robert Falk, *Woman in a White Turban*, 1922–23

Naum
Gabo

(Neemia Borisovich
Pevzner)
Klimovich 1890–
1977 Waterbury,
Connecticut

Known in the West for his contributions to European Constructivism and early kinetic art, Naum Gabo's most notable achievement in Soviet Russia was the publication of the "Realistic Manifesto" with his older brother, Noton Pevsner. Gabo entered the medical faculty at the university in Munich in 1910 and, in 1912, enrolled in the Technische Hochschule there. He created his first constructions in Norway during 1915; on his return to Moscow in 1917, he worked on projects for Izo Narkompros. Gabo spent only six years of his career in Russia, following the February Revolution. He and his two brothers moved to Moscow, where Noton, Naum, and Alexel Pevsner shared a flat in a building which contained artists' studios. During this period Gabo worked in Noton's studio and taught informally. Gabo took part in only one exhibition during this time: an outdoor show in 1920 on Tverskoy Boulevard, together with Noton Pevsner, Gustav Klutsis, and several students. Accompanying the exhibition was the "Realistic Manifesto," a statement written by Gabo and also signed by Pevsner. The manifesto advocated Constructivism as an art of the future. It also stressed the significance of an expression of the energy of motion and quality of pure structure without any representational allusion. His innovative, multi-faceted sculptures, often made of plexiglass, capture the clarity of light and space, creating a continuously evolving work. Gabo's only subsequent Russian project, and the most ambitious architectural design of his career, was his competition submission for the Palace of Soviets. After 1922, he worked in various European capitals, spending the most formative years of his artistic career in Berlin between 1922 (see pl. 14) and 1932. In 1926 Gabo visited Paris, by which time he was familiar with the work of western European artists. The ten years he spent in England, from 1936 to 1946, resulted in the conception of important works. In 1946 he finally settled in the United States. Pevsner died in 1962. That year, Gabo returned to Moscow and Leningrad for his only visit. Thereafter, he continued his distinguished career in the United States. A retrospective of his work was held at the Tate Gallery in London the year before his death, and between 1985 and 1987 a major retrospective traveled to museums in the United States, Canada, Germany, and England.

Selected Bibliography

Gabo, Naum. *Of Divers Arts*. New York: Pantheon, 1962.

Gabo—Pevsner. Exh. cat. New York: Museum of Modern Art, 1948.

Nash, Steven, and Jörg Merkert, eds. *Naum Gabo: Sixty Years of Constructivism*. Exh. cat. Dallas: Dallas Museum of Fine Arts, 1985.

Naum Gabo: Ein russischer Konstruktivist in Berlin 1922–1932. Exh. cat. Berlin: Berlinische Galerie, 1989.

Naum Gabo: The Constructivist Process. Exh. cat. London: Tate Gallery, 1977.

Read, Herbert, and Leslie Martin. *Gabo: Constructions, Sculpture, Paintings, Drawings, Engravings*. London: Lund Humphries, 1957.

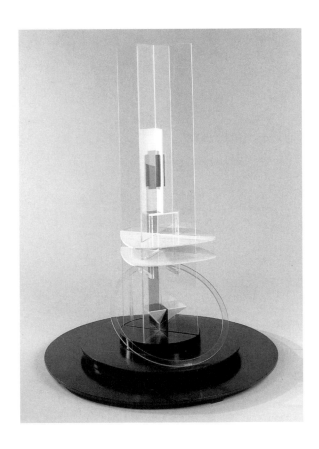

Plate 14
Naum Gabo, *Column*, ca. 1923

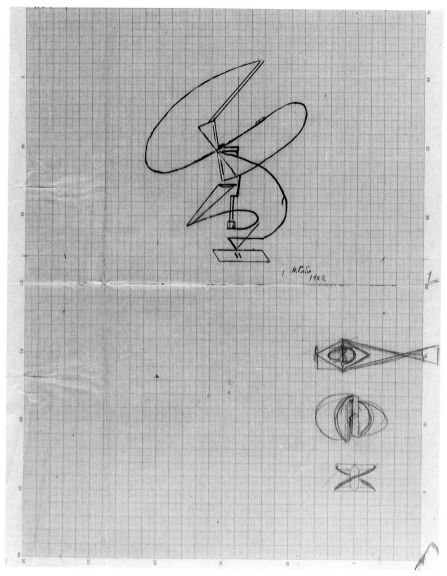

Ill. 29
Naum Gabo, *Sketch for a Kinetic Construction*, 1922

Ill. 30
Naum Gabo, *Sketch for Relief Construction*, 1917

Ill. 31 (right)
Naum Gabo, *Kinetic Construction (Standing Wave)*, 1919–20, replica 1985

Moisei Yakovlevich
Ginzburg
Minsk 1892–
1946 Moscow

As an architect, theoretician, teacher, and engineer, Ginzburg devoted himself to the creation of new types of urban designs to meet socialist needs. Through the principles of Constructivism, he sought to facilitate the activities of everyday life. As the primary spokesman of Constructivist architecture, he expressed his views through numerous publications and lectures. While still in school, Ginzburg worked as an assistant to his father, who was an architect in Minsk. He traveled to Italy in the early 1910s to study classical architecture, graduating in 1914 from the Milan Academy. Ginzburg attended the Riga Polytechnical Institute from 1914 to 1917, earning a degree in engineering, and from 1917 to 1921 worked in the Crimea. He moved to Moscow in 1921, becoming a professor at Vkhutemas, where he headed the faculty of Architectural Theory and the History of Architecture. In 1924, he published a significant work, *Style and Epoch*, laying out the evolving style of Constructivism in architecture as well as the necessity of a new architecture for a new state. In 1925, he helped found OSA, a group composed primarily of Moscow Constructivists, and he contributed to the *First Exhibition of Contemporary Architecture* in Moscow in 1927. In 1929 Ginzburg became a founding member of Moscow's October group and the head of the Section for Socialist

Resettlement in Gosplan. In the 1930s, he again took part in a number of competitions, including that for the Palace of Soviets, Moscow, in 1932 (see ill. 33). In that same year, Ginzburg was elected to the board of the Union of Soviet Architects; during the 1940s he headed the project to rebuild Sevastopol (see pl. 28). Among Ginzburg's theories was that of the "Functional Method," which defined the social and technological role of the architect and of architecture. When Ginzburg was made head of a committee to study standardized mass housing, he produced, within a few months, designs for five types of prefabricated units. The most famous one was a "transitional" apartment intended as a step between private and communal living. As head of the Section for Socialist Resettlement, Ginzburg collaborated with the economist M. Okhitovich to propose a "de-urbanized" socialist population resettlement system. Similar ideas appeared in Ginzburg and Mikhail Barshch's entry for the "Green City" competition, which proposed the restructuring of Moscow as a garden city, with small free-standing houses constructed from local materials. Although many of Ginzburg's ideas remain unrealized, they had a huge impact on modern housing and planning in the Soviet Union.

Selected Bibliography

Ginzburg, Moisei. *Saggi sull'architettura construttivista*. Ed. Emilio Battisti. Milan: Feltrinelli, 1977.

————. *Style and Epoch*. Cambridge, MA.: MIT Press, 1982.

Khan-Magomedov, S.O. *Moisej Ginzburg*. Preface by V. Quilici. Milan: Franco Angeli Editore, 1975.

Noever, Peter, ed. *Tyrannei des Schönen: Architektur der Stalin-Zeit*. Exh. cat. Vienna: Österreichisches Museum für Angewandte Kunst, 1994.

Pasini, Ernesto. *La "Casa-comune" e il Narkomfin di Ginzburg*. Rome: Officina, 1980.

Plate 28
Moisei Ginzburg, *Project for the Rebuilding of Downtown Sevastopol—Twice-Defended Square*, 1943

Ill. 32
Moisei Ginzburg with Gustav Hassenpflug, *Facade for the Nemirovich-Danchenko Theater, Moscow* (Competition Project), 1933

Ill. 33
Moisei Ginzburg with Gustav Hassenpflug and Solomon Lisagor, *Facade for the Palace of Soviets, Moscow* (Competition Project), 1932

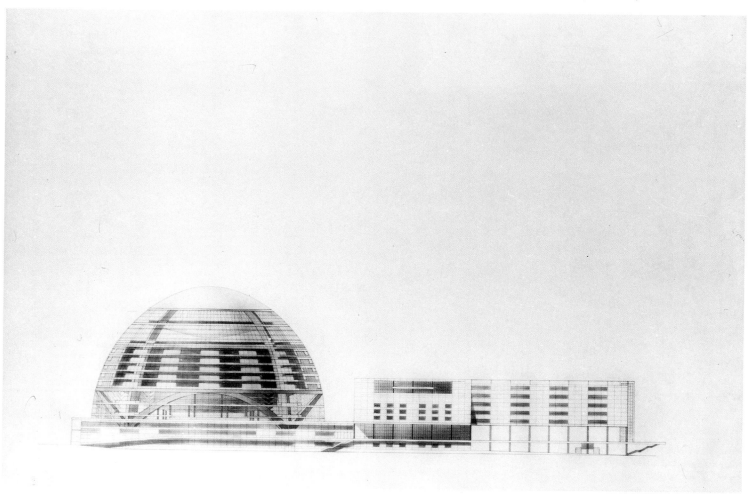

Eduard Semenovich
Gorokhovsky
Vinnitsa 1929;
lives in Offenbach

Gorokhovsky was one of the first artists in Russia to use photographs as the source for his prints and paintings, and he began to experiment with colored etchings while working as an illustrator of children's books. He graduated in 1954 from the Odessa Institute of Civil Engineering with a degree in architecture. He moved to Novosibirsk in 1955 and from that time until 1967 worked as a graphic designer and children's book illustrator. In 1967, the first solo exhibition of his work was held at the Novosibirsk Union of Soviet Artists. In 1973, Gorokhovsky moved to Moscow and began to develop his "easel graphics" or "easel sheets," compositions usually based on photographs that were reproduced as silk screen or lithographic prints, on which the artist subsequently painted. As his privately produced work became increasingly experimental, his participation in official exhibitions was limited. His first exhibition outside the country, *Graphic Art from Siberia*, was in Paris, and as artistic policies became more relaxed after 1984, he began to exhibit more often in Europe. In his early work, pre-Revolutionary Russia was represented by family photographs, suggesting that the destruction of the family was a corollary of the destruction of the state. Gorokhovsky juxtaposed or layered such images with other pictures from differing times and contexts. His later works convey a sense of history or the process of change; the 12-sheet *Airplane Game* (see ill. 34) alludes to the disappearance of individuality in a totalitarian society. Gorokhovsky has also used photography to transform concrete representations, giving them metaphorical content. In *Spiele (Games)* (see pl. 44), the use of a photograph of a married couple from the turn of the century evinces his interest in a dialogue between generations and in using unknown individuals as the subjects of a complex contemporary optical game. Gorokhovsky's interest in political subjects became especially keen in the 1980s, and he began producing works on historical and political themes, resurrecting obscure myths of the Soviet state along with personal memories. His use of official portraits of the country's leaders was a means of reappraising the past. Images of Lenin and Stalin appeared along with images of their anonymous victims. Gorokhovsky had a retrospective exhibition in Moscow in 1987 and a solo exhibition at the Central Artists' House, Moscow, in 1994. Recently, he moved to Germany.

Selected Bibliography

Eduard Gorokhovsky. Exh. cat. Jersey City: C.A.S.E. Museum of Contemporary Russian Art, 1989.

Kabakov, Ilya. "Eduard Gorokhovsky." *A-Ya*, no. 6 (1984), pp. 8–12. (In Russian and English.)

Manevich, G. "Eduard Gorokhovsky." *A-Ya*, no. 2 (1980), pp. 23–25.

Misiano, Victor. "Eduard Gorokhovsky." *Flash Art*, no. 151 (1991), pp. 156–57.

Peschler, Eric A. "Eduard Gorokhovsky." In *Künstler in Moskau*. Zurich: Edition Stemmle, 1988, pp. 98–104.

Tupitsyn, Margarita and Victor. "Six Months in Moscow." *Flash Art*, no. 1 (1989), pp. 115–17.

Plate 44
Eduard Gorokhovsky, *Spiele (Games)*, 1983,
from a series of 9 works

Ill. 34
Eduard Gorokhovsky, *Airplane Game*, 1979,
from a series of 12 works

Ill. 35
Eduard Gorokhovsky, *Spiele (Games)*, 1983,
from a series of 9 works

Boris Mikhailovich
Iofan
Odessa 1891–
1976 Moscow

To many, Iofan's designs epitomize Stalinist architecture at its height. His plans were grandiose, redolent of Roman and Egyptian monuments, embellished with symbolic decoration, and scaled to accommodate the assembled masses. After studying at the Odessa Art Institute from 1903 to 1911 and traveling in France and Italy, he attended the Accademia delle Belle Arti in Rome from 1914 to 1916. His years in Rome had a strong impact on his work, and his more practical projects adapted Italianate and classical elements. Drawn back to the USSR in 1924, Iofan began to submit projects to architectural competitions. In 1925, he won the competition for the workers' housing project for Rusakovskaya Street in Moscow, and, between 1927 and 1931, he was chief architect of the House of Government, Moscow. Among his first large commissions, the housing complex on Serafimovich Street (1928–31) included the first Soviet movie theater in Moscow entirely constructed and furnished with materials and equipment manufactured in the USSR. In 1931, Iofan headed the regional planning workshop for the City of Moscow. His most famous design was his prize-winning proposal for the Palace of Soviets (1931–33), an immense monument,

meeting hall, and civic center to be constructed in Moscow (see pl. 22). Vastly different in style from the Constructivist entries submitted by graduates of Vkhutein and Leningrad studios, Iofan's design rose in tiers, topped by a huge statue of Lenin. Only the excavation for the building was accomplished. Iofan's concept of a monument topped by a gigantic statue was realized in two pavilions. The first, at the Soviet Pavilion for the 1937 Exposition Universelle in Paris, rose in a dynamic sweep, its towering facade acting as the base for Vera Mukhina's 32-foot sculpture *The Worker and the Collective-Farm Girl*, which became the most familiar Socialist Realist sculpture in the West. The Soviet Pavilion for the 1939 New York World's Fair was slightly more static, if similarly grand. The tallest building at the fair after the Trylon, its tower was faced with the same red marble used on Lenin's tomb. More practical and less heroic were Iofan's sanatorium and housing complexes for workers. Both his monumental and more domestic works defined the architectural style of Moscow during Stalin's lifetime. In 1970, Iofan was named People's Artist of the USSR and was awarded the Order of Lenin.

Selected Bibliography

Cunliffe, Antonia. "The Competition for the Palace of Soviets in Moscow, 1931–1933." *Architectural Association Quarterly* 11, no. 2 (1979), pp. 36–48.

Eigel, I. Yu. *Boris Mikhailovich Iofan.* Moscow: Stroizdat, 1978.

Ikonnikov, Andrei V. *Russian Architecture of the Soviet Period.* Trans. Lev Lyapin. Moscow: Raduga, 1988.

Melnikov, E. "Boris Mikhailovich Iofan." *Arkhitektura SSSR*, no. 5 (1971), pp. 39–42.

Noever, Peter, ed. *Tyrannei des Schönen: Architektur der Stalin-Zeit.* Exh. cat. Vienna: Österreichisches Museum für Angewandte Kunst, 1994.

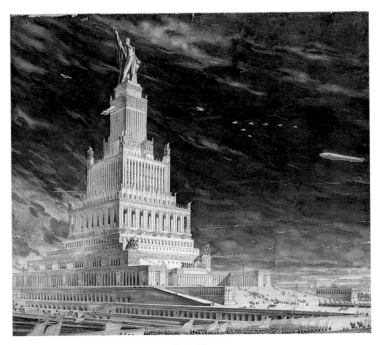

Plate 22
Boris Iofan with B. Shchuko and V. Gelfreikh, *Perspective for the Palace of Soviets, Moscow* (Competition Project), 1933

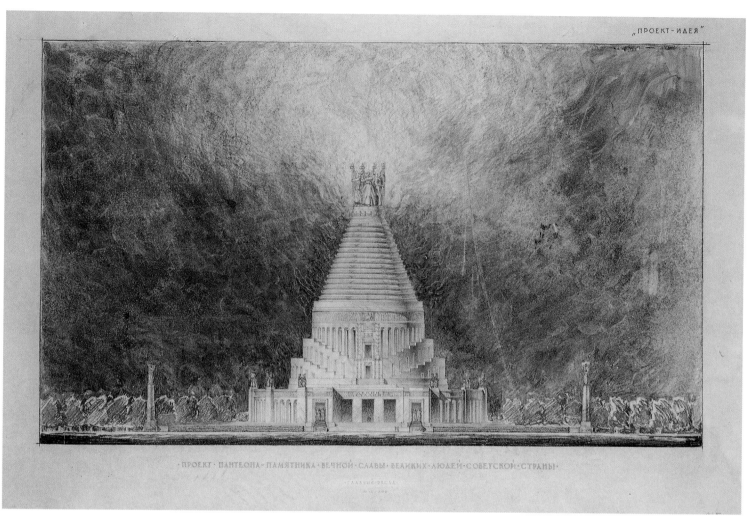

·ПРОЕКТ · ПАНТЕОНА · ПАМЯТНИКА · ВЕЧНОЙ · СЛАВЫ · ВЕЛИКИХ · ЛЮДЕЙ · СОВЕТСКОЙ · СТРАНЫ·

Ill. 36
Boris Iofan, *Facade for Pantheon of Eternal Glory of the Great People of the Soviet Nation*, 1952–53

Ill. 37
Boris Iofan, *Lobby Interior of the Palace of Soviets*, 1940 variant

Ilya Iosifovich
Kabakov
Dnepropetrovsk 1933;
lives in Paris and
New York

As a leader of a generation of artists whose activities were not sanctioned by the authorities, Kabakov was one of the first to transmit social criticism by describing life in a system that disregarded the dignity of human life. Like most Soviet Jews, he had grown up with an awareness of his ethnic identity, though with no knowledge of Jewish religious practice and tradition. After graduation from the Moscow School of Art in 1951, Kabakov studied at the Surikov Institute of Arts (1951–57). For his diploma work, he chose to create illustrations for texts by Sholem Aleichem. From 1956, he worked as a children's book illustrator; from 1965 to 1975, he participated in many notable exhibitions, including shows at the Blue Bird Café, Moscow (1968); *Russian Avant-Garde, Moscow-73* at the Galerie Dina Vierny in Paris (1973); and *Progressive Tendencies in Moscow 1957–70* at the Museum Bochum. Together with Bulatov and Oleg Vasiliev, he frequented the apartments of Vladimir Favorsky, Falk, and Artur Fonvizen. Conceptual artists in Moscow had no possibility of exhibiting regularly as a group, and this hermetic existence had an impact on Kabakov's art. During the early l970s, he produced a series of albums, unbound books of cards with illustrations often accompanied by fragments of text. Created with materials available to officially sanctioned graphic artists, the albums were convenient to show friends, to lend, or to hide (see ill. 39). Kabakov intended them—and his multimedia works and later installations—to function metaphorically. In 1975, he began to host conceptual artists' meetings at his Moscow apartment. By evoking the confined quality of existence in the USSR, his later installations suggest the average Soviet citizen's attempt to create a neutral, nonpolitical zone of safety in which individuality has a place. But while Kabakov's work is not explicit in its presentation of Soviet life, his straightforward representations of ordinary phrases and everyday objects make one consider shared aspects of the human condition (see pl. 39). Kabakov's solo exhibitions have included showings at the Kunsthalle Bern (1985); the Centre National des Arts, Paris (1987); Ronald Feldman Fine Arts, New York (1988); the Institute of Contemporary Art, Philadelphia (1989); the Stedelijk Museum, Amsterdam (1993); the Venice Biennale (1993); the Museum of Contemporary Art, Helsinki (1994); and the Center for Contemporary Art, Warsaw (1994).

Selected Bibliography

Bonami, Francesco. "Ilya Kabakov: Tales from the Dark Side." *Flash Art 25*, no. 177 (Summer 1994), pp. 91–93.

Cembalest, Robin. "The Man Who Flew into Space." *Art News* 89 (May 1990), pp. 176–81.

Groys, Boris. "Ilya Kabakov." *A-Ya*, no. 2 (1980), pp. 5–7, 17–23. (In Russian and English.)

Heartney, Eleanor. "Nowhere to Fly." *Art in America* 78 (March 1990), pp. 176–77.

Storr, Robert. "An Interview with Ilya Kabakov." *Art in America* 83, no. 1 (January 1995), pp. 60–69, 125.

Tupitsyn, Victor. "The Communal Kitchen: A Conversation with Ilya Kabakov." *Arts Magazine* 66 (October 1991), pp. 48–55.

Plate 39
Ilya Kabakov, *Answers of an Experimental Group*, 1970–71

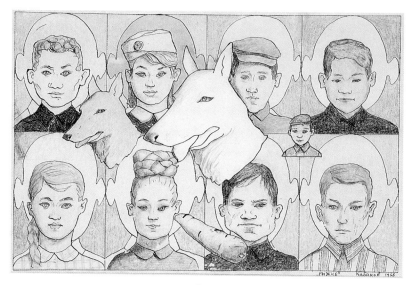

Ill. 38
Ilya Kabakov, *Drawing of Children*, 1968

Ill. 39
Ilya Kabakov, Man under the Shower, 1974, from a series of 16 works

Ill. 40
Ilya Kabakov, *Number 25.XII in Our District*, 1983

Anna Abelevna
Kagan
Vitebsk Province 1902–
1974 Leningrad

As is the case with many Russian women artists of the early twentieth century, little has been published about Kagan; for some time she was confused with a fellow Unovis student, Nina Kogan. Although secular education, particularly in the arts, was difficult for Jewish women within the Pale of Settlement, Kagan was able to study at the Vitebsk Popular Art Institute (which employed at least one female instructor and where Vera Ermolaeva was appointed rector in 1919) from 1919 until 1922. In 1920, she became a member of Unovis. Kagan exhibited with Unovis in Vitebsk (1920–21), Moscow (1920–21), and Petrograd. Together with Ermolaeva, Kogan, and many other young students, she was attracted to Suprematism and the circle forming around Malevich, who was then an instructor at the school in Vitebsk, and she worked in a Suprematist style (only her abstract works are

known; see ill. 42). She subscribed to the group's tenet that artworks should be identified as communal creations and in 1923, as a member of Unovis, exhibited anonymously in the *Exhibition of Petrograd Artists of All Trends.* Without graduating from Vitebsk, Kagan followed Malevich to Petrograd in 1922, assisting him at the Museum of Artistic Culture from 1924 until 1925. She contributed to the *Erste russische Kunstausstellung* in Berlin (1922).

Kagan intended her wood and plaster geometric reliefs to function between sculpture and architecture, and, like other Unovis émigrés to Petrograd, she created designs for textiles and ceramics. She continued to explore nonobjective painting into the 1930s, a time when other members of the avant-garde were compelled to work in a Socialist Realist style. Kagan ceased to exhibit in the 1930s. No information about her later work, if any, has surfaced.

Selected Bibliography

Vitali, Christoph, ed. *Die grosse Utopie: Die russische Avantgarde 1915–1932.* Exh. cat. Frankfurt: Schirn Kunsthalle, 1992, p. 744.

Plate 16
Anna Kagan, *Suprematist Architectonic Composition*, 1926

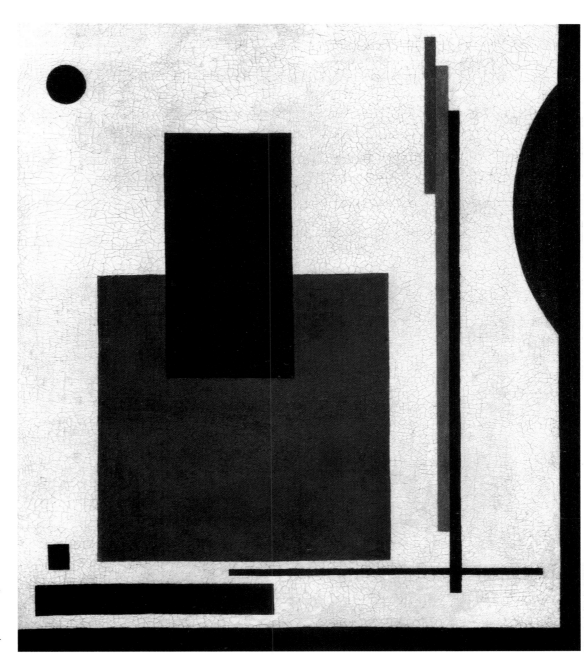

Ill. 41
Anna Kagan, *Suprematist Compo-sition (Large Red Square)*, 1922–23

Ill. 42 (bottom right)
Anna Kagan, *Suprematist Compo-sition*, ca. 1920

Ill. 43
Anna Kagan, *Large Black Suprem-atist Square*, 1923

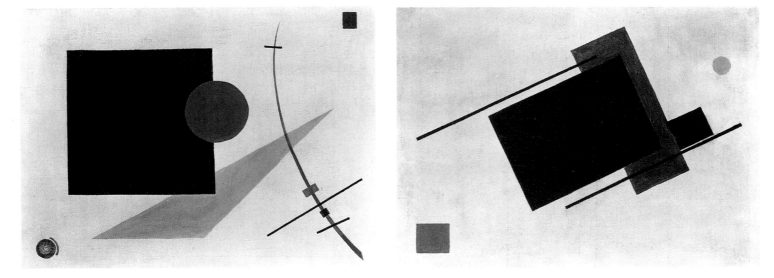

Anatoly Lvovich
Kaplan

(Tanhum ben Levi ben
Itzchak)
Rogachev 1902–
1980 Leningrad

In a society that did not encourage the expression of Jewish culture, Kaplan was unusual in his dedication to Jewish subjects and the illustration of Yiddish literature. His work was tolerated by the Soviet authorities and known during the 1960s and 1970s in the West, but he was never given a solo exhibition. Nostalgia for his youth in a provincial town in Belorussia created indelible impressions that inspired Kaplan's art throughout his life. After the Bolshevik Revolution, he traveled to Petrograd to study painting at the reorganized Academy of Arts. Although he studied under various artists of the avant-garde, abstraction held no interest for Kaplan, and he concentrated on color lithography. In 1937, he was commissioned by the State Ethnographic Museum in Leningrad to create a series of lithographs depicting life in the Jewish Autonomous Region of Birobidzhan. During the late 1930s, amid a rising tide of official anti-Semitism, Kaplan began the first of an extensive series of illustrations of the stories of Sholem Aleichem, which he continued throughout his life. His first graphic cycle *Kasrilovka* drew its inspiration from nostalgic recollections of his native town of Rogachov. Becoming a member of the Union of Soviet Artists in 1939 enabled Kaplan to enroll in the Leningrad Experimental Lithograph Workshop; however, his work failed to meet the requirements of official Soviet realism. On his return to Leningrad in

1944 after evacuation to the Urals during the Second World War, Kaplan began to make expressive lithographs that provide a unique portrait of the city in the aftermath of the German blockade as well as the rebuilding that followed (see ill. 44 a). He also continued to work on graphic renditions of stories by Aleichem, with whose work he felt a spiritual affinity, as he did for themes from Jewish songs and folk tales. Kaplan's lithographs for *The Bewitched Tailor*, *The Song of Songs*, *Stempenu*, *Stories for Children*, and *Tevye the Milkman* are nostalgic renderings of shtetl life exhibiting a profound understanding of the Jewish national character and sympathy with common people. In his lithographs, Kaplan employed various techniques to create rich surfaces and gradations of light and shade; he also experimented with materials and approaches to application in order to create diverse, rich effects (see ill. 45). In his later graphic work, he introduced intense colors and dominant shapes just as he did in his still life paintings, ceramic reliefs, and small-scale sculptures, often reworking motifs from his Jewish illustrations. As an artist whose work recaptures a century-old folk art culture, Kaplan's rendition offers a link with a vanished tradition. A retrospective exhibition of his work was held at the State Russian Museum, St. Petersburg, in 1995.

Selected Bibliography

Anatoly Kaplan. St. Petersburg: State Russian Museum and Palace Edition, 1994.

Goodman, Susan Tumarkin. *Anatole Kaplan: Graphic Works.* Exh. broch. New York: The Jewish Museum, 1972.

Kaplan: Anatoli Kaplan, Lithographs. Exh. cat. London: Grosvenor Gallery, 1961.

Kusnezow, Juri, ed. *Anatoli L. Kaplan: Das zeichnerische Werk, 1928 bis 1977: Zeichnungen, Aquarelle, Gouachen, Temperamalereien und Pastelle.* Leipzig: Insel-Verlag Anton Kippenberg, 1979.

Mayer, Rudolf, and Lia Strodt. *Anatoli L. Kaplan: Far scholem, Ein jüdischer Bilderbogen: Das grafische Werk, Die Lithografien und Radierungen.* Exh. cat. Leipzig: Museum der Bildenden Kunste, 1989.

Suris, Boris D. *Anatoly Lvovich Kaplan: Ocherk tvorchestva.* Leningrad: Khudozhnik RSFSR, 1972.

Ill. 44 a
Anatoly Kaplan, *Repairing St. Isaac's Square*, 1945

Ill. 44 b
Anatoly Kaplan, *Village of Kozodoyevka*
from *The Bewitched Taylor*, 1957

Ill. 45 (right)
Anatoly Kaplan, *Portrait of a Writer* from *Fishke the Lame*, 1967

Evgeny Alexandrovich
Katsman

Kharkov 1890–
1976 Moscow

Katsman epitomizes the conservatism of painting from the early Soviet period: Revolutionary themes; realistic patriotic portraits; and peasant and proletarian images geared to mass taste and comprehension. He was a student at the Bogolyubov Art Institute of Saratov from 1902 to 1905 and attended classes at the Drawing Institute Society for the Encouragement of the Arts (1906–09). Between 1909 and 1916, he studied at the Moscow College of Painting, Sculpture, and Architecture. In 1918 he contributed to the *Exhibition of Paintings and Sculpture by Jewish Artists*, and, in the following year, he became the secretary of the Moscow Soviet department overseeing public celebrations. Katsman worked primarily as a portraitist in pastels and chalk (see ill. 46), although he executed some genre and agitprop work and helped decorate Moscow for the second anniversary of the Bolshevik Revolution. Such didactic themes as the stereotypically rough but intelligent *Village Teacher* (see pl. 25), realistically rendered, were typical of AKhRR and established standards adopted by Socialist Realism. In 1922, after assuming the post of secretary-general of

AKhRR, Katsman concentrated more on administrative matters than on creating art. Despite his dedication to realism, he was criticized by the group in 1929 for "political error" due to the intimate scale of his work. Following the dissolution of art organizations in 1932 and the proposal of a single Union of Soviet Artists, Katsman remained active in MOSSKh. During a 1933 meeting with Stalin, Kliment Voroshilov, Alexander Gerasimov, and Brodsky, the artist heard Stalin express his preference for realistic works in the manner of Ilya Repin and the Wanderers, and he understood that this approach was to be promoted as the official Soviet style. Katsman rigorously pursued Stalin's aims; that and his closeness to Gerasimov helped him to survive the decades of persecution when even Socialist Realist artists found themselves, as Jews, denied commissions and administrative positions. In 1947, Katsman was appointed a member of the USSR Academy of Arts after having been named an Honored Arts Worker of the RSFSR. Katsman continued to produce portraits and idealized images of laborers into the early 1970s.

Selected Bibliography

Katalog vystavki proizvedenii zasluzhennogo deiatelia iskusstv RSFSR Evgeniia Katsmana. Exh. cat. Moscow: Sovetskii khudozhnik, 1947.

Katsman, Evgeny. *Zapiski khudozhnika.* Moscow: Akademiya khudozhestv SSSR, 1962.

Perelman, Viktor. *Evgeny Aleksandrovich Katsman.* Moscow: Vsekokhudozhnik, 1935.

Vystavka proizvedenii chlenov akademy khudozhestv SSSR. Exh. cat. Moscow: Iskusstvo, 1974, pp. 134–35.

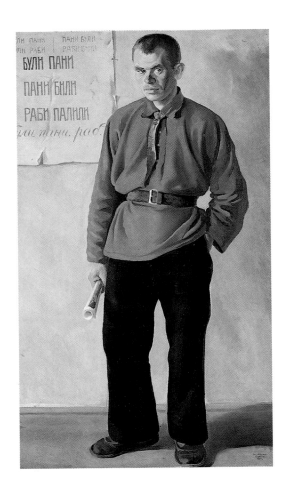

Plate 25
Evgeny Katsman, *Village Teacher*, 1925

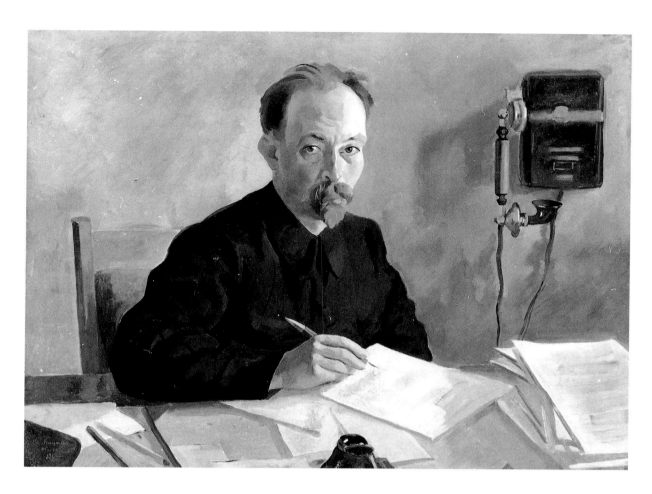

Ill. 46
Evgeny Katsman, *Portrait of Feliks Dzerzhinsky*, 1923

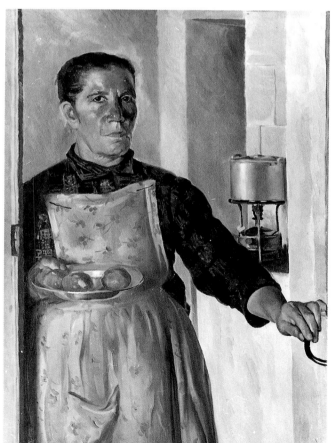

Ill. 47
Evgeny Katsman, *Stepanida*, 1928

Lazar Markovich
Khidekel

Vitebsk Province 1904–
1986 Leningrad

Khidekel was one of the generation of young Jewish artists who received training entirely in institutions created or reorganized by the new government. From 1919 to 1922, he attended the Vitebsk Popular Art Institute and was appointed a member of its staff. In 1919 he contributed to the *First State Exhibition of Local and Moscow Artists* in Vitebsk and in 1920 became a founding member of Unovis. His contact with Malevich and Unovis members continued through the 1920s, as he worked with Malevich in the theoretical section of Ginkhuk and extended Suprematist ideas and geometric forms to architecture and city planning. Khidekel's interest in architecture had already been evident in Vitebsk. Some sources claim that he was a member of the architecture faculty there in 1920, and the journal *Aero*, which he edited with Chashnik, contains articles and projects about floating and grounded buildings. After his move to Petrograd in 1922, Khidekel began to develop his own brand of Suprematism, labeled "Architectonic" (see ill. 48). In 1922, he also entered the Petrograd Institute of Civil Engineering; he was the only member of

Unovis to receive a professional degree in architecture. He took part in the 1923 *Exhibition of Paintings by Petrograd Artists of All Trends.* Beginning in 1925, along with Chashnik and Nikolai Suetin, he worked in the studio of Alexander Nikolsky, thus exposing himself to innovative city plans, competition projects, and models for communal dwellings influenced by Suprematism and architectural Constructivism. In 1927, Khidekel contributed to the *First Exhibition of Contemporary Architecture* in Moscow. While associated with the Nikolsky studio, he himself created designs for cities and building complexes raised up on piers or pontoons, or floating freely in space. Like most of the experimental architecture of the period, Khidekel's projects were never realized, yet they survive as evidence of the fertile field of utopian planning in the early Soviet years. Khidekel assisted with various architectural projects from the 1930s through the 1950s, including the design for the Soviet Pavilion for the 1937 Exposition Universelle in Paris. From 1930 to 1985, he taught architecture at the Leningrad Institute of Civil Engineering.

Selected Bibliography

Blanchette, Antoine. *Lazare Markovich Khidekel: Oeuvres suprématistes/ Suprematist Works, 1920–1924.* Exh. cat. Quebec: Musée d'Art de Joliette, 1992.

Lazar Markovich Khidekel. Exh. cat. New York: Leonard Hutton Galleries, 1995.

Sarabyianov, Dmitry Vladimirovich, and Alexandra Semenovna Shatskikh. *Malevich.* Moscow: Iskusstvo, 1993.

Vitali, Christoph, ed. *Die grosse Utopie: Die russische Avantgarde 1915–1932.* Exh. cat. Frankfurt: Schirn Kunsthalle, 1992, p. 735.

Zhadova, Larissa A. *Malevich: Suprematism and Revolution in Russian Art 1910–1930.* London: Thames and Hudson, 1982.

Plate 11
Lazar Khidekel, *Suprematist Concentric Circles*, 1921

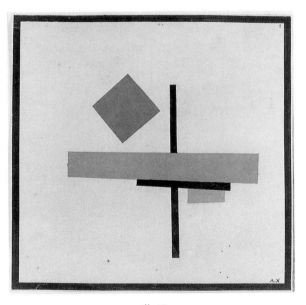

Ill. 48
Lazar Khidekel, *Colored Suprematism—*
Suprematist Composition with Blue Square, 1921

Ill. 49
Lazar Khidekel, *Yellow Cross*, 1923

Vitaly Anatolevich
Komar
and
Alexander Danilovich
Melamid
Moscow 1943;
lives in New York;
Moscow, 1945;
lives in Jersey City

Selected Bibliography

Nathanson, Melvyn B., ed. *Komar and Melamid: Two Soviet Dissident Artists.* Carbondale and Edwardsville: Southern Illinois University Press, 1979.

Ratcliff, Carter. *Komar & Melamid.* New York: Abbeville Press, 1989.

Ross, Andrew. "Poll Stars: Komar & Melamid's 'The People's Choice.'" *Artforum* 33, no. 5 (January 1995), pp. 72–77, 109.

"The Search for a People's Art." *Nation* 258, no. 10 (14 March 1994), pp. 334–55.

Wollen, Peter. "Painting History." In *Komar & Melamid.* Exh. cat. Edinburgh: Fruitmarket Gallery, 1985, pp. 38–57.

Woodward, Richard B. "Nobody's Fools." *Artnews* 86 (November 1987), pp. 172–78.

Both Komar and Melamid graduated from the Stroganov Institute of Applied Arts in 1967. Central to much of their collaborative work are their memories of art from the Stalin era of their childhood, art that was suppressed during de-Stalinization. In 1972, they developed Sots Art, ironically combining the first syllable of "Socialist Realism" with "Pop Art." Sots Art was based on a subversive appropriation of the visual language of Communist propaganda and Socialist Realist art. Komar and Melamid's period of collaboration, which began in 1965 in Moscow, was eclectic and productive, resulting, among other works, in performance actions, conceptual pieces, and those that presented encoded information related to the Soviet bureaucracy in mixed media. In 1967, they exhibited at the Blue Bird Café, Moscow, and in 1968, both artists entered the Youth Section, MOSSKh. In 1976, while they were still in Russia, their work was shown at the Ronald Feldman Gallery in New York. By creating paintings that expressed the banality of the system or applied the overblown language of Socialist Realism to the tedious unpleasantness of life in the Soviet Union, they were able to deconstruct the claims and utopian assumptions of that society, as in *Factory for the Pro-*

duction of Blue Smoke (see pl. 42). Both artists were active participants in challenging the restrictive exhibition policies of the Soviet government (see ill. 52). In 1974, they listed their names on the invitation to the "Bulldozer" exhibition and also appeared at the follow-up exhibition in Izmailovsky Park. As a result, they were expelled from the Youth Section of the Moscow Union of Artists that same year. Their seven-part photo piece, *Prophet Obadiah* (see ill. 50), representing fragments of an ancient text and dedicated to a minor Old Testament prophet, preceded their emigration to Israel. This followed their 1977 expulsion from the Union of Graphic Artists for having applied for exit visas. In Israel, they erected *Third Temple*, an aluminum-frame pyramid topped with a red star. On a schematized altar inside the "temple," they set fire to the suitcase Komar had brought from Russia. Following their arrival in the United States in 1978, the artists had solo exhibitions at the Bowdoin College Museum of Art, Brunswick, Maine (1989), and at The Brooklyn Museum, New York (Grand Lobby Installation, 1990), and participated in numerous group exhibitions in the United States and abroad.

Ill. 50
Vitaly Komar and Alexander Melamid, *Prophet Obadiah,* 1976

Ill. 51
Vitaly Komar and Alexander Melamid
Double Self-Portrait, 1973

Ill. 52
Vitaly Komar and Alexander Melamid
Color Writing: Ideological Abstraction No. 1, 1974

Plate 42
Vitaly Komar and Alexander Melamid,
Factory for the Production of Blue Smoke, 1975

Alexander Semenovich
Kosolapov

Moscow 1943;
lives in New York

In 1968, Kosolapov graduated from the Stroganov Institute of Applied Arts as a monumental sculptor, but, like many of his nonconformist contemporaries, he suffered from a lack of commissions. In the early 1970s, he began to work in mixed media, producing pieces based on a fusion of logically incompatible elements. The wit and irony of these pieces sprang from two sources: Russian absurdist poetry of the 1920s and the poetics of Dada. Kosolapov believed that it was necessary to free objects from their traditional associations. He had an interest in joining unfamiliar elements in his art to evoke improbable reactions, leading viewers to consider symbolic context instead of literal content. Like many of the Sots artists, Kosolapov satirized Soviet ideological mass production. But the originality of his early art lies in his obsession with everyday objects, exemplary of Soviet kitsch and often found by chance (see ill. 54). *Aurora* is an assemblage based on the ballet

Swan Lake in which Aurora dances a pas de deux in the embrace of her prince, a cosmonaut; in the background, the magic forest has been replaced by the revolutionary cruiser *Aurora* (see pl. 38). He did, however, receive a solo exhibition in Moscow in 1974. In the mocking postmodernist style of works Kosolapov has created since his 1975 emigration to New York, he has parodied and juxtaposed American Pop Art and Socialist Realist banalities using representations of Lenin and Stalin as well as slogans and images of heroes of American "consumer idealism." From 1975 to 1984, he worked as editor and director of the émigré artists' journal *A-Ya*. He participated in *20 Years of Unofficial Art from the Soviet Union* at the Museum Bochum in 1979, in solo exhibitions in galleries in Germany and New York, and in numerous group exhibitions in Russia, Europe, and the United States.

Selected Bibliography

Alexander Kosolapov. Exh. cat. Cologne: Galerie Anna Friebe, 1987.

Alexander Kosolapov: New Work. Exh. cat. New York: Eduard Nakhamkin Fine Arts, 1990.

Patsyukov, V. "Project—Myth—Concept." *A-Ya*, no. 2 (1980), pp. 9–11, 32–34. (In Russian and English.)

Sots Art. Exh. cat. New York: New Museum of Contemporary Art, 1986.

Transit: Russian Artists between the East and the West. Exh. cat. Hempstead, NY: Fine Arts Museum of Long Island, 1989.

Ill. 53
Alexander Kosolapov, *North*, 1975

Ill. 55
Alexander Kosolapov, *Study Sonny*, 1974

Ill. 54
Alexander Kosolapov, *Baltika*, 1973

Plate 38
Alexander Kosolapov, *Aurora*, 1973

Alexander Arkadevich
Labas
Smolensk 1900–
1983 Moscow

Known for his lyrical paintings depicting new modes of transportation, Labas extolled the urban technology of modern life. His obvious delight in the age of air travel recalls the enthusiasm of the Russian and Italian Futurists for technology and the machine. Labas studied at the Stroganov Institute of Applied Arts from 1912 until 1917 and, later, at the State Free Artistic Studios. During his student years at Vkhutemas, Moscow, from 1921 until 1924, Labas made the acquaintance of Tyshler and Nikritin and began to paint abstract compositions with scientific and technological references. These artists—the Projectionists—maintained that they should not produce actual art objects, but rather projects or "Projections," the conceptions, ideas, and plans associated with such objects. After exhibiting with the group, Labas began to teach painting at Vkhutemas and moved away from abstraction, becoming a founding member of OST in 1925. Three years later, he created stage designs for BelGoset. His paintings of the late 1920s tended to stress the power of engines and aircraft, which effectively reduce human beings to ephemera (see ill. 56). His interest in aviation and trains coincided with one of the principal goals of the Soviet Union's first Five-Year Plan, which was the development of a strong transportation industry (see pl. 23). All of his paintings featured washes of color over which buildings, railroad tracks, interior details, or other environmental rudiments were sketchily delineated. Human figures became mere notations, even in his interiors of metro stations (see ill. 57). After being criticized by Osip Beskin for nonconformity, Labas lost favor temporarily and became isolated from the official art world. Fortunately, his style was easily adapted to panoramas and exhibition backdrops, which he created from the late 1930s, and he took part in the *All-Union Agricultural Exhibition*, Moscow. He also held life-drawing sessions in Vladimir Tatlin's studio during the 1930s. In 1931 he took part in the *Anti-Imperialist Exhibition* in Moscow, and became a member of MOSSKh the next year. He had a brief career (1934–35) as a stage designer for the Yiddish theater and in 1937 designed the decorative panel for the Soviet Pavilion at the Exposition Universelle in Paris. Labas was fortunate in being able to work throughout his life. In 1962, he took part in *Thirty Years of Moscow Art* at the Manezh, and received a solo exhibition in 1976 at the State Tretyakov Gallery, Moscow. Late in his career, he produced cityscapes and landscapes, painting until the year of his death.

Selected Bibliography

A. A. Labas: Katalog. Exh. cat. Moscow: Sovetskii khudozhnik, 1976.

Alexander Arkadevich Labas. Exh. cat. Moscow: State Tretyakov Gallery, 1991.

Butorina, Evgeniya. *Alexander Labas.* Moscow: Sovetskii khudozhnik, 1979.

Kostin, V. *OST.* Leningrad: Khudozhnik RSFSR, 1976.

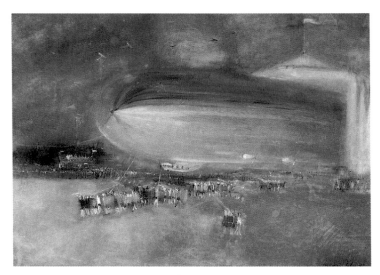

Plate 23
Alexander Labas, *The First Soviet Dirigible*, 1931

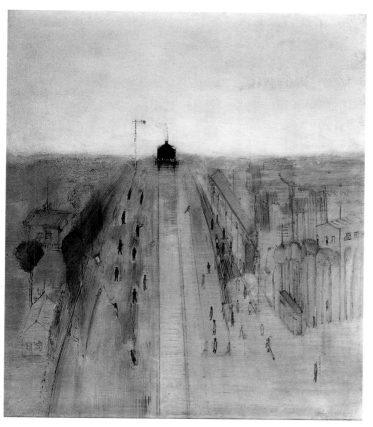

Ill. 56
Alexander Labas, *The Approaching Train*, 1928

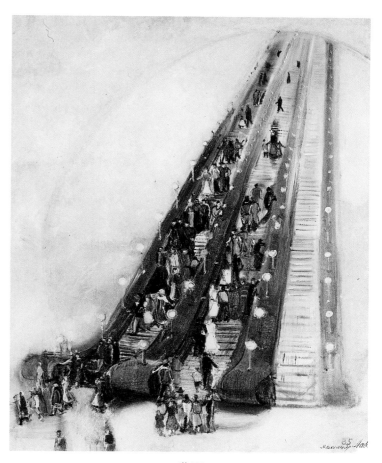

Ill. 57
Alexander Labas, *Metro*, 1935

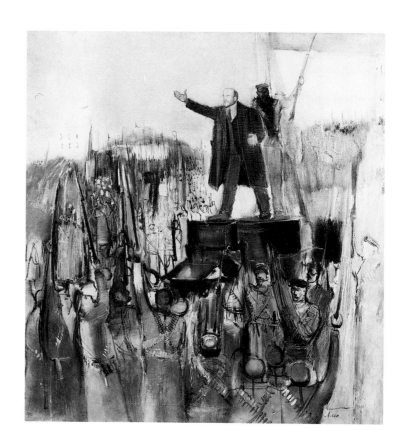

Ill. 58
Alexander Labas, *Lenin's Arrival in Petrograd in 1917*
(from *October Series*), 1930

Leonid Israelovich
Lamm
Moscow 1928;
lives in New York

Lamm's work has often contained political messages and some of his strongest Realist paintings depict his experience in prison and in labor camps. He graduated in 1947 from the Moscow Architectural Institute, where, through his professor, Yakov Chernikhov, he created a link between the avant-garde of the 1920s and the underground of the 1970s. Like many serious artists, Lamm supported himself as an illustrator and book designer throughout his working years in the Soviet Union. He participated regularly in official exhibitions of graphic and book arts while painting in private and sharing work with friends. He contributed to the 1959 International Book Fair in Leipzig, where he won a silver medal. During the mid-1960s, Lamm became interested in Jewish mysticism and began to produce abstract paintings influenced by Kabbalistic writing (see ill. 60). He created a mystical theory positing the existence of a "Supersignal," described by the artist as "a permanent signal" creating and directing everything in the universe. Later, Lamm translated his mystical ideas into abstract paintings. Lamm's application in 1973 for a visa to emigrate to Israel resulted in his arrest and imprisonment in Butyrka Prison, where he continued to work as an artist, creating a series of watercolors. In 1974, he was represented at the *Second Autumn Open-Air Exhibition* in Izmailovsky Park, Moscow. After his release in 1976, many of the small compositions he had created in prison were realized in larger canvases, such as *Assembly Hall* from the Butyrka Prison Series (see pl. 45). Another set of small watercolors made during Lamm's confinement consists of semi-surreal compositions with biomorphic shapes evoking the oppressive reality of being observed by guards and intimidated by inmates. Lamm often includes mathematical equations and arrows in his paintings and multimedia works (see ill. 59). While they appear to measure spaces, they actually refer to the tendency of contemporary societies to quantify everything in order to control and standardize life. In 1978, Lamm had solo shows at the Dostoyevsky Museum in Leningrad and the Central Artists' House in Moscow. He contributed to *20 Years of Unofficial Art from the Soviet Union* at the Museum Bochum (1979). Following his emigration to New York in 1982, Lamm continued to draw on his prison sketches as well as on life in a totalitarian society, creating large-scale paintings with strong political content. He has had exhibitions at numerous galleries in the United States and abroad.

Selected Bibliography

Back to Square One. Exh. cat. New York: Nathan Berman Gallery, 1991.

Dodge, Norton, ed. *Leonid Lamm: Recollections from the Twilight Zone 1973–1985.* Exh. cat. Alexandria, VA: Firebird Gallery, 1985.

Four Russian Messages: Carnival or Drama?. Exh. cat. New York: Hal Bromm Gallery, 1994.

Leonid Lamm: Homage to Yakov Chernikhov. Exh. cat. New York: Howard Schickler Fine Art, 1994.

Transit: Russian Artists Between the East and the West. Exh. cat. Hempstead: Fine Arts Museum of Long Island, 1989.

Ill. 59
Leonid Lamm, *Three Years: My Last Days in the Labor Camp,*
1976–83

Ill. 60
Leonid Lamm, *Untitled (Red Corner)*, 1974–78

Ill. 61
Leonid Lamm, *Yes . . . Hell . . . Yes*, 1964

Plate 45
Leonid Lamm, *Assembly Hall* (from *Butyrka Prison Series*),
1976–86

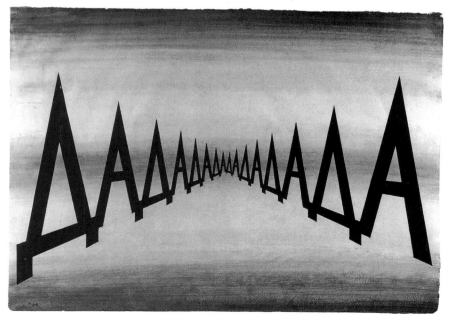

Isaak Ilich
Levitan
Kibarty 1860–
1900 Moscow

One of the most admired landscapists of his generation, Levitan was caught between two identities. As a Jew, he faced obstacles and persecution; as a Russian artist, he was described as "the most Russian of painters" and "a real poet of the Russian landscape." Levitan's father, a railway employee, was influenced by the Haskalah movement. Levitan's family moved to Moscow, where his father barely qualified them for residency by working as a tutor. Levitan studied at the Moscow College of Painting, Sculpture, and Architecture under Alexei Savrasov and Vasily Perov from 1873 until 1885. The young art student soon made a name for himself in school, where he concentrated on landscape. His first showing, in 1877, was in the Students' Section of the *Fifth Exhibition of the Wanderers* in Moscow. As his reputation increased, the maecenas Savva Morozov provided him with a Moscow studio, which he maintained from 1889. In 1884, he was accepted as a contributing member of the Wanderers, becoming a full member in 1891. Levitan's trips to the Volga, Crimea, Italy, France, and Switzerland in 1887–91 played an important role in his artistic development. His landscapes of the first two regions satisfied a market for essentially Russian themes during a period of rising nationalism (see

pl. 2). Influenced by the Barbizon School, Levitan painted from plein-air sketches. He exhibited in the Russian section of the 1893 Great Columbian Exposition in Chicago and, in 1896, with the Secessionists in Munich. In 1898, he became a member of the Imperial Academy of Arts, St. Petersburg. From 1898 to 1900, Levitan headed the landscape painting department at the Moscow College of Painting, Sculpture, and Architecture. His greatest paintings, dating from the 1890s, express the Sublime through expanses of water and twilit vistas. Roads or human structures—frequently Russian Orthodox churches or monasteries—often are shown empty or minute in size, overwhelmed by an uncultivated environment (see ill. 62). Despite his success, Levitan suffered from restrictive policies rooted in the very nationalism that promoted his art. Though he was forced to leave Moscow twice, in 1879 and 1892, during general expulsions of Jews from the city that represented the Imperial and religious heart of Russia, his artistic status and the interest of influential patrons, such as the writer Anton Chekhov, finally gained him the right to legal residence in Moscow the year before his death. In 1901, he was given posthumous solo exhibitions in both St. Petersburg and Moscow.

Selected Bibliography

Fedorov-Davydov, Alexei A. *Isaak Ilich Levitan: Dokumenty, materialy, bibliografiya.* Moscow: Iskusstvo, 1966.

———. *Isaak Ilich Levitan: Zhizn i tvorchestvo.* 2 vols. Moscow: Iskusstvo, 1966.

Fetzer, Leland, and Ita Sheres. "The Jewish Predicament of Isaak Levitan." *Soviet Jewish Affairs* 11, no. 1, (1981), pp. 53–62.

Isaak Levitan. Exh. cat. Tel Aviv Museum of Art, 1994.

Isaak Levitan 1860–1900: Sketches and Paintings. Exh. cat. Tel Aviv Museum of Art, 1991.

Levitan. Leningrad: Aurora, 1981.

Plate 2
Isaak Levitan, *Study for Above Eternal Peace,* 1894

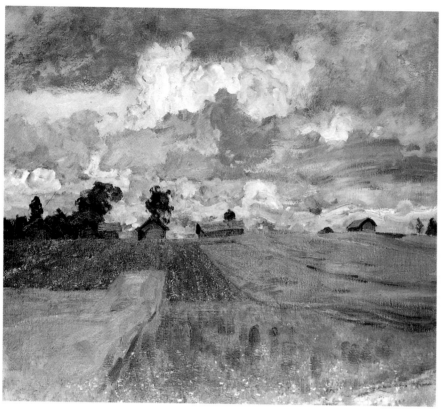

III. 63
Isaak Levitan, *Jewish Tombstone*, ca. 1881

III. 62
Isaak Levitan, *Stormy Day*, ca. 1897

III. 64
Isaak Levitan, *Zvenigrod Monastery, Russian Village*, ca.

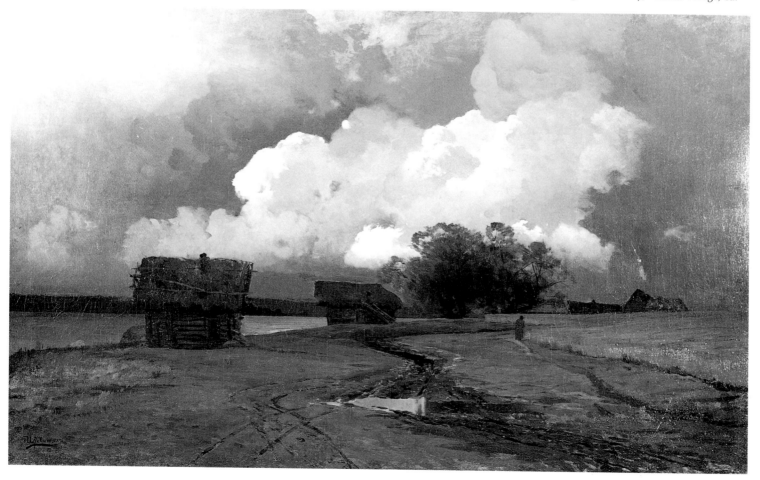

Dmitry Borisovich
Lion
Kaluga 1925–
1993 Moscow

Lion graduated from the Moscow Secondary Art School in 1941. From 1943 until 1952, he served in the Soviet Army, engaged in the Eastern front. The artist learned about the Holocaust from witnesses encountered during his demobilization as well as from documentary films and foreign accounts, and it was the impact of the Holocaust that led him to articulate the spiritual beliefs and tragic fate of the Jewish people. From 1953 to 1958, Lion studied at the Moscow Institute of Graphic Arts. When he settled in Moscow as an art student, he posted the figure 6,351,000 (representing the Holocaust death toll) on the wall of his room, and his artwork from the late 1950s and early 1960s manifests apocalyptic visions of dead bodies and gas chambers. During that same period, he began to create large scrolls; in 1963, he created a monumental compostion on paper, *People of Warsaw Going to the Gas Chamber* (Moscow, Estate of the Artist). Subsequently, his graphic works became more symbolic and metaphorical. He took part in the *Fifth Exhibition of Works by Young Moscow Artists* in 1959. In series begun in the 1950s and 1960s, Lion used biblical allusions in

his compositions, which reveal "washed" forms and figures mixed with feverish, illegible handwriting. Combining Old Testament and contemporary history, the majority of Lion's graphics consist of ink on paper, although occasionally he employed mixed media. Lion also worked as a book designer and illustrator; however, only a few of his drawings were published. From the 1970s on, he produced several series of drawings and prints based on biblical figures such as David and Bathsheba. A number of these compositions show figures in ceremonial and ambiguous processions, while in other cycles and individual works, his partially realized figures are enveloped in a cryptic language of scribbled and crossed-out words (see ill. 68). Though Lion participated in some of the unofficial art exhibitions, he saw himself, as did his contemporaries, outside any group or movement. Nonetheless, in 1977, he was admitted to MOSSKh, and continued working as a graphic artist and illustrator, mostly for the Sovietish Heimland publishing house, where he published in Yiddish. Lion had his first solo exhibition in Moscow in 1990.

Selected Bibliography

Dmitry Lion: Procession. Exh. cat. Moscow: Central Artists' House, 1990.

Drugoe iskusstvo: Moskva 1956–76. 2 vols. Exh. cat. Moscow: Moskovskaya galereya, 1991.

Kazovsky, Lola Kantor. "Dmitry Lion: Jewish Experience and Philosophy of Drawing." Unpub. manuscript. Jerusalem.

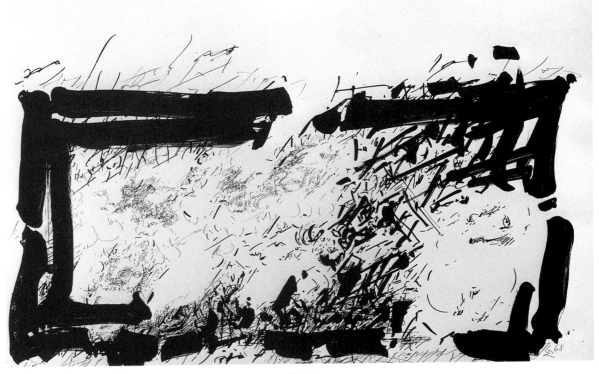

Ill. 65
Dmitry Lion, *Chained Humanity*, 1968

Ill. 68 (right)
Dmitry Lion, *Procession in Wooden Collars*, ca. 1968

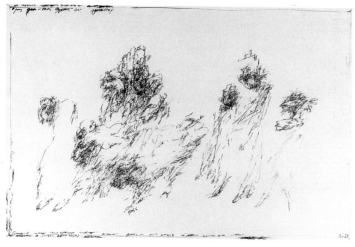

Ill. 66
Dmitry Lion, *Untitled*, 1957

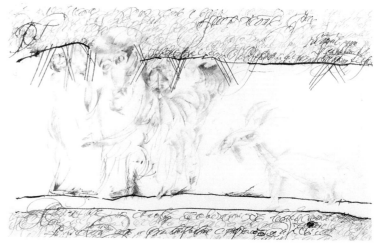

Ill. 67
Dmitry Lion, *Untitled*, 1969

El Lissitzky

(Lazar Mordukhovich
Lisitsky)
Pochinok (Smolensk
region) 1890–
1941 Moscow

El Lissitzky has become one of the most familiar figures of the Soviet avant-garde. For a period of time, he also contributed to the development of Jewish modernism through his illustrations for the Yiddish press and his activities with Jewish art and ethnographic societies. Initially, Lissizsky studied with Pen in Vitebsk (1903). Denied admission to the Imperial Academy of Arts because of his Jewish nationality, Lissitzky studied architecture and engineering in Darmstadt, where he attended the Technische Hochschule from 1909 until 1914. He accompanied Ryback on an expedition sponsored by the Jewish Historical and Ethnographical Society along the Dnieper River to the Mogilev Synagogue around 1916 and for the next few years devoted himself to the creation of a national Jewish art. In 1917, he contributed to the *Exhibition of Paintings and Sculpture by Jewish Artists* in Moscow. The majority of Lissitzky's Yiddish book illustrations between 1917 and 1920 used traditional Jewish motifs adapted to a loosely Cubo-Futurist style. The use of such themes was intended to enhance the abstract effect preferred by the avant-garde (see pl. 8). Lissitzky became a member of Izo Narkompros in 1918, and in the following year he left Kiev to accept a position as head of the graphic arts and architecture workshops at Chagall's Vitebsk Popular

Art Institute. His work there with Kazimir Malevich proved to be a decisive influence on Lissitzky. Within a short time he discovered that Jewish content was too limiting; through an abstract idiom, he felt better able to express the universal content that was more in keeping with the aims of the Revolution, which he supported enthusiastically. He devoted himself to Suprematism, in the company of Malevich and his supporters. Lissitzky's unique vision found expression in his Prouns (an acronym for "Project for the Affirmation of the New"), which he claimed functioned as an innovative link between painting and architecture (see ill. 70). He exhibited with Unovis, Moscow, in 1920 and also contributed to the *First Jewish Art Exhibition of Sculpture, Graphics, and Drawings* held that year. From 1922 to 1925, Lissitzky lived in Europe, where he had his first solo exhibition (1923) in Hannover. Throughout his career, experimental photography was a continuing interest, and, during the early 1920s, he produced a series of photograms and photomontages. Some of Lissitzky's most dramatic works from the late 1920s were realized in foreign exhibitions of Soviet goods and industry. From the mid-1930s on, he devoted himself primarily to typography and exhibition design.

Selected Bibliography

Apter-Gabriel, Ruth, ed. "El Lissitzky's Jewish Works." In *Tradition and Revolution: The Jewish Renaissance in Russian Avant-Garde Art, 1912–1928*. Exh. cat. Jerusalem: Israel Museum, 1987.

El Lissitzky 1890–1941. Exh. cat. Cambridge, MA: Harvard University Art Museums, Busch-Reisinger Museum, 1988.

El Lissitzky 1890–1941: Architect, Painter, Photographer, Typographer. Exh. cat. Eindhoven: Stedelijk Van Abbemuseum, 1990.

El Lissitzky—1890–1941—Retrospektive. Exh. cat. Hannover: Sprengel Museum, 1988.

Friedberg, Haia. "Lissitzky's Had Gadya." *Jewish Art* 12/13 (1986–87), pp. 293–303.

Lissitzky-Küppers, Sophie. *El Lissitzky: Life, Letters, Texts*. Rev. edn. London: Thames and Hudson, 1992.

L.M. Lisitsky 1890–1941. Exh. cat. Moscow: State Tretyakov Gallery, 1990.

Ill. 69
El Lissitzky, *Self-Portrait with Wrapped Head and Compass*, ca. 1924–25

Ill. 70
El Lissitzky, *Proun 3A*, ca. 1920

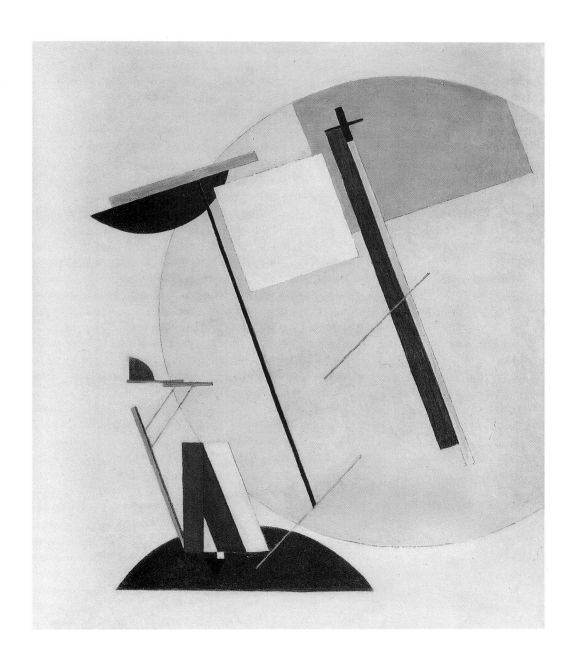

Ill. 71 (bottom right)
El Lissitzky, *Beat the Whites with
the Red Wedge*, 1920

Plate 8
El Lissitzky, "Then Came a Fire
and Burnt the Stick" from
Had Gadya Suite, 1919

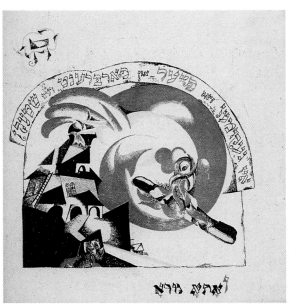

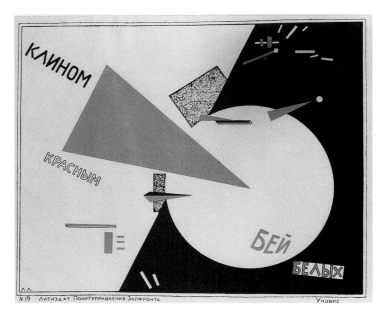

Abraham
Manievich

(Abram Anshelovich
Manevich)
Mstislav, Mogilev
District, 1881–
1942 New York

Known during his life in the United States as a painter of Russian and Ukrainian landscapes and village scenes, Manievich had attained recognition in Russia prior to the Revolution. Like many artists from the Pale, he received an art education at the Kiev Art Institute (1903–05), and a government grant enabled him to continue his studies at the academy in Munich (1905–07). He neglected Jewish subjects, primarily painting landscapes and villages of the Ukraine and Lithuania, and exhibited from 1907 to 1910 with the World of Art in Moscow and the Society of South Russian Artists, Odessa. A solo exhibition was held at the Kiev State Museum in 1910. Following successful exhibits in Paris, he returned to Russia, in 1914 moving to Moscow. The influence of international movements can be observed in Manievich's decorative style. His 1916 solo exhibition at Dobychina's Bureau in Petrograd was highly successful, visited by about two thousand viewers.

In 1917, he returned to Kiev, where he was appointed a professor at the Ukraine Academy of Arts. He participated in the 1918 *Exhibition of Paintings and Sculpture by Jewish Artists* in Moscow. Manievich's son was killed in a pogrom in 1919, and that year, he painted the major work *Destruction of the Ghetto, Kiev* and its pendent, *Russian Village at Peace* (see pl. 10; ill. 73). The former is a dynamic evocation of the pogroms that swept the Ukraine following the Bolshevik Revolution. In a Cézannesque/expressionist style, it shows a ghetto crowded with buildings but drained of life, with the exception of a black goat observing the scene from the foreground. Manievich emigrated two years later. He exhibited widely in the United States. As an exhibitor at the Jewish Art Center and as a member of the Yiddish Culture Association (YKUF), he participated in the large community of native and emigrant Jewish artists in New York.

Selected Bibliography

Abraham Manievich (1881–1942). Exh. cat. Danville Museum of Fine Arts and History, 1980.

Abraham Manievich (1881–1942). Exh. cat. Miami Museum of Modern Art, 1960.

Vystavka kartin i etyudov A.A. Manevicha. Exh. cat. Petrograd: M. Pivovarsky, Ts. Tipograf, 1916.

Ill. 72
Abraham Manievich, *Through the Trees (Fairy Park)*, 1919

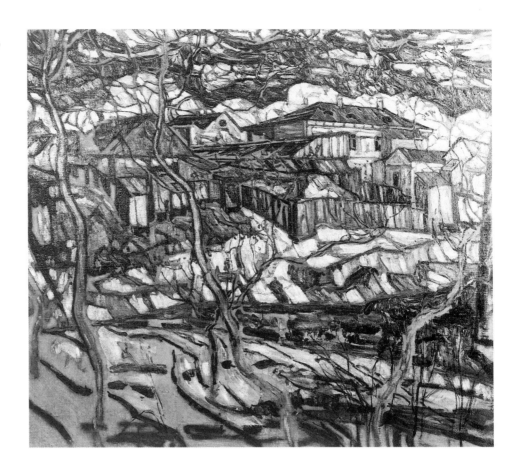

Ill. 73
Abraham Manievich, *Russian Village at Peace*, 1919

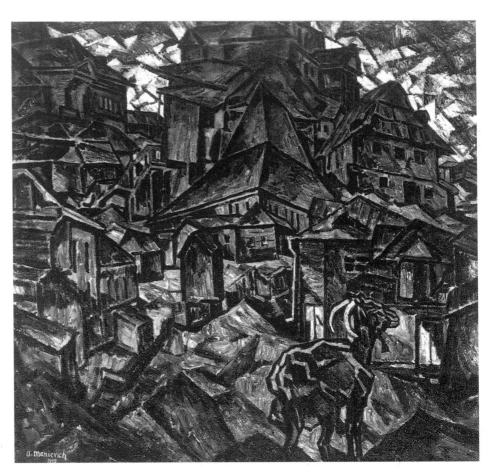

Plate 10
Abraham Manievich, *Destruction of the Ghetto, Kiev*, 1919

Boris Andreievich
Mihailov
Kharkov 1938;
lives in Kharkov

Considered an influential figure in contemporary Russian art photography, Mihailov, refusing to cultivate a single style, obsessively photographs and manipulates photographs of any and all aspects of life. Although his Jewish identity rarely figures overtly in his work, his commitment to nonconformist practice has always been driven in large part by his experiences with and constant awareness of anti-Semitism. Except for the period 1941–44, when he and his mother were evacuated to the Urals, Mihailov has always lived in Kharkov. As a small child, he was repeatedly called the Russian equivalent of "kike" by other children; in 1994, the same slur was scrawled on the wall label of *I Am Not I*, his installation of nude self-portraits in Moscow. Having trained as an engineer in the early 1960s, Mihailov supported himself in this way when he began to photograph at age 28. In the late 1960s, the KGB caused him to be excluded from the engineering profession, the consequence of labeling his photography "pornography." During the 1970s, he worked as an independent commercial photographer and photo retoucher. Mihailov's photographs were considered adequate grounds for imprisonment, since they violated laws against the representation of certain subjects such as naked people, poor social or ecological conditions, and the military. Since then, his work has ranged from analyses of the social environment (see pl. 43) to more personal themes. Although his work manifests an economy of means, it offers great visual detail. He variously employs photodocumentary, staged tableaux, and studio set-ups (see ill. 75); he may additionally tone, paint, or otherwise alter his own or found photographs. Mihailov was the first Russian photographer to exploit the poor quality of Soviet photographic materials to represent "average" Soviet life. His various international exhibitions have included solo showings at the Museum of Contemporary Art, Tampere, Finland (1989); the Central House of Cinematographers, Moscow (1990); and the Tel Aviv Museum of Art (1990).

Selected Bibliography

Efimova, Alla. "Photographic Ethics in the Work of Boris Mihailov." *Art Journal* 53, no. 2 (Summer 1994), pp. 63–69.

Frisinghelli, Christine, and Manfred Willmann. "A Sort of Unprotected Pain." *Camera Austria*, no. 42 (1993), pp. 15–38.

Jacob, John P. *The Missing Picture*. Exh. cat. Cambridge: MIT List Visual Art Center, 1990, pp. 2–12.

Neumaier, Diane. "ReRepresenting Russia." In Sunil Gupta, ed. *Disrupted Borders*. London: Rivers Oram Press, 1993.

Rutledge, Virginia. "New Photography 9." *Art in America*, no. 4 (April 1994), p. 124.

Salzirn, Tatiana. *Herbarium*. Exh. cat. Vienna: Fotogalerie Wein and Kunsthalle Exnergass, 1992.

Plate 43
Boris Mihailov, *May Day Parade* (from *Sots Art Series I*),
1975

Ill. 74
Boris Mihailov, *Untitled* (from *Sots
Art Series I*), 1975

Ill. 75 (left)
Boris Mihailov, *Unfinished
Dissertation*, 1983

Ill. 76 (right)
Boris Mihailov, *Salt Lake Series*,
1985

Moisei Solomonovich
Nappelbaum
Minsk 1869–
1958 Moscow

Driven by curiosity and the drive to perfect his art, Nappelbaum made the journey from poverty in Minsk to professional success as a photographer in St. Petersburg while maintaining his identity as a Jew. His career progressed with government support during the tolerant decades following the Revolution. Around 1884, Nappelbaum entered the Boretti Photograph Studio in Minsk. After achieving professional status, he traveled throughout the Pale and in 1889 moved secretly to Moscow without a residence permit. He quickly left for the United States, which he crossed from New York to San Francisco over a period of five years. Returning to Minsk in 1895, he set up a portrait studio, later that year establishing himself in St. Petersburg as a fashionable portraitist who was known to emphasize the psyche and character of his subjects. In January 1918, Nappelbaum was summoned by Lenin to take his portrait; this was followed by commissions to photograph other members of the new government, many of them prominent Jews. In 1919, Nappel-

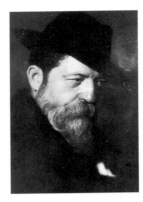

baum set up the first State Photographic Studio at the Central Executive Committee of the Congress of Soviets with the help of its chairman, Yakov Sverdlov, one of his sitters. During the 1920s and 1930s, he photographed all the leading writers, artists, and scholars (see ill. 79; pl. 18). In 1928, he participated in the *Ten Years of Soviet Photography* exhibition in Moscow and had solo exhibitions there in 1935, 1946, and 1950. During his travels through America, Nappelbaum may have come into contact with the photographers who founded the Photo-Secessionist movement, which emerged shortly after his return to Belorussia; certainly, his portraits show their strong influence. Nappelbaum brushed watercolors onto his glass negatives until the sitters appeared to have been painted, thus intensifying the expressive power of his portraits. Nappelbaum's techniques remained tied to pictorialism and were antithetical to contemporary avant-garde developments in the field of photography. He was named an Honored Artist of the RSFSR in 1935.

Selected Bibliography

Nappelbaum, M.S. *Izbran-nye fotografii*. Moscow: Planeta, 1985.

———. *Ot remesla k iskusstvu: Iskusstvo fotoportreta*. Moscow: Iskusstvo, 1958.

Rudiak, Ilya, ed. *Nash vek: Moisei Nappelbaum/Our Age: Moses Nappelbaum*. Ann Arbor: Ardis, 1984.

Shudakov, Grigory, with Olga Suslova and Lilya Ukhtomskaya. *Pioneers of Soviet Photography*. New York: Thames and Hudson, 1983, pp. 15, 250.

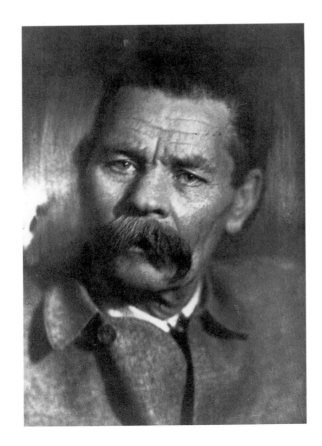

Plate 18
Moisei Nappelbaum, *Maxim Gorky*, 1927

Ill. 77
Moisei Nappelbaum, *Feliks Dzerzhinsky*, 1918

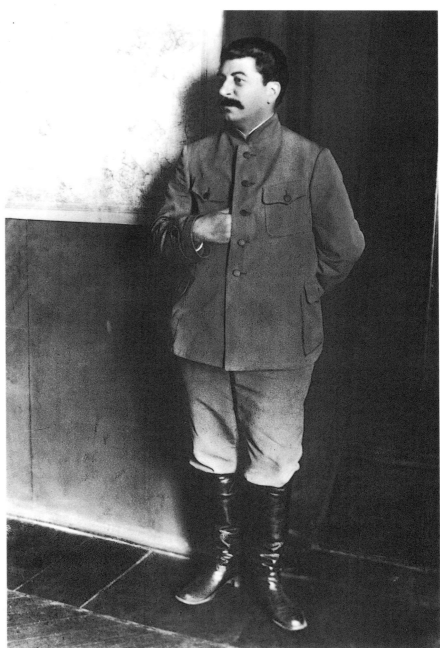

Ill. 78
Moisei Nappelbaum, *Stalin*, ca. 1934

Ill. 79
Moisei Nappelbaum, *Boris Pasternak*, 1926

Ernst Iosifovich
Neizvestny
Sverdlovsk 1925;
lives in New York

Neizvestny was among the first generation of nonconformist artists. His drawings and bronze sculptures express human suffering through the metaphor of the body (see ill. 80). His own experience of disfigurement and pain began when he was severely wounded during the Second World War, having volunteered in 1942. Following his recovery, he decided to concentrate on sculpture despite his doctors' objections because of injuries to his spine. In 1946–47, he attended the Latvian Academy of Arts in Riga; he studied at the Surikov Institute of Arts in Moscow from 1947 until 1955. In Moscow, Neizvestny joined Eli Belyutin's studio, where he worked closely with Yankilevsky. He participated in exhibitions of Moscow artists during the period 1954–58, including the *International Exhibition of Young Artists* (1957). Accepted into the Union of Soviet Artists, he took part in exhibitions of both official and experimental art. Neizvestny had his first solo show at the International Friendship House, Moscow (1961). In 1962, having been invited to participate in the exhibition *Thirty Years of Moscow Art* at the Manezh, marking the 30th anniversary of the Moscow section of the Union of Artists, Neizvestny engaged in a well-publicized confrontation with

Nikita Khrushchev. Ironically, following Khrushchev's death, Neizvestny was asked by the premier's son to create a monument for his father's grave (Goodman, fig. 8). Neizvestny rendered the naturalistic portrait, using both black and white bronze to express the Soviet leader's dual nature. During the 1960s, Neizvestny began to exhibit abroad and had solo shows at the Grosvenor Gallery, London (1965), and Palais des Expositions, Geneva (1966), attracting the attention of the English critic John Berger, who published *Art and Revolution*, a book on Neizvestny and his role in the Soviet art world, in 1969. He also had solo exhibitions at the Musée d'Art Moderne de la Ville in Paris (1970), Tel Aviv Museum of Art (1972), Stedelijk Museum, Amsterdam (1976), and Städtisches Museum, Leverkusen (1977). Even as restrictions loosened in the 1970s, Neizvestny's conflicts with Soviet officials remained unresolved, and in 1976 he left Russia (see Misiano, fig. 5). His expressionist sculptures and graphic works represent a world of harmony and distortion in which the primary means of measurement is the human body. Since 1977, he has made his home in New York, pursuing a career as sculptor, illustrator, lecturer, and author.

Selected Bibliography

Berger, John. *Art and Revolution: Ernst Neizvestny and the Role of the Artist in the USSR.* New York: Pantheon Books, 1969.

Bronze. Exh. cat. New York: Eduard Nakhamkin Fine Arts, 1989.

Egeland, Erik. *Ernst Neizvestny: Life and Work.* New York: Mosaic Press, 1984.

Leong, A., ed. *Space, Time and Synthesis in Art: Essays on Art, Literature and Philosophy.* Oakville: Mosaic Press, 1990.

Micheli, Mario de. *Ernst Neizvestny.* Milan: Giangiacomo Feltrinelli Editore, 1978.

Neizvestny, Ernst. *Fate* (portfolio with poetry by Nikolai Novikov). Moscow: Third Wave, 1992. (In Russian and English.)

Plate 36
Ernst Neizvestny, *Dmitry Shostakovich*, 1976

Ill. 80
Ernst Neizvestny
Dead Soldier, 1953–54

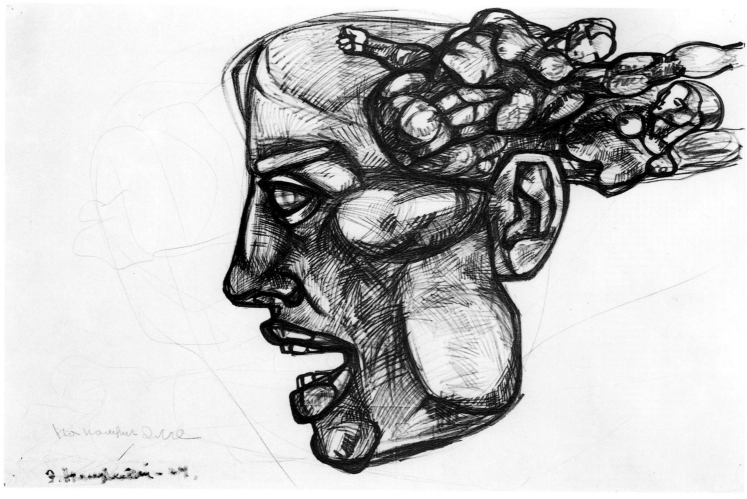

Ill. 81
Ernst Neizvestny, *Drawing for Battle of Giants*, 1964

Solomon Borisovich
Nikritin
Chernigov 1898–
1965 Moscow

Nikritin studied at the Kiev Art Institute from 1904 until 1914, when he began to work with Pasternak in Moscow and Yakovlev in Petrograd. From 1917 to 1920, he studied in the Kiev studio of Alexandra Exter. Nikritin associated closely with Kliment Redko in Kiev, working on agitprop street decorations from 1917 until they fled the city for Moscow in 1920 during a period of pogroms. Eventually, they reached Odessa, where they met Shterenberg, who took an interest in their work. He introduced them to Anatoly Lunacharsky, who gave his personal recommendation for their admission to Vkhutemas. Nikritin then returned to Moscow, where he studied at the State Free Artistic Studios (GSKhM)/Vkhutemas (1920–22). In Moscow, he and Redko lived and worked in the same studio, but began to develop independent theories of art. In the face of fervent interest among Vkhutemas artists in productivism, both artists maintained the validity of easel painting and nonutilitarian art. At the *First Discussional Exhibition*, Nikritin displayed texts, photographs, sketches, reliefs, and constructions labeled "Tectonic Research." He took a special interest in the explanation of conceptual and formal problems, becoming the organizer and chief theorist of the Projectionists in 1922. He proposed that the artist could produce "projections" of works of art or theatrical performances that could serve as the basis for the creation of objects or performances by others, thus foreshadowing the conceptual art of the 1970s. Nikritin worked at the Museum of Painterly Culture from 1922 until 1929. In the late 1920s, he did a group of paintings in an expressionist style, showing screaming women or menacing figures oppressed or obscured by ambiguous clouds, a symbolic representation of society and politics in the Soviet Union (see pl. 20). In 1931, he became a member of Izobrigada and Asnova. In 1935, Nikritin faced condemnation by the art review board of MOSSKh, which controlled the sale and distribution of artworks. Although he designed for the *All-Union Agricultural Exhibition*, a painting he submitted was branded fascistic, individualistic, and pornographic, and Nikritin was viciously attacked. His career as a fine artist never recovered.

Selected Bibliography

"Artists and the Soviets: The Interrogation of Nikritin." *Art News* 52 (September 1953), pp. 37ff.

Danzker, Jo-Anne Birnie, *et al.*, eds. *Avantgarde & Ukraine*. Exh. cat. Munich: Villa Stuck, 1993.

Kostin, V.I. *Solomon Borisovich Nikritin*. Moscow: Sovetskii khudozhnik, 1969.

Lebedeva, Irina. "The Poetry of Science: Projectionism and Electroorganism." In *The Great Utopia: The Russian and Soviet Avant-Garde, 1915–1932*. Exh. cat. New York: Solomon R. Guggenheim Museum, 1992, pp. 441–49.

London, Kurt. *The Seven Soviet Arts*. London: Faber, 1937.

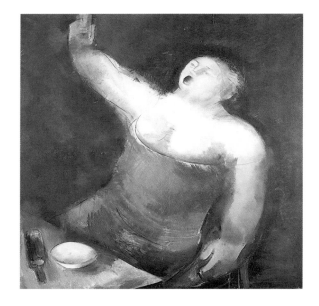

Plate 20
Solomon Nikritin, *Screaming Woman*, 1928

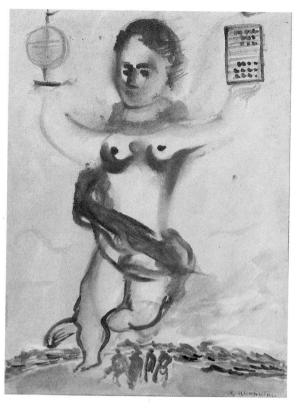

Ill. 82
Solomon Nikritin, *Nude with Red Cloth*, ca. 1920

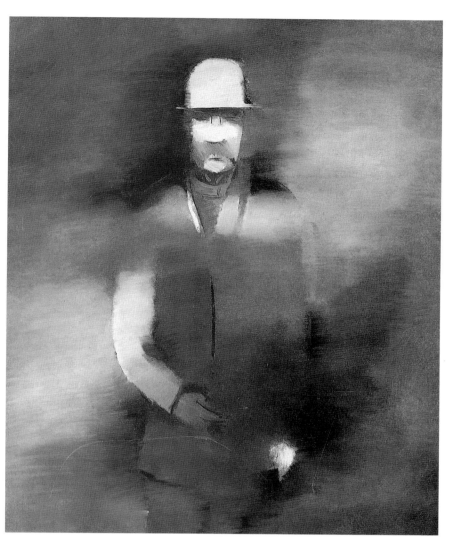

Ill. 83
Solomon Nikritin, *Man in Top Hat*, 1927

Ill. 84
Solomon Nikritin, *Towers with Red Flares*, ca. 1930

Leonid Osipovich
Pasternak
Odessa 1862–
1945 Oxford

Selected Bibliography

Bialik, C., and M. Osborn. *L. Pasternak: His Life and Work.* Berlin: Stybel Publishing House, 1924. (In Yiddish.)

Buckman, David. *Leonid Pasternak: A Russian Impressionist, 1862–1945.* Exh. cat. London: Maltzahan Gallery, Ltd., 1974.

Gurdus, Luba K. "The Forgotten Friendship: L.O. Pasternak and A.J. Stybel." *First Jewish Art Annual.* New York: National Council on Art in Jewish Life, 1978.

Pasternak, Leonid O. *Memoirs of Leonid Pasternak.* Trans. Jennifer Bradshaw. Intro. Josephine Pasternak. London: Quartet Books, 1982.

A Russian Impressionist: Paintings and Drawings by Leonid Pasternak, 1890–1945. Exh. cat. Washington, DC: Smithsonian Institution Traveling Exhibition Service, 1987.

Salys, Rimgaila. "Boris Pasternak and His Father's Art." *Oxford Slavonic Papers* 25 (1992), pp. 120–35.

A member of the first generation of Russian Jews to become professional artists, Pasternak attended the Odessa School of Drawing from 1879 until 1881. Early in his career, he became associated with the Wanderers, which he joined in 1888. As a result of his many trips to Europe between the 1890s and the 1910s, his mature work reveals the influence of French and German Impressionism. In 1892, he was commissioned by the St. Petersburg magazine *Sever* to illustrate Tolstoy's *War and Peace.* The Pasternaks were able to settle permanently in Moscow in 1889, and Leonid received an appointment at MUZhVZ (1894–1917), which was very unusual for a Jew at the time. He was even invited to participate in the 1900 Exposition Universelle in Paris. While late nineteenth-century Russian artists rebelled in different ways against the Wanderers' emphasis on social criticism, Pasternak's first exhibited works were done in their realistic, programmatic manner. Later, he turned to domestic themes, private portraits, interiors, and informal landscapes done in pastels, watercolors, and charcoal rather than oils. He exhibited with the World of Art in St. Petersburg in the years 1901–03 and was elected a member of the Imperial Academy of Arts, St. Petersburg, in 1905. Pasternak was a frequent visitor at Tolstoy's estate from the mid-1890s and became known for his illustrations of Tolstoy's novels (see ill. 86). In fact, he painted a well-known deathbed portrait of the writer. In 1915, Pasternak met Abraham Stiebel, a Polish-born entrepreneur active on the Moscow Jewish cultural scene. Stiebel established a Hebrew printing company in Moscow and attempted to settle Hebrew and Yiddish writers on his nearby estate. One such writer was Semyon An-sky, who wrote *The Dybbuk* on the estate; Pasternak recorded a literary evening there in *The Writer An-sky Reading The Dybbuk in the Home of Stiebel* (see ill. 87). Pasternak lived in Moscow through the First World War and the Bolshevik Revolution of 1917. He adapted to the new Soviet society by creating political-historical paintings as well as several drawings of Lenin and other leading political figures. In 1919, he contributed to the *Second State Exhibition of Paintings* and the *Sixth State Exhibition of Engravings*, both in Moscow. During this time, he also painted portraits of many Jewish leaders in Moscow (see Stanislawski, fig. 2). Seeking medical assistance for his wife, Pasternak traveled with her and his daughters to Berlin in 1921. His son, Boris, remained in the Soviet Union. Although they intended the visit to be temporary, they never returned to Russia. An invitation to accompany an exhibition to Palestine in 1924 resulted in a series of drawings and paintings of the area, which were published in the Russian periodical *Zhar ptitsa*. Following his wife's death, he moved to Oxford.

Plate 3
Leonid Pasternak, *News from the Motherland*, 1889

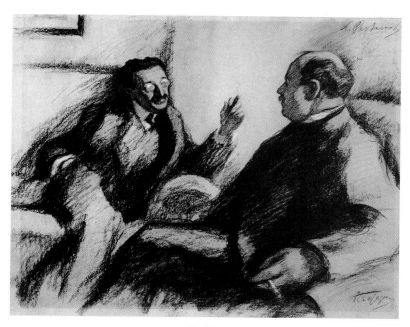

Ill. 85
Leonid Pasternak, *David Frischmann and Chaim Nachman Bialik in Conversation*, 1921–22

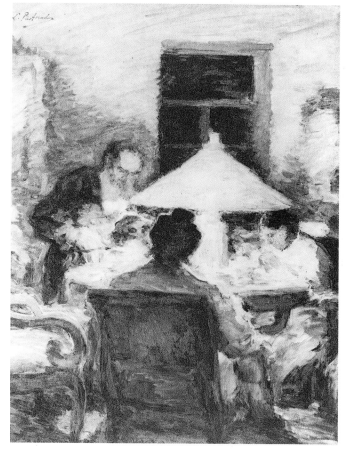

Ill. 86 (right)
Leonid Pasternak, *Tolstoy with Family Seated Round the Table*, ca. 1900

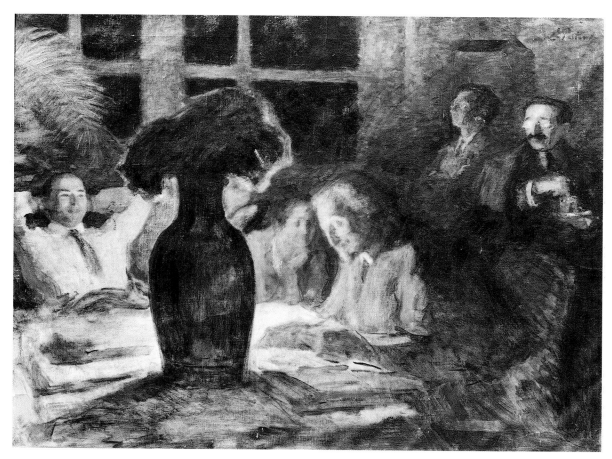

Ill. 87
Leonid Pasternak,
The Writer An-sky Reading The Dybbuk in the Home of Stiebel, ca. 1919

Yehuda
(Yury Moiseevich)
Pen

Novoalexandrovsk
1854–1937 Vitebsk

Pen founded the first Jewish art school in the Russian Empire in 1897, the School of Drawing and Painting in Vitebsk, and it was attended by many of the most prominent artists of the pre-Revolutionary period. He was equally celebrated as an early painter of traditional Jewish genre scenes and landscapes. It was Pen's acquaintance with a local student at the Imperial Academy of Arts in St. Petersburg that influenced him to apply for admission. After failing the entrance exam, he lived illegally in St. Petersburg for a year, practicing drawing at the Hermitage, before being admitted on his second attempt. At the academy, where he studied under Pavel Christyakov from 1880 until 1886, he was exposed to Vladimir Stasov's ideas on national art. From 1891 until 1896, Pen worked as an artist on the estate of Baron Korg near Kreisburg; while there, he associated with Ilya Repin. Once Pen opened his school, his presence began to inspire local Jewish youth to enter the art world. Over the next two decades, a steady stream of talented students passed through its doors, including Chagall, Lissitzky, Chashnik, Yudovin, Abel Pann, Benjamin Kopman, David Yakerson, and Elena Kabishcher-Yakerson. Pen's own paintings, which generally focus on sympathetic domestic views of shtetl life (see ill. 90), have been associated with the art of the Wanderers as well as with the Jewish

national revival (see pl. 4). Stylistically, he drew on the Old Masters rather than on academic models. To Pen and his generation of Jewish artists in Russia, artistic activity was a form of national action and a means of Jewish spiritual revival. In 1919, he took part in the *First State Free Exhibition of Paintings* in Petrograd and in the *First State Exhibition of Local and Moscow Artists* at Vitebsk, contributing to the *Erste russische Kunstausstellung* in Berlin in 1922. Pen's school existed until Chagall opened the Popular Art Institute in Vitebsk and invited his teacher to head one of its studios, which he did between 1919 and 1923. Pen became the school's vice-rector, weathering the stylistic and ideological storms there until a new administration was installed. In 1925, he was represented in the *First All-Belorussian Art Exposition* in Minsk, as he was in the 1927–30 showing. He participated in the *Jubilee Exhibition of Art of the Peoples of the USSR* in Moscow in 1931. Pen went on working in Vitebsk until he was murdered under mysterious circumstances. During the Nazi invasion of Belorussia, his works were evacuated to the Urals for safekeeping. After the war, three hundred paintings were returned to the State Museum of Art of the Republic of Belorussia, Minsk, where they remained in storage until their rediscovery in the late 1980s.

Selected Bibliography

Kasovsky, Grigory. *Artists from Vitebsk: Yehuda Pen and His Pupils.* Masterpieces of Jewish Art. Trans. L. Lezhneva. Moscow: Image, 1992.

———. "Chagall and the Jewish Art Programme." In *Marc Chagall: The Russian Years 1906–1922.* Exh. cat. Frankfurt: Schirn Kunsthalle, 1991, pp. 53–58.

Shagal, M. "Moi pervye uchitelya." *Rassvet*, no. 4 (1927), pp. 6–7. Also published in Yiddish in *Shtern*, no. 3 (1927), pp. 41–42.

Wolitz, Seth L. "The Jewish National Art Renaissance in Russia." In Ruth Apter-Gabriel, ed. *Tradition and Revolution: The Jewish Renaissance in Russian Avant-Garde Art, 1912–1928.* Exh. cat. Jerusalem: Israel Museum, 1987, pp. 21–42.

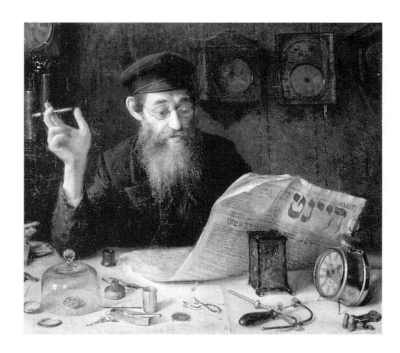

Plate 4
Yehuda Pen, *The Watchmaker*, 1914

Ill. 88
Yehuda Pen, *Portrait of a Jew in a Black Hat*, 1900

Ill. 89
Yehuda Pen, *The Talmudist*, 1925

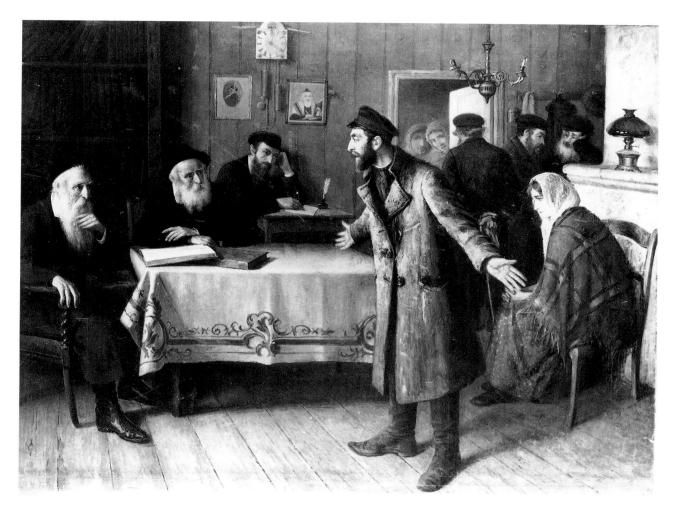

Ill. 90
Yehuda Pen
Divorce, 1917

Viktor Dmitrievich

Pivovarov

Moscow 1937;
lives in Prague

After graduating from the Art Department of the Moscow Institute of Polygraphy in 1962, Pivovarov began his artistic career in Moscow. By the 1980s, he had become an officially recognized illustrator of children's books, with followers among other young artists. At the same time, he continued to be a primary figure among Moscow's nonconformist conceptual artists. Like Kabakov, Pivovarov developed variations on the album or portfolio genre, producing 12 albums between 1975 and 1982. His individual, conceptual works were accompanied by texts and, like the albums, were intended to be read as well as seen, engaging the viewer's memories, emotions, and ideas. Pivovarov established his style by denying painterly texture and rich color in favor of flat colors and a stencil-like technique. His works are marked by the breakdown of pictorial space as the result of a destruction of logical connections between objects (see ill. 91). From 1977 to 1982, he contributed to exhibitions in Russia and abroad, including *New Soviet Art: A Non Official Perspective* at the Venice Biennale (1977); *New Art from the Soviet Union* at the Arts Club of Washington in Washington, DC, and in Ithaca (1977); *New Soviet Art* at the Turin Biennale (1978); and *Light, Form, Space* at Malaya Gruzinskaya, Moscow (1979). In the 1980s, Pivovarov became obsessed with emptiness, nothingness, absence. In his album *Do You Remember Me?*, his hero reflects the vagueness, fluidity, and indeterminacy of lost memory (see pl. 40). Since his emigration to Prague in 1982, Pivovarov has continued to maintain close contact with artists in Moscow. In recent large compositions, the act of painting has become a kind of psychedelic ritual or nostalgia for a lost context. Since 1987, he has had solo exhibitions at galleries in Western Europe and at the Kulturhaus, Prague (1988); the Stadthaus, Prague (1989); and the Kunsthalle, Brno (1990).

Selected Bibliography

Ich lebe—Ich sehe: Künstler der achtziger Jahre in Moskau. Exh. cat. Kunstmuseum Bern, 1988.

Jolles, Claudia. "Moscou années 80." *Cahiers du Musée National d'Art Moderne*, no. 26 (Winter 1988), pp. 13–26.

Peschler, Eric A. "Viktor Pivovarov." In *Künstler in Moskau.* Zurich: Editions Stemmle, 1988, pp. 124–30.

Pivovarov, Viktor. "Then and Now: An Eastern Artist Remembers." *Flash Art* (international edition), no. 167 (November–December 1992), p. 32.

———. "Thoughts on Art." *A-Ya*, no. 6 (1984), pp. 18–23. (In Russian and English.)

Russische Avantgarde im 20. Jahrhundert: Von Malewitsch bis Kabakov. Exh. cat. Cologne: Sammlung Ludwig, 1993, pp. 257–58.

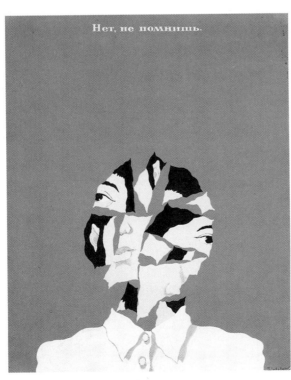

Plate 40
Viktor Pivovarov, *No, You Don't Remember*
(from *Do You Remember Me?*), 1975

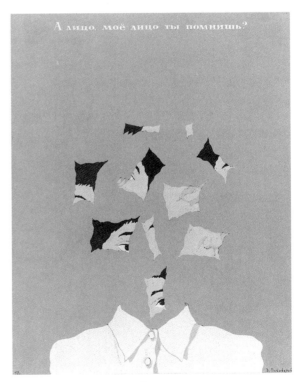

Ill. 91
Viktor Pivovarov, *But Do You Remember My Face?*
(from *Do You Remember Me?*), 1975

Ill. 92 (right)
Viktor Pivovarov, *Do You Remember the Evening . . .*
(from *Do You Remember Me?*), 1975

Ты помнишь вечер, зеленая скамья в тени кустов...

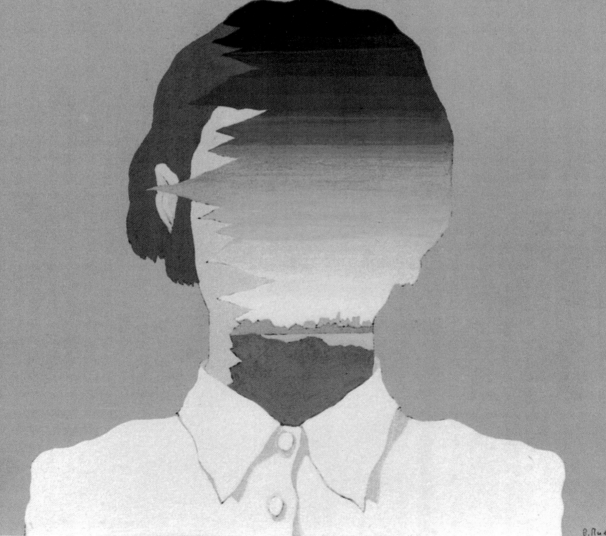

Oscar
(Oskar Yakovlevich)

Rabin

Moscow 1928;
lives in Paris

Selected Bibliography

German, Mikhail. *Oscar Rabin.* Moscow: Third Wave, 1992. (In Russian, English, and French.)

Glezer, Alexander. *Contemporary Russian Art.* Paris: Third Wave, 1993.

Golomshtok, Igor, and Alexander Glezer. *Unofficial Art from the Soviet Union.* London: Secker and Warburg, 1977.

Oscar Rabin: Retrospective Exhibition 1957–1984. Exh. cat. Jersey City: CASE (Museum of Russian Contemporary Art in Exile), 1984.

Oskar Rabin/Valentina Kropivnitskaya. Exh. cat. St. Petersburg: State Russian Museum, 1993. (In Russian and English.)

Rabin, Oscar, with Claude Day. *L'Artiste et les bulldozers: Etre peintre en URSS.* Paris: Editions Robert Laffont, 1981.

Sjeklocha, Paul, and Igor Mead. *Unofficial Art in the Soviet Union.* Berkeley and Los Angeles: Universitiy of California Press, 1967, pp. 138–43.

As a nonconformist artist creating work in opposition to official government policies, Rabin used art to reveal the extent of censorship in everyday Soviet life and to make an ironic commentary on the artificiality of state-approved cultural expression. Orphaned at the age of four, he was adopted by the Russian painter Evgeny Kropivnitsky, who was his first teacher and who gave him an understanding of the poetics of early avant-garde art. Rabin studied at the Academy of Arts in Riga from 1946 until 1948, when he moved to Moscow. There he studied at the Surikov Institute of Arts until he was expelled for "formalism" in 1949. Between 1950 and 1964, he lived with his wife, artist Valentina Kropivnitskaya, in Lianozovo near Moscow. He began to participate in Moscow exhibitions in 1957, including the *International Exhibition of Young Artists* of that year. In the 1960s, a group of young artists, poets, and writers gathered around Kropivnitsky and Rabin which came to be known as the Lianozovo Group (see ill. 95). At this time, Rabin began to insinuate everyday objects into his paintings, creating a dual feeling of intimacy and remoteness. This device helped him create his own semiotics, which allowed the apparent reality of his compositions to take on symbolic meaning. His subdued, almost drab colors, expressive surfaces, and use of outline to flatten objects while reinforcing emotional intensity were elements that contradicted accepted style (see pl. 30). With its emphasis on the dramatic contrasts in Russian life, Rabin's work marked the originating point for nonconformist art. Since 1965, he has regularly exhibited abroad; he had a solo show at the Grosvenor Gallery, London, in that year and was included in *Russian Avant-Garde, Moscow-73* at the Galerie Dina Vierny in Paris (1973). As a result of his crucial role in organizing the 1974 "Bulldozer" exhibition, Rabin was expelled from his local union of artists and designers and for the next several years became a target of harassment in the official press. In 1975, he participated in *Twenty Moscow Artists* in the Beekeeping Pavilion at the *Exhibition of Achievements of the People's Economy* in Moscow. After several arrests, he was stripped of his Soviet citizenship in 1978. The Jewish theme of exile was foreshadowed in his two versions (1964 and 1972) of *Passport* (see ill. 93), the later one providing the date and place of death for the still-living Rabin. His first solo exhibition in the United States was in 1984 at the Museum of Modern Russian Art, Jersey City, New Jersey. Three years later, he emigrated. In 1993, a retrospective of his and Kropivnitskaya's work was held at the State Russian Museum in St. Petersburg.

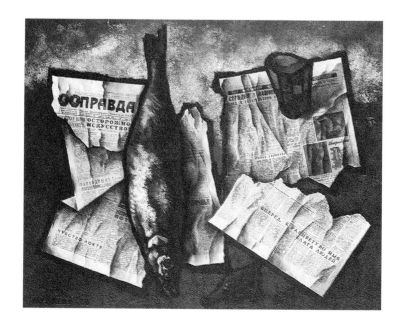

Plate 30
Oscar Rabin, *Still Life with Fish and Newspaper "Pravda" 7*, 1968

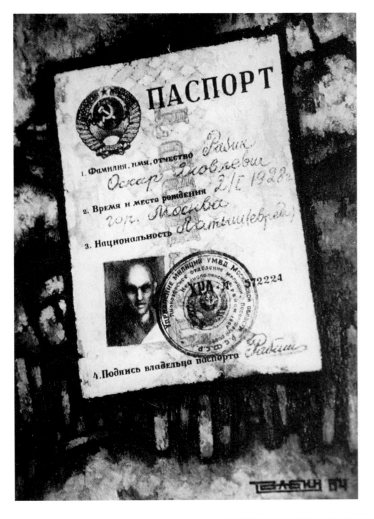

Ill. 93
Oscar Rabin, *Passport*, 1964

Ill. 94 (top right)
Oscar Rabin, *Stolichnaya Vodka*, 1964

Ill. 95
Oscar Rabin, *Farewell Lianozovo*, 1965

Mikhail Alexandrovich
Roginsky
Moscow 1931;
lives in Paris

Roginsky's work has had a significant impact on many artists of his generation. From 1946 to 1951, he attended the Moscow State Art Institute. He worked as a stage designer (1954–60) and taught at the Moscow City Art School for children from 1962 to 1977. In the early 1960s, he began to produce a series of works excerpting the everyday reality of domestic life. These mixed-media constructions incorporate real hardware, such as doorknobs and electrical outlets. He also began to experiment with the technique of collage, painting doors and walls onto large canvases and combining them with wires and doorknobs. These works were succeeded by illusionistic paintings of objects and everyday settings, likewise devoid of narrative content (see ill. 97). According to the artist, his early compositions were influenced by American Realist painting of the 1930s and 1940s, which Roginsky saw at the World Festival of Youth in Moscow in 1957, as well as the early abstract works of Turetsky. His first compositions were later referred to as examples of Soviet Pop Art by many critics, although the artist himself knew nothing about Pop Art in 1962. Unlike Pop artifacts, his works did not function as commentary on, or criticism of, consumable objects or mass icons. In the early 1970s, Roginsky's fascination with eighteenth-century Neoclassical painting and Dutch still lifes resulted in his developing a "retro" style in his own still lifes and urban landscapes (see ill. 98), influenced by the color and manner of the Old Masters. In 1975, he was included in *Twenty Moscow Artists* in the Beekeeping Pavilion of the *Exhibition of Achievements of the People's Economy* held in Moscow. Since 1978 Roginsky has lived and worked in Paris, creating paintings dedicated to his new environment. His work appeared in a 1987 retrospective exhibition in Moscow, as well as in the 1993 retrospective with Turetsky shown at the Central Artists' House in Moscow.

Selected Bibliography

Drugoe iskusstvo: Moskva 1956–76. 2 vols. Exh. cat. Moscow: Moskovskaya galereya, State Tretyakov Gallery, 1991.

Glezer, Alexander. *Contemporary Russian Art.* Paris: Third Wave, 1993.

"Mikhail Roginsky." *A-Ya,* no. 3 (1981), pp. 23–25.

Mikhail Roginsky. Exh. cat. Paris: Galerie Georges Alyskewicz, 1991.

Transit: Russian Artists between the East and the West. Exh. cat. Hempstead: Fine Arts Museum of Long Island, 1990.

Plate 29
Mikhail Roginsky, *Metro*, 1962

Ill. 96
Mikhail Roginsky *Meat and Fish*,
1962

Ill. 97 (bottom right)
Mikhail Roginsky, *Toilet*, 1966

Ill. 98
Mikhail Roginsky, *Venus sur
Tabouret*, 1965

Issachar Ber
Ryback
(Rybak)
Elizavetgrad 1897–
1935 Paris

Ryback devoted his entire career to the portrayal of Jewish subjects, and his efforts to combine ethnographic sources with contemporary styles contributed to the evolution of a unique Jewish expression. He grew up haunted by an awareness of the pogroms that swept his and other cities in the Ukraine following the Revolution (see ill. 99). His father's death in the course of one of these attacks left Ryback feeling abandoned, but also intensified his devotion to his roots; this is reflected in his later lithograph cycles, which chronicle the vanishing life of the rural shtetl. Between 1911 and 1916, he attended the Kiev Art Institute. The motifs he recorded and observed on an ethnographic expedition with Lissitzky sponsored by the Jewish Historical and Ethnographical Society around 1916 formed the basis for his later artwork and theories. The material he gathered on that trip included sketches of wooden synagogues, copies of wall paintings, and *lubki*. Working with the Kultur Lige in Kiev from 1917, in 1919 Ryback published a key article with Boris Aronson in *Oif-gang* on the creation of an intrinsically Jewish style.

Rather than the realistic genre scenes typical of Pen, Ryback advocated the development of a contemporary style whose formal elements were grounded in religious/folk art. He began experimenting with a modified form of cubism, using structures to express emotions while pursuing his interest in folklore (see ill. 101). In 1919, he moved to Moscow, where he taught at the State Free Artistic Studios (GSKhM). Ryback received much critical attention in Berlin after moving there in 1921, participating in exhibitions of the Novembergruppe and the Secession. He also had his first solo show in Berlin in 1923. There he completed his series of lithographs depicting scenes of Jewish life in the shtetl and illustrated Yiddish children's books and poetry by Leib Kvitko. Ryback returned to the Ukraine in 1925 to visit Jewish settlements and in 1925–26 created stage designs for Jewish theaters in Moscow and Kharkov. After he settled in Paris for good in 1926, his art became increasingly sentimental, primarily depicting scenes from the childhood world he simultaneously loved and rejected.

Selected Bibliography

Apter-Gabriel, Ruth. "A Drawing Comes to Light: The Ceiling of the Mohilev Synagogue by Ryback." *Israel Museum News* 6 (1987), pp. 769–74.

Cogniat, R. *Ryback*. Paris, 1935.

Ryback, I., and B. Aronson. "Paths of Jewish Painting." Trans. Reuben Szklowin. In Ruth Apter-Gabriel, ed. *Tradition and Revolution: The Jewish Renaissance in Russian Avant-Garde Art, 1912–1928*. Exh. cat. Jerusalem: Israel Museum, 1987, p. 229.

Plate 7
Issachar Ryback, *Aleph–Beth*, 1918

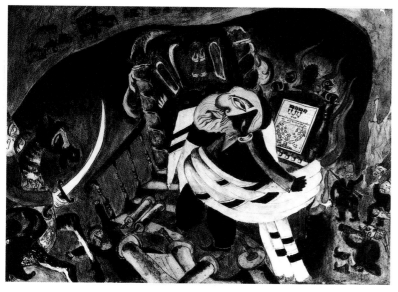

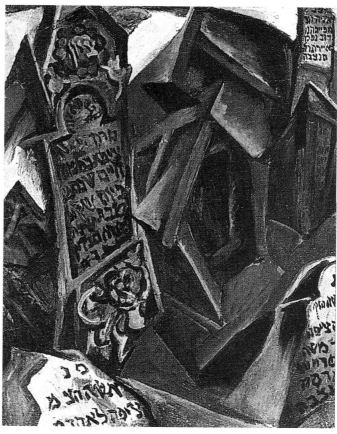

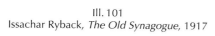

Ill. 99
Issachar Ryback, *Man with Tallit in Synagogue* (from *Pogrom Series*), 1918

Ill. 100 (right)
Issachar Ryback, *The Cemetery*, 1917

Ill. 101
Issachar Ryback, *The Old Synagogue*, 1917

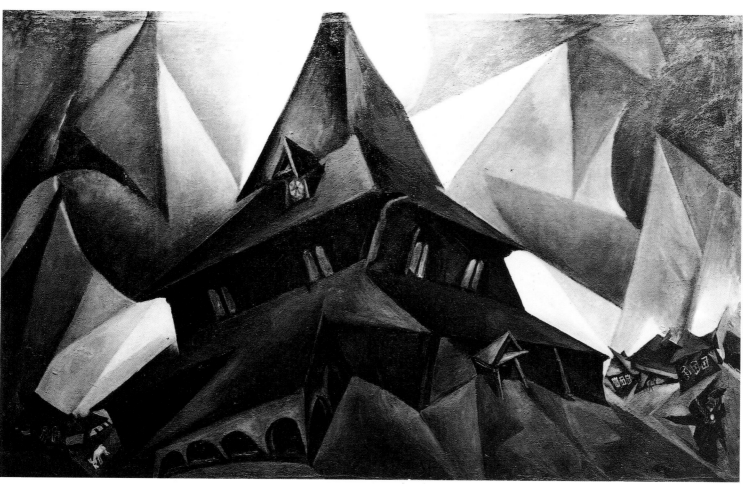

Arkady Samoilovich
Shaikhet

Nikolaev 1898–
1959 Moscow

Shaikhet was outstanding in a generation of photographers who defined photojournalism and the photographic essay. His photography evinced strong social engagement, and he was particularly recognized for his reportage of everyday life (see ill. 102) as well as of the technical milestones of the first Five-Year Plan (see ill. 104). During the Second World War, Shaikhet became a front-line news photographer; his work became so well known that it came to symbolize the war for many Russians. Following his move to Moscow, he began to work as a retoucher in a private photography studio in 1922. Eventually, he found work as a photojournalist for the illustrated news magazine *Rabochaya gazeta* and the weekly *Ogonyok*. People and the changes that had affected them since the Revolution were at the center of Shaikhet's interests. Photographed from above, masses of people became his dominant motif, suggesting an ideology uniting different individuals toward a common goal (see ill. 103). In 1928, Shaikhet

exhibited in *Ten Years of Soviet Photography* in Moscow, and in the 1930s, he began working for the journals *SSSR na stroike* and *Illustrierte Zeitung*. In 1931, he signed a declaration published in *Proletarskoe foto* that criticized "leftist" photographer-members of the October group, including Alexander Rodchenko, for aping Western experimental trends. That same year, Shaikhet collaborated with Maks Alpert and Solomon Tules on a series of 78 photos called *24 Hours in the Life of the Worker Family Filippov*. Commissioned by a German organization, the photo display was exhibited in Vienna, Prague, and Berlin; the all-photograph format initiated the photo-essay approach widely used later in the USSR. Between 1939 and 1945, Shaikhet took war photographs for *Frontovaya illustratsiya*, photographing the Soviet Army on several fronts, including Moscow, Stalingrad, the Kursk Bulge, and the fall of Berlin. After the war he worked for *Ogonyok*.

Selected Bibliography

Eliot, David, ed. *Photography in Russia 1840–1940*. London: Thames and Hudson, 1992.

Lachmann, A., *et al. Arkadij Schaichet: Pionier Sowjetischer Photographie*. Exh. cat. Cologne: Galerie Alex Lachmann, 1995.

Lloyd, Valerie, ed. *Soviet Photography: An Age of Realism*. New York: Crown, 1984, p. 84.

Shudakov, Grigory, with Olga Suslova and Lilya Ukhtomskaya. *Pioneers of Soviet Photography*. New York: Thames and Hudson, 1983, pp. 20–22, 251.

20 Soviet Photographers: 1917–1940. Exh. cat. Amsterdam: Fiolet & Draaijer Interphoto, 1990.

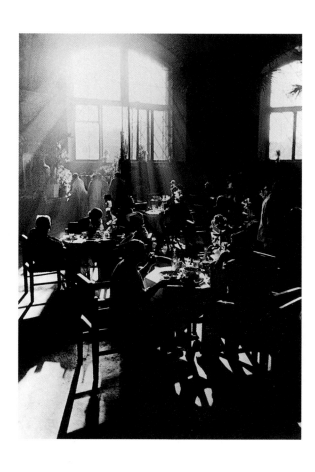

Ill. 102
Arkady Shaikhet, *In the Coffeehouse*, 1930

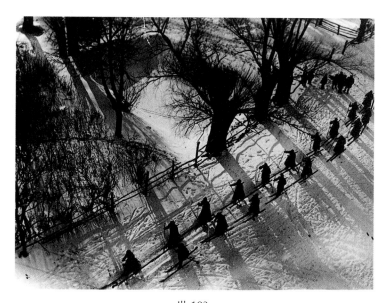

Ill. 103
Arkady Shaikhet, *Red Army Soldiers Marching in the Snow*, 1928

Ill. 104 (right)
Arkady Shaikhet, *Pulling up a Gas Tank*, 1930

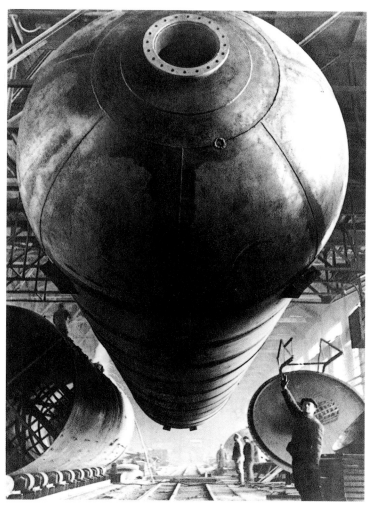

Ill. 105
Arkady Shaikhet, *Light Bulb in a Hut*, 1925

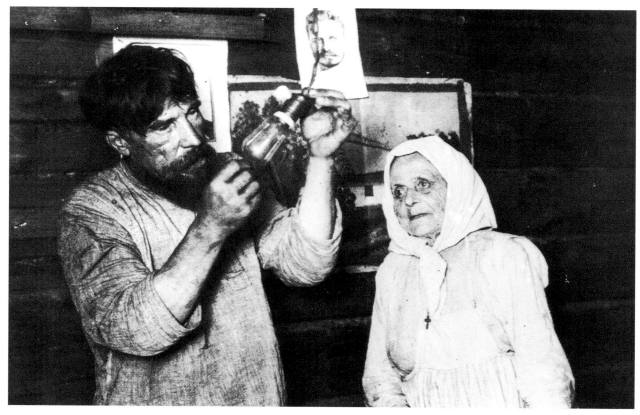

Grigory Mikhailovich
Shegal
Kozelsk 1889–
1956 Moscow

Shegal was a Socialist Realist who specialized in Revolutionary-historical themes (see pl. 26) and depictions of changing life in the eastern Soviet republics. He was known particularly for his images of the "new Soviet woman" (see ill. 106) and appears to have completely assimilated Russian, and then Soviet, culture. During the 1910s, he studied at the Drawing School of the Jewish Society for the Encouragement of the Arts. He continued his studies in 1917–18 in Petrograd at the Secondary Art School, formerly the St. Petersburg Academy of Arts, and subsequently taught at various art studios in Tula. His work of the early 1920s consists of cubist portraits and Cézannesque landscapes; however, his graduation painting for Vkhutemas (1925) was of a proletarian theme. Throughout the 1920s, Shegal's paintings became increasingly realistic. He contributed to the *First Exhibition of Studio Artists* in Moscow and in 1924 showed in the *Exhibition of Paintings Organized by the Russian Red Cross Society*, also in Moscow. During the next five years, he worked as a book illustrator and joined AKhRR as well as the Society of Moscow Artists (OMKh). While Shegal's extensive travels in the Turkmen and Kazakh republics resulted in a large body of work, he also depicted events from the early Revolutionary and Civil War period. A particularly notable painting, *Leader, Teacher, and Friend* (see ill. 107), portrays Stalin appearing before a statue of Lenin, listening to a young Uzbek woman delegate to a conference of collective farmers. One of the most popular images of Stalin, this picture was produced in several versions by Shegal to answer a demand for its wider exhibition to the public. In 1932, he exhibited in *Artists of the RSFSR over the Last 15 Years* in Leningrad. He began to teach at the Surikov Institute of Arts in Moscow in 1937, and from 1947 to 1956 was a professor at the All-Union State Institute of Cinematography (VGIK) in Moscow. Shegal was named a corresponding member of the USSR Academy of Arts.

Selected Bibliography

Grigory Mikhailovich Shegal. Portfolio of prints with essay by Sofya Vasilevna Razumovskaya. Moscow: Sovetskii khudozhnik, 1958.

Razumovskaya, Sofya. *Grigory Mikhailovich Shegal.* Moscow: Sovetskii khudozhnik, 1963.

Shegal, Grigory. *Kolorit v zhivopisi.* Moscow: Iskusstvo, 1957.

Plate 26
Grigory Shegal, *Kerensky's Flight from Gatchina in 1917*, 1936–38

Ill. 106
Grigory Shegal, *Nurse in a Free Moment*, 1945

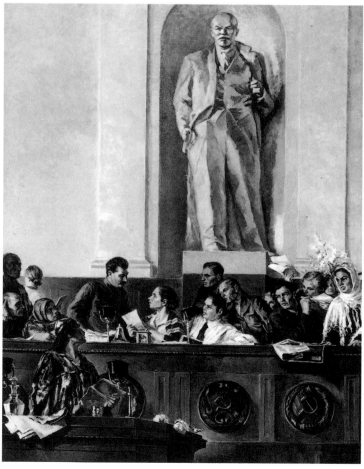

Ill. 107
Grigory Shegal, *Leader, Teacher, and Friend*, 1937

Eduard Arkadevich
Shteinberg
Moscow 1937;
lives in Moscow
and Paris

Since the 1970s, Shteinberg has articulated an artistic language noted for its restrained organic lyricism. From 1957 until 1961, he lived in Tarusa, where he received no formal art training except for studies with his father, Arkady Shteinberg, a poet, translator, and artist who had studied at Vkhutemas during the 1920s. In 1961, the younger Shteinberg contributed to the *Exhibition of Moscow Artists* in Tarusa and in the same year moved to Moscow. He had to leave school to earn a living as a fisherman and manual laborer. After the move back to Moscow, his apartment became a meeting place for artists, poets, and musicians of the Sretensky Boulevard group, including Kabakov, Yankilevsky, Pivovarov, Mikhail Shvartsman, and Bulatov. In the early 1960s, Shteinberg temporarily gave up figurative painting and produced a small number of ink sketches. Early exhibitions from 1967 included showings at the Druzhba Club, Moscow, and *The Exhibition of Painting and Graphics from the Collection of A. Glezer* in Tbilisi. After 1965, influenced by Vladimir Solovyov's ideas of beauty, Shteinberg began work on a series of metaphysical still lifes, painterly compositions of organic forms such as stones, skeletons of birds, or skulls. In these works, he emphasized the metaphysical opposition between earth and sky. Since that period, this theme has been intrinsic to his art, and he has transformed the elements of landscape into a form of geometric abstraction (see pl. 37). In the early 1970s, Shteinberg made an abrupt move from lyrical abstraction to a geometric style rooted in the work of the Russian avant-garde, whose paintings he saw at George Costakis's Moscow apartment during the 1960s. These works emphasize strong color contrasts that create dynamic tension between figure and ground. He took part in *Progressive Tendencies in Moscow, 1957–1970* at the Museum Bochum (1974); *Twenty Moscow Artists* in the Beekeeping Pavilion of the *Exhibition of Achievements of the People's Economy* in Moscow (1975); *The New Soviet Art: A Non-Official Perspective* at the Venice Biennale; and *New Art from the Soviet Union* at the Museum Bochum (both 1977). From 1980, Shteinberg also worked in gouache in addition to exploring collage technique. His dark-hued paintings became richer in texture and overlaid with an implied symbolism of numbers and abstract geometric figures (see ill. 109). In 1983, the artist had a solo exhibition at the Interdisciplinary Research Center of the university in Bielefeld, Germany, followed in 1985 by an exhibition with Yankilevsky and Kabakov at the Museum Bochum. Since the 1980s, Shteinberg has exhibited widely in the West at the Galerie Claude Bernard, Paris (1988, 1989); the Grand Palais, Paris (1991); the State Tretyakov Gallery, Moscow; and the Union of Artists, Jerusalem (both 1992).

Selected Bibliography

Brossard, Jean-Pierre, ed. *Eduard Steinberg: An Attempt at a Monograph.* Moscow: ART MIF, 1992. (In Russian and English.)

Eduard Steinberg Paintings 1975–1989. Exh. cat. New York: Galerie Claude Bernard, 1989.

Hüttel, Martin. "Zwischen Moderne und Postmoderne —Edward Stejnberg." In *Meine Zeit mein Raubtier.* Exh. cat. Düsseldorf: Kunstpalast, 1988.

Peschler, Eric A. "Eduard Steinberg." In *Künstler in Moskau.* Zurich: Edition Stemmle, 1988, pp. 54–62.

Vladimir Jankilewskij, Ilja Kabakov, Edward Stejnberg. Exh. cat. Museum Bochum, 1985.

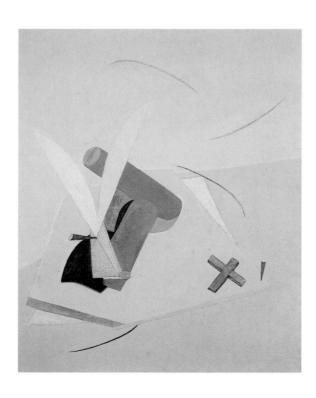

Plate 37
Eduard Shteinberg, *Abstract Composition*, 1969–70

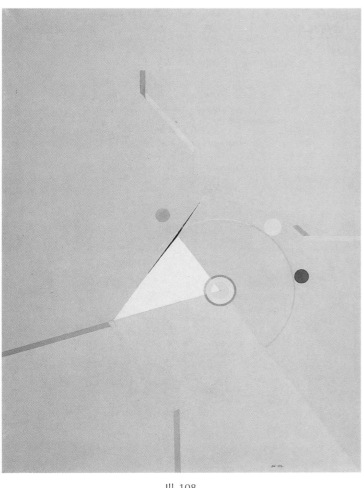

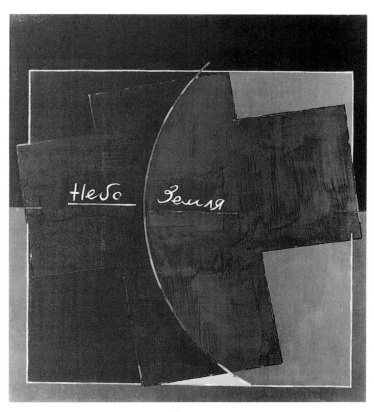

Ill. 109
Eduard Shteinberg, *Composition Sky-Earth November 1988*, 1988

Ill. 108
Eduard Shteinberg, *Composition November 1976*, 1976

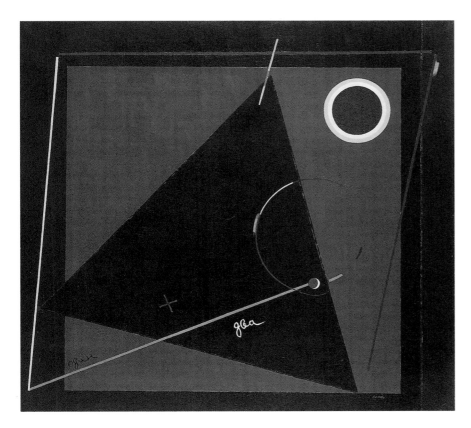

Ill. 110
Eduard Shteinberg, *Composition January
(one + two) 1989*, 1989

David Petrovich
Shterenberg
Zhitomir 1881–
1948 Moscow

Shterenberg profited from the lifting of restrictions following the Revolution that allowed Jews greater access to government positions, and he emerged almost immediately as an important figure in the new regime. He attended the Ecole des Beaux-Arts and the Académie Vitti in Paris from 1907 to 1917, exhibiting at the Salon des Indépendants there in 1912–14 and 1917 and at the Salon de Printemps in 1912–13. Returning to Russia in 1917, Shterenberg was appointed Art Commissar and became head of Izo Narkompros in 1918. As an official, he enabled a number of artists to obtain teaching positions and facilitated the emigration of certain artists during the early 1920s. He also participated actively in Jewish arts organizations and exhibitions. Shterenberg contributed to the *Exhibition of Paintings and Sculpture by Jewish Artists* in Moscow (1918) and the *First Free State Exhibition of Art* in Petrograd (1919). From 1920 to 1930, he taught at Vkhutemas/Vkhutein in Moscow, and in 1922 he was named the head of the Art Education Department, Narkompros. Shterenberg was an active member of Kultur Lige, which sponsored the *Exhibition of the Three*, in which he showed paintings and stage designs with Chagall and Altman. In 1922, he organized and was included in the *Erste russische Kunstausstellung* in

Berlin; he also participated in each exhibition of the Venice Biennale between 1924 and 1932. Under his direction, the Russian Section at the Exposition Universelle of 1925 included a variety of practical objects and theater designs in addition to painting and sculpture. Despite his public support for the artist-designed object, Shterenberg's own work was almost exclusively two-dimensional. His still lifes and portraits of both friends and family and his choice of social types show an affinity with the flattened, simplified forms of French art of the 1910s and 1920s and are distinguished by vivid colors, textured surfaces, and radical perspective (see pl. 19). To promote the activities of easel painters and defend painting from claims that it was socially atavistic, Shterenberg founded OST in 1925 with several others, exhibiting with them in 1925–28. The group was condemned as "anti-Semitic, fascist, and reactionary," the first seemingly a reference to Shterenberg's occasional identifiable Jewish subjects. In 1927, he had a solo exhibition in Moscow, but divisions deepened within OST, and in 1931 Shterenberg himself was pushed out by a group who condemned his work as bourgeois. Although his influence waned, he remained active as an illustrator and poster designer through the Second World War.

Selected Bibliography

David Shterenberg (1881–1948): Zhivopis, grafika, katalog vystavki. Exh. cat. Moscow: Sovetskii khudozhnik, 1991.

D. Shterenberg: Katalog. Exh. cat. Moscow: Sovetskii khudozhnik, 1978.

Lazarev, M. *David Shterenberg.* Moscow: Galaktika, 1992.

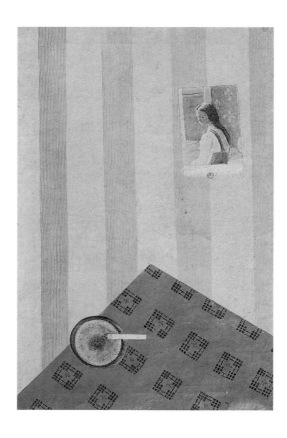

Plate 19
David Shterenberg, *Still Life with Picture on Wall*, ca. 1925

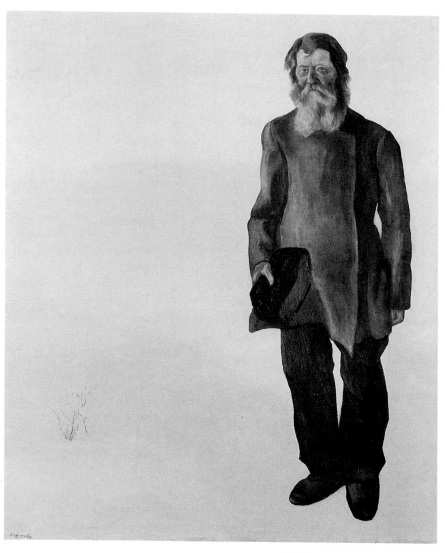

Ill. 111
David Shterenberg, *The Old Man*, 1927

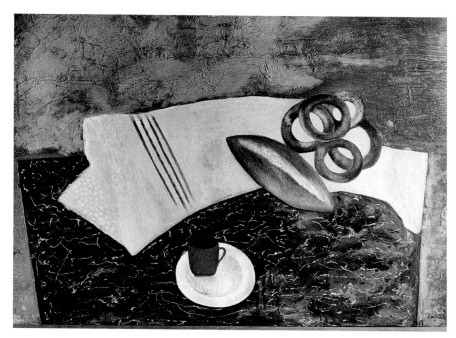

Ill. 112
David Shterenberg, *Red Cup on Marble Paper*, 1920

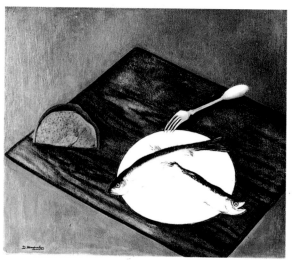

Ill. 113
David Shterenberg, *Still Life with Herrings*, 1917

Solomon Benediktovich
Telingater
Tiflis 1903–
1969 Moscow

Telingater began his career in 1919, designing propaganda posters in Baku. The practice of artfully fusing text, slogans, and illustrations provided him with an important direction for his future work. It became Telingater's goal to create designs that would be accessible to the masses. From 1920–21, he studied at Vkhutemas in Moscow; between 1921 and 1925, he worked in Baku for various journals. He designed books for Moscow publishing houses from 1925 to 1927, and, from 1927, he participated in numerous exhibitions, among them *Moscow Ex-Librists of the Year 1926* (Moscow) and *Art of the Book* (Leipzig). The year 1928 marked his professional breakthrough in the art of book design. His interpretation of Alexander Bezymensky's poem "Komsomoliya" led him to design the type in such a way that its inherent powers of expression came to play the primary role. Telingater also invented his own typeface. Searching for innovative solutions, he bound *Stainless Steel of the USSR* in stainless steel, a material the USSR had just started to produce. He collaborated with such artists as Lissitzky

for the 1928 *Pressa* exhibition in Cologne, helping to demonstrate the achievements of the Soviet press in information dissemination and propaganda, and in 1931 exhibited in *Art of the Book* in Paris. In 1932, he worked for the Theater of the Red Army in Moscow, experimenting boldly with photomontage and collage as these media proved effective for demonstrating the achievements of the Five-Year Plan (see pl. 24). He combined photos representing different aspects of society to reinforce the impression of simultaneity, movement, and meaning. Thus, his photocollages are permeated by his belief in Stalin's policies and goals (see ill. 114). Although his most striking work was executed during the 1920s, Telingater continued to produce award-winning designs through the 1960s. He received a gold medal at the 1937 Exposition Universelle, Paris, and a gold medal at the 1959 *International Exhibition of Book Design of Socialist Countries*, Leipzig; in 1963, he was awarded the International Gutenberg Prize in Leipzig.

Selected Bibliography

Compton, Susan. *Russian Avant-Garde Books 1917–1934*. London: Thames and Hudson, 1992.

Gerchuk, Yury. "S.B. Telingater." In K. Kravchenko, ed. *Iskusstvo knigi 5, 1963–1964* (1965), pp. 134–45.

Katalog personalnoi vystavki S. Telingater. Exh. cat. Moscow, 1975.

Salomon Benediktovich Telingater: L'Oeuvre graphique, 1903–1969. Exh. cat. Paris: Association France-URSS, 1978.

Telingater, Solomon B., and D. Shmarinov, eds. *Iskustvo knigi 1955*, 3 (1960).

Zhukov, M. "Aksidentsiya Telingatera." *Dekorativnoe iskusstvo SSSR,* no. 9 (1979), pp. 34–38.

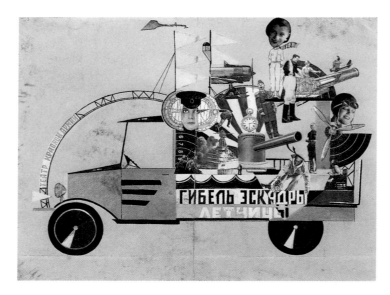

Plate 24
Solomon Telingater, *Design for Decoration of Red Army Theater Truck*, 1932

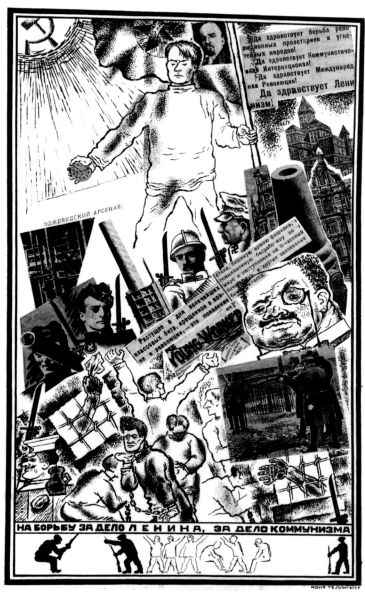

Ill. 114
Solomon Telingater, *Untitled*, ca. 1927

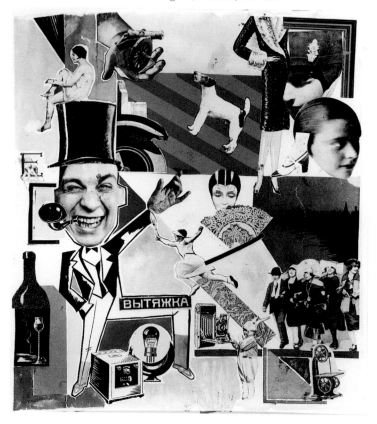

Ill. 115
Solomon Telingater, *Untitled*, ca. 1930

Oleg Nikolaevich
Tselkov
Moscow 1934;
lives in Paris

Tselkov's disturbing art, as if touched by a surrealist nightmare, seemed dangerous and aggressive in the subdued atmosphere of "classical" Socialist Realism. In 1954, he studied stage design for a short period under Nikolai Akimov at the Minsk Institute of Arts, adopting Akimov's illusionistic style of cold, surrealistic forms. Tselkov was expelled from the institute for "formalism." In 1956, he attended the St. Petersburg Academy of Arts, from which he was also expelled on the same charge. He took part in the 1957 *Third Exhibition of Works by Young Artists of Moscow and the Moscow Area* (and also the fifth exhibition in 1959), as well as the 1957 *International Exhibition of Young Artists*, all in Moscow. In 1958, he graduated from the Leningrad Theater Institute. The spirit of theater strongly influenced Tselkov's later paintings. One of his main achievements was to revive the grotesque theater of masks in his works (see ill. 117). In the early 1960s, he began painting deformed masks and figures emerging from apparently liquid color fields. In an effort to highlight his grotesque subjects, Tselkov discarded painterly effects, using nearly monochromatic color schemes. Ambiguous, bald or cloaked, vapid and emotionless with small, empty eye sockets, his subjects served as anti-utopian images of humankind. While bizarre in appearance, Tselkov's paintings were intended as metaphors for the human condition. Since the 1960s, he has concentrated on this approach almost entirely, although he has also produced a few still lifes (see pl. 33). Explicit themes of violence and suicide dominate Tselkov's painted and graphic works of the early 1970s; one of the most significant artists for him was van Gogh, due to his passionate expressionism and tragic personality. In 1975, Tselkov exhibited in *Twenty Moscow Artists* in the Beekeeping Pavilion of the *Exhibition of Achievements of the People's Economy* in Moscow. In 1976, he participated in *Modern Russian Art* at the Palais de Congrès in Paris and in 1977, *New Art from the Soviet Union* at the Institute of Contemporary Art in London. During the same year, Tselkov was granted permission to emigrate, and since 1978 he has lived and worked in Paris. In 1985, there was a solo exhibition at the Grand Palais in Paris.

Selected Bibliography

Boske, A. "Oleg Tselkov." *A-Ya*, no.6 (1984), pp. 38–39.

Ernst Neizvestny/Oscar Rabine/Oleg Tselkov. Exh. cat. Paris: Le Monde de l'Art, 1992.

Glezer, Alexander. *Oleg Tselkov.* Exh. broch. Montreal: Russian Museum in Exile, 1976.

Gribaudo, Ezio, ed. *Oleg Tselkov.* Milan: Fabbri Editori, 1988. (In English and French.)

Kamensky, Alexander. *Oleg Tselkov.* Moscow: Third Wave, 1992.

Oleg Tselkov. Exh. cat. New York: Gallery E. Nahamkin, 1986.

Plate 33
Oleg Tselkov, *Still Life*, 1965

Ill. 116
Oleg Tselkov, *Portrait of George Costakis*, 1976

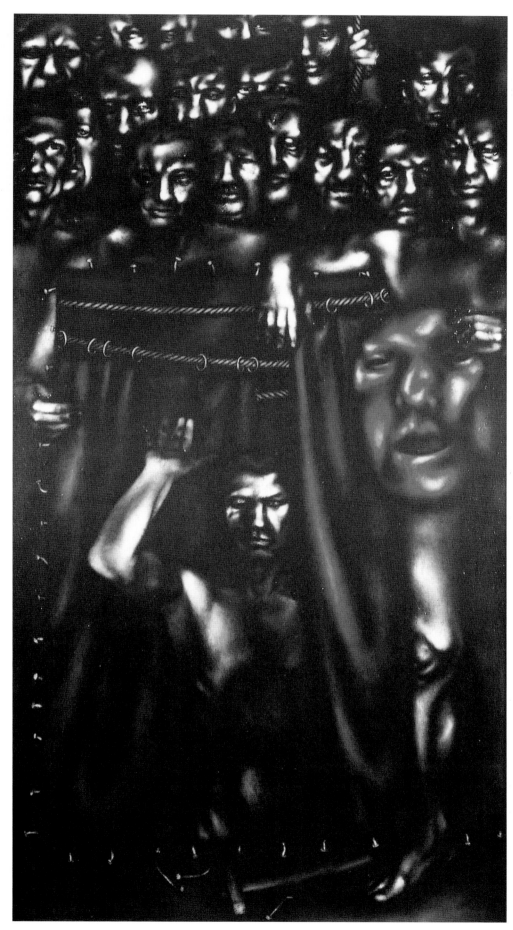

Ill. 117
Oleg Tselkov, *Obituary*, 1971

Boris Zakharovich
Turetsky
Voronezh 1928;
lives in Moscow

One of the few Soviet abstract artists since the Second World War, Turetsky has remained outside any school or group. From 1939 until 1941, he studied in a studio in Voronezh. At the age of six, he was awarded second place in an All-Union contest of children's drawings, and in his teens, he painted realistic watercolor portraits and still lifes. He entered the Savitsky Art School in Penza in 1946, and, after transferring in 1947 to the Moscow School of Art, he became interested in early modernist styles, which were officially condemned. In the 1950s, Turetsky gained access to reproductions of modern and contemporary Western paintings, as well as reproductions of Russian avant-garde art. By the middle of the decade, he had begun to create abstract compositions in ink on paper. He usually limited his palette to black and white in order to express universal ideas. It is therefore intentional that many of his compositions are untitled (see ill. 119). This reflects the essence of his belief in the imperceptible, changeable world that exists beyond human expression. Turetsky's meditative graphic abstractions, despite the intimacy of the technique itself and the small scale of the individual pieces, could "play" together almost like parts of a symphony. Under the influence of Roginsky, around 1962 he began to produce figurative works. His first large paintings in gouache on paper were renderings of automobile parts. About a year later, he painted large, multifigured compositions set in subway cars, hospitals, or other public places. He continued to produce abstract graphics and paintings, including, in the early 1970s, an assemblage series made from trash. In 1975, he contributed to *Twenty Moscow Artists* in the Beekeeping Pavilion of the *Exhibition of Achievements of the People's Economy* in Moscow. From 1975 to 1983, his work was interrupted by illness; he resumed his activities in 1983 on small abstract graphics and paper compositions and reliefs. He had a solo exhibition at the Hermitage in Troitsk (1988) and a retrospective exhibition with Roginsky at the Central Artists' House (Moscow, 1993).

Selected Bibliography

Sammlung Lenz Schönberg: Eine Europäische Bewegung in der Bildenden Kunst von 1958 bis Heute. Exh. cat. Moscow: Central Artists' House, 1989.

Drugoe iskusstvo: Moskva 1956–76. 2 vols. Exh. cat. Moscow: Moskovskaya galereya, State Tretyakov Gallery, 1991.

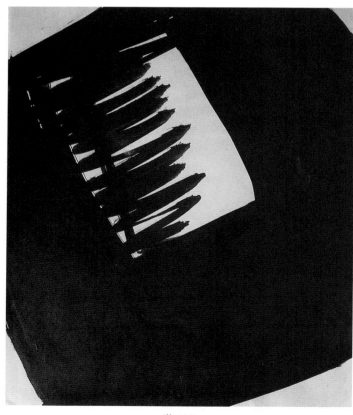

Ill. 118
Boris Turetsky, *Untitled*, 1960s

Ill. 119 (right)
Boris Turetsky, *Untitled*, 1960s

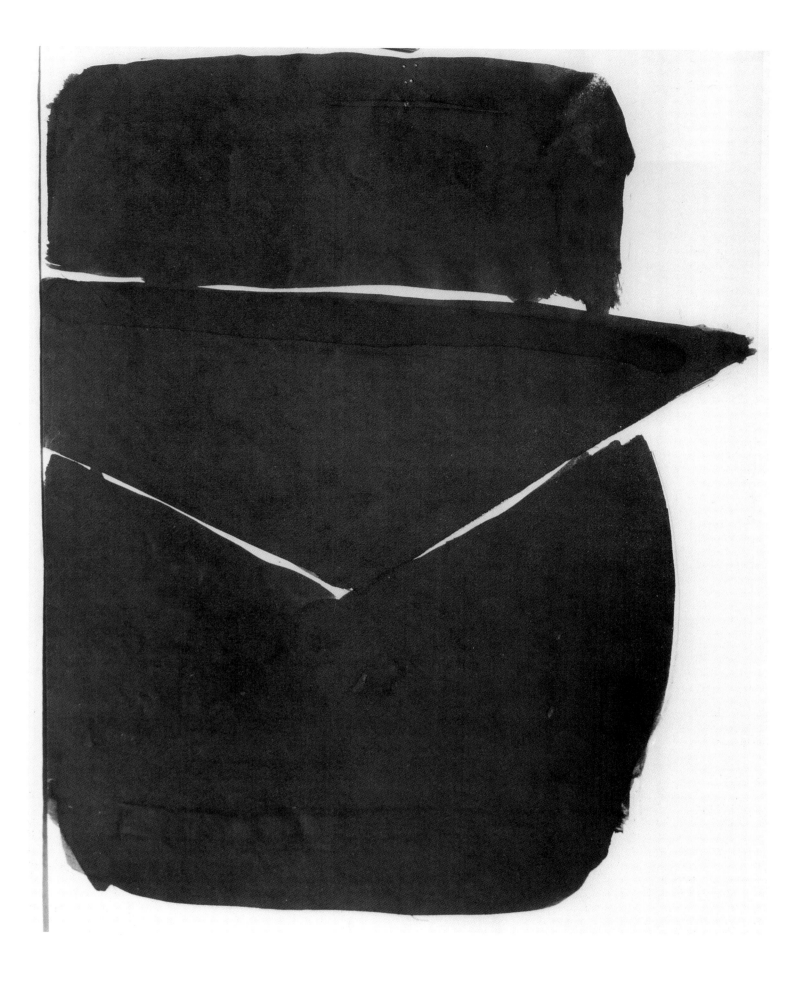

Alexander Grigorevich
Tyshler

Melitopol 1898–
1980 Moscow

One of the most individualistic experimental figure painters of the mid-1920s, Tyshler created a unique type of fantasy painting with private allegorical significance often based on Jewish life and lore. After having completed his art studies at the Kiev Art Institute in 1917, he worked primarily on graphics. During the Civil War, he enlisted in the Red Army (as the only government force battling the pogroms in the Ukraine, the Red Army attracted many Jewish volunteers) and worked on war propaganda. Having relocated to Moscow, he associated with fellow Ukrainian artists Labas and Nikritin. While studying at Vkhutemas from 1921 to 1923, they formed the Projectionists together with Kliment Redko, Mikhail Plaksin, and others. In keeping with the group's scientific-technological focus, Tyshler's abstractions of this period represent "Color-Form Constructions" or "Color-Dynamic Tensions" in space—vibrant lines and complex compositions against saturated backgrounds. He took part in the *First Discussional Exhibition of Associations of Active Revolutionary Art* in 1924 in Moscow. In the following year he became a founding member of OST, exhibiting with them in Moscow from 1926 through 1928. Turning away from abstraction, he began to work in a more figurative style (see ill. 120). In 1926–27, he exhibited a series of paintings based on the activities of Nestor Makhno, the leader of a peasant rebellion against the Bolsheviks in the Ukraine. Tyshler contributed to the *Jubilee Exhibition of Art of the Peoples of the USSR* in Moscow in 1927, by which time his figurative work had become notable for its metaphorical fantasy (see ill. 121). Between 1927 and 1930, he created a series of allegorical paintings of figures adorned with attributes and symbols; frequently, these were enclosed in baskets or wickerlike structures. Often, he included portraits of poor Jews, street vendors, families, and his childhood neighbors (see Goodman, fig. 7). From 1927 until the mid–1930s, he created stage designs for Bel Goset in Minsk, the Jewish Theater in Kharkov, and the Jewish Theater in Vitebsk. Tyshler was branded a formalist in the 1930s and criticized for the fantastic elements of his work, and in 1933 he was excluded from the massive retrospective *Artists of the RSFSR over the Last 15 Years.* He created stage designs for Goset from 1935 until 1949. In 1941, he was evacuated to Tashkent (until 1949), where he had a solo exhibition in 1943 and worked in the Uzbek theater. In 1945, he was awarded the Stalin Prize. Criticized again in 1949, his work was better tolerated in the theatrical world, where he worked through 1961. He continued to draw and paint in private, however, inspiring younger generations of artists. Providentially, Tyshler survived to exhibit his private works under the more relaxed policies of the 1970s. He had solo exhibitions in Leningrad (1956) and Moscow (1956, 1964, 1965, 1966, 1978). A 1981 posthumous exhibition of his work was held in Moscow. Tyshler was named Honored Arts Worker, Uzbekistan SSR.

Selected Bibliography

A.G. Tyshler: Teatr, zhivopis, grafika: Iz leningradskikh sobranii. Exh. cat. Leningrad: Leningrad Theater Museum, 1981.

Alexander Tyshler. Exh. cat. Moscow: Pushkin Museum of Visual Arts, 1966.

Alexander Tyshler. Exh. cat. Moscow: Sovetskii khudozhnik, 1969.

Alexander Tyshler 1898–1980. Exh. cat. Moscow: Sovetskii khudozhnik, 1983.

A. Tyshler: Zhivopis, grafika, skulptura. Moscow: Sovetskii khudozhnik, 1978.

Syrkina, Frida Yakovlevna. *Alexander G. Tyshler.* Moscow: Sovetskii khudozhnik, 1987.

Ill. 120
Alexander Tyshler, *Portrait of Anastasiya Tyshler,* 1926

Plate 21
Alexander Tyshler, *Sacco
and Vanzetti*, 1927

Ill. 121 (top right)
Alexander Tyshler, *From the
Lyrical Cycle Number 4*, 1928

Ill. 122
Alexander Tyshler, *City Land-
scape with Airplane*, 1933

Vladimir Grigorevich
Weisberg
(Veisberg)
Moscow 1924–
1985 Moscow

In his early work, Weisberg was greatly influenced by Impressionist and Post-Impressionist art. His preference for portraits and still lifes was formed in the early 1950s, when he adopted a modified Cézannesque style, experimenting with the fragmentation of color on canvas (see ill. 125). Later, he tried to reshape Cézanne's ideas about color to coincide with his own painterly experiences. He formulated his theories in a paper of 1962. Based on his observation of painting by European masters, Weisberg discerned a progression in the way color was handled, from a sensual to an analytical and, finally, a "subconscious" appreciation. The last category applied to Weisberg's own mature still lifes, portraits, and nudes. From 1959 until 1984, he taught painting in a studio authorized by the Union of Soviet Architects, popularly known as the Weisberg School, and in 1961, he began to exhibit with the Group of Eight in Moscow. His first still lifes using white plaster geometrical objects were painted in 1962, and in the mid-1960s, he began his series of white-on-white paintings, which also reveal geometric shapes. These works are noted for their complex fusion of colors employed to create forms that are arranged against grounds of similar hue (see ill. 123). They require intense attention to decipher their compositions. While never completely abstract, such painting had no place within the dictates of Socialist Realism and was vulnerable to accusations of formalism. Thus, Weisberg was rarely able to show his "white" paintings in large official exhibitions of the 1960s and 1970s. His approach was so unique for his time that—despite his pedagogical talent—his style was not replicated by other notable artists. His radical notions about artistic perception nonetheless made him one of the most influential artists of the 1960s. He showed in the 1962 show *Thirty Years of Moscow Art* in Moscow. In 1974, his work appeared in *Progressive Tendencies in Moscow, 1957–1970* at the Museum Bochum and in *Eight Moscow Painters* at the Musée de Peinture et de Sculpture, Grenoble. Weisberg was given solo exhibitions at the Israel Museum, Jerusalem (1975); the Tel Aviv Museum of Art (1979); and the Galerie Garig Basmadjian, Paris (1984). He received posthumous solo exhibitions in 1988 and 1994 at the State Tretyakov Gallery, Moscow.

Selected Bibliography

Glezer, Alexander. *Vladimir Veisberg*. Exh. broch. Montreal: Russian Museum in Exile, 1976.

Murina, E. "Vladimir Veisberg." *A-Ya*, no. 4 (1982), pp. 36–39. (In Russian and English.)

Vladimir Grigorevich Veisberg: Zhivopis, risunok, akvarel, 1924–1985. Exh. cat. Moscow: Sovetskii khudozhnik, 1988.

Vladimir Grigorevich Veisberg 1924–1985: Paintings, Watercolors, Drawings. Exh. cat. Moscow: State Tretyakov Gallery, 1994. (In Russian and English.)

Weisberg. Exh. cat. Paris: Galerie Garig Basmadjian, 1984.

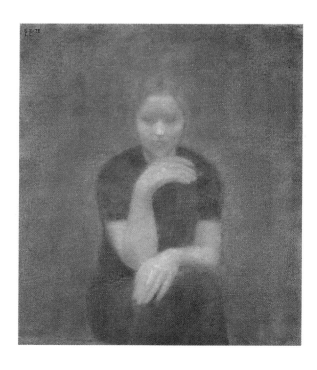

Plate 34
Vladimir Weisberg, *Portrait of Olga Kikina*, 1978

Ill. 123
Vladimir Weisberg, *Composition No. 11*, 1975

Ill. 124 (top right)
Vladimir Weisberg, *Composition with Torso*, 1982

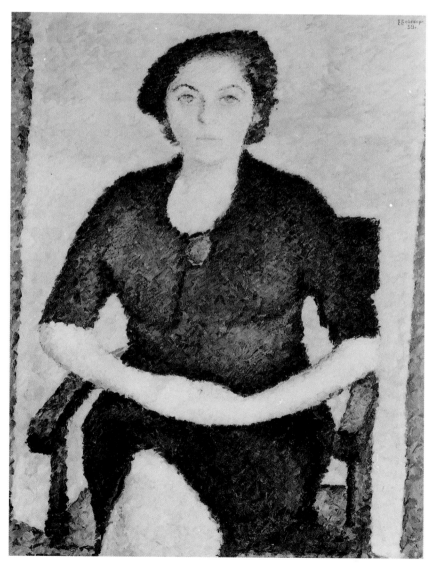

Ill. 125
Vladimir Weisberg, *Portrait of Paola Walkova*, 1959

Vladimir Igorevich
Yakovlev
Balakhna 1934;
lives in Moscow

Yakovlev studied to be a professional photograph retoucher. Otherwise, he had no training related to art, although his grandfather was a Russian painter, famous at the turn of the century. Yakovlev was hampered in his work by a serious eye disease with which he was afflicted at the age of 16. By the mid-1970s, only a small fraction of his vision remained. His fear of blindness was reflected in many graphic portraits, in which imaginary characters appear with damaged, crossed eyes, and his degenerating sight led to severe depressions, resulting in numerous stays in mental hospitals. From his childhood, Yakovlev tried to work in gouache and watercolor, but became seriously involved in painting when he saw Western works in 1957 at the Festival of Youth in Moscow. His first abstract work was created in the same year, and shortly thereafter he turned to painting portraits and flowers from his imagination rather than from nature. A solo exhibition was held at the Druzhba Club, Moscow, in 1962, and in 1963, he exhibited with Shteinberg at the Dostoyevsky Museum in Moscow and in 1968, again with

Shteinberg at MOSSKh in Moscow. Yakovlev's tormented figural works remained unique aesthetic sources for other artists in the 1960s and 1970s. Since 1970, he has participated in various exhibitions in Russia and abroad, including a solo exhibition at the Tel Aviv Museum of Art (1972); *Progressive Tendencies in Moscow, 1957–1970* at the Museum Bochum (1974); *Twenty Moscow Artists* in the Beekeeping Pavillion of the *Exhibition of Achievements of the People's Economy* in Moscow (1975); and *20 Years of Unofficial Art from the Soviet Union* at the Museum Bochum (1979). During the 1970s, he produced numerous portraits, still lifes, and figurative compositions, often with animals and flowers. Paintings such as *Religious Curtain* and *Portrait of Boris Pasternak* (see ill. 126; pl. 32), which exemplify Yakovlev's bold, expressive style, are noted for their rich textures and painterly surfaces. Although Yakovlev has not painted during the last decade, his works have been included in various group exhibitions.

Selected Bibliography

Bozo, D., and J. Nicholson. "Kabakov, Boulatov, Yakovlev." *L'Art vivant*, no. 23 (September 1971).

Peschler, Eric A. "Vladimir Jakowlew." In *Künstler in Moskau*. Zurich: Edition Stemmle, 1988, pp. 16–22.

Russische Avantgarde im 20. Jahrhundert: Von Malewitsch bis Kabakov Die Sammlung Ludwig. Exh. cat. Cologne: Kunsthalle, 1993.

Sjeklocha, Paul, and Igor Mead. *Unofficial Art in the Soviet Union*. Berkeley: University of California Press, 1967, pp. 170–81.

Vladimir Yakovlev. Exh. cat. Moscow: Soviet Culture Foundation, 1990. (In Russian.)

Vladimir Yakovlev/Anatoly Zverev/Igor Voroshilov. Exh. cat. Moscow: Central Writers' House, 1990. (In Russian.)

Plate 32
Vladimir Yakovlev, *Portrait of Boris Pasternak*, 1974–77

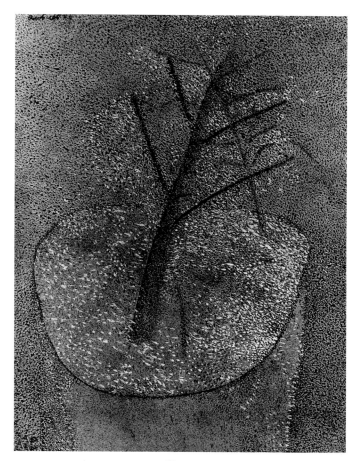

Ill. 127
Vladimir Yakovlev, Twig, 1960

Ill. 126
Vladimir Yakovlev, *Religious Curtain*, 1969

Ill. 128
Vladimir Yakovlev, *Self-Portrait*, 1977

Vladimir Borisovich
Yankilevsky
Moscow 1938;
lives in Bochum

A strong artistic thread ran through Yankilevsky's family. His father, an advertising artist, was his first art teacher, and his uncle, Eli Jacoby (Ilya Yankilevsky), emigrated to Palestine in 1910 and later became a graphic artist in the United States. Yankilevsky himself graduated in 1962 from the Moscow Institute of Graphic Arts. His first paintings reflect the influence of Eli Belyutin, in whose quasi-official Moscow painting studio Yankilevsky also studied. His first exhibition took place with the Belyutin Studio Group in 1962. That same year he and Neizvestny participated in an exhibition at Moscow University. A participant in the Moscow conceptual art movement, Yankilevsky was a member of the Sretensky Boulevard group, which included Kabakov, Bulatov, Pivovarov, and Shteinberg. Though Yankilevsky was invited to take part in *Thirty Years of Moscow Art* at the Manezh, his work was criticized by Khrushchev for both its form and its content. He was more warmly received by Italian and Czech critics in the mid-1960s and was widely included in Western exhibitions from the mid-1970s through the 1990s. Yankilevsky had begun producing triptychs—mixed-media works incorporating reliefs—in the early 1960s. By means of these works and his later constructions, the artist wished to express human beings' place in the cosmos through the contrast of binary opposites (see ill. 130). Often a robot-like male appeared at one end and his female counterpart at the other, with the central panel devoted to a depiction of a primeval landscape with biological and cybernetic forms. The artist's anthropomorphic but nonetheless fantastic figures tend to be expressed as grossly contorted, sexualized bodies or in geometric, abstract, or "robotic" forms (see ill. 129). Among the many international group exhibitions in which Yankilevsky has taken part are *Russian Avant-Garde, Moscow-73* in Paris (1973); *Progressive Tendencies in Moscow, 1957–1970* at the Museum Bochum (1974); *Twenty Moscow Artists* in the Beekeeping Pavilion of the *Exhibition of Achievements of the People's Economy* in Moscow (1975); and the Venice Biennale (1977). He has had solo exhibitions at the Museum Bochum (1988); the Paris Art Center (1991); and the Centre d'Art Contemporain, Paris (1994). In recent years, Yankilevsky has turned to constructions incorporating mixed-media male and female figures boxed within wooden frames.

Selected Bibliography

Glezer, Alexander. *Vladimir Iankilevskii.* Exh. broch. Montreal: Russian Museum in Exile, 1976.

Peschler, Eric A. "Vladimir Yankilevsky." In *Künstler in Moskau.* Zurich: Edition Stemmle, 1988, pp. 22–30.

Vladimir Jankilewskij, Eduard Stejnberg, Ilja Kabakov. Exh. cat. Museum Bochum, 1985.

Vladimir Jankilevskij, 1958–1988. Exh. cat. Museum Bochum, 1988.

Vladimir Yankilevsky: Retrospective. Exh. cat. New York and San Francisco: Nahamkin Fine Arts Gallery, 1988.

Ill. 129
Vladimir Yankilevsky,
Untitled, 1975

Ill. 130
Vladimir Yankilevsky, *Triptychon No. 4*, 1964 (see plate 31)

Ill. 131
Vladimir Yankilevsky, *Prophet*, n.d.

Solomon Borisovich

Yudovin

Beshenkovichi 1892–
1954 Leningrad

Yudovin's career extended from the height of the Jewish renaissance to the period of Socialist Realism. As a graphic artist he worked as a recorder of vanishing shtetl life and the violence that frequently disrupted it. His art conveys a sense of a lost Jewish world. On Seymon An-sky's 1912–14 ethnographic expedition, he photographed and drew folk motifs, tombstones, and ritual objects; these records, along with artifacts, documents, and photographs, were deposited in the Jewish National Museum, Petrograd, established by An-sky. Yudovin's accurate renderings provided the basis for modernist adaptations of folk themes in newly emerging Jewish national art. In 1917–18, he took part in the *Exhibition of Jewish Artists* in Petrograd and the *Exhibition of Paintings and Sculpture by Jewish Artists* in Moscow and in 1919, the *First State Exhibition of Local and Moscow Artists* in Vitebsk. From linoleum cuts Yudovin moved on to woodcuts, and after 1920 he worked solely as a printmaker and illustrator. A student at Chagall's school in Vitebsk from 1919 to 1923, he was one of the artists who did not ally himself with Kazimir Malevich and Suprematist abstraction. Remaining close to Pen, he stayed at the school until its change in administration in 1923. Having acted as caretaker for the An-sky collection at the Jewish National Museum at its new facilities on Vas-

ilevsky Island, between 1923 and 1928 he apparently also lived in the museum, guarding its collection while the institution was shut down. This might explain the artist's sustained preoccupation with traditional Jewish themes (see ill. 133). From 1921 until 1940, he worked intermittently on a series of prints of life in the shtetl, tellingly entitled Bygone Days, and works referring to the pogroms that shook Belorussia and the Ukraine from Tsarist times through the Civil War (see ill. 132). Yudovin's large series Jewish Folk Ornament, based on traditional decorative motifs, was executed between 1924 and 1941. He participated in the *Exhibition of Leningrad Society of Ex-Librists* in 1925, as well as the *First All-Belorussian Art Exhibition* in Minsk. His first solo exhibition took place in Vitebsk in 1926, and thereafter he participated in exhibitions of graphic arts in the USSR and abroad. In the 1930s, the artist depicted scenes of life on a Jewish collective farm (Kolkhoz), adopting a Socialist Realist style. Yudovin was both a designer of and a participant in *Jews in Tsarist Russia and the USSR* at the State Ethnographic Museum, Leningrad (1939). In 1944 he had a solo exhibition in Yaroslavl, and he continued to make engravings until the late 1940s, when, due to a serious illness, he was forced to abandoned printmaking for drawing.

Selected Bibliography

Apter-Gabriel, Ruth. *The Jewish Art of Solomon Yudovin (1892–1954): From Folk Art to Socialist Realism.* Exh. cat. Jerusalem: Israel Museum, 1991.

Brodsky, V. Ya., and A. M. Zemtsova. *Solomon Borisovich Yudovin.* Leningrad: Khudozhnik RSFSR, 1962.

Vilenskaya, N. Kh., and A. M. Zemtsova. *Solomon Borisovich Yudovin 1892–1954.* Leningrad, 1956.

Yudovin, Solomon B. *Jewish Folk Ornament.* Kiev: Y. L. Peretz Society, 1920.

Ill. 132
Solomon Yudovin, *Man and Woman*
(from *Pogrom Series*), 1928

Ill. 133
Solomon Yudovin, *Shabbat*, ca. 1920–26

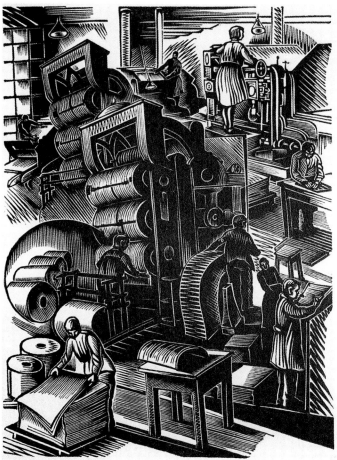

Ill. 134
Solomon Yudovin, *Scenes from a
Publishing Press*, 1932

Georgy Anatolevich
Zelma
Tashkent 1906–
1984 Moscow

The burgeoning number of illustrated photographic magazines for leisure and entertainment provided work for photographers like Zelma during the early and mid-1920s, and for a time he worked in a Petrograd portrait studio. He then joined the Russfoto agency, under Shterenberg, gaining experience covering news stories, political demonstrations, and factory openings. Zelma's knowledge of the Uzbek language and culture led to his being made the agency's representative in Tashkent from 1924 to 1927, with responsibility for covering Central Asia and neighboring countries (see pl. 17). Zelma's photographs from this period (and from his 1929 stint for the Uzbekino studio in Tashkent) established his reputation as an ethnographic reporter. Returning to Moscow, he contributed to *Ten Years of Soviet Photography* in 1928. Many of his photographs featured the changing status of women, whose liberation from traditional roles and dress was frequently used during the first decades following the Revolution to illustrate progress under Communism. Beginning in the mid-1930s, he started working for the Soyuzfoto Agency, contributing regularly to *SSSR na stroike* and to the newspapers *Krasnaya zvezda* and *Izvestiya*. In 1937, he was represented in the *First All-Union Exhibition of Photographic Art* at the State Pushkin Museum in Moscow. Zelma's earliest military subjects date from his return to Moscow after being drafted into the Red Army. The small hand-held Russian Leica camera enhanced the possibilities for documentary work, enabling him to photograph industrialization projects of the first Five-Year Plan. He collaborated with fellow photographers on special issues of *USSR in Construction* and on albums. In 1939, he took part in the *International Photographic Exhibition* in Preston, England. At this time, he also produced propaganda photographs of soldiers and weapons, touting the military preparedness of the Soviet Union. From the beginning of the Second World War, Zelma worked as a war correspondent for *Izvestiya*, capturing stirring images from the front lines (see ill. 137). His coverage of the winter campaign of 1942–43 around Stalingrad produced some of the most memorable images of the war. After the war, Zelma worked for various magazines and news agencies in Moscow. In 1982, he was represented in *Early Soviet Photographers* in Oxford. Zelma never lost his love of travel and continued to photograph in the various regions of the USSR until late in life. He was awarded the Order of the Red Star and named Honored Cultural Worker of the USSR.

Selected Bibliography

Elliott, David. *Georgij Zelma*. Exh. cat. Cologne: Galerie Alex Lachmann, 1992.

Georgii Zelma: The Mystery of Central Asia. Exh. cat. New York: Howard Schickler Fine Art, 1994.

Shudakov, Grigory, with Olga Suslova and Lilya Ukhtomskaya. *Pioneers of Soviet Photography*. New York: Thames and Hudson, 1983, p. 252.

Vilenkin, B. *Georgy Zelma*. Moscow: Planeta, 1978.

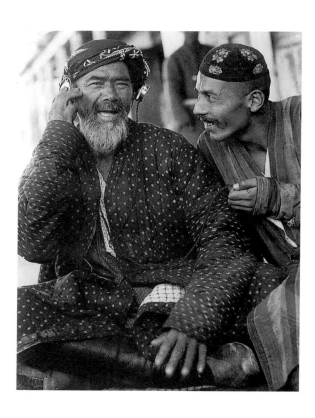

Plate 17
Georgy Zelma, *The Voice of Moscow, Uzbekistan*, 1925

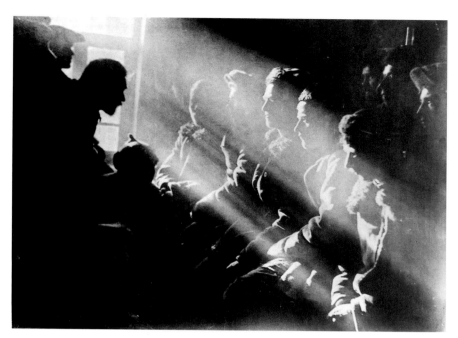

Ill. 135
Georgy Zelma, *Brigade Meeting on the Kolkhoz*, 1929

Ill. 136
Georgy Zelma, *On Guard*, ca. 1931

Ill. 137
Georgy Zelma, *Soldier with Molotov Cocktail*, 1942

Checklist of the Exhibition

Natan Altman

Study for Jewish Funeral, 1911
Watercolor and gouache on paper, 10 x 12 in.
(25.5 x 30.5 cm)
Collection Evgenia and Feliks Chudnovsky,
St. Petersburg

Catholic Saint, 1913
Oil on canvas, 46¼ x 28⅜ in. (117.5 x 72 cm)
Collection Vladimir Paleev, St. Petersburg

Portrait of Nadezhda Dobychina, 1913
Oil on canvas, 33½ x 26¼ in. (85 x 67 cm)
Collection Evgenia and Feliks Chudnovsky,
St. Petersburg

Head of a Young Jew, 1916
Bronze and wood, h: 18 in. (45.7 cm)
State Tretyakov Gallery, Moscow
© 1995 Natan Altman/Licensed by VAGA, New York
See ill. 1

Female Beggar (Costume Design for
The Dybbuk), 1920
Pencil and gouache on paper, 13 x 7 in.
(33 x 17.8 cm)
The Israel Goor Theater Archives & Museum, Jerusalem; from the Collection of Nahum D. Zemach

In-laws on a Bench (Costume Design for
The Dybbuk), 1920
Pencil and gouache on paper, 13¾ x 8⅝ in.
(34.9 x 21.9 cm)
The Israel Goor Theater Archives & Museum, Jerusalem; from the Collection of Nahum D. Zemach

Male Beggar (Costume Design for *The
Dybbuk*), 1920
Pencil and gouache on paper, 13¾ x 8¾ in.
(35 x 22 cm)
The Israel Goor Theater Archives & Museum, Jerusalem; from the Collection of Nahum D. Zemach
© 1995 Natan Altman/Licensed by VAGA, New York
See ill. 3

Synagogue (Stage Design for *The Dybbuk*),
1920
Gouache, india ink, and collage on paper,
10½ x 16 in. (26.5 x 40.5 cm)
Habimah Theater, Tel Aviv

Female Beggar (Costume Design for *The
Dybbuk*), 1920
Pencil and gouache on paper, 13 x 6⅞ in.
(33 x 17.5 cm)
The Israel Goor Theater Archives & Museum, Jerusalem; from the Collection of Nahum D. Zemach

Land to the Workers, 1921
Porcelain, diam: 9¼ in. (24 cm)
Collection Craig H. and Kay A. Tuber, Northfield,
Illinois

Russian Labor, 1921
Wood, paper, charcoal, and enamel on canvas,
38¾ x 19⅜ in. (98.5 x 49 cm)
State Tretyakov Gallery, Moscow
© 1995 Natan Altman/Licensed by VAGA, New York
See plate 15

Portrait of Silviya Grinberg, 1923
Oil and asphalt on canvas, 23½ x 17¾ in.
(59.8 x 45 cm)
Collection Vladimir Paleev, St. Petersburg
© 1995 Natan Altman/Licensed by VAGA, New York
See ill. 2

Set Design for Tenth Commandment, 1926
Pencil, pen and india ink, wash, and collage on
paper, 10 x 11 in. (25.5 x 27.9 cm)
Bakhrushin State Central Theater Museum, Moscow

Tsybulsky and Karalla (Costume Designs for
Tenth Commandment), 1926
Pencil and colored pencil on paper, 17⅜ x 11 in.
(44.7 x 27.9 cm)
Bakhrushin State Central Theater Museum, Moscow

Mark Antokolsky

Head of Ivan the Terrible, ca. 1880
Bronze, 17¾ x 11 ⅞ x 11⅞ in. (45 x 30 x 30 cm)
The Israel Museum, Jerusalem; Gift of Mrs. Levin,
New York
See ill. 4

Mephistopheles, ca. 1880
Bronze on granite base, 34 x 15 x 19 in.
(86.4 x 48.3 x 38 cm)
Lent by A La Vieille Russie
See plate 1

Peter the Great, ca. 1880
Bronze, h: 31 in. (76.3 cm)
Lent by A La Vieille Russie

Spinoza, ca. 1882
Marble, 27 x 15 x 23 in. (68.6 x 38 x 58.5 cm)
Private Collection, Courtesy A La Vieille Russie
See ill. 5

Léon Bakst

Countess M. Keller, 1902
Oil on canvas, 90½ x 35½ in. (230 x 90 cm)
Zaraisk Museum of History and Art, Russia
See ill. 8

Messenger (Costume Design for Euripides'
Hippolytus), 1902
Watercolor, pencil, wash, and silver on paper,
11¼ x 8⅜ in. (28.4 x 21.3 cm)
State Museum of Theater and Musical Art,
St. Petersburg
See ill. 6

Phaedra (Costume Design for Euripides'
Hippolytus), 1902
Watercolor, pencil, wash, bronze, and india ink on
paper, 11¼ x 8¼ in. (28.3 x 21 cm)
State Museum of Theater and Musical Art,
St. Petersburg

Phaedra's Nurse (Costume Design for Euripides'
Hippolytus), 1902
Watercolor, pencil, india ink, bronze, and wash on
paper, 10¾ x 8½ in. (27.4 x 21.5 cm)
State Museum of Theater and Musical Art,
St. Petersburg

Theseus in Festive Attire (Costume Design for
Euripides' *Hippolytus*), 1902
Watercolor, pencil, bronze, and india ink on paper,
11¼ x 8⅓ in. (28.5 x 21.1 cm)
State Museum of Theater and Musical Art,
St. Petersburg

Vera Trefilova as a Japanese Doll (Costume for
The Fairy Doll), 1903
Silk
State Museum of Theater and Musical Art,
St. Petersburg

Syrian Dancer (Costume Design for *Cleopatra*),
1909
Pencil, watercolor, and gold paint on paper,
11 x 8¼ in. (28 x 21 cm)
Private Collection
See plate 5

Ida Rubinstein, 1910
Watercolor, gouache, and pencil on paper, mounted
on canvas, 50½ x 27¼ in. (128.3 x 69.2 cm)
The Metropolitan Museum of Art, New York; Bequest
of Chester Dale, The Chester Dale Collection, 1962
See ill. 7

Isaak Brodsky

Self-Portrait with Daughter, 1911
Oil on canvas, 28⅜ x 39 in. (72 x 99 cm)
Museum of the Russian Academy of Arts,
St. Petersburg
See ill. 9

*Vladimir Ilich Lenin with Kremlin in
Background*, 1924
Oil on wood, 28⅜ x 20½ in. (74 x 52 cm)
Museum of the Russian Academy of Arts,
St. Petersburg

Portrait of Maxim Gorky, 1936
Oil on canvas, 52 x 42 in. (132 x 107 cm)
State Tretyakov Gallery, Moscow
See ill. 10

Kliment Voroshilov Skiing, 1937
Oil on canvas, 6 ft. 9⅞ in. x 12 ft. 3 ⅝ in.
(2.1 x 3.8 m)
Central Museum of the Armed Forces, Moscow
See ill. 11

Vladimir Ilich Lenin at the Smolny Institute,
1937
Oil on canvas, 37½ x 47⅝ in. (95 x 121 cm)
Museum of the Russian Academy of Arts,
St. Petersburg
See plate 27

Grisha Bruskin

Memorial, 1983
Oil on canvas, 40¼ x 47 in. (102 x 120 cm)
Collection Mirielle and James I. Levy, Lausanne
© 1995 Grisha Bruskin/Licensed by VAGA, New York
See ill. 13

Birth of the Hero, 1985–88
Bronze with white patina, 15 works of varying size,
max. h: 25 x 12 x 16 in. (63.5 x 30.5 x 15.2 cm)
Lent by Marlborough Gallery, New York
© 1995 Grisha Bruskin/Licensed by VAGA, New York
See ill. 12

Alefbet, 1987
a) *Lexicon No. 1*
b) *Lexicon No. 2*
Oil on canvas, each 45³/4 x 34¹/2 in. (116 x 88 cm)
Museum Ludwig, Cologne; Ludwig Donation

Alefbet, 1988
a) *Lexicon No. 3*
b) *Lexicon No. 4*
Oil on canvas, each 45³/4 x 34¹/2 in. (116 x 88 cm)
Kunsthalle in Emden—Stiftung Henri Nannen
© 1995 Grisha Bruskin/Licensed by VAGA, New York
See plate 46

Erik Bulatov

Red Horizon, 1971–72
Oil on canvas, 59¹/8 x 70⁷/8 in. (150 x 180 cm)
Private Collection
© 1995 Eric Bulatov/Licensed by VAGA, New York
See ill. 14

Two Landscapes with Red Background,
1972–74
Oil on canvas, 43¹/2 x 43¹/2 in. (110.5 x 110.5 cm)
Jane Voorhees Zimmerli Art Museum, Rutgers,
The State University of New Jersey, The Norton and
Nancy Dodge Collection of Nonconformist Art from
the Soviet Union

Welcome, 1973–74
Oil on canvas, 31¹/2 x 90¹/2 in. (80 x 230 cm)
Collection Alexander Sidorov, Moscow
© 1995 Eric Bulatov/Licensed by VAGA, New York
See plate 41

People in the Countryside, 1976
Oil on canvas, 55¹/2 x 70⁷/8 in. (141 x 180 cm)
Jane Voorhees Zimmerli Art Museum, Rutgers,
The State University of New Jersey, The Norton and
Nancy Dodge Collection of Nonconformist Art from
the Soviet Union
© 1995 Eric Bulatov/Licensed by VAGA, New York
See ill. 16

Brezhnev in the Crimea, 1981–85
Oil on canvas, 50 x 38 in. (19.7 x 14.7 cm)
Private Collection
© 1995 Eric Bulatov/Licensed by VAGA, New York
See ill. 15

Marc Chagall

Festival Day (Rabbi with Etrog*)*, 1914
Oil on canvas, 41 x 33 in. (104 x 84 cm)
Collection Himan Brown, New York

Over Vitebsk, 1915–20 (after a painting of
1914)
Oil on canvas, 26³/8 x 36¹/2 in. (67.1 x 92.7 cm)
The Museum of Modern Art, New York; Acquired
through the Lillie P. Bliss Bequest, 1949
© 1995 Artists Rights Society (ARS), New York/ADAGP,
Paris
See ill. 18

Purim, 1916–18
Oil on canvas, 1³/4 x 28¹/4 in. (50.2 x 71.7 cm)
The Philadelphia Museum of Art; The Louis E. Stern
Collection
© 1995 Artists Rights Society (ARS), New York/ADAGP,
Paris
See ill. 19

The Cemetery, 1917
Oil on canvas, 27¹/4 x 39¹/2 in. (69.3 x 100 cm)
Musée National d'Art Moderne, Centre Georges
Pompidou, Paris
© 1995 Artists Rights Society (ARS), New York/ADAGP,
Paris
See plate 9

The Market Place, Vitebsk, 1917
Oil on canvas, 26¹/8 x 38¹/4 in. (66.4 x 97.2 cm)
The Metropolitan Museum of Art, New York;
Bequest of Scofield Thayer, 1982

Father's Grave, 1922
Etching, 4¹/2 x 5³/4 in. (11.4 x 14.6 cm)
The Jewish Museum, New York (JM 198-67a)

The Rabbi, 1922
Etching, 10¹/2 x 8¹/4 in. (26.7 x 21 cm)
The Jewish Museum, New York; Gift of Mrs. Samuel
Atlas (JM 1982-112)

The Praying Jew (The Rabbi of Vitebsk), 1923
(copy of a work of 1914)
Oil on canvas, 46 x 35 in. (116.9 x 88.9 cm)
The Art Institute of Chicago; Collection Joseph
Winterbotham
© 1995 Artists Rights Society (ARS), New York/ADAGP,
Paris
See ill. 17

Iosif Chaikov

Electrifier, 1921
Watercolor, india ink, and pencil on paper,
13⁵/8 x 9⁷/8 in. (34.6 x 25.2 cm)
State Tretyakov Gallery, Moscow
See plate 13

Portrait of a Woman, 1921
India ink on paper, 13 x 9¹/2 in. (33 x 24.5 cm)
State Tretyakov Gallery, Moscow
See ill. 21

*Project for an Arch: Drawing for Tractor
Factory*, 1922
India ink and pencil on paper, 13 x 9¹/4 in.
(33.4 x 23.4 cm)
State Tretyakov Gallery, Moscow

Fisherman, 1926
Bronze, h: 25⁵/8 in. (65 cm)
State Tretyakov Gallery, Moscow
See ill. 22

Lenin the Orator, 1927
Ink on paper, 13¹/2 x 9¹/2 in. (34.9 x 24.1 cm)
State Tretyakov Gallery, Moscow
See ill. 20

Power Drill, 1932
Watercolor and ink on paper, 17³/8 x 12⁵/8 in.
(44 x 32 cm)
State Tretyakov Gallery, Moscow

Ilya Chashnik

Red Square (Unovis), 1921
Watercolor and india ink on paper, 8¹/2 x 7³/4 in.
(21.4 x 19.4 cm)
Lent by Leonard Hutton Galleries, New York

Suprematist Cross, 1922
Gouache on paper, 10 x 9¹/2 in. (25.4 x 24 cm)
Lent by Leonard Hutton Galleries, New York
See ill. 24

Suprematist Soup Tureen and Lid, 1923
Painted porcelain, h: 8 in., diam: 9⁷/8 in.
(20.3 cm, 25 cm)
Virginia Museum of Fine Arts, Richmond;
The Glasgow Fund
See ill. 25

Color Lines in Vertical Motion, 1923–25
Watercolor on paper, 14 x 10 in. (35.5 x 25.5 cm)
Lent by Leonard Hutton Galleries, New York

Maxim Gorky—Vladimir Lenin, 1924
Ink, watercolor, and graphite, 10¹/2 x 7³/4 in.
(26 x 19.8 cm)
Sackner Archive of Concrete and Visual Poetry, Miami
See ill. 23

Cup and Saucer, 1925
Porcelain, h cup: 2³/4 in., diam saucer: 6¹/2 in.
(6.7 cm, 16.6 cm)
Badisches Landesmuseum, Karlsruhe

*"The Seventh Dimension." Suprematist Stripe
Relief*, 1925
Painted wood, paper, cardboard, and glass,
10 x 8⁷/8 x ⁵/8 in. (26 x 22.5 x 1.5 cm)
Lent by Leonard Hutton Galleries, New York

Flying Structure in Suprematist Space, ca. 1925
Gouache and watercolor on paper, 13¹/8 x 9³/8 in.
(33.4 x 23.6 cm)
Lent by Leonard Hutton Galleries, New York

Suprematist Composition, 1926–27
Gouache, watercolor, and pencil on paper,
11⁵/8 x 8¹/8 in. (29.6 x 20.6 cm)
Lent by Barry Friedman Ltd., New York
See plate 12

Attributed to Chashnik
Cup and Saucer, 1923
Porcelain, h cup: 16 in., diam saucer: 35 in.
(6.3 cm, 13.8 cm)
Badisches Landesmuseum, Karlsruhe

Robert Falk

Portrait of My Parents, 1911
Oil on canvas, 40¹/2 x 34¹/2 in. (103.5 x 87.5 cm)
Collection Evgenia and Feliks Chudnovsky,
St. Petersburg
© 1995 Robert Falk/Licensed by VAGA, New York
See ill. 26

Environs of Moscow, 1912
Oil on canvas, 34⁷/8 x 40¹/4 in. (88.5 x 102 cm)
Tambov Gallery of Art, Russia
© 1995 Robert Falk/Licensed by VAGA, New York
See plate 6

Paper Flowers, 1915
Oil on canvas, 41¹/2 x 35¹/4 in. (105.5 x 89.5 cm)
Collection Vladimir Paleev, St. Petersburg
© 1995 Robert Falk/Licensed by VAGA, New York
See ill. 28

Self-Portrait with Bandaged Ear, 1921
Oil on canvas, 34³/₄ x 31¹/₈ in. (88 x 79 cm)
State Tretyakov Gallery, Moscow

Woman in a White Turban, 1922–23
Oil on canvas, 45⁵/₈ x 26¹/₈ in. (116 x 66.3 cm)
State Tretyakov Gallery, Moscow
© 1995 Robert Falk/Licensed by VAGA, New York
See ill. 27

Krasinsky as the Dead Man (Costume Design
for *A Night at the Old Market*), 1925
Pencil, watercolor, wash, and india ink on paper,
12³/₈ x 8⁷/₈ in. (31.3 x 22.5 cm)
Bakhrushin State Central Theater Museum, Moscow

Minaeva as the Aunt (Costume Design for *A
Night at the Old Market*), 1925
Pencil, gouache, wash, india ink on paper,
14 x 8⁷/₈ in. (35.5 x 22.2 cm)
Bakhrushin State Central Theater Museum, Moscow

Old Woman (Costume Design for Part I of *A
Night at the Old Market*), 1925
Pencil, watercolor, and gouache on paper,
13³/₄ x 8³/₈ in. (34.8 x 21.3 cm)
Bakhrushin State Central Theater Museum, Moscow

Abraham (Costume Design for *The Journey
of Benjamin III*), 1927
Pencil, watercolor, wash, and gouache on paper,
13¹/₄ x 8³/₄ in. (33.5 x 22.2 cm)
Bakhrushin State Central Theater Museum, Moscow

Nei as Reb Alter (Costume Design for
The Journey of Benjamin III), 1927
Pencil, watercolor, pen and india ink on paper,
14¹/₄ x 8⁷/₈ in. (36.2 x 22.6 cm)
Bakhrushin State Central Theater Museum, Moscow

Rogaler (Costume Design for *The Journey
of Benjamin III*), 1927
Pencil, watercolor, and wash on paper,
12³/₄ x 8¹/₂ in. (32.3 x 21.4 cm)
Bakhrushin State Central Theater Museum, Moscow

Portrait of Mikhoels, 1941
Watercolor on paper, 23⁵/₈ x 17³/₄ in. (60 x 45 cm)
Collection Vladimir Paleev, St. Petersburg

Naum Gabo

Sketch, 1917
Pencil on paper, 12 x 8³/₄ in. (30.5 x 22.2 cm)
The Tate Gallery, London; Presented by the Artist
1977

Sketch for Relief Construction, 1917
Pencil and black crayon on paper, 7¹/₈ x 5⁵/₈ in.
(18.1 x 14.3 cm)
The Tate Gallery, London; Presented by the Artist 1977
See ill. 30

Kinetic Construction (Standing Wave),
1919–20, replica 1985
Metal rod, painted wood, and electric motor,
24¹/₄ x 9¹/₂ x 7¹/₂ in. (61.6 x 24.1 x 19 cm)
The Tate Gallery, London; Presented by the Artist
through the American Federation of Arts, 1966
See Ill. 31

Sketch for a Kinetic Construction, 1922
Pencil and ink on paper, 17 x 12³/₈ in. (43.2 x 31.4 cm)
The Tate Gallery, London; Presented by the Artist 1977
See ill. 29

Column, ca. 1923
Perspex, wood, metal, and glass, 41¹/₄ x 29 x 19¹/₂ in.
(104.8 x 73.6 x 75 cm)
The Solomon R. Guggenheim Museum, New York
See plate 14

Moisei Ginzburg

With Gustav Hassenpflug and
Solomon Lisagor
Facade for the Palace of Soviets, Moscow
(Competition Project), 1932
India ink and watercolor on paper, 38³/₄ x 38³/₄ in.
(98.5 x 98.5 cm)
Shchusev State Scientific Research Museum of
Architecture, Moscow
See ill. 33

With Gustav Hassenpflug
*Facade for the Nemirovich-Danchenko
Theater, Moscow* (Competition Project), 1933
India ink, gouache and collage on paper, 27 x 29 in.
(68.5 x 73.7 cm)
Shchusev State Scientific Research Museum of
Architecture, Moscow
See ill. 32

*Project for the Rebuilding of Downtown
Sevastopol—Twice-Defended Square*, 1943
India ink and watercolor on paper, 32³/₄ x 43¹/₄ in.
(83.2 x 109.6 cm)
Shchusev State Scientific Research Museum of
Architecture, Moscow
See plate 28

Eduard Gorokhovsky

Airplane Game, 1979
Photo silkscreen and ink, 8 of 12 works,
each 23⁵/₈ x 31¹/₂ in. (60 x 80 cm)
Jane Voorhees Zimmerli Art Museum, Rutgers,
The State University of New Jersey, The Norton and
Nancy Dodge Collection of Nonconformist Art from
the Soviet Union
See ill. 34

Spiele (Games), 1983
Oil on screen print on pressed wood,
9 works, each 49³/₄ x 34 in. (126 x 86 cm)
Ludwig Forum für Internationale Kunst, Aachen
See plate 44; ill. 35

Boris Iofan

With Vladimir Shchuko and Vladimir Gelfreikh
Perspective for the Palace of Soviets, Moscow
(Competition Project), 1933
Watercolor, india ink, gouache, wash, and collage on
paper, 51¹/₈ x 56³/₄ in. (130.7 x 144.2 cm)
Shchusev State Scientific Research Museum of
Architecture, Moscow
See plate 22

Lobby Interior of the Palace of Soviets, 1940
variant
Charcoal and pastel on tracing paper mounted on
paper, 32³/₄ x 29¹/₂ in. (83 x 75 cm)
Shchusev State Scientific Research Museum of
Architecture, Moscow
See ill. 37

Model for the Palace of Soviets, 1942–43
Plaster and wood, 20 x 21¹/₄ x 34¹/₄ in.
(51 x 51.5 x 87 cm)
Shchusev State Scientific Research Museum of
Architecture, Moscow

*Facade for Pantheon of Eternal Glory of the
Great People of the Soviet Nation*, 1952–53
Colored pencil, pastel, and charcoal on tracing
paper, 29¹/₂ x 43¹/₈ in. (75 x 109.5 cm)
Shchusev State Scientific Research Museum of
Architecture, Moscow
See ill. 36

Ilya Kabakov

Drawing of Children, 1968
Watercolor and gouache on paper, 8¹/₂ x 12 in.
(21.6 x 30.4 cm)
Collection Anatole and Maya Bekkerman, New York
© 1995 Ilya Kabakov/Licensed by VAGA, New York
See ill. 38

Untitled (Grid with Houses and Head), 1968
Colored pencil on paper, 8¹/₄ x 11¹/₄ in.
(20.9 x 28.6 cm)
Collection Alexander Levin, New York

Answers of an Experimental Group, 1970–71
Oil, enamel, and mixed media on board,
59 in. x 10 ft. 2 in. (1.5 x 3.1 m)
Collection John L. Stewart, New York
© 1995 Ilya Kabakov/Licensed by VAGA, New York
See plate 39

Man under the Shower, 1974
Ink and colored pencil on paper, 16 works,
each 5¹/₂ x 7¹/₂ in. (14 x 19.1 cm)
Collection Drs. Irene and Alex Valger, New York
© 1995 Ilya Kabakov/Licensed by VAGA, New York
See ill. 39

Number 25.XII in Our District, 1983
Enamel paint on plywood, diptych:
8 ft. 6 in. x 12 ft. 5 in. x 9¹/₂ in. (2.6 x 3.8 x 0.2 m)
Musée National d'Art Moderne, Centre Georges
Pompidou, Paris
© 1995 Ilya Kabakov/Licensed by VAGA, New York
See ill. 40

Anna Kagan

Suprematist Composition, ca. 1920
Oil on canvas, 27 x 34³/₄ in. (10.6 x 13.7 cm)
Collection Barry Friedman/Patricia Pastor, New York
See ill. 42

Suprematist Composition (Large Red Square),
1922–23
Oil on canvas, 31 x 27 in. (78.7 x 68.6 cm)
Lent by Barry Friedman Ltd., New York
See ill. 41

Large Black Suprematist Square, 1923
Oil on canvas, 26 x 34 in. (10.2 x 13.4 cm)
Collection Francine and Samuel Klagsbrun, New York
See ill. 43

Suprematist Architectonic Composition, 1926
Oil on canvas, 29¹/₂ x 40 in. (74.9 x 101.6 cm)
Lent by Barry Friedman, Ltd., New York
See plate 16

Anatoly Kaplan

At the Griboyedov Canal, 1944–45
Lithograph on paper, 17¹/₂ x 13¹/₂ in. (44.6 x 34 cm)
Collection Alexander M. Shedrinsky, New York

Repairing St. Isaac's Square, 1945
Lithograph on paper, 17³/₈ x 13¹/₈ in. (44 x 33.5 cm)
Collection Alexander M. Shedrinsky, New York
© 1995 Anatoly Kaplan/Licensed by VAGA, New York
See ill. 44a

Sleet, 1945
Lithograph on paper, 18 x 12¹/₄ in. (45.7 x 31 cm)
Collection Alexander M. Shedrinsky, New York

The Bewitched Tailor, 1957
a) *The Sixth Chapter*
b) *Village of Kozodoyevka*
Lithographs on paper, each 23¹/₂ x 17³/₄ in.
(59.7 x 45.1 cm)
The Jewish Museum, New York
See ill. 44b

Flowers and Portrait, 1964
Tempera on paper, 19¹/₂ x 15¹/₂ in. (49.5 x 39.3 cm)
Collection Alexander M. Shedrinsky, New York
© 1995 Anatoly Kaplan/Licensed by VAGA, New York
See plate 35

Fishke the Lame, 1967
a) *Faybushke and Basya*
b) *Portrait of a Writer*
Lithographs on paper, each 22¹/₂ x 16¹/₂ in.
(57 x 42 cm)
Collection Alexander M. Shedrinsky, New York
© 1995 Anatoly Kaplan/Licensed by VAGA, New York
See ill. 45

At the Photographer, 1969
Gouache on paper, 20⁷/₈ x 15 in. (53 x 38 cm)
Collection Vladimir Paleev, St. Petersburg

Evgeny Katsman

Portrait of Feliks Dzerzhinsky, 1923
Oil on canvas, 30 x 40⁵/₈ in. (76 x 103 cm)
State Tretyakov Gallery, Moscow
© 1995 Evgeny Katsman/Licensed by VAGA, New York
See ill. 46

Village Teacher, 1925
Oil on canvas, 47³/₄ x 27 in. (121 x 68.5 cm)
State Tretyakov Gallery, Moscow
© 1995 Evgeny Katsman/Licensed by VAGA, New York
See plate 25

Stepanida, 1928
Oil on canvas, 36⁷/₈ x 25³/₄ in. (93.5 x 65.5 cm)
State Tretyakov Gallery, Moscow
© 1995 Evgeny Katsman/Licensed by VAGA, New York
See ill. 47

Lazar Khidekel

Colored Suprematism—Dynamic Balance, 1921
Gouache and india ink on paper, 6¹/₂ x 8¹/₂ in. (16.5 x 21.5 cm)
Private Collection, Courtesy Leonard Hutton Galleries, New York

Colored Suprematism—Suprematist Composition, 1921
Gouache and india ink on paper, 6 x 6 in. (15.3 x 15.3 cm)
Lent by Leonard Hutton Galleries, New York

Colored Suprematism—Suprematist Composition with Blue Square, 1921
Gouache and india ink on paper, 7¹/₄ x 7¹/₄ in. (18.4 x 18.4 cm)
Private Collection, Courtesy Leonard Hutton Galleries, New York
See ill. 48

Suprematist Concentric Circles, 1921
Watercolor, plaster, paper collage, and pencil on board, 5¹/₈ x 5¹/₂ in. (13.2 x 14 cm)
Lent by Leonard Hutton Galleries, New York
See plate 11

Suprematist Cross: White on White, 1922
Gouache, plaster, and pencil on paper, 4⁵/₈ x 4⁷/₈ in. (11.7 x 12.5 cm)
Lent by Leonard Hutton Galleries, New York

Yellow Cross, 1923
Oil on canvas, 20⁷/₈ x 24¹/₂ in. (53 x 62 cm)
Private Collection, Courtesy Leonard Hutton Galleries, New York
See ill. 49

Vitaly Komar and Alexander Melamid

Laika Cigarette Box (from *Sots Art Series*), 1972
Oil on canvas, 30³/₄ x 23¹/₂ in. (78 x 59.5 cm)
Lent by Ronald Feldman Fine Arts, Inc., New York

Double Self-Portrait, 1973
Oil on canvas, diam: 36 in. (91.4 cm)
Lent by Frankel Nathanson Gallery, New York
See ill. 51

Color Writing: Ideological Abstraction No. 1, 1974
Oil on canvas, 83 x 39 in. (210 x 99 cm)
Lent by Ronald Feldman Fine Arts, Inc., New York
See ill. 52

Factory for the Production of Blue Smoke, 1975
Oil on canvas, 84 x 39 in. (213.4 x 99.1 cm)
Collection Alfred and Pie Friendly, Washington, DC
See plate 42

Prophet Obadiah, 1976
Black and white photographs, 7 works, each 8³/₄ x 4 in. (22.5 x 10 cm)
Jane Voorhees Zimmerli Art Museum, Rutgers, The State University of New Jersey, The Norton and Nancy Dodge Collection of Nonconformist Art from the Soviet Union
See ill. 50

Double Self-Portrait, from Cut-Off Corner Series, 1977
Oil on canvas, 43¹/₄ x 39¹/₂ in. (109.9 x 100.3 cm)
Wadsworth Atheneum, Hartford; The Ella Gallup Sumner and Mary Catlin Sumner Collection Fund

Alexander Kosolapov

Aurora, 1973
Orgalite, oil paint, tempera, and lacquer, 16¹/₈ x 19¹/₄ x 2¹/₂ in. (41 x 49 x 6.5 cm)
Collection Alexander Yulikov, Moscow
See plate 38

Baltika, 1973
Oil paint and wood, overall 41 x 14⁵/₈ x 3¹/₂ in. (104 x 37 x 9 cm)
Jane Voorhees Zimmerli Art Museum, Rutgers, The State University of New Jersey, The Norton and Nancy Dodge Collection of Nonconformist Art from the Soviet Union
See ill. 54

Study Sonny, 1974
Oil paint and wood, 15³/₄ x 11⁷/₈ x 5⁷/₈ in. (40 x 30 x 15 cm)
Collection Vyacheslav Sohransky, Moscow
See ill. 55

North, 1975
Plastic, paint, wood, fabric, and ready-made objects, 6 pieces, overall 26 x 39 in. (66 x 99.1 cm)
Collection of the Artist, New York
See ill. 53

Alexander Labas

The Approaching Train, 1928
Oil on canvas, 39 x 31 in. (99 x 79 cm)
Collection John Githens, New York
© 1995 Alexander Labas/Licensed by VAGA, New York
See ill. 56

Lenin's Arrival in Petrograd in 1917 (from *October Series*), 1930
Oil on canvas, 37¹/₂ x 33 in. (95 x 84 cm)
State Tretyakov Gallery, Moscow
© 1995 Alexander Labas/Licensed by VAGA, New York
See ill. 58

The First Soviet Dirigible, 1931
Oil on canvas, 30 x 40¹/₄ in. (76.2 x 102 cm)
State Tretyakov Gallery, Moscow
© 1995 Alexander Labas/Licensed by VAGA, New York
See plate 23

Metro, 1935
Oil on canvas, 33¹/₂ x 26 in. (83 x 63.5 cm)
State Tretyakov Gallery, Moscow
© 1995 Alexander Labas/Licensed by VAGA, New York
See ill. 57

Leonid Lamm

Yes . . . Hell . . . Yes, 1964
Tempera on paper, 25¹/₄ x 34⁷/₈ in. (64 x 88.5 cm)
Jane Voorhees Zimmerli Art Museum, Rutgers, The State University of New Jersey, The Norton and Nancy Dodge Collection of Nonconformist Art from the Soviet Union
See ill. 61

Butyrka Courtyard, 1974
Watercolor and ink on paper, 14 x 19 in. (35. x 48.3 cm)
The Jewish Museum, New York; Gift of D. Neil Levy

Power and Man, 1974
Watercolor and ink on paper, 19 x 14¼ in.
(48.3 x 36.2 cm)
The Jewish Museum, New York; Gift of D. Neil Levy

Untitled (Red Corner), 1974–78
Oil on canvas, 79½ x 67¾ in. (201.9 x 172.1 cm)
Collection Inessa and Olga Lamm, New York
See ill. 60

Three Years: My Last Days in the Labor Camp,
1976–83
Watercolor, ink, and collage on paper, 29½ x 21¾ in.
(77.5 x 57.2 cm)
Collection Steven and Susan Rosefielde, Chapel Hill,
North Carolina
See ill. 59

Assembly Hall (from *Butyrka Prison Series*),
1976–86
Oil on canvas, 80 x 80 in. (203.2 x 203.2 cm)
Lent by the Artist, New York
See plate 45

Isaak Levitan

Jewish Tombstone, ca. 1881
Oil on canvas, 27¼ x 21⅝ in. (69 x 55 cm)
Collection Arledan Properties Ltd., Jerusalem
See ill. 63

Tatar Cemetery, ca. 1886
Oil on canvas, 17¾ x 29¼ in. (45 x 75 cm)
State Tretyakov Gallery, Moscow

Zvenigrod Monastery, Russian Village, ca. 1889
Oil on canvas, 17 x 26 in. (43 x 66.5 cm)
The Israel Museum Collection, Jerusalem
See ill. 64

Study for Above Eternal Peace, 1894
Oil on canvas, 37½ x 50 in. (95 x 127 cm)
State Tretyakov Gallery, Moscow
See plate 2

Stormy Day, ca. 1897
Oil on canvas, 32¼ x 33⅞ in. (82 x 86 cm)
State Tretyakov Gallery, Moscow
See ill. 62

Dmitry Lion

Untitled, 1957
Ink on paper, 17⅛ x 24¼ in. (43.5 x 61.6 cm)
K. Nowikovsky Collection, Vienna
© 1995 Dmitry Lion/Licensed by VAGA, New York
See ill. 66

Chained Humanity, 1968
Ink on paper, 18⅛ x 27½ in. (46 x 70 cm)
Collection Lilya Lion, Moscow
© 1995 Dmitry Lion/Licensed by VAGA, New York
See ill. 65

Composition with Bull, 1968
Ink on paper, 27½ x 35½ in. (70 x 90 cm)
Collection Lilya Lion, Moscow

Procession in Wooden Collars, ca. 1968
Ink on paper, 27½ x 31½ in. (70 x 80 cm)
Collection Lilya Lion, Moscow
© 1995 Dmitry Lion/Licensed by VAGA, New York
See ill. 68

Untitled, 1969
Ink on paper, 12 x 17 in. (30.5 x 43.1 cm)
K. Nowikovsky Collection, Vienna
© 1995 Dmitry Lion/Licensed by VAGA, New York
See ill. 67

The Long Way, 1975
Ink on paper, 23¼ x 30⅜ in. (59 x 77 cm)
Collection Lilya Lion, Moscow

El Lissitzky

*Committee on the Struggle against Unemploy-
ment, Vitebsk, 1917 4/17 XII*, 1917
Gouache, black ink, and pencil on paper,
9½ x 13¼ in. (24.1 x 33.7 cm)
Lent by Barry Friedman Ltd., New York

Had Gadya
Kiev: Kultur Lige, 1919
Bound volume with title page and 10 Illustrations
plus cover
Color lithographs on paper, 11 x 10¾ in.
(27.9 x 25.8 cm)
Lent by Svetlana Aronov, New York

Had Gadya Suite
Kiev: Kultur Lige, 1919
Title page
"Father Bought a Kid for Two Zuzim," Scene I
"Then Came a Stick and Beat the Dog,"
Scene IV
"Then Came a Fire and Burnt the Stick,"
Scene V
Color lithographs on paper, 4 of 11 works,
each 10¾ x 10 in. (27.3 x 25.4 cm)
The Jewish Museum, New York; Gift of Phyliss
and Leonard E. Greenberg
© 1995 Artists Rights Society (ARS), New York/VG
Bild-Kunst, Bonn
See plate 8

Beat the Whites with the Red Wedge, 1920
Lithograph on paper, 18¾ x 22⅝ in. (47.5 x 57.5 cm)
Sackner Archive of Concrete and Visual Poetry, Miami
© 1995 Artists Rights Society (ARS), New York/VG
Bild-Kunst, Bonn
See ill. 71

Proun 3A, ca. 1920
Oil on canvas, 28 x 23 in. (71.7 x 58.4 cm)
Los Angeles County Museum of Art; Purchased with
Funds Provided by Mr. and Mrs. David E. Bright
© 1995 Artists Rights Society (ARS), New York/VG
Bild-Kunst, Bonn
See ill. 70

Proun (Entwurf zu Proun S.K.), 1922–23
Gouache, india ink, pencil, conte crayon, and varnish
on buff paper, 8½ x 11¾ in. (21.4 x 29.4 cm)
The Solomon R. Guggenheim Museum, New York;
Gift, Estate of Katherine S. Dreier, 1953

Untitled (Mannequin), ca. 1923–29
Positive photogram, gelatin-silver print, 11½ x 9¼ in.
(29.4 x 23.4 cm)
Collection Alexandra R. Marshall

Self-Portrait with Wrapped Head and Compass,
ca. 1924–25
Photogram and photograph, gelatin-silver print,
6¾ x 4⅞ in. (17.2 x 12.1 cm)
Gilman Paper Company Collection
© 1995 Artists Rights Society (ARS), New York/VG
Bild-Kunst, Bonn
See ill. 69

Runner in the City, ca. 1926
Photomontage, gelatin-silver print,
5¼ x 5⅛ in. (13.1 x 12.8)
Courtesy Houk Friedman, New York

Russian Exhibition, Kunstverein Museum, 1929
Colored lithograph on paper, proof copy,
49¾ x 35⅝ in. (126.5 x 90.5 cm)
Collection Merrill C. Berman

Self-Portrait, 1935
Photograph, 15½ x 9¾ in. (39.2 x 24.7 cm)
Russian State Archive of Art and Literature, Moscow

Abraham Manievich

Destruction of the Ghetto, Kiev, 1919
Oil on canvas, 72 x 72 in. (182.9 x 182.9 cm)
The Jewish Museum, New York; Museum Purchase
See plate 10

Russian Village at Peace, 1919
Oil on canvas, 70 x 72 in. (177.8 x 182.9 cm)
Lent by Rifkin Young Fine Art Inc., New York
See ill. 73

Through the Trees (Fairy Park), 1919
Oil on canvas, 33 x 35 in. (83.8 x 89.9 cm)
Lent by Rifkin Young Fine Art Inc., New York
See ill. 72

Boris Mihailov

Sots Art Series I, 1975
Gelatin-silver prints with applied color,
19¾ x 23⅝ in. (50 x 60 cm)
a) *May Day Parade*
The Metropolitan Museum of Art; Purchase, The Hor-
ace W. Goldsmith Foundation Gift, 1994 (1994.37.3)
© 1995 Boris Mihailov/Licensed by VAGA, New York
See plate 43
b) *Untitled*
Private Collection, Courtesy Diane Neumaier,
New York
See ill. 74
c) *Untitled*
Private Collection, Courtesy Diane Neumaier,
New York
© 1995 Boris Mihailov/Licensed by VAGA, New York

Unfinished Dissertation, 1983
Black and white photographs and ink on paper,
7 works from series, each 11¼ x 8¼ in.
(28.5 x 20.9 cm)
Lent by the Artist, Kharkov, Ukraine
© 1995 Boris Mihailov/Licensed by VAGA, New York
See ill. 75

Salt Lake Series, 1985
Gelatin-silver prints, 7 works from series,
each 11¾ x 9¾ in. (29.8 x 24.8 cm)
Lent by the Artist, Kharkov, Ukraine
© 1995 Boris Mihailov/Licensed by VAGA, New York
See ill. 76

Moisei Nappelbaum

Feliks Dzerzhinsky, 1918
Gelatin-silver print, 8 x 6 1/8 in. (20.5 x 15.7 cm)
Museum Ludwig, Cologne; Ludwig Donation
© 1995 Moisei Nappelbaum/Licensed by VAGA,
New York
See ill. 77

Vladimir Lenin, 1918
Gelatin-silver print, 11 1/4 x 8 3/4 in. (28.5 x 22.5 cm)
Lent by Galerie Alex Lachmann, Cologne

Boris Pasternak, 1926
Gelatin-silver print, 14 1/2 x 10 3/4 in. (37 x 27.6 cm)
Collection Manfred Heiting, Amsterdam
© 1995 Moisei Nappelbaum/Licensed by VAGA,
New York
See ill. 79

Maxim Gorky, 1927
Gelatin-silver print, 8 3/4 x 6 in. (22 x 15 cm)
Lent by Galerie Alex Lachmann, Cologne
© 1995 Moisei Nappelbaum/Licensed by VAGA,
New York
See plate 18

Stalin, ca. 1934
Gelatin-silver print, 22 1/4 x 14 5/8 in. (56.5 x 37 cm)
Lent by Galerie Alex Lachmann, Cologne
© 1995 Moisei Nappelbaum/Licensed by VAGA,
New York
See ill. 78

Ernst Neizvestny

Dead Soldier, 1953–54
Bronze, 4 1/2 x 15 1/8 x 2 5/8 in.
(10.7 x 38.4 x 6.7 cm)
Collection Jeff Bliumis, New York
See ill. 80

Soldier Being Bayonetted, 1955
Bronze, 7 x 5 x 3 in. (17.8 x 12.7 x 7.6 cm)
Collection Bernie Bercuson, Bal Harbour

Drawing for Battle of Giants, 1964
Pencil, brush, and brown ink on paper,
24 3/8 x 36 1/4 in. (61.7 x 92 cm)
The Museum of Modern Art, New York; Gift of Olga
A. Carlisle
See ill. 81

Drawing for Tree of Life—Numbers 11, 12, 28,
1967–68
Ink and paper on board, 3 works, each 15 1/2 x 23 in.
(39.4 x 58.4 cm)
Lent by the Artist, New York

Centaur, 1972
Bronze, 17 x 15 x 8 in. (43 x 38.1 x 20.3 cm)
Collection Drs. Irene and Alex Valger, New York

Dmitry Shostakovich, 1976
Bronze, 12 5/8 x 17 3/8 in. (32 x 44 cm)
The John F. Kennedy Center for the Performing Arts,
Washington, D.C.
See plate 36

Solomon Nikritin

Seated Male Nude, 1918
Watercolor on paper mounted on board,
12 1/4 x 8 5/8 in. (31 x 22 cm)
The George Costakis Collection, Athens

Nude with Red Cloth, ca. 1920
Watercolor on board, 11 1/8 x 7 5/8 in. (28 x 19.5 cm)
The George Costakis Collection, Athens
See ill. 82

Man in Top Hat, 1927
Oil on canvas, 26 7/8 x 11 in. (68.4 x 28.2 cm)
Art Co. Ltd. (The George Costakis Collection)
See ill. 83

Screaming Woman, 1928
Oil on canvas, 69 1/4 x 69 1/4 in. (176 x 176 cm)
Art Co. Ltd. (The George Costakis Collection)
See plate 20

Head of a Man, ca. 1928
Oil on board, 10 1/2 x 8 in. (26.5 x 20.5 cm)
The George Costakis Collection, Athens

Towers with Red Flares, ca. 1930
Mixed media on paper, 10 5/8 x 8 1/2 in. (27 x 21.5 cm)
The George Costakis Collection, Athens
See ill. 84

Stadium, ca. 1945
Oil on board, 11 1/4 x 8 5/8 in. (28.5 x 22 cm)
The George Costakis Collection, Athens

Leonid Pasternak

News from the Motherland, 1889
Oil on canvas, 43 3/8 x 59 7/8 in. (110 x 152 cm)
State Tretyakov Gallery, Moscow
© 1995 Leonid Pasternak/Licensed by VAGA,
New York
See plate 3

Tolstoy with Family Seated Round the Table,
ca. 1900
Oil on canvas, 31 1/8 x 23 1/4 in. (79 x 59 cm)
Pasternak Trust, Bristol (PT357)
© 1995 Leonid Pasternak/Licensed by VAGA,
New York
See ill. 86

Winter View of the Kremlin, 1917
Gouache, watercolor, and pencil on tan paper,
13 x 9 in. (33 x 23 cm)
Pasternak Trust, Bristol (PT62)

*The Writer An-sky Reading The Dybbuk in the
Home of Stiebel*, ca. 1919
Oil on canvas, 27 5/8 x 35 1/2 in. (70 x 90 cm)
The Israel Museum Collection, Jerusalem
© 1995 Leonid Pasternak/Licensed by VAGA,
New York
See ill. 87

*David Frischmann and Chaim Nachman Bialik
in Conversation*, 1921–22
Charcoal and pencil on paper, 20 x 25 in.
(50.8 x 63.5 cm)
The Leo Baeck Institute, New York
© 1995 Leonid Pasternak/Licensed by VAGA,
New York
See ill. 85

Boris Pasternak, 1922
Charcoal on onionskin paper, 12 5/8 x 9 3/8 in.
(32 x 24 cm)
Pasternak Trust, Bristol (PT72)

Portrait of Tschernikowski, 1923
Oil on canvas, 27 1/2 x 22 3/4 in. (70 x 58 cm)
Tel Aviv Museum of Art; Gift of the Artist, Berlin,
1935

Yehuda Pen

Portrait of a Jew in a Black Hat, 1900
Oil on canvas, 17 3/8 x 27 in. (44 x 68.5 cm)
Vitebsk Museum of Regional and Local History
See ill. 88

The Watchmaker, 1914
Oil on canvas, 23 5/8 x 26 3/8 in. (60 x 67 cm)
State Museum of Art of the Republic of Belorussia,
Minsk
See plate 4

Divorce, 1917
Oil on canvas, 58 x 73 1/2 in. (147 x 187 cm)
Vitebsk Museum of Regional and Local History
See ill. 90

The Talmudist, 1925
Oil on canvas, 42 1/8 x 28 1/4 in. (107 x 71.5 cm)
Vitebsk Museum of Regional and Local History
See ill. 89

Viktor Pivovarov

Do You Remember Me?, 1975
Gouache on paper, 18 of 20 works,
each 12 3/4 x 9 3/4 in. (32.5 x 24.5 cm)
Collection Norton and Nancy Dodge
See plate 40; ills. 91, 92

Oscar Rabin

Russian Pop Art, 1963
Oil on canvas, 27 1/2 x 35 1/2 in. (70 x 90 cm)
Fondation Dina Vierny—Musée Maillol, Paris

Passport, 1964
Oil on canvas, 36 x 28 in. (88.9 x 71.1 cm)
Collection Natalia Kropivnitskaya, Stamford,
Connecticut
© 1995 Artists Rights Society (ARS), New York/
ADAGP, Paris
See ill. 93; frontispiece

Stolichnaya Vodka, 1964
Oil on canvas, 43 x 31 7/8 in. (109.2 x 81 cm)
Fondation Dina Vierny—Musée Maillol, Paris
© 1995 Artists Rights Society (ARS), New York/
ADAGP, Paris
See ill. 94

Detour 2 Metres, 1965
Oil on canvas, 35 3/8 x 27 5/8 in. (90 x 70 cm)
Jane Voorhees Zimmerli Art Museum, Rutgers,
The State University of New Jersey, The Norton and
Nancy Dodge Collection of Nonconformist Art from
the Soviet Union

Farewell Lianozovo, 1965
Oil on canvas, 27 1/2 x 35 1/2 in. (70 x 90 cm)
Fondation Dina Vierny–Musée Maillol, Paris
© 1995 Artists Rights Society (ARS), New York/
ADAGP, Paris
See ill. 95

Still Life with Fish and Newspaper "Pravda" 7,
1968
Oil on canvas, 35¹/₂ x 34³/₈ in. (90 x 110 cm)
Collection Alexander Glezer, Moscow
© 1995 Artists Rights Society (ARS), New York/
ADAGP, Paris
See plate 30

Mikhail Roginsky

Meat and Fish, 1962
Oil on canvas, 35¹/₂ x 41¹/₂ in. (90 x 105.5 cm)
Collection Farideh Cadot, Paris
© 1995 Artists Rights Society (ARS), New York/
SPADEM, Paris
See ill. 96

Metro, 1962
Oil on canvas, 39³/₈ x 35¹/₂ in. (100 x 90 cm)
Collection Farideh Cadot, Paris
© 1995 Artists Rights Society (ARS), New York/
SPADEM, Paris
See plate 29

Primus Stove 1-2-3, 1965
Oil on canvas, 31¹/₂ x 25¹/₂ in. (80 x 65 cm)
Jane Voorhees Zimmerli Art Museum, Rutgers,
The State University of New Jersey, The Norton and
Nancy Dodge Collection of Nonconformist Art from
the Soviet Union

Venus sur Tabouret, 1965
Oil on canvas, 31¹/₂ x 23¹/₂ in. (80 x 59.3 cm)
Collection Farideh Cadot, Paris
© 1995 Artists Rights Society (ARS), New York/
SPADEM, Paris
See ill. 98

Toilet, 1966
Oil on canvas, 35¹/₂ x 30 in. (90 x 76 cm)
Jane Voorhees Zimmerli Art Museum, Rutgers,
The State University of New Jersey, The Norton and
Nancy Dodge Collection of Nonconformist Art from
the Soviet Union
© 1995 Artists Rights Society (ARS), New York/
SPADEM, Paris
See ill. 97

Issachar Ryback

The Cemetery, 1917
Oil on canvas, 26¹/₂ x 20¹/₂ in. (67.7 x 51.5 cm)
Ryback Art Museum, Bat Yam, Israel
See ill. 100

The Old Synagogue, 1917
Oil on canvas, 38¹/₄ x 57¹/₂ in. (97 x 146 cm)
Tel Aviv Museum of Art
See ill. 101

Aleph-Beth, 1918
Oil and collage on canvas, 38¹/₂ x 31¹/₈ in.
(98 x 79 cm)
Ryback Art Museum, Bat Yam, Israel
See plate 7

Man with Tallit in Synagogue (from *Pogrom
Series*), 1918
Pencil, india ink, and watercolor on paper,
13 x 17³/₄ in. (33 x 45 cm)
Mishkan Le'Omanut, Museum of Art, Ein Harod,
Israel
See ill. 99

Woman Nursing Baby (from *Pogrom Series*),
1918
Pencil, india ink, and watercolor on paper,
13 x 17³/₄ in. (33 x 45 cm)
Mishkan Le'Omanut, Museum of Art, Ein Harod,
Israel
See ill. 99

Yiddish Theater Scene, 1920
Charcoal on paper, 15 x 18⁷/₈ in. (5.9 x 7.4 cm)
The Jewish Museum, New York

Arkady Shaikhet

Light Bulb in a Hut, 1925
Gelatin-silver print, 4⁵/₈ x 8⁷/₈ in. (11.6 x 17.3 cm)
Lent by Galerie Alex Lachmann, Cologne
See ill. 105

Physical Training, 1927
Gelatin-silver print, 12¹/₂ x 16 in. (31.5 x 41 cm)
Museum Ludwig, Cologne; Ludwig Donation

Red Army Soldiers Marching in the Snow,
1928
Gelatin-silver print, 13¹/₂ x 17¹/₄ in. (34.5 x 43.8 cm)
Lent by Galerie Alex Lachmann, Cologne
See ill. 103

In the Coffeehouse, 1930
Gelatin-silver print, 16³/₄ x 11¹/₂ in. (42.5 x 29.3 cm)
Lent by Galerie Alex Lachmann, Cologne
See ill. 102

Pulling up a Gas Tank, 1930
Gelatin-silver print, 21⁷/₈ x 15¹/₈ in. (55.5 x 38.5 cm)
The Museum of Modern Art, New York
Joel and Anne Ehrenkranz Fund, Samuel J. Wagstaff,
Jr. Fund, and Anonymous Purchase Fund
Copy print © 1995 The Museum of Modern Art,
New York
See ill. 104

Meeting of Friends, ca. 1930
Gelatin-silver print, 15¹/₄ x 15¹/₈ in. (38.5 x 38.3 cm)
Lent by Galerie Alex Lachmann, Cologne

Express, 1939
Gelatin-silver print, 15³/₈ x 23 in. (38.9 x 58.5 cm)
Lent by Galerie Alex Lachmann, Cologne

Grigory Shegal

Kerensky's Flight from Gatchina in 1917,
1936–38
Oil on canvas, 7 ft. 1³/₈ in. x 8 ft. 6 in. (2.2 x 2.6 m)
State Tretyakov Gallery, Moscow
See plate 26

Leader, Teacher, and Friend, 1937
Oil on canvas, 47 x 35 in. (120 x 90 cm)
Private Collection
See ill. 107

Nurse in a Free Moment, 1945
Oil on canvas, 34¹/₄ x 26¹/₂ in. (87 x 67 cm)
State Tretyakov Gallery, Moscow
See ill. 106

Eduard Shteinberg

Abstract Composition, 1969–70
Oil on canvas, 39¹/₄ x 31¹/₂ in. (99.7 x 80 cm)
Collection Anatole and Maya Bekkerman, New York
See plate 37

Composition May 1973, 1973
Oil on canvas, 47¹/₂ x 59¹/₂ in. (121 x 151 cm)
Museum Ludwig, Cologne; Ludwig Donation

Composition November 1976, 1976
Oil on canvas, 55¹/₈ x 41 in. (140 x 104.1 cm)
Lent by Claude Bernard Gallery, Ltd., New York
See ill. 108

Composition Sky-Earth November 1988, 1988
Oil on canvas, 39³/₈ x 35¹/₄ in. (100 x 89.5 cm)
Lent by Leonard Hutton Galleries, New York
See ill. 109

Composition January (one + two) 1989, 1989
Oil on canvas, 47¹/₄ x 51¹/₈ in. (120 x 130 cm)
Private Collection, New York
See ill. 110

David Shterenberg

Still Life with Herrings, 1917
Oil on plywood, 21³/₄ x 24⁵/₈ in. (55 x 62.5 cm)
State Tretyakov Gallery, Moscow
See ill. 113

Red Cup on Marble Paper, 1920
Oil on cardboard, 29¹/₈ x 39 in. (74 x 99 cm)
Collection the Artist's Family, Moscow
See ill. 112

Still Life with Picture on Wall, ca. 1925
Oil on canvas, 23⁵/₈ x 15³/₈ in. (60 x 39 cm)
Collection Evgenia and Feliks Chudnovsky,
St. Petersburg
See plate 19

The Old Man, 1927
Oil on canvas, 69³/₈ x 56³/₈ in. (176 x 143 cm)
State Tretyakov Gallery, Moscow
See ill. 111

Solomon Telingater

Untitled, ca. 1927
Collage and ink on paper, 14³/₄ x 8³/₄ in.
(29.8 x 22.2 cm)
Lent by Barry Friedman Ltd., New York
See ill. 114

Untitled, ca. 1930
Collage, 17³/₄ x 14³/₄ in. (45 x 37.5 cm)
Collection Merrill C. Berman
See ill. 115

*Design for Decoration of Red Army Theater
Truck,* 1932
Graphite, gouache, and collage on paper,
14³/₄ x 19⁵/₈ in. (37.5 x 50 cm)
Collection Merrill C. Berman
See plate 24

Oleg Tselkov

Still Life, 1965
Oil on canvas mounted on plywood, 28³/8 x 24¹/2 in.
(72 x 62 cm)
Collection Vladimir Maramzin, Paris
See plate 33

Obituary, 1971
Oil on canvas, 89¹/4 x 43³/4 in. (209 x 111 cm)
Jane Voorhees Zimmerli Art Museum, Rutgers,
The State University of New Jersey, The Norton and
Nancy Dodge Collection of Nonconformist Art from
the Soviet Union
See ill. 117

Portrait of George Costakis, 1976
Oil on canvas, 25⁵/8 x 21³/4 in. (65 x 55 cm)
The George Costakis Collection, Athens
See ill. 116

Boris Turetsky

Untitled, 1960s
Watercolor on paper, 28 works, various sizes,
average 10 x 8 in. (25.4 x 20.3 cm)
Collection Mikhail Yershov, Moscow
See ills. 118, 119

Alexander Tyshler

*Shooting of the 26 Red Army Commissars in
Baku*, 1919
Watercolor on paper, 16¹/2 x 25³/4 in. (42 x 65.1 cm)
State Tretyakov Gallery, Moscow

Portrait of Anastasiya Tyshler, 1926
Oil on canvas, 31 x 27¹/2 in. (78.6 x 69.8 cm)
Museum of Private Collections of The State Pushkin
Museum of Fine Arts, Moscow
See ill. 120

Sacco and Vanzetti, 1927
Oil on canvas, 35 x 28 in. (89 x 71 cm)
State Tretyakov Gallery, Moscow
See plate 21

From the Lyrical Cycle Number 4, 1928
Oil on canvas, 28⁷/8 x 21⁷/8 in. (73.4 x 55.6 cm)
Museum Ludwig, Cologne
See ill. 121

News about Veils, 1930
Watercolor on paper, 19¹/2 x 25¹/2 in. (49.7 x 64.8 cm)
State Tretyakov Gallery, Moscow

When the Veils Come Off, 1930
Watercolor on paper, 19¹/2 x 25¹/2 in. (49.7 x 64.8 cm)
State Tretyakov Gallery, Moscow

City Landscape with Airplane, 1933
Oil on canvas, 30³/8 x 35⁷/8 in. (77 x 91 cm)
State Tretyakov Gallery, Moscow
See ill. 122

Haim the Cheat (Costume Design for
The Recruit), 1933
Pencil and india ink on paper, 14⁵/8 x 10¹/2 in.
(37 x 26.5 cm)
Bakhrushin State Central Theater Museum, Moscow

The Rabbi (Costume Design for *The Recruit*),
1933
Pencil and india ink on paper, 14⁵/8 x 10¹/2 in.
(37 x 26.5 cm)
Bakhrushin State Central Theater Museum, Moscow

Solomon Mikhoels as King Lear (Make-up
Design), 1935
Pencil and watercolor on paper, 8¹/4 x 6³/4 in.
(20.8 x 17.5 cm)
Bakhrushin State Central Theater Museum, Moscow

Freylekhs (Stage Design), 1947
Pencil and watercolor on paper, 27⁵/8 x 22¹/2 in.
(70.2 x 57 cm)
Bakhrushin State Central Theater Museum, Moscow

Makhno, 1927
Watercolor on paper, 21¹/4 x 28¹/2 in. (54 x 72.4 cm)
Museum of Private Collections of The State Pushkin
Museum of Fine Arts, Moscow

Vladimir Weisberg

Portrait of Paola Walkova, 1959
Oil on canvas, 41³/8 x 30³/4 in. (105 x 78 cm)
State Tretyakov Gallery, Moscow
See ill. 125

*Still Life with White Pitcher and Plate on
Towel*, 1960
Oil on canvas, 21¹/4 x 39³/8 in. (54 x 100 cm)
State Tretyakov Gallery, Moscow

Composition No. 11, 1975
Oil on canvas, 19¹/4 x 19¹/4 in. (49 x 49 cm)
Private Collection
See ill. 123

Composition No. 21, 1975
Oil on canvas, 20¹/2 x 22 in. (52 x 56 cm)
Lent by Galerie Garig Basmadjian, Paris

Portrait of Olga Kikina, 1978
Oil on canvas, 21¹/4 x 18¹/8 in. (54 x 46 cm)
Lent by Galerie Garig Basmadjian, Paris
See plate 34

Composition with Torso, 1982
Oil on canvas, 21 x 20¹/2 in. (53 x 52 cm)
Ludwig Forum für Internationale Kunst, Aachen
See ill. 124

Vladimir Yakovlev

Cosmic Portrait, 1959
Gouache on paper, 17³/8 x 11⁵/8 in. (41.5 x 29.5 cm)
Museum Ludwig, Cologne; Ludwig Donation

Twig, 1960
Gouache on paper, 16¹/2 x 11⁵/8 in. (41.3 x 29.4 cm)
Museum Ludwig, Cologne; Ludwig Donation
© 1995 Vladimir Yakovlev/Licensed by VAGA,
New York
See ill. 127

Religious Curtain, 1969
Gouache and oil on paper, 33⁷/8 x 24 in. (86 x 61 cm)
Collection Kenda and Jacob Bar-Gera, Cologne
© 1995 Vladimir Yakovlev/Licensed by VAGA,
New York
See ill. 126

Portrait of Boris Pasternak, 1974–77
Gouache on paper, 31¹/2 x 23¹/2 in. (80 x 60 cm)
Collection Vladimir Patsukov, Moscow
© 1995 Vladimir Yakovlev/Licensed by VAGA,
New York
See plate 32

Self-Portrait, 1977
Oil on canvas, 32 x 39³/4 in. (81.5 x 101 cm)
K. Nowikovsky Collection, Vienna
© 1995 Vladimir Yakovlev/Licensed by VAGA,
New York
See ill. 128

Vladimir Yankilevsky

Triptychon No. 4, 1964
Oil, metal, orgalite, and wood,
3 ft. 10¹/2 in. x 13 ft. 5¹/4 in. x 8³/4 in. (1.2 x 4.1 x.2 m)
Museum Bochum, Germany; Permanent Loan from
the Artist
© 1995 Vladimir Yankilevsky/Licensed by VAGA,
New York
See plate 31; ill. 130

Mutants (from *The Mutants Series*), 1975
Ink and watercolor on paper, 8¹/2 x 12³/4 in.
(21.5 x 32.5 cm)
Jane Voorhees Zimmerli Art Museum, Rutgers,
The State University of New Jersey, The Norton and
Nancy Dodge Collection of Nonconformist Art from
the Soviet Union

Sketch for the Moment of Eternity, 1975
Pastel and gouache on paper, 17¹/2 x 25¹/2 in.
(44.5 x 65 cm)
Jane Voorhees Zimmerli Art Museum, Rutgers,
The State University of New Jersey, The Norton and
Nancy Dodge Collection of Nonconformist Art from
the Soviet Union

Untitled, 1975
Ink and watercolor on paper, 9 x 13 in. (23 x 33 cm)
Jane Voorhees Zimmerli Art Museum, Rutgers,
The State University of New Jersey, The Norton and
Nancy Dodge Collection of Nonconformist Art from
the Soviet Union
© 1995 Vladimir Yankilevsky/Licensed by VAGA,
New York
See ill. 129

Prophet, n.d.
Oil, wood, and metal, 58³/4 x 35¹/2 in. (149 x 90 cm)
Jane Voorhees Zimmerli Art Museum, Rutgers,
The State University of New Jersey, The Norton and
Nancy Dodge Collection of Nonconformist Art from
the Soviet Union
© 1995 Vladimir Yankilevsky/Licensed by VAGA,
New York
See ill. 131

Solomon Yudovin

Head of an Old Man, 1922
Wood engraving on paper, 7 x 4¹/4 in. (17.8 x 10.8 cm)
YIVO Institute for Jewish Research, New York

Market (from *Bygone Days Series*), 1924
Wood engraving on paper, 2 x 3¹/2 in. (5 x 8.9 cm)
YIVO Institute for Jewish Research, New York

At the Well (from *Bygone Days Series*), 1926
Wood engraving, 4¹/4 x 4⁷/8 in. (10.8 x 12.4 cm)
YIVO Institute for Jewish Research, New York

Bathhouse (from *Bygone Days Series*), 1926
Wood engraving on paper, 4¼ x 4 in (10.8 x 10.1 cm)
YIVO Institute for Jewish Research, New York

By the Graveyard, 1926
Wood engraving, 3⅞ x 3 in. (9.8 x 7.6 cm)
YIVO Institute for Jewish Research, New York

Vitebsk Outskirts (from *Bygone Days Series*),
1926
Woodcut on paper, 4¼ x 4¼ in. (10.8 x 10.8 cm)
YIVO Institute for Jewish Research, New York

Shabbat, ca. 1920–26
India ink on paper, 4¾ x 6½ in. (12 x 16.5 cm)
Collection Vladimir Paleev, Moscow
See ill. 133

Funeral, 1927
Wood engraving on paper, 4⅝ x 6¾ in.
(11.7 x 17.1 cm)
YIVO Institute for Jewish Research, New York

Old Synagogue, 1927
Wood engraving on paper, 3½ x 4¼ in.
(8.9 x 10.8 cm)
YIVO Institute for Jewish Research, New York

Through a Shtetl, 1927
Wood engraving on paper, 2½ x 4 in. (6.3 x 10.1 cm)
YIVO Institute for Jewish Research, New York

Man and Woman (from *Pogrom Series*), 1928
Wood engraving on paper, 5¼ x 3⅞ in.
(13.3 x 9.8 cm)
YIVO Institute for Jewish Research, New York
See ill. 132

On the March, 1928
Linoleum cut on paper, 4 x 4½ in. (10.1 x 11.4 cm)
YIVO Institute for Jewish Research, New York

Factory Scene, 1932
Wood engraving on paper, 2½ x 1⅝ in. (6.3 x 4.1 cm)
YIVO Institute for Jewish Research, New York

In the Factory: A Call to Fight Injustice, 1932
Engraving on paper, sheet size: 4¼ x 5⅝ in.
(10.8 x 14.3 cm)
YIVO Institute for Jewish Research, New York

Scenes from a Publishing Press, 1932
Wood engraving on paper, 4⅞ x 3½ in.
(12.3 x 8.9 cm)
YIVO Institute for Jewish Research, New York
See ill. 134

From *Jewish Folk Ornament Series*, 1933
Wood engraving on paper, 1⅞ x 3¼ in. (4.7 x 8.2 cm)
YIVO Institute for Jewish Research, New York

From *Jewish Folk Ornament Series*, 1935
Wood engraving on paper, 2½ x 6⅜ in.
(6.3 x 16.2 cm)
YIVO Institute for Jewish Research, New York

From *Jewish Folk Ornament Series*, 1935
Wood engraving on paper, 3½ x 3⅜ in. (8.2 x 8.6 cm)
YIVO Institute for Jewish Research, New York

The Shoemaker, 1935
Wood engraving on paper, 5⅞ x 3¾ in.
(14.7 x 9.5 cm)
Moldovan Family Collection, New York

Georgy Zelma

Samarkand—Call of the Muezzin, 1924
Gelatin-silver print, 13¼ x 10¾ in. (33.65 x 27.3 cm)
Lent by Howard Schickler Fine Art, New York

The Voice of Moscow, Uzbekistan, 1925
Gelatin-silver print, 15¾ x 11⅞ in. (40 x 30 cm)
Lent by Galerie Alex Lachmann, Cologne
See plate 17

Brigade Meeting on the Kolkhoz, 1929
Gelatin-silver print, 14½ x 18⅞ in. (37 x 48 cm)
Lent by Galerie Alex Lachmann, Cologne
See ill. 135

The Tanks Are under Way, late 1920s
Gelatin-silver print, 11¾ x 19½ in. (29.8 x 49.5 cm)
Lent by Galerie Alex Lachmann, Cologne

On Guard, ca. 1931
Gelatin-silver print, 15⅛ x 11½ in. (39.5 x 29 cm)
Lent by Galerie Alex Lachmann, Cologne
See ill. 136

German Soldiers, 1942
Gelatin-silver print, 14¾ x 9⅞ in. (37.5 x 25 cm)
Lent by Galerie Alex Lachmann, Cologne

Helmets, 1942
Gelatin-silver print, 7⅞ x 11⅝ in. (19.9 x 29.5 cm)
Lent by Galerie Alex Lachmann, Cologne

Soldier with Molotov Cocktail, 1942
Gelatin-silver print, 7⅞ x 11⅜ in. (19.9 x 28.2 cm)
Lent by Galerie Alex Lachmann, Cologne
See ill. 137

Selected Documents in the Exhibition

Books, Periodicals, and Exhibition Catalogues

Vladimir Stasov and Baron David Guenzberg
L'Ornement hébreu (Hebrew Ornament)
Berlin: S. Calvary and Co., 1905
23 1/4 x 18 1/2 in. (59 x 47 cm)
Collection of the Library of The Jewish Theological
Seminary of America, New York

Nikolai Lavrsky
Iskusstvo i evrei (Art and the Jews)
Moscow: Zhizn, 1915
8 x 5 1/2 in. (20.3 x 14 cm)
Helix Art Center, San Diego

El Lissitzky
*Katalog vystavki khudozhnikov-evreev
(Catalogue of the Exhibition of Jewish Artists)*
Moscow: Jewish Society for the Encourage-
ment of the Arts, 1917
6 1/2 x 5 in. (16.5 x 12.7 cm)
Collection Alex Rabinovich, New York

Iosif Chaikov
Shveln (Doorways), by Peretz Markish
Kiev: Yidisher Folks Farlag, 1919
8 1/2 x 5 3/8 in. (21.7 x 13.8 cm)
YIVO Institute for Jewish Research, New York
See Stanislawski, fig. 4

Iosif Chaikov and Alexander Tyshler
Shretelakh (Gnomes)
Kiev: Yidisher Folks Farlag, 1919
11 x 8 1/2 in. (27.9 x 21.6 cm)
YIVO Institute for Jewish Research, New York

El Lissitzky
Yingl tsingl khvat (The Mischievous Boy),
by Mani Leib
Kiev and St. Petersburg: Yidisher Folks Farlag,
1919
10 x 8 1/8 in. (25.4 x 20.6 cm)
Collection of the Library of The Jewish Theological
Seminary of America, New York

Natan Altman
Vladimir Ilich Lenin
St. Petersburg, 1921
9 1/2 x 7 1/2 in. (24.1 x 19.1 cm)
Lent by Svetlana Aronov, New York

Marc Chagall
Troier (Mourning), poems by David Gofshtein
Kiev: Kultur Lige, 1922
12 1/2 x 10 1/4 in. (31.8 x 26 cm)
Collection Alex Rabinovich, New York

El Lissitzky
Pro dva kvadrata (Of Two Squares)
Berlin: Skythen Verlag, 1922
10 5/8 x 8 5/8 in. (27 x 21.9 cm)
Lent by Svetlana Aronov, New York

El Lissitzky
*Shest povestei o legkikh kontsakh (Six Tales
with Easy Endings)*, by Ilya Ehrenburg
Moscow and Berlin: Gelikon, 1922
8 1/4 x 14 in. (20.2 x 13.8 cm)
Sackner Archive of Concrete and Visual Poetry,
Miami
See Shatskikh, fig. 3

El Lissitzky
*Der milner, di milnerin un di milshtayner
(For Little Children: The Miller, His Wife
and the Millstones)*, by Uncle Ben Zion
(Ben Zion Raskin)
Warsaw: Kultur Lige, 1922
9 3/4 x 8 in. (25 x 20.5 cm)
Sackner Archive of Concrete and Visual Poetry,
Miami

El Lissitzky
*Vaysrusische folkmayses (Belorussian Folk-
tales)*, translated into Yiddish by Leib Kvitko
FSSR: Jewish Section of the People's Commis-
sariat for Education, 1923
8 3/8 x 6 1/4 in. (21.3 x 15.9 cm)
YIVO Institute for Jewish Research, New York

Issachar Ryback
*Mayselekh far kleyninke kinderlekh (Stories
for Little Children)*, by Miriam Margolin
Petrograd: Jewish Section of the People's
Commissariat for Education, 1922
8 1/4 x 10 7/8 in. (21 x 27.6 cm)
YIVO Institute for Jewish Research, New York

Natan Altman, David Shterenberg, and
Marc Chagall
Exhibition of the Three
Moscow: Kultur Lige, March–April 1922
5 3/8 x 8 1/2 in. (13.5 x 21.6 cm)
Helix Art Center, San Diego

Natan Altman
Evreiskaya grafika (Jewish Graphics),
by Max Osborn
Berlin: Petropolis, 1923
12 x 9 3/8 in. (30.5 x 23.8 cm)
Collection Nicolas V. Iljine, Frankfurt/Main
See Maisels, fig. 6

El Lissitzky
Dlya golosa (For the Voice), by Vladimir
Mayakovsky
Berlin: Lutze & Vogt GmbH, 1923
7 3/8 x 5 1/4 in. (18.7 x 13.3 cm)
Lent by Svetlana Aronov, New York

Nisson Shifrin
*Yungvald, tsvayvokhnblat far yunge arbeter
(Young Forest, A Biweekly for Young
Workers)*, 1923
10 x 8 in. (25.4 x 20.3 cm)
Russian State Archive of Art and Literature, Moscow

Rimon, a Hebrew Magazine of Arts and Letters
Berlin: Jewish Art and Literature Publishing
Company, Ltd., 1923
13 1/4 x 9 7/8 in. (33.6 x 25.1 cm)
Private Collection

Isaak Rabichev
*Moskver melukhisher yidisher kamer teater
(Moscow State Jewish Chamber Theater)*
Kiev: Kultur Lige, 1924
10 3/4 x 7 3/4 in. (27.3 x 19.7 cm)
Helix Art Center, San Diego

Iosif Chaikov
Bereshit (In the Beginning)
Moscow and Leningrad, 1926
9 x 6 1/4 in. (23.1 x 15.9 cm)
Moldovan Family Collection, New York

Issachar Ryback
*Sur les champs juifs de l'Ukraine (On the
Jewish Fields of the Ukraine)*
Paris: A. Simon et Cie, 1926
15 x 11 in. (38 x 28 cm)
The Jewish Museum, New York

Alexander Tyshler
*Hagodeh far gloiber un apikorsim (Haggadah
for Believers and Atheists)*, by M. Altschuler
Moscow: Tsentral Farlag, 1927
7 3/4 x 5 1/2 x 1/4 in. (19.7 x 14 x .7 cm)
Beinecke Rare Book and Manuscript Library,
Yale University, New Haven

Oktyabryata (October Children)
Moscow: Central Publishing House of the
Peoples of the USSR, 1927
9 1/2 x 6 1/2 in. (24 x 16.5 cm)
Collection Dr. and Mrs. Ira Rezak, Stony Brook,
New York

Issachar Ryback
*Pionern-bikhl: me shlist oys derfar (Little Book
for Pioneers: You Can Be Dismissed for This)*,
by Leib Kvitko
Kharkov: Knihaspilka, 1928
10 1/4 x 7 in. (26 x 17.8 cm)
YIVO Institute for Jewish Research, New York

*Komsomolishe Hagodeh (Komsomol
Haggadah)*
Kharkov, 1930
9 1/8 x 6 1/8 in. (23.2 x 15.6 cm)
The Jewish National and University Library,
Jerusalem

El Lissitzky
Der apikoires (The Atheist)
Moscow: Association of Militant Atheists, May
1931, no. 3
12 x 8¹/2 in. (30.5 x 21.6 cm)
YIVO Institute for Jewish Research, New York
See fig. on p. 15

El Lissitzky
*Raboche-krestyanskaya krasnaya armiya
(Workers' and Peasants' Red Army)*
Moscow: Izogiz, 1934
11⁷/8 x 14 in. (30 x 35.5 cm)
Lent by Svetlana Aronov, New York

Solomon Telingater
1914, 1934
11 x 10³/8 in. (27.8 x 26.5 cm)
Collection Merrill C. Berman

Solomon Telingater
1914, by Ilya Feinberg
Moscow, 1934
9⁷/8 x 7 in. (25.1 x 17.8 cm)
Lent by Barbara Leibowits Graphics Ltd.,
New York

Alexander Tyshler
Ulyalayevschina, by Ilya Selvinsky
Moscow: OGIZ GIKhL (Main Publishing House
of Literature), 1934
10¹/2 x 7¹/2 in. (26.7 x 19.1 cm)
Helix Art Center, San Diego

A. Dovgal
*A mayse vegn a maydele mitn royten tichele
(A Story about a Girl with a Red Scarf)*, by Leib
Kvitko
Odessa: Kinder Farlag, 1936
9 x 11¹/2 in. (22.9 x 29.2 cm)
Moldovan Family Collection, New York
See fig. on p. 23 (top)

Igor Palmin
Artists participating in "Twenty Moscow Artists,"
***Beekeeping Pavilion of the Exhibition of Economic
Achievements, Moscow,** February–March 1975
**Photograph, 7¹/4 x 9¹/4 in. (18.4 x 23.5 cm)
Courtesy Igor Palmin, Moscow**

Boris Friedland
*Podzhigateli voiny (karikatury)
(The Warmongers [caricatures])*
Moscow: Iskusstvo, 1938
10 x 7¹/2 in. (25.4 x 19.1 cm)
New York Public Library

*Dertsaylungen vegn khaver Stalin (Stories
about Comrade Stalin)*
Kiev: Ukranian State National Minorities
Publishing House, 1939
9 x 7 in. (23 x 18 cm)
Collection Dr. and Mrs. Ira Rezak, Stony Brook,
New York

Ilya Kabakov
Osya i ego druzya (Osya and His Friends),
by Boris Olevsky; translated from Yiddish
by L. Yutkevich
Moscow: Detgiz, 1956
9 x 6¹/2 in. (22⁷/8 x 16.5 cm)
Collection Ilya and Emilia Kabakov, New York

A-Ya, Unoffical Russian Art Review
Paris, 1980, 1981, 1983, 1984, 1986
Each 11³/4 x 9¹/2 in. (29.9 x 24.1 cm)
Collection Leonid Lamm, New York

*Di velt is far dir ofn (The World Is Open
for You)*
Khabarovsk: Khabarovsk Book Publishing
House, 1989
8³/4 x 6³/4 in. (22.2 x 17.1 cm)
Moldovan Family Collection, New York

Sheet Music

Leonid Pasternak
Jüdische volkslieder (Jewish Folk Melodies),
arranged by Joel Engel
Moscow: P. Jurgenson, ca. 1912
11⁷/8 x 8¹/4 in. (30.2 x 20.9 cm)
YIVO Institute for Jewish Research, New York

Moisei Maimon
Oi, efn mir oif (Open the Door for Me),
arranged by H. Kopit
St. Petersburg: Society for Jewish Folk Music,
1914
13³/8 x 10⁵/8 in. (34 x 27 cm)
YIVO Institute for Jewish Research, New York

El Lissitzky
*Az ikh volt gehat ot do vos ikh mayn (If I Only
Had What I Wish . . .)*, by Joel Engel
Moscow: Society for Jewish Music, 1919
12³/8 x 9³/4 in. (31.4 x 24.8 cm)
The Jewish Museum, New York; Gift of William and
Lisa Gross, Tel Aviv
See Goodman, fig. 2

Tsvitchi, tsvitchi by A. Dmitrovsky, translated
into Yiddish by Leib Kvitko
Kiev: Kultur Lige Music Section, ca. 1920
9¹/8 x 6³/8 in. (23.2 x 16.2 cm)
Helix Art Center, San Diego

Grigory Bondarenko
*Evreiskaya melodiya dlya fortepiano (A Jewish
Melody for the Piano)*, by Mark Ulshtein
Kiev, ca. 1924
12¹/2 x 10 in. (31.8 x 25.4 cm)
Helix Art Center, San Diego

Ephemera

Mark Antokolsky
Letter to Baron Horace Guenzberg,
30 May 1893
11¹/2 x 8 in. (29.2 x 20.3 cm)
Russian State Archive of Art and Literature, Moscow

Vladimir Stasov
Letter to Baron Horace Guenzberg,
28 October 1902
11¹/2 x 8 in. (29.2 x 20.3 cm)
Russian State Archive of Art and Literature, Moscow

Minutes of the Organizing Session of the
An-sky Expedition, St. Petersburg, 1911
14 x 8¹/2 in. (35.5 x 21.6 cm)
YIVO Institute for Jewish Research, New York

Marc Chagall
Two Letters to Mstislav Valerianovich (Dobu-
zhinsky), Paris, 1911
Each 6⁷/8 x 8³/4 in. (17.5 x 22.2 cm)
Collection Nicolas V. Iljine, Frankfurt/Main

Semyon An-sky (Shlomo-Zanvel Rappaport)
The Dybbuk, Vilna, 1919
Manuscript, 14 x 8¹/2 in. (35.5 x 21.6 cm)
YIVO Institute for Jewish Research, New York

Abraham Manievich
Memoir about the 1918 Pogrom in Kiev,
ca. 1919
Manuscript, seven pages, 11 x 7¹/2 in. (27.9 x 19 cm)
YIVO Institute for Jewish Research, New York

Mikhail Adamovich
Kto ne rabotaet tot ne est (He Who Does Not Work Does Not Eat), after a portrait of Lenin
by Natan Altman, 1921
Porcelain plate, d: 10 in. (25.4 cm)
Private Collection, Courtesy of A La Vieille Russie

Mikhail Adamovich
Soviet Porcelain Mug, ca. 1924–28
H: 3³/4 in. (9.5 cm)
Collection Craig H. and Kay A. Tuber, Illinois

Marc Chagall
Eygns (My Own), 1924
Manuscript, pages 1–5, 10¹/2 x 8¹/4 in. (26.7 x 21 cm)
YIVO Institute for Jewish Research, New York

Minutes of the Jewish Ethnographic and Historical Society, Leningrad, 1925
13¹/4 x 8¹/2 in. (35.5 x 21.6 cm)
YIVO Institute for Jewish Research, New York

Alexander Bykhovsky
Bluzhdayushchye zvyozdy (Wandering Stars),
screenplay by Isaak Babel, based on story by
Sholem Aleichem
Moscow: Kinopechat, 1926
8³/4 x 7 in. (21.3 x 17.8 cm)
Helix Art Center, San Diego

OZET Lottery Ticket, 1932
3³/8 x 4⁵/8 in. (8.5 x 11.5 cm)
Collection Dr. and Mrs. Ira Rezak, Stony Brook, New York

Marc Chagall
Letter to Isaak Brodsky, Paris, December 1933
6⁷/8 x 8³/4 in. (17.5 x 22.2 cm)
Russian State Archive of Art and Literature, Moscow

Letter from Laverty Beria to Isaak Brodsky,
27 November 1935
11¹/2 x 8 in. (29.2 x 20.3 cm)
Russian State Archive of Art and Literature, Moscow

Isaak Brodsky
Kak ya risoval Lenina (How I Painted Lenin),
1936
Manuscript, 11³/4 x 8³/8 in. (29.7 x 21.1 cm)
Russian State Archive of Art and Literature, Moscow

Isaak Brodsky
Moi vstrechi so Stalinym (My Meetings with Stalin), April 1938
Manuscript, 11³/4 x 8³/8 in. (29.7 x 21.1 cm)
Russian State Archive of Art and Literature, Moscow

Natan Altman
Kogda ya lepil Lenina (When I Sculpted Lenin),
1 January 1940
Manuscript, 11³/4 x 8³/8 in. (29.7 x 21.1 cm)
Russian State Archive of Art and Literature, Moscow

"The Second Meeting of the Representatives of the Jewish People," Founding Declaration of the Jewish Anti-Fascist Committee
Pravda, Moscow, 25 May 1942
23¹/2 x 16³/8 in. (59.6 x 41.5 cm)
YIVO Institute for Jewish Research, New York

Moisei Nappelbaum
Autobiography, 1951
Manuscript, 12 x 8 in. (30.5 x 20.3 cm)
Russian State Archive of Art and Literature, Moscow

Ernst Neizvestny
Sketch for Khrushchev's Tomb, 1971–72
Pencil and pen on paper, 17 x 14 in. (43.2 x 35.6 cm)
Lent by the Artist, New York
See Goodman, fig. 8

Vitaly Komar and Alexander Melamid
Letter to the Union of Artists Petitioning for an Exhibition, 23 October 1972
11¹/2 x 8¹/2 in. (29.2 x 21.6 cm)
Collection Vitaly Komar and Alexander Melamid, New York

Invitation to "Bulldozer" Exhibition, Moscow,
1974
6⁷/8 x 9 in. (17.5 x 22.9 cm)
Collection Vitaly Komar and Alexander Melamid, New York

Letter from the Soviet Court to Komar and Melamid Refusing Compensation for Destruction of Their Works during the "Bulldozer" Exhibition, Moscow, 3 November 1975
6⁷/8 x 9 in. (14.5 x 22.9 cm)
Collection Vitaly Komar and Alexander Melamid, New York

Letter from I. A. Popov, Chairman of the Moscow Chapter of the Union of Artists, to the Court in Rostov: Request to Commute Leonid Lamm's Imprisonment, Moscow, 23 March 1976
11³/4 x 8¹/4 in. (29.8 x 21 cm)
Collection Leonid Lamm, New York

Posters

Artist Unknown
Stimt far dem tsiyonistishen tsetl 6 (Vote for Zionist List No. 6), 1917
23¹/4 x 18¹/8 in. (59 x 46.2 cm)
Moldovan Family Collection, New York

Artist Unknown
Stimt nor farn tsetl 18 (Vote for Slate No. 18),
1918
29³/4 x 19⁷/8 in. (75.6 x 50.5 cm)
Moldovan Family Collection, New York

Solomon Yudovin
Yidishe Folkspartei Election Poster, 1918
28 x 21 in. (71.1 x 53.3 cm)
Moldovan Family Collection, New York
See Stanislawski, fig. 3

Jewish State Chamber (Kamerny) Theater, 1919
61¹/2 x 45⁷/8 in. (156.2 x 116.5 cm)
Russian State Archive of Art and Literature, Moscow

Three one-acters by Sholem Aleichem: Agentn. Salign, Get, and Mazeltov; Gosekt, Moscow,
ca. 1922
35⁷/8 x 25³/8 in. (91 x 64.5 cm)
Russian State Archive of Art and Literature, Moscow

Isaac Rabinovich
Di kishefmakherin (The Sorceress),
by Abraham Goldfaden; Goset, Moscow,
1930s
35¹/4 x 105¹/2 in. (89.5 x 268 cm)
Russian State Archive of Art and Literature, Moscow

Natan Altman
Evreiskoe schaste (Jewish Luck), directed by
Alexander Granovsky; based on the story by
Sholem Aleichem, 1925
40³/4 x 29 in. (103.5 x 73.7cm)
Collection Merrill C. Berman

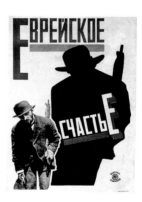

Robert Falk
Noch na starom rynke (Night on the Old Market Square), by Issac Leib Peretz; Goset,
Moscow, 1925
36³/4 x 24¹/2 in. (93.3 x 62 cm)
Russian State Archive of Art and Literature, Moscow

Desyatyved (The Tenth Commandment), by Jacob Gordin; Goset, Moscow, 17 January 1926
93¹/₂ x 62¹/₂ in. (237.5 x 158.8 cm)
Russian State Archive of Art and Literature, Moscow

Issachar Ryback
Boit a komunistishn lebn in the felder fun SSSR (Build Communist Life in the Fields of the Soviet Union),
1926
38 x 26³/₄ in.
(96.5 x 67.9 cm)
Moldovan Family
Collection, New York

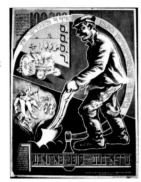

Natan Altman
The Dybbuk, by Semyon An-sky; Habimah, Moscow, 18 January 1927
The Theater Museum (Haaretz Museum), Tel Aviv

Mikhail Dlugach
Bluzhdayushchie zvyozdy (Wandering Stars), film based on the story by Sholem Aleichem, 1927
42 x 27³/₄ in. (106.5 x 70.5 cm)
Lent by Productive Arts, Brooklyn Heights, Ohio
See fig. on p. 23, (bottom)

Truadek, ekstsentrichnaya operetta (Trouhadec, Eccentric Operetta), after the novel by Jules Romaine; Goset, Moscow, 1927
42 x 28³/₈ in. (108 x 72 cm)
Russian State Archive of Art and Literature, Moscow

Nikolai Denisovsky
Kto antisemit (Who Is an Anti-Semite?),
ca. 1927–30
42³/₄ x 29⁵/₈ in. (108.6 x 75.2 cm)
The Jewish Museum, New York
See Stanislawski, fig. 7

Mikhail Dlugach
Second OZET Lottery ("Jewish Farmer Builds Socialism with Every Turn of the Tractor Wheel. Help Him!"), 1929
25¹/₄ x 18¹/₂ in. (63 x 46 cm)
Lent by Productive Arts, Brooklyn Heights, Ohio

Mikhail Dlugach
Second OZET Lottery ("Thousands of Chances to Win in the Second OZET Lottery"), 1929
42³/₄ x 29 in. (108.6 x 73.6 cm)
Moldovan Family Collection, New York

Mikhail Dlugach
Second OZET Lottery ("We Will Do Away with the Past Sooner if We Play the OZET Lottery"), 1929
28 x 42¹/₈ in. (71 x 107 cm)
Lent by Productive Arts, Brooklyn Heights, Ohio

Alexander Tyshler
Antisemitizm – soznatelnaya kontr-revolyutsiya. Antisemitizm – nash klassovy vrag (Anti-Semitism Is a Conscious Counterrevolution. Anti-Semitism Is Our Class Enemy), 1929
19³/₈ x 27¹/₈ in. (49.2 x 68.9 cm)
Collection Nicolas V. Iljine, Frankfurt/Main

Artist Unknown
Der kheyder firt tsum . . . (Cheder Leads to . . .), ca. 1929
42¹/₈ x 28³/₈ in. (107 x 72 cm)
On Loan from the Witnesses to History Poster Collection, The Judah L. Magnes Museum, Berkeley, California

Far der Leninisher generaler linie fun der partei un Komintern (For Leninist General Line, for the Party and the Comintern), 1930s
24³/₄ x 40¹/₂ in. (62.9 x 102.9 cm)
Moldovan Family Collection, New York

Mikhail Dlugach
Third OZET Lottery ("Three Million for Agriculture and Industrialization of Jewish Masses"), 1930
41 x 28 in. (102.5 x 69 cm)
Lent by Productive Arts, Brooklyn Heights, Ohio

Mikhail Dlugach
Third OZET Lottery, 1930
28¹/₄ x 40 in. (71 x 99 cm)
Lent by Productive Arts, Brooklyn Heights, Ohio

Mikhail Dlugach
Cherez ferband ORT mogut poluchit: bezrabotnie kustary i remeslenniki . . .(Through the ORT Union the Jobless Artisans and Craftsmen Can Receive . . .), 1930
28 x 42¹/₈ in. (71.1 x 107 cm)
Moldovan Family Collection, New York

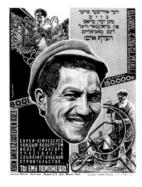

Mikhail Dlugach
Stroite sotsialistichesky Birobidzhan (Build a Socialist Birobidzhan), 1932
41³/₈ x 27¹/₈ in. (105.1 x 68.9 cm)
Moldovan Family Collection, New York
See Stanislawski, fig. 6

Mikhail Dlugach
Fifth OZET Lottery, 1933
15³/₄ x 20⁷/₈ in. (40 x 53 cm)
Lent by Productive Arts, Brooklyn Heights, Ohio

Mikhail Dlugach
Stroiteli Birobidzhana (Builders of Birobidzhan), 1933
33¹/₂ x 23 in. (85.1 x 58.4 cm)
Lent by Productive Arts, Brooklyn Heights, Ohio

Artist Unknown
Religie iz a shterung farn finfyor plan (Religion Is an Obstacle to the Five-Year Plan), 1930s
30¹/₄ x 42 in. (76.8 x 106.7 cm)
Moldovan Family Collection, New York
See Stanislawski, fig. 5

Alexander Tyshler
Moltsayt (The Meal), by Peretz Markish; Goset, Moscow, 16 November 1939
86⁷/₈ x 61⁷/₈ in. (220.6 x 157.2 cm)
Russian State Archive of Art and Literature, Moscow

Nikolai Denisovsky and Nina Vatolina
Shtimt far der partei fun Lenin-Stalin (Vote for the Party of Lenin-Stalin), 1940
35¹/₂ x 24¹/₂ in. (90.2 x 62.2 cm)
Helix Art Center, San Diego

Alexander Tyshler
Freylekhs (With Joy); Goset, Moscow, 27 August 1946
66¹/₂ x 90¹/₂ in. (168.9 x 229.9 cm)
Russian State Archive of Art and Literature, Moscow

N. A. Cherepanov
Zionism – Puppet of CIA, 1982
26¹/₂ x 17¹/₂ in. (67.3 x 44.5 cm)
Collection Evgeny and Irina Lein, Jerusalem
See Stanislawski, fig. 8

Di letste role (Her Last Performance); Jewish Chamber Musical Theater, Moscow, ca. 1980
33³/₈ x 22³/₄ in. (84.7 x 57.8 cm)
YIVO Institute for Jewish Research, New York

Lomir ale ineinem (Let Us All Together); Jewish Chamber Musical Theater, Moscow, 1980s
33³/₄ x 22¹/₂ in. (85.7 x 57.8 cm)
YIVO Institute for Jewish Research, New York

Russian Avant-Garde and Soviet Contemporary Art, Sotheby's, Moscow, 7 July 1988
25 x 18¹/₂ in. (63.5 x 47 cm)
Collection Grisha Bruskin, New York

Glossary

Academy of Arts, St. Petersburg: The primary center for art education in Russia/USSR and the ultimate authority for maintaining artistic standards and controlling the content of exhibitions and commissions. Founded in 1757, the academy became the major influence on the development of Russian painting. After the Bolshevik Revolution of 1917, the academy's main functions were to implement the Communist Party line in the fine arts and to oversee the training of Soviet professional artists. In the 1920s, the academy was also referred to as *Vkhutemas*. After 1947 its name was changed to I. E. Repin Institute of Painting, Sculpture, and Architecture of the USSR.

All-Union: USSR-wide. The term refers to all republics in the Union of Soviet Socialist Republics.

agitprop: "Agitational propaganda" art of the post-Revolutionary period that promoted Soviet state ideology. The term is applied to public art, street decorations, posters, and decorative arts.

AKhRR/AKhR: The AKhRR (Association of Artists of Revolutionary Russia) was organized in 1922. Based on the traditions of the *Wanderers*, this conservative association advocated a return to representationalism in the form of Heroic Realism; its members laid the groundwork for *Socialist Realism* and functioned primarily as an exhibition society based in Moscow. In 1928 the name was change to AKhR (Association of Artists of the Revolution). The group was disbanded in 1932.

Apt Art: An underground alternative socio-artistic movement created by nonconformist artists that centered on artists' apartments or studios.

Asnova: The Association of New Architects (1923–32).

BelGoset: See *Gosekt/Goset*.

Belyutin Studio: A private studio of experimental artists in Moscow, headed by E. M. Belyutin. Formed in 1956, it was tolerated by state authorities. Members were invited to participate in the 1962 show *Thirty Years of Moscow Art* at the Manezh, thus providing artwork for Khrushchev to attack.

Bund: Also known as the General League, a Marxist/Social Democratic labor organization of Jewish workers in Russia and Poland formed in 1897. Lithuania was added in 1901.

Constructivism: An artistic movement that emerged in Petrograd after a series of debates on composition and construction in art. Widespread in the 1920s, the movement initially focused on sculpture created from industrial materials, reflecting contemporary engineering and building techniques. The Constructivists first advocated the abandonment of fine art for *productivism*, but later allowed abstract explorations in painting.

CPSU: Communist Party of the Soviet Union.

Donkey's Tail: A group organized by Mikhail Larionov in 1911. Its one exhibition in Moscow in 1912 included contributions by Natalya Goncharova, Larionov, Kazimir Malevich, Alexander Shevchenko, and others.

Evsektsiya: The Jewish Sections of the propaganda department of the Communist Party, 1918–30. They were committed to assimilating Jews into the new Soviet system, often by eradicating traditional culture.

Ginkhuk: State Institute of Artistic Culture. Ginkhuk was the Petrograd/Leningrad counterpart of *Inkhuk*, which developed from the Petrograd affiliation of the *MZhK* in 1923.

Gosekt/Goset: State Jewish Chamber Theater, 1920–25; State Jewish Theater, 1925–49. Originally founded as the Jewish Chamber Theater studio in Petrograd (1919–20) by Alexander Granovsky, the group relocated to Moscow in November 1920. It was directed by Granovsky until 1938, then by chief actor Solomon Mikhoels until his death in 1948. The organization was also known as the Kamerny Theater or Yiddish State Theater. BelGoset, the Belorussian State Jewish Theater in Minsk, was organized in the 1920s and closed in 1948.

Habimah: Hebrew theater founded in Moscow (1917) following the Revolution. Relocated from the Soviet Union in 1926 to Israel

Haskalah: An Enlightenment movement within Jewish society in Europe from the late 1700s through the late 1800s that promoted secular studies and occupations and contributed to the assimilation of Russian Jews.

Inkhuk: Institute of Artistic Culture. Inkhuk was established as a research institute in Moscow in 1920. Its aim was to formulate an ideological and theoretical approach to the arts based on scientific research and analysis. Inkhuk had affiliations in Petrograd, Vitebsk, and other cities.

Izo Narkompros: Fine Arts Department, People's Commissariat for Education. The art department founded in 1918 under Shterenberg. Izo Narkompros was responsible for art exhibitions, official commissions, art institutes, art education, etc. At first, many of the avant-garde artists were involved in its activities.

Jack of Diamonds (Jack of Diamond): Group organized by Larionov in Moscow in 1910 and supported at first by many radical artists, including Goncharova and Malevich. After its first exhibition in Moscow in 1910–11, the group split into two factions, one led by Larionov—giving rise to *Donkey's Tail*—the other including Falk, Petr Konchalovsky, Aristarkh Lentulov, and others. The Jack of Diamonds organized regular exhibitions in Moscow and St. Petersburg between 1910 and 1917, some of them international in scope.

JSEA: Jewish Society for the Encouragement of the Arts. A Jewish arts society in Petrograd between 1915 and 1917. Branches were formed in Kiev and Kharkov.

Kamerny: Popular name for the Jewish Chamber Theater. Founded by Granovsky as a studio at the end of 1918 in Petrograd, formally named in 1919, and relocated to Moscow in 1920.

kheder: A Jewish elementary school for boys.

Komfut: The Communist Futurists.

Kultur Lige: A Yiddish cultural organization founded in Kiev in 1916 that sponsored art workshops, publications, and exhibitions. When it was taken over by the *Evsektsiya* in 1920, its leaders moved to Warsaw.

La Ruche: "The Beehive," an artists' residence with studios in Paris that served as a home to many East European and Russian Jewish artists from 1902 on.

Lianozovo Group: A group of artists organized by Rabin whose focus was on the immediate environment. Members employed the detritus of life in their work to show off the absurdity of the Soviet system.

lubok (pl: *lubki*): Russian hand-colored popular prints or broadsides generally used for entertainment and instruction. Often depicting allegorical, satirical, or folk figures from ordinary life, most *lubki* were copper engravings, but wood-engraved and manuscript examples were also common.

Makhmadim (Precious Ones): An artists' group centered at *La Ruche* whose members were interested in developing Jewish art. They published the journal *Makhmadim* (1912), considered to be the first modern Jewish art journal.

Manezh: The Central Exhibition Hall in Moscow.

mestechko: Literally "small town," the Russian-language equivalent of *shtetl*.

MOSSKh: The Moscow Section of the Union of Soviet Artists, formed in 1932. In 1938 it was renamed Moscow Union of Soviet Artists (MSSKh) and in 1957, Moscow Organization of the RSFSR Union of Artists (MOSKh).

MUZhVZ: Moscow College of Painting, Sculpture, and Architecture. Founded in 1843, this was the main Moscow art school at which many of Russia's nineteenth- and twentieth-century artists studied, including most of the avant-garde. In 1918 it was integrated with the *Stroganov Art College* to form *Svomas*.

MZhK: Museum of Painterly Culture, Moscow (1919–29).

NEP: New Economic Policy. An economic reform program initiated by Lenin, allowing limited return of private ownership and commerce (1921–28).

numerus clausus: The quota system that regulated Jewish enrollment in Russian Imperial educational institutions between 1882 and 1917.

OSA: Society of Contemporary Architects. Active in Moscow from 1925 until 1930, this group was founded by A. A. and V. A. Vesnin and M. Ia. Ginzburg. Between 1926 and 1930, it regularly published a journal, *Contemporary Architecture (SA/Sovremennaia arkhitektura)*, the principal journal on Constructivist architecture in the Soviet Union.

OST: Society of Easel Painters. Founded in 1925, the group's four exhibitions, held between 1925 and 1928, demonstrated its orientation toward figurative art. Most of the members were former *Vkhutemas* students who often used Expressionist and Surrealist styles.

Pale of Settlement: The area of Tsarist Russia in Poland, Lithuania, Belorussia, Ukraine, Bessarabia, and the Crimea to which Jews were confined by laws of 1791 and 1835. Residency outside the Pale was regulated by permits. The Pale was abolished in March 1915.

Peredvizhniki: Shortened form of Association of Itinerant Art Exhibitions; also known as *Wanderers* or Itinerants. The Wanderers determined the development of Russian art during the second half of the nineteenth century. They rejected the dominant academic styles, concentrating primarily on contemporary Russian themes in order to express their populist humanism. They took their exhibitions to several cities, including Kiev, Odessa, and Kharkov.

pogrom: A Russian word indicating an attack by one social group on another, used to describe the numerous massacres of Jewish populations within the *Pale of Settlement* and Poland from the 1880s through the end of the Civil War in 1921.

productivism: A practice advocated by promoters of *Constructivism* and others. Productivists wanted to extend their experiments in purely abstract art into the real environment by participating in the industrial production of useful objects.

Rayonism: An abstract painting movement started in Russia by Larionov and Goncharova (1911–12).

shtetl: Yiddish term for a small town.

Socialist Realism: An ideology enforced by the Soviet state as the official standard for art, literature, music, etc., established and defined in 1934 at the First *All-Union* Congress of Soviet Writers. Socialist Realism was based on the principle that the arts should promote political and social ideals set by the state in a readily comprehensible manner. The approved artistic styles initially derived from realism, but varied over time.

Sots Art: A term coined by the artists Komar and Melamid in 1972 to describe a Soviet/Soviet émigré art form that originated in the 1970s. It represents a play on words with "Sots" from "Socialist" in Russian and "Pop Art." Sots artists based their works on Soviet propaganda posters and paintings; their approach was frequently ironic and politically oriented.

Stroganov Art College: Central Stroganov Institute of Technical Drawing, Moscow, also known as the Stroganov Art and Industry Institute. After 1917 it merged with the *MUZhVZ* to form *Svomas*.

Suprematism: Malevich originated the term "suprematism" in 1915 to describe "the supremacy of feelings." Suprematist art provides a nonobjective image of the generalized order of nature. According to Malevich, Suprematism was divisible into three stages: black, red, and white. All three of these stages took place between the years 1915 and 1935. Suprematist ideas were applied to architecture and the decorative arts in the 1920s and provided the foundation for the ideas of *Unovis*.

Svomas/GSKhM: State Free Artistic Studios. In 1918 *MUZhVZ* and the *Stroganov Art College* were integrated to form Svomas, and leading art schools in other major cities, including the *Academy of Arts* in Petrograd, were also disbanded. In 1920 Svomas, Moscow, was renamed *Vkhutemas*, and the academy in Petrograd was reinstated. Many avant-garde artists, including Popova, Alexander Rodchenko, and Vladimir Tatlin, contributed to the radical pedagogical and administrative developments that accompanied these name changes.

Union of Soviet Artists: The single official artists' union of the Soviet Union, authorized and controlled by the state. Proposed in 1932, it was fully realized in 1957.

Union of Youth: A group of artists, critics, and aesthetes initiated by Vladimir Markov, Olga Rozanova, Iosif Shkolnik, and others in St. Petersburg in 1910. The group published an art journal under the same name in 1912–13 and sponsored a series of exhibitions between 1910 and 1914 to which many of the avant-garde contributed.

Unovis (Affirmers of the New Art): A group of Suprematist artists founded by Malevich in Vitebsk at the end of 1919 which included Chashnik, Kogan, Lissitzky, and Nikolai Suetin. Unovis had affiliations in Smolensk, Samara, and other cities and held exhibitions in Vitebsk and Moscow.

Vkhutemas/Vkhutein: Vkhutemas (Higher Artistic and Technical Studios) was formed in 1920. Although its structure was altered during its existence, it comprised seven basic departments: painting, sculpture, architecture, ceramics, metal and woodwork, textiles, and typography. It replaced *Svomas* in 1920 and was itself replaced by Vkhutein (Higher Artistic and Technical Institute) in 1926.

Wanderers: See *Peredvizhniki.*

White Russia: Belorussia. The independent Belorussian Soviet Socialist Republic (BSSR), comprising the districts of Vitebsk, Gomel, Minsk, Mogilev, and Polese and those of Western Belorussia, was annexed in 1939. As of that year, approximately one-tenth of its total population were Jews.

World of Art (Mir iskusstva): A group of St. Petersburg artists, critics, and aesthetes founded by Alexandre Benois, Sergei Diaghilev, and others in the late 1890s. They published an art journal under the same name between 1898 and 1904 and sponsored a series of exhibitions between 1899 and 1906 in order to disseminate contemporary art. In 1910 the group was revived as an exhibition society, lasting through 1924. World of Art artists created stage designs for the Ballets Russes (1909–29) and also contributed to the renaissance of book design and illustration in Russia.

YKUF: The Yiddish Culture Association (Yidischer Kultur Farband), which existed in New York during the 1930s and the 1940s.

Zhdanov decrees: Resolutions adopted by the Central Committee of the Communist Party in 1946. Formulated by the Party's secretary and cultural boss, Andrei Zhdanov, these decrees called for stricter government control of the arts and promoted an extreme anti-Western bias.

Selected General Bibliography

I. Jewish Art in Russia and the Soviet Union

Abramsky, Chimen. "The Rise and Fall of Soviet Yiddish Literature." *Soviet Jewish Affairs* 12, no. 3 (1982).

Apter-Gabriel, Ruth, ed. *Tradition and Revolution: The Jewish Renaissance in Russian Avant-Garde Art, 1912–1928.* Exhibition catalogue. Jerusalem: Israel Museum, 1987.

Belinfante, Judith C. E., and Igor Dubov, eds. *Tracing An-sky: Jewish Collections from The State Ethnographic Museum in St. Petersburg.* Exhibition catalogue. Amsterdam: Joods Historisch Museum, 1992.

Berkowitz, Michael. "Art in Zionist Popular Culture and Jewish National Self-Consciousness, 1897–1914." In *Art and Its Uses,* vol. 6. New York: Oxford University Press, 1990.

Golomstock, Igor. "Jews in Soviet Art." In Jack Miller, ed. *Jews in Soviet Culture.* New Brunswick and London: Transaction Books, 1984.

Kampf, Avram. *Chagall to Kitaj.* New York: Praeger, 1990.

———. "In Quest of Jewish Style in the Era of the Russian Revolution." *Journal of Jewish Art* 5 (1978), pp. 48–75.

———. *Jewish Experience in the Art of the Twentieth Century.* South Hadley: Bergin and Garvey, 1984.

Kantsedikas, Alexander. *Semyon An-sky: The Jewish Artistic Heritage—An Album.* Moscow: RA, 1994.

———. ed. *Shedevry evreiskogo iskusstva.* Moscow: Imidzh, 1993.

Kazovskii, Hillel. "The Art Section of the *Kultur Lige.*" *Jews in Eastern Europe* 20–23 (Winter 1993).

Kasovsky, G. *Artists from Vitebsk: Yehuda Pen and His Pupils.* Masterpieces of Jewish Art. Trans. L. Lezhneva. Moscow: Image, 1992.

Marc Chagall and the Jewish Theater. Exhibition catalogue. New York: Solomon R. Guggenheim Museum, 1992.

Old Voices New Faces: Soviet Jewish Artists from the 1920s–1990s. Exhibition catalogue. Washington, DC: B'nai B'rith Klutznick National Jewish Museum, 199[1].

Olkhovsky, Yuri. *Vladimir Stasov and Russian National Culture.* Ann Arbor: UMI Research Press, 1983.

Picon-Vallin, Béatrice. *Le Théâtre juif soviétique pendant les années vingt.* Lausanne: L'Age d'Homme, 1973.

Rajner, Miriam. "The Awakening of Jewish National Art in Russia." *Jewish Art* 16–17 (1990–91), pp. 98–121.

Silver, Kenneth. *The Circle of Montparnasse: Jewish Artists in Paris, 1905–1945.* Exhibition catalogue. New York: The Jewish Museum, 1985.

Tradition and the Vanguard: Jewish Culture in the Russian Revolutionary Era. Exhibition catalogue. San Diego: Founders Gallery, University of San Diego, 1994.

II. History of the Jews and Jewish Culture in Russia and the Soviet Union

Baron, Salo W. *The Russian Jew under Tsars and Soviets.* 2nd edn. New York: Schocken Books, 1987.

Brym, Robert J., and Rozalina Ryvkina. *Between East and West: The Jews of Moscow, Kiev and Minsk.* New York: New York University Press, 1994.

Ehrenburg, Ilya. *Memoirs 1921–1941.* Trans. Tatiana Shebunina. Cleveland and New York: World Publishing Company, 1963.

———. *People and Life: 1891–1921.* New York: Knopf, 1962.

———, and Vasily Grossman. *The Black Book.* New York: Holocaust Library, 1980.

Freedman, Theodore, ed. *Anti-Semitism in the Soviet Union: Its Roots and Consequences.* New York: Freedom Library Press, 1984.

Gitelman, Zvi. *A Century of Ambivalence: The Jews of Russia and the Soviet Union, 1881 to the Present.* New York: Schocken Books, 1988.

———. *Jewish Nationality and Soviet Politics: The Jewish Sections of the CPSU, 1917–1930.* Princeton: Princeton University Press, 1972.

Kochan, Lionel, ed. *The Jews in Soviet Russia since 1917.* London: Oxford University Press, 1972.

Levin, Nora. *The Jews of the Soviet Union since 1917.* 2 vols. New York: New York University Press, 1988.

Miller, Jack, ed. *Jews in Soviet Culture.* New Brunswick and London: Transaction Books, 1984.

Nakhimovsky, Alice Stone. *Russian-Jewish Literature and Identity.* Baltimore and London: Johns Hopkins University Press, 1992.

Roi, Yaacov, and Avi Beker, eds. *Jewish Culture and Identity in the Soviet Union.* New York: New York University Press, 1991.

Samuel, Maurice. *The World of Sholem Aleichem.* New York: Knopf, 1943.

Stanislawski, Michael. *Tsar Nicholas I and the Jews: The Transformation of Jewish Society in Russia, 1825–1855.* Philadelphia: Jewish Publication Society of America, 1983.

Wisse, Ruth R. *I. L. Peretz and the Making of Modern Jewish Culture.* Seattle: University of Washington Press, 1991.

III. History of Russian and Soviet Art

The Aesthetic Arsenal: Socialist Realism under Stalin. Exhibition catalogue. New York: Institute for Contemporary Art, P. S. 1 Museum, 1993.

Agitation for Happiness: Soviet Art of the Stalin Era. Exhibition catalogue. Kassel: Documenta-Halle, 1993.

Anikst, M., and E. Chernevich. *Russian Graphic Design 1880–1917.* New York: Abbeville Press, 1990.

Apt Art: Moscow Vanguard in the '80s. Exhibition catalogue. New York: Contemporary Russian Art Center of America, 1984.

Architectural Drawings of the Russian Avant-Garde. Exhibition catalogue. New York: Museum of Modern Art, 1990.

Art into Life: Russian Constructivism 1914–1932. Exhibition catalogue. Seattle: Henry Art Gallery, University of Washington, 1990.

Avant Garde Revolution Avant Garde: Russian Art from the Michail Grobman Collection. Exhibition catalogue. Tel Aviv: Tel Aviv Museum of Art, 1988.

Baer, Nancy Van Norman. *Theater in Revolution: Russian Avant-Garde Stage Design, 1913–1935.* New York: Thames and Hudson, 1991.

Barron, Stephanie, and Maurice Tuchman, eds. *The Avant-Garde in Russia 1910–1930: New Perspectives*. Exhibition catalogue. Los Angeles: Los Angeles County Museum of Art, 1980.

Barzel, Amnon, and Claudia Jolles, eds. *Contemporary Russian Artists*. Exhibition catalogue. Prato: Museo d'Arte Contemporanea Prato, 1990.

Bird, A. *A History of Russian Painting*. Oxford: Phaidon, 1987.

Bowlt, John E. *The Silver Age: Russian Art of the Early Twentieth Century and the "World of Art" Group*. Massachusetts: Oriental Research Partners, 1979.

———, ed. *Journal of Decorative and Propaganda Arts*, no. 11 (1989). Special issue devoted to Russian design 1880–1980. See also no. 5 (1987), devoted to the same subject and edited by Bowlt.

———, ed. *Russian Art of the Avant-Garde: Theory and Criticism 1902–1934*. New York: Viking Press, 1976; 2nd edn. London: Thames and Hudson, 1988.

———, and Nicoletta Misler. *The Thyssen-Bornemisza Collection: Twentieth-Century Russian and East European Painting*. London: Wilson, 1993.

Bown, Matthew Cullerne. *Art under Stalin*. New York: Holmes and Meier, 1991.

———. *Contemporary Russian Art*. Oxford: Phaidon, 1989.

———, and David Elliot. *Soviet Socialist Realist Painting 1930s–1960s*. Oxford: Museum of Modern Art, 1992.

———, and Brandon Taylor, eds. *Art of the Soviets: Painting, Sculpture and Architecture in a One-Party State, 1917-1992*. Manchester and New York: Manchester University Press, 1993.

Chan-Magomedow, Selim. *Pioniere der sowjetischen Architektur*. Dresden: VEB, 1983. Published in English as *Pioneers of Soviet Architecture*. New York: Rizzoli, 1987.

Chudakov, Grigory, ed. *Pioneers of Soviet Photography*. London: Thames and Hudson, 1983.

Danzker, Jo-Anne Birnie, *et al.*, eds. *Avantgarde & Ukraine*. Exhibition catalogue. Munich: Villa Stuck, 1993.

Drugoe iskusstvo: Moskva 1956–76. 2 vols. Exhibition catalogue. Moscow: Moskovskaya galereya, 1991.

Elliott, David. *New Worlds: Russian Art and Society 1900–1937*. London: Thames and Hudson, 1986.

———, ed. *Photography in Russia, 1840–1940*. London: Thames and Hudson, 1992.

———, and Valary Dudakov. *100 Years of Russian Art 1889–1989 from Private Collections in the USSR*. Exhibition catalogue. London: Lund Humphries, 1989.

Erofeev, Andrei, and Jean-Hubert Martin, eds. *Kunst im Verborgenen: Nonkonformisten in Rußland, 1957–1995*. Exhibition catalogue. Ludwigshafen am Rhein: Wilhelm-Hack-Museum, 1995.

Glezer, Alexander. *Contemporary Russian Art*. Paris, Moscow, and New York: Third Wave, 1993.

Golomshtok, Igor. *Totalitarian Art*. London: Icon, 1990.

———, and Alexander Glezer. *Unofficial Art from the Soviet Union*. London: Secker and Warburg, 1977.

Gray, Camilla. *The Great Experiment: Russian Art 1863–1922*. London: Thames and Hudson, 1962. Reissued as *The Russian Experiment in Art: 1863–1922*. London: Thames and Hudson, 1970. Rev. edn. London: Thames and Hudson, 1986.

Groys, Boris. *The Total Art of Stalinism: Avant-Garde, Aesthetic Dictatorship, and Beyond*. Princeton: Princeton University Press, 1992.

Holo, Selma, ed. *Keepers of the Flame: Unofficial Artists of Leningrad*. Exhibition catalogue. Los Angeles: Fisher Gallery, University of Southern California, 1991.

Ich lebe—Ich sehe: Künstler der achtziger Jahre in Moskau. Exhibition catalogue. Bern: Kunstmuseum, 1988.

Kennedy, J. *The "Mir iskusstva" Group and Russian Art 1898–1912*. New York: Garland, 1977.

Lobanov-Rostovsky, Nina. *Revolutionary Ceramics: Soviet Porcelain 1917–1927*. New York: Rizzoli, 1990.

Lodder, Christina. *Russian Constructivism*. New Haven and London: Yale University Press, 1983.

Noever, Peter, ed. *Tyrannei des Schönen: Architektur der Stalin-Zeit*. Exhibition catalogue. Vienna: Österreichisches Museum für Angewandte Kunst, 1994.

Paris—Moscou 1900–1930. Exhibition catalogue. Moscow and Paris: Ministère de la Culture de l'URSS and Centre Georges Pompidou, 1979.

The Quest for Self-Expression: Painting in Moscow and Leningrad 1965–1990. Exhibition catalogue. Columbus: Columbus Museum of Art, 1990.

Rudenstine, A., S. F. Starr, and G. Costakis, eds. *Russian Avant-Garde Art: The George Costakis Collection*. New York: Harry N. Abrams, 1981.

Rudnitsky, Konstantin. *Russian and Soviet Theater: Tradition and the Avant-Garde*. London: Thames and Hudson, 1988.

Russian and Soviet Painting. Exhibition catalogue. New York: Rizzoli, 1977.

Russische Avantgarde im 20. Jahrhundert: Von Malewitsch bis Kabakov: Die Sammlung Ludwig. Exhibition catalogue. Cologne: Kunsthalle, 1993.

Sarabianov, Dmitrii V. *Russian Art from Neoclassicism to the Avant-Garde: Painting, Sculpture, Architecture*. London: Thames and Hudson, 1990.

Sjeklocha, Paul, and Igor Mead. *Unofficial Art in the Soviet Union*. Berkeley and Los Angeles: University of California Press, 1967.

Sots Art. Exhibition catalogue. New York: New Museum of Contemporary Art, 1986.

Soviet Photography of the 20's and 30's. Exhibition catalogue. Cologne: Galerie Alex Lachmann, 1991.

Tupitsyn, Margarita. *Margins of Soviet Art*. Milan: Giancarlo Politi Editore, 1989.

The Utopian Dream: Photography in Soviet Russia, 1918–1939. Essay by Max Kozloff. Exhibition catalogue. New York: Laurence Miller Gallery, 1992.

Valkenier, Elizabeth K. *Russian Realist Art: The State and Society*. Ann Arbor: Ardis, 1977.

Vitali, Christoph, ed. *Die Grosse Utopie: Die russische Avantgarde 1915–1932*. Exhibition catalogue. Frankfurt: Schirn Kunsthalle, 1992. Published in English as *The Great Utopia: The Russian and Soviet Avant-Garde, 1915–1932*. New York: Solomon R. Guggenheim Museum, 1992.

Von der Revolution zu Perestroika: Sowjetische Kunst aus der Sammlung Ludwig. Exhibition catalogue. Lucerne: Kunstmuseum, 1989.

Yablonskaya, Miuda. *Women Artists of Russia's New Age 1900–1935*. London: Thames and Hudson, 1990.

Index